We Americans have yet to really learn our own
antecedents . . . we tacitly abandon ourselves
to the notion that our United States have been
fashioned from the British Islands only . . .
which is a very great mistake.

—WALT WHITMAN
The Spanish Element in Our Nationality, 1883

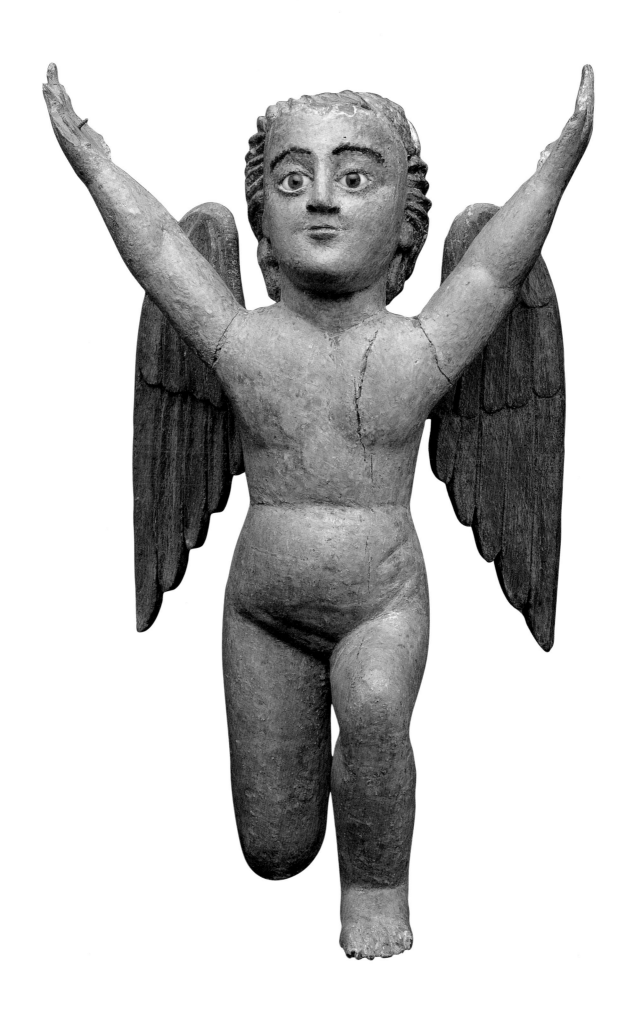

Folk Art of Spain
and the Americas

El Alma del Pueblo

Edited and with an Introduction by
Marion Oettinger, Jr.
Senior Curator
San Antonio Museum of Art

Translated by
Mervyn Samuel

San Antonio Museum of Art
Abbeville Press Publishers
New York London Paris

Published on the occasion of the exhibition *El Alma del Pueblo: Spanish Folk Art and Its Transformation in the Americas,* organized by the San Antonio Museum of Art.

Major funding for this exhibition has been provided by Ford Motor Company.

The United States Tour:

San Antonio Museum of Art
October 17–early January 1998

The Art Museum at Florida
International University, Miami
January–early spring 1998

The Tucson Museum of Art
Spring 1998

Americas Society and The Spanish
Institute, New York
Fall 1998

Chicago Cultural Center
Early 1999

Crocker Art Museum,
Sacramento, California
Spring 1999

San Diego Museum of Art
Summer 1999

First edition
10 9 8 7 6 5 4 3 2 1

Copyedited by Jennifer Lorenzo with assistance by
 Sharon Vonasch and Marie Weiler
Designed by John Hubbard
Produced by Marquand Books, Inc., Seattle

The text of this book was set in Adobe Garamond with display type in Esprit.

Printed in Singapore

Front cover: *La Inmaculada (Our Lady of the Immaculate Conception),* 19th c., plate 82, p. 172

Back cover: *Three Oil Jars,* 18th–19th c., plate 32, p. 63

Page 8: *The World in Reverse,* replica of early 19th c. relief print, Spain, 17½ × 12½ in. (44 × 32 cm), San Antonio Museum of Art

PLATE 1 (frontispiece)
Cherub with Outstretched Arms, 18th c.
Central Spain
Wood, glass eyes, 15 × 12 in. (38 × 30 cm)
Peter P. Cecere, Reston, Virginia

Originally, this cherub was polychromed and probably supported a shelf or column inside a church or chapel. The glass eyes were inserted from behind, after the head had been carved and the face removed. Later, the face was reattached, gessoed, and painted.

PLATE 2 (pages 6–7)
José Cubero, n.d.
Genre Figures Showing Regional Attire, early 19th c.
Valencia, Spain
Painted earthenware, H. approx. 12 in. (30 cm)
The Hispanic Society of America, New York

Library of Congress Cataloging-in-Publication Data

Folk art of Spain and the Americas : El Alma del Pueblo /
 edited and with an introduction by Marion Oettinger, Jr. ;
 translated by Mervyn Samuel.
 p. cm.
 Includes bibliographical references and index.
 Exhibition catalog.
 ISBN 0-7892-0378-2 (hardcover : alk. paper)
 1. Folk art—Spain—Exhibitions. 2. Folk art—Latin
America—Exhibitions. I. Oettinger, Marion. II. San
Antonio Museum of Art.
 NK999.F65 1997
 745'.0946'074764351—dc21 97-14719

Sponsor's Statement

Ford Motor Company is pleased to sponsor the first traveling exhibition devoted to the folk culture of Spain and its influence on the folk art of Latin America and the United States.

El Alma del Pueblo features more than three hundred objects on loan from thirty museums and private collections. It explores the vital role that folk art has played in capturing the traditions of religion, politics, music, dance, and domestic life in Spain since the sixteenth century.

Ford has a long history in Spain dating back to 1907, and our commitment to its rich culture remains strong. Today we employ more than eighty-two hundred people in our state-of-the-art manufacturing and assembly complex in Valencia, components operation in Cádiz, and sales office in Madrid.

All of us at Ford salute the San Antonio Museum of Art, Spain's Ministry of Culture, and the Spanish Embassy in Washington, D.C., for helping to organize this pioneering exhibition. As a strong supporter of the arts, Ford believes they enrich our lives and our communities and help to promote mutual understanding among nations.

May this exhibition help to increase that understanding.

Alex Trotman
FORD MOTOR COMPANY

<-+->

Contents

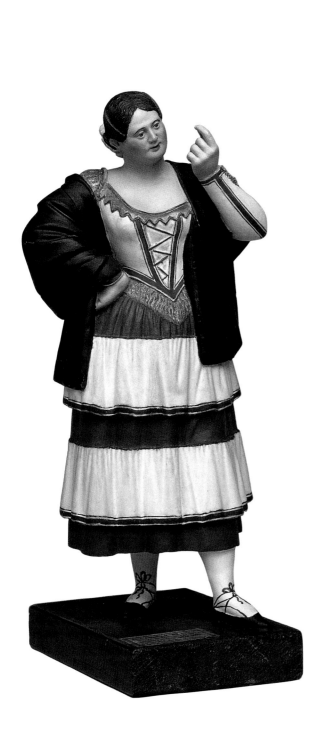

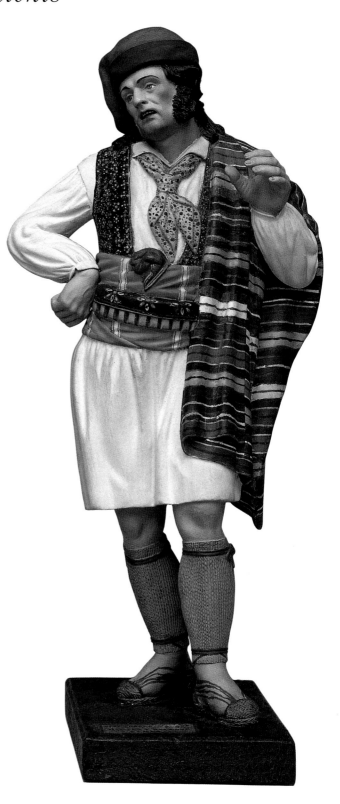

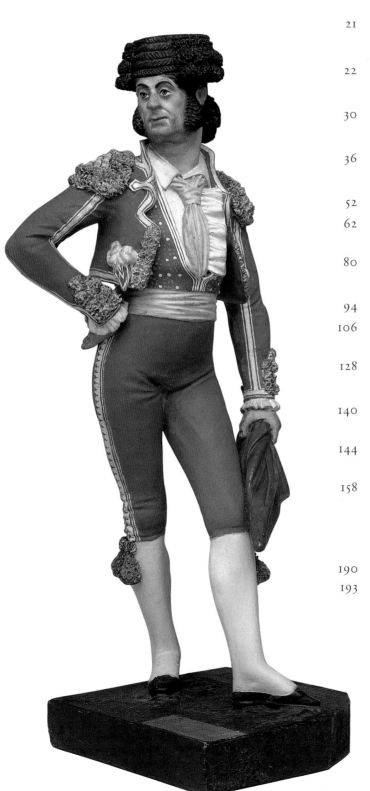

11 Foreword
 Douglas K. S. Hyland, San Antonio

13 Foreword
 Alberto Bartolomé Arraiza, Madrid

19 Preface
 Manuel Berges Soriano, Madrid

21 Map of Spain

22 INTRODUCTION
 Marion Oettinger, Jr., San Antonio

30 COMMON THEMES AND REGIONAL VARIATIONS
 María Antònia Pélauzy, Barcelona

36 POPULAR PRINTS: A REFLECTION OF SOCIETY
 Vicente Ribes Iborra, Valencia

52 UTILITARIAN FOLK ART

62 Folk Ceramics
 Andrés Carretero Pérez, Madrid

80 Popular Furniture
 Carlos Piñel, Zamora

94 CEREMONIAL FOLK ART

106 Votive Art: Miracles of Two Thousand Years
 María del Carmen Medina San Román, Sevilla

128 Popular Performance in Traditional Spain
 Stanley Brandes, Berkeley, California

140 THE TRANSFORMATION OF SPANISH FOLK ART
 IN THE AMERICAS

144 Constructing a Tradition
 María Concepción García Sáiz, Madrid

158 Miraculous Images and Living Saints in Mexican
 Folk Catholicism
 William Wroth, Bloomington, Indiana

190 List of Illustrations

193 Index

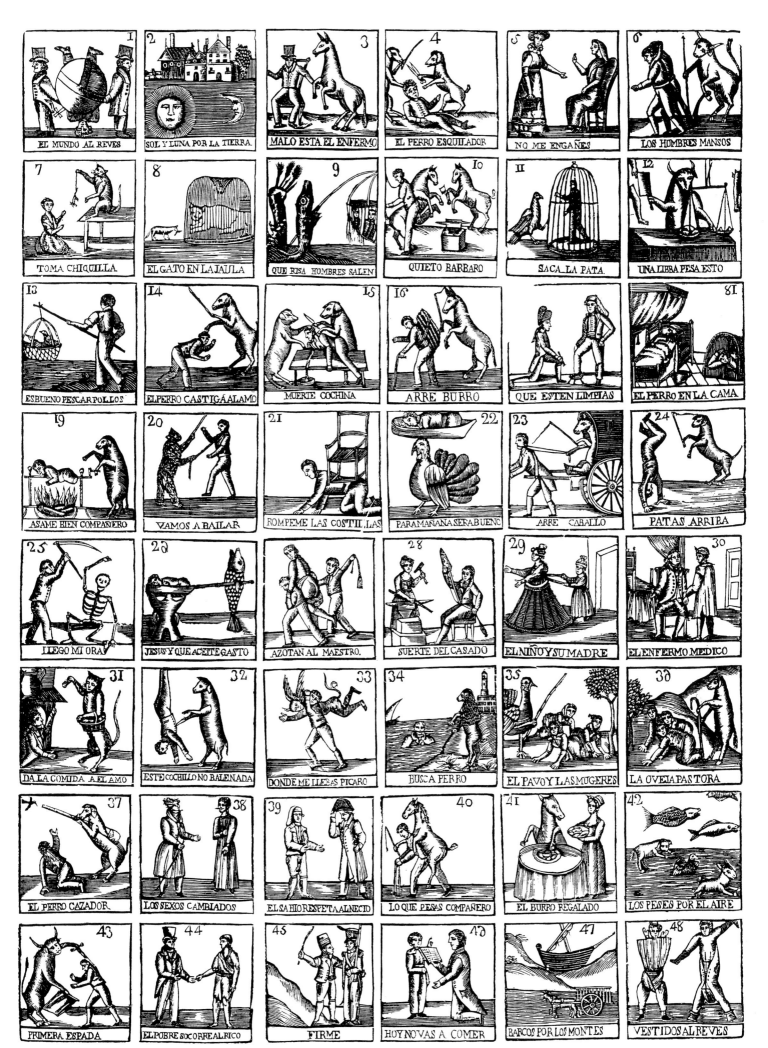

1 EL MUNDO AL REVES	2 SOL Y LUNA POR LA TIERRA	3 MALO ESTA EL ENFERMO	4 EL PERRO ESQUILADOR	5 NO ME ENGAÑES	6 LOS HOMBRES MANSOS
7 TOMA CHIQUILLA	8 EL GATO EN LA JAULA	9 QUE RISA HOMBRES SALEN	10 QUIETO BARBARO	11 SACA LA PATA	12 UNA LIBRA PESA ESTO
13 ES BUENO PESCAR POLLOS	14 EL PERRO CASTIGA A LAMO	15 MUERTE COCHINA	16 ARRE BURRO	17 QUE ESTEN LIMPIAS	18 EL PERRO EN LA CAMA
19 ASAME BIEN COMPAÑERO	20 VAMOS A BAILAR	21 ROMPEME LAS COSTILLAS	22 PARA MAÑANA SERA BUENO	23 ARRE CABALLO	24 PATAS ARRIBA
25 LLEGO MI ORA	26 JESUS Y QUE ACEITE GASTO	27 AZOTAN AL MAESTRO	28 SUERTE DEL CASADO	29 EL NIÑO Y SU MADRE	30 EL ENFERMO MEDICO
31 DA LA COMIDA A EL AMO	32 ESTE COCHILLO NO BALE NADA	33 DONDE ME LLEVAS PICARO	34 BUSCA PERRO	35 EL PAVO Y LAS MUGERES	36 LA OVEJA PASTORA
37 EL PERRO CAZADOR	38 LOS SEXOS CAMBIADOS	39 EL SABIO RESPETA AL NECIO	40 LO QUE PESAS COMPAÑERO	41 EL BURRO REGALADO	42 LOS PESES POR EL AIRE
43 PRIMERA ESPADA	44 EL POBRE SOCORRE AL RICO	45 FIRME	46 HOY NO VAS A COMER	47 BARCOS POR LOS MONTES	48 VESTIDOS AL REVES

Lenders to the Exhibition

Sarah Campbell Blaffer Foundation, Houston
The Brooklyn Museum, New York
Peter P. Cecere, Reston, Virginia
Davenport Museum of Art, Iowa
Martha Egan, Santa Fe, New Mexico
El Paso Museum of Art
Kit Goldsbury, San Antonio
Hearst Castle, San Simeon, California
Chris Hill, San Antonio
The Hispanic Society of America, New York
Barbara and Gino Hollander, Aspen, Colorado
Randy and Carol Jinkins, San Antonio
Fred Kline, Santa Fe, New Mexico
McNay Art Museum, San Antonio
Meadows Museum, Southern Methodist University, Dallas
Luis F. Mejia, Houston
The Metropolitan Museum of Art, New York
Museo Nacional de Antropología, Madrid
Museo Nacional de Artes Decorativas, Madrid
Museo San Telmo, San Sebastián, Spain
Museu d'Arts, Industries i Tradicions Populars, Barcelona, Spain
Museu Marítim, Barcelona, Spain
Museum of International Folk Art, Santa Fe, New Mexico
New Orleans Museum of Art
Alan Moss Reveron and Robert Day Walsh, New York
San Antonio Museum of Art
Valery Taylor Gallery, New York
August Uribe, New York
Jonathan Williams, Austin, Texas
Philip Wrench, Houston

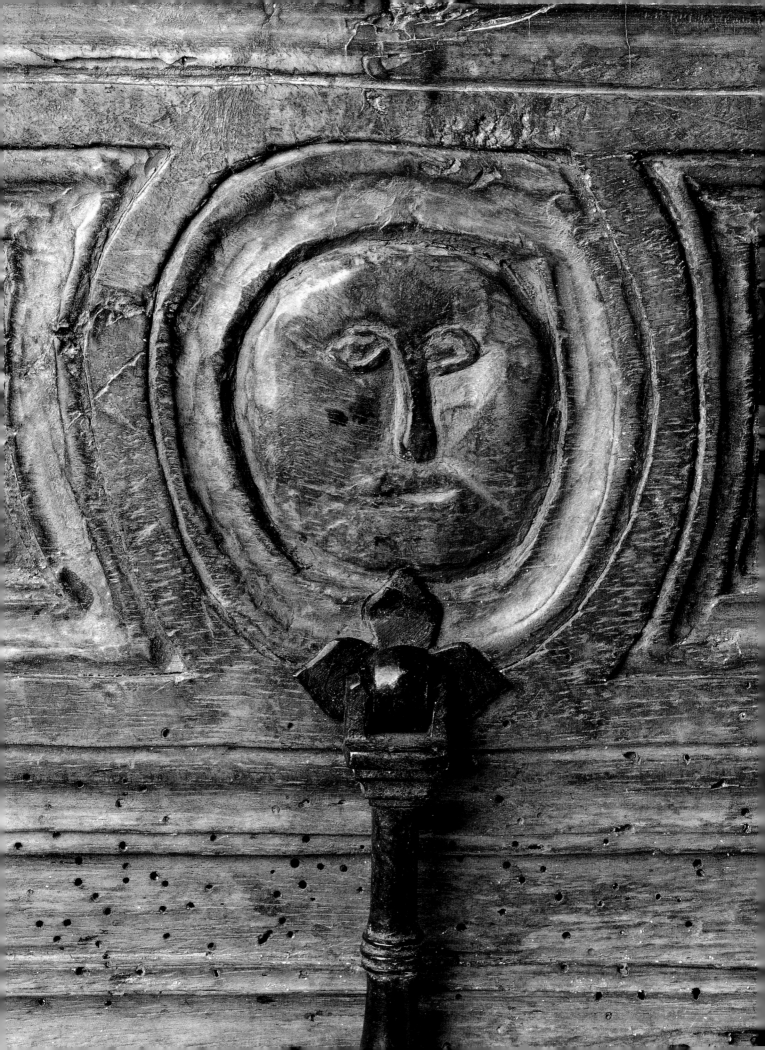

Foreword

Spain has contributed enormously to the cultural fabric of Europe and other parts of the world. Her rich cultural mosaic includes artistic idioms rooted in Roman, Arabic, and Northern European sources. The confluence of these various cultural traditions has produced a unique hybrid. In art, this is expressed in ways as diverse and dramatic as the geography of the Iberian Peninsula. Spain's rich artistic heritage includes both academic art created by masters such as Velázquez, Goya, Miró, and Picasso, as well as regional folk art created by the artisans of local villages. The blend of these traditions places Spain at the forefront of the world's artistic expression. In the sixteenth century, when European colonialism spread throughout the world, Spain focused her expansion on the Americas. Perhaps nowhere can this expansion be more clearly seen than in the art that resulted from this encounter.

The Folk Art of Spain and the Americas: El Alma del Pueblo provides an overview of Spanish folk art and examines the Spanish traditions that serve as a source for Latin American folk art. Until recently, when the Brooklyn Museum mounted the provocative exhibition *Converging Cultures: Art and Identity in Spanish America,* scant attention had been paid to tracing individual strains of influence and how they were modified. The primary accomplishment of the Brooklyn exhibition was to underscore the accommodations made by Spanish artists when they encountered native traditions. For example, an eighteenth-century Mexican carved wooden figurine of the Virgin Mary remains decidedly Iberian. However, the costume's design is based on a traditional *huipil* (smock) worn by pre-Columbians, while the vaguely Asian, ivory face was inspired by the brisk trade with the Orient enjoyed by eighteenth-century Mexicans. Thus, three cultural strains are unmasked and a cultural hybrid revealed.

San Antonio is the ideal place in which to explore the themes of survival and adaptation because our city was founded as an extension of the network of missions that were established throughout New Spain as religious, cultural, and military outposts. Our surviving missions, which range in style from starkly simple to elaborately baroque, provide ample proof of the differences that existed in Spain and were continued in the Americas.

After the missions were built by Franciscans who arrived in San Antonio from what is today Mexico, the Spanish king chose sixteen families —comprising fifty-six people—from the Canary Islands to settle in what is now San Antonio. When they arrived on 19 March 1731, they came with all the rights and privileges of Spanish colonial landowners and the title *hidalgo.* Their descendants are among those who populate San Antonio to this day. No one will ever know just when the transformation occurred, the transference of heart and soul from Spain to their new homes in Texas. Today the descendants of these original families reconvene periodically to discuss and review their histories and family connections. Their pride in their Spanish heritage and their collective influence on the course of San Antonio's history is obvious.

Although the museum's first Latin American objects were acquired in the 1920s, it was not

PLATE 3
Drawer with Facial Motif (det.), late 17th c.
Segovia, Spain
Wood and iron
13 × 51 in. (33 × 130 cm)
Lent anonymously

This charming drawer front, decorated with a face around a metal pull, illustrates the urge of folk artists to go beyond the purely utilitarian to create satisfying works of art.

until the mid-1980s, when the Rockefeller, Winn, Echaverria, and Nicholson collections were donated, that the museum was able to display significant numbers of Latin American objects. In style and concept, many trace their origins directly to Spain. The image of the Virgin of Atocha, for example, is venerated by many more Latinos outside the Iberian Peninsula than in Spain. Every image, no matter how grandiose or how humble, is replete with iconographic references to the Spanish original. The continuity of this artistic creation has never been broken. Indeed, artists throughout the Western Hemisphere are forging new links every day as this tradition continues and folkways persist.

El Alma del Pueblo is an ideal complement and introduction to the museum's thirty-thousand-square-foot Nelson A. Rockefeller Center for Latin American Art, which will open in 1998. In years past, many changing exhibitions have focused attention on Latin American art from the pre-Columbian period to the present. In 1993, we presented *Visiones del Pueblo,* organized under the auspices of the Museum of American Folk Art, New York, which presented a survey of folk art from seventeen countries in Latin America. The present exhibition examines some of the roots of the art displayed in that exhibition.

We are most grateful to the Ford Motor Company for sponsoring *El Alma del Pueblo,* which will provide valuable understanding of our living Latino culture, so pervasive, not only in San Antonio, but increasingly throughout the United States. We would also like to thank the government of Spain, especially those connected with the Ministry of Culture and the Spanish Embassy in Washington, D.C., for their support and encouragement throughout this project. In addition, we appreciate the generosity of the Spanish museums from which the majority of the objects in this exhibition were borrowed.

Dr. Marion Oettinger, Senior Curator and Curator of Latin American Art, brings to his subject over thirty years of experience spent not only in the field, but also as a distinguished academic and museum curator. He is eminently suited to the daunting task of collecting many objects from Spain and Latin America and interpreting them effectively. He has enlisted a most distinguished group of contributors, whose research and subsequent essays break new ground. We are very pleased that the exhibition will travel throughout this country and then to Spain over the next two years. We appreciate the support and enthusiasm of our colleagues at the many museums where *El Alma del Pueblo* will be displayed. By studying the art of Spain and the Americas, our common history, religion, literature, philosophy, and the other humanities are more easily understood and will prove more inspirational. In a frenetic world of ever-pervasive technology, it is spiritually comforting to know that through art our souls may be touched.

Douglas K. S. Hyland, Director
SAN ANTONIO MUSEUM OF ART

Foreword

The Museo Nacional de Artes Decorativas in Madrid is located between the Paseo del Prado and Retiro Park and is housed in a mansion built at the end of the nineteenth century, which used to belong to the Duke of Santona, related to the House of Alba. The museum itself was created by the Royal Decree of Amadeus I, dated 5 May 1871, under the title of Industrial Museum. This was changed to National Museum of Industrial Arts in 1912, and the present name was adopted in 1940.

From the outset the institution was intended to have a pedagogic function—to be a place of learning for craftsmen, manufacturers, artists, and connoisseurs of the industrial arts. This concept of museum followed the criteria inspiring similar institutions, such as the Victoria and Albert Museum in London and the Musée des Arts Décoratifs in Paris. Our museum maintains this conservation function, protecting associations of craftsmen in order to safeguard the memory of our traditions. Some fifteen thousand items are exhibited in sixty rooms, but the whole collection consists of approximately forty thousand pieces. Though most of the exhibits are Spanish, there is an important collection of foreign items which aims to demonstrate international artistic relationships and the importance of both objects for daily use and luxury pieces over the centuries.

The museum contains the most complete and important collections in Spain in the following fields: Spanish carpets from the fifteenth to the eighteenth century; Spanish furniture from the fifteenth to the seventeenth century; Spanish leather *(cordobanes* and *guadamecies)* from the sixteenth to the nineteenth century; ceramics from Talavera de la Reina, Teruel, and Alcora; glass and crystal of La Granja; flat textiles and clothing in addition to embroidery; as well as the oriental collection (from China and Japan), corresponding to the Ming and Qing dynasties, brought to Spain during the reign of Carlos III. In addition to these exceptional collections, the museum has extraordinary silver- and goldwork and jewelry from the fifteenth to the nineteenth century, tapestries, porcelain, ivory, enamels, and fans.

The exhibition of these pieces does not merely aim to show the various useful luxury items, which have come to be admired as works of art, but also proudly displays a wide range of popular crafts, most of which contributed for centuries to improving the conditions of human life, not only by fulfilling basic needs but also by making it more agreeable and comfortable.

It is a pleasure for the museum to collaborate with this exhibition by lending works from its permanent collection of Spanish popular arts. In this way, we hope to spread knowledge about artistic contributions, which are the best reflection of that quality intrinsic to human beings which drives them to create.

Alberto Bartolomé Arraiza, Director
MUSEO NACIONAL DE ARTES DECORATIVAS
MADRID

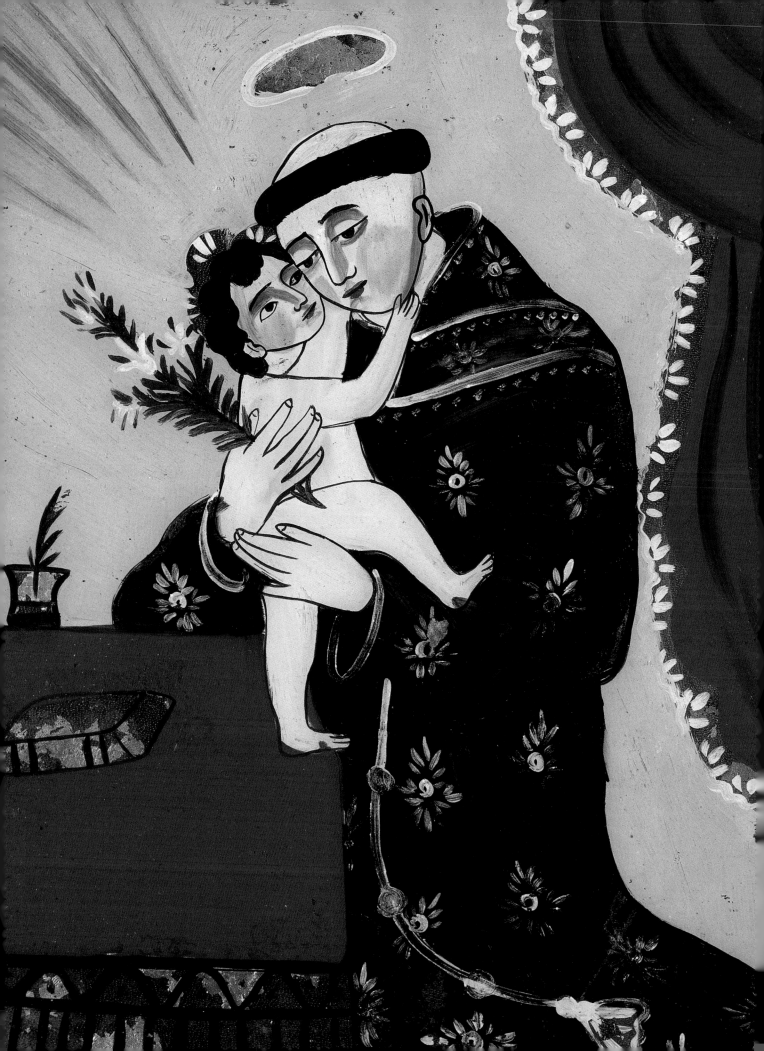

Acknowledgments

El *Alma del Pueblo* is the result of the combined efforts of dozens of people on both sides of the Atlantic. Because of the broad scope of the exhibition and the need to work with material from Spain, the United States, and various parts of Latin America, it was essential to call on the generous help of scores of art historians, anthropologists, collectors, photographers, historians, and museum specialists, as well as other devotees of the popular culture of Spain; without their valuable assistance this exhibition would never have been born.

All projects start from ideological seedlings. Long before we had a game plan for the exhibition, at a time when money was needed to pay for travel, photography, and other expenses related to grant proposals, a small group of supporters stepped forward and provided backing. Alice Lynch and her hearty group of travelers to Spain generously provided such assistance. I am especially thankful to Nancy Allen of Houston for contributing to the project while I sought focus and attempted to formulate a proposal for full funding. Fred Pottinger of San Antonio expressed early faith in the exhibition by donating the first work of art.

This exhibition has been supported by a generous grant from Ford Motor Company.

As it has demonstrated so clearly through past stewardships both here and abroad, Ford is committed to fostering better international understanding through the arts, and we are grateful for their staunch support in this instance. Leo Padilla, former head of the office of Community Relations at Ford, had lived and worked for many years in Madrid and Valencia and remembered, with great warmth, the many friends he and his family made there and the richness of Spanish culture. He was an early and constant supporter of this project. Leo J. Brennan, Jr., Gary Nielsen, and Helen Love, all of Ford, have been strong supporters throughout the project, and we greatly appreciate their help. Mabel H. Brandon, Director of Corporate Programming, was instrumental at the beginning of the project and has served as Ford's key representative, and she has fulfilled that role with her usual energy and enthusiasm. Her excellent instincts about what works well in the museum business, together with her many years of experience with international projects, have made this exhibition much better than it would have been without her mature judgment and understanding. We deeply appreciate her help and guidance at every stage of this adventure.

Janet Tabor, Gloria Rodriguez, and Fred Schroeder, also with the Ford team for this project, contributed tremendously, especially in the areas of marketing, publicity, and community relations. In Spain, Steve Lyons and Jaime Carvajal, both of Ford España, were very helpful from the earliest stages of exhibition planning, and their support was critical to making the dream a reality.

We also want to thank Iberia Airlines, the "official airlines of the exhibition" for its generosity and valuable assistance.

Mervyn Samuel, who has lived in Spain for over twenty years and has spent much of his life studying Spanish culture, was involved with many aspects of the exhibition and was always enormously helpful. His deep knowledge of and

PLATE 4
San Antonio de Padua
(Saint Anthony of Padua)
Late 19th c.
Southern Spain
Oil on glass
14 × 12 in. (35 × 29 cm)
San Antonio Museum of Art

Reverse painting on glass was popular throughout Europe during the eighteenth and nineteenth centuries. In Spain, it was commonly used to represent popular religious images. San Antonio de Padua is among the most widely revered saints in southern Europe. Here, he is dressed in the blue garb of the Franciscan order, holding a white lily in his right hand as a symbol of purity. The Christ Child in his arms alludes to a miraculous apparition of the infant Christ to San Antonio during his stay in a country inn.

respect for Spanish art, architecture, and mores were invaluable and contributed significantly to whatever success this project might realize. His excellent translation of the text from English to Spanish and vice versa reflects his depth of understanding of Spanish culture. In addition, his many years of residency in Peru and his clear understanding of Latin American culture provided yet another fountain of information, from which we frequently drank. Mervyn deserves our special thanks.

Many others in Spain also generously assisted. I wish to thank Javier Lizarza and Barbara Fulford de Lizarza of Madrid, Pedro Roca de Togores of Sevilla, Laura Salcines, owner of Sevilla's charming folk art shop Populart, and Christiane Kugel of Granada.

From the very first days of this project, Spanish art historians, anthropologists, and museum officials were very helpful. Dr. Manuel Berges Soriano, Director of Madrid's Museo Nacional de Antropología, extended a helping hand from the beginning and was extremely generous with his time and professional assistance. Others at the same institution I would also like to thank are Andrés Carretero Pérez, Juan Valadés Sierra, María Antonia Herradón Figueroa, Concha Herranz Rodriguez, and Rosario de Casso. Alberto Bartolomé Arraiza, Director of the Museo Nacional de Artes Decorativas, guided me through his institution's excellent collection of Spanish furniture and other material. Dolors Llopart, Director of Barcelona's Museu d'Arts, Industries i Tradicions Populars, generously gave her time and advice in arranging loans of key materials from her museum. Professionals with Barcelona's exciting Museu Marítim were exceptionally helpful. Elvira Mata i Enrich, the museum's director, and Maria Lluisa Mirete i Mata, its curator, kindly showed me through their important collection of maritime folk art and gave me essential advice on subjects about which I previously knew very little. Rafael Zulaika, Director, and Arantza Barandiaran, Chief Curator of the Museo San Telmo in San Sebastián, were very helpful in arranging the loan of key objects from the Basque Country and displayed exceptional patience while I wrestled with Basque vocabularies.

A number of institutions and people in the United States were very helpful. Former Ambassador Excmo. Jaime de Ojeda and Alvaro de Erice, the former Spanish cultural attaché in Washington, were behind this project from the start and provided me with valuable contacts in Spain. Excmo. Antonio Oyarzabal, Spain's current ambassador to Washington, and Juan Romero de Terreros, Spain's present cultural attaché in this country, have been enormously supportive of this project, and we are deeply grateful. The former and present Consul Generals of Spain in Houston, Hon. Gonzalo de Benito and Hon. Leopoldo Stampa, respectively, and Isabel de Pedro, Honorary Consul of Spain in San Antonio, volunteered their good offices if needed. Joaquín Mira and Rodrigo Domínguez, past and present heads, respectively, of Casa España in San Antonio, coordinated complementary events during the exhibition. Inmaculada de Habsburgo and Dr. Suzanna Stratton, Director and former Curator of the Spanish Institute in New York, respectively, have an excellent track record of staging Spanish exhibitions in this country—we are grateful for their valuable experience and encouragement.

Zubi Advertising in Miami did most of the graphic design for the exhibition; we thank Tere Zubizarreta and Ric Porven for their creative input. Orlando Romero designed the informative map and Brook Rosser created the line drawings.

Ed Marquand provided valuable energy and vision and shepherded this book into print; his kind assistance is greatly appreciated. No publication as complex as this could appear without a keen and intelligent editor. Jennifer Lorenzo brilliantly edited both the English and Spanish versions of this text. We also appreciate the work of Sharon Vonasch and Marie Weiler, who copyedited and proofread the book.

We are also grateful to institutions in the United States and their professional staffs who worked with us to secure loans from their collections. We sincerely thank Dr. Marcus Burke, Patrick Lanahan, and Margaret Connors of the Hispanic Society of America in New York; Hoyt Fields of the Hearst Castle at San Simeon, California; Barbara Maulden, Charlene Cerny, Robin Gavin, and Judith Chiba Smith of the Museum of International Folk Art in Santa Fe, New Mexico; William Fagaly of the New Orleans Museum of Art; Steve Vollmer of the El Paso Museum of Art; Jessie McNab of the Metropolitan Museum of Art, New York; Steve Bradley

and Brady Roberts of the Davenport Museum of Art in Iowa; James Clifton of the Sarah Campbell Blaffer Foundation in Houston; Bill Chiego, Lyle Williams, Linda Hardburger, and Heather Lammers of the McNay Art Museum in San Antonio; and John Lunsford of the Meadows Museum at Southern Methodist University in Dallas. Private collectors in this country also have been very generous. We wish to thank Martha Egan and Fred Kline of Santa Fe, New Mexico; Peter Cecere of Reston, Virginia; Kit Goldsbury and Randy and Carol Jinkins of San Antonio; Gino and Barbara Hollander of Aspen, Colorado; Valery Taylor, David Brown, Alan Moss Reveron and Robert Day Walsh, and August Uribe of New York; Philip Wrench and Luis Mejia of Houston; and Jonathan Williams of Austin, Texas.

Essayists for the catalogue have done an excellent job contributing articles which are both scholarly and palatable for the general educated public. Their task was not easy, and I appreciate the quality of their contributions as well as the length of their patience. Once again, Mervyn Samuel, this volume's translator, was faced with one of the biggest challenges of all, and he pulled through with flying colors (or is it colours?).

Exhibitions such as this require an army of dedicated folk from the organizing institution. Douglas Hyland, Director of the San Antonio Museum of Art, was an early supporter of this project and worked hard to allow me the time I needed to do the necessary fieldwork and other research in preparation for this project. Nancy Fullerton, my assistant in the Latin American Department was, as usual, loyal and true, and provided the necessary back-up during my many long absences from the museum. Consuelo Ulrich admirably assisted Nancy and me during this project. Rachel Mauldin, our registrar, and her assistant, Debra Zumstein, spent many long hours arranging for transoceanic and domestic loans and setting up venue contracts, and did so in a thoroughly professional fashion. Tracy Baker-White, Mary Meek, Mobi Phillips, Rose Demir, Alma Cantú, and Kathleen Scanlon creatively designed our exciting education package, and they are to be commended for their originality and hard work. Pony Allen and his excellent exhibitions crew transformed ideas into physical reality through an exciting installation; their valuable expertise will be long remembered. Lila

Cockrell, George DiGiacomo, and Dawn de los Santos provided excellent leadership with marketing and publicity, and their long hours and creative work must account for a significant portion of the success this project might enjoy. Sandra Ferguson, Joanie Barr, and Larry Rice patiently assisted with the budget.

Peggy Tenison was the lead photographer of the objects shown in this catalogue. Her fine technical knowledge and her excellent eye are greatly appreciated. I also want to thank Tom Humphrey for his outstanding photography of objects from the collection of Peter Cecere. Miguel Angel Otero, Adolfo Sánchez de la Cruz, and Gustavo Nacarimo also provided excellent photographs for inclusion in this volume.

I offer special thanks to my wife, Jill, and our two daughters, Julia and Helen, for their love and support. Their patience during long periods away from home and their valuable help with the fieldwork we conducted together during the summer of 1996 have made this project special. I am indebted to them for their continuing love and understanding.

Finally, I want to thank the thousands of Spaniards I have met during the three years since this project formally began. I apologize for my intrusiveness and persistent questions about things I did not understand. I was always shown politeness, patience, and cooperation during my many travels throughout Spain, and I am deeply grateful for their showing me Spanish folkways and thereby providing me the opportunity to catch a glimpse of *El Alma del Pueblo*.

Marion Oettinger, Jr.

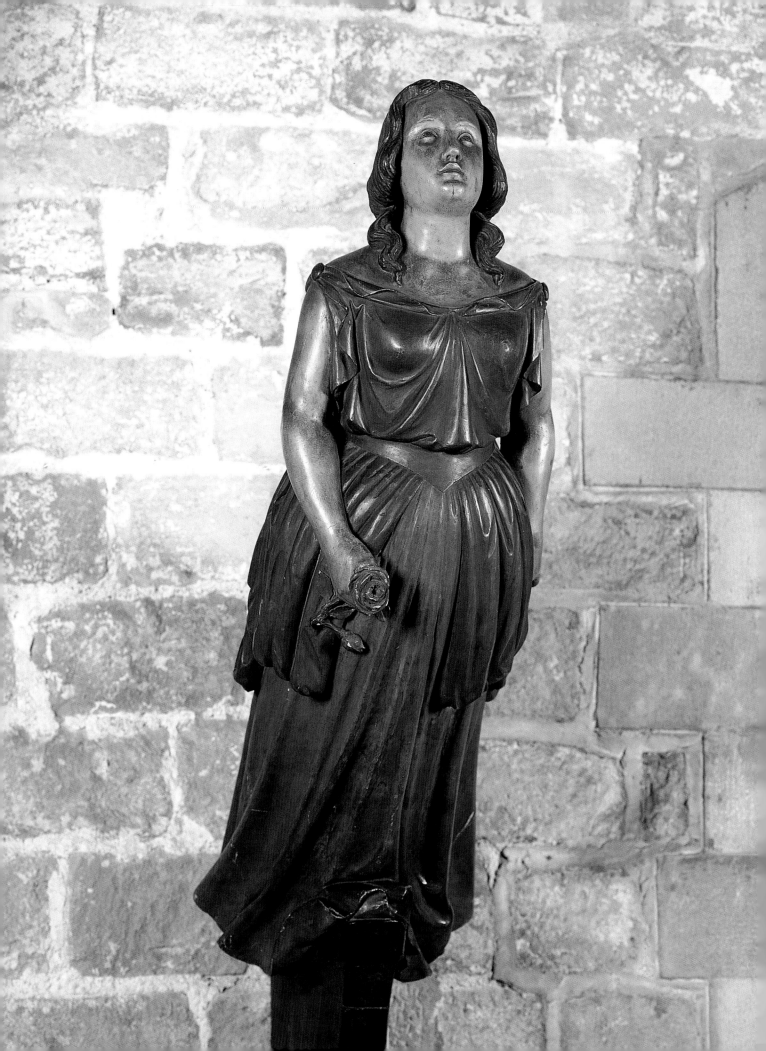

Preface

The cultured Western world began to take a lively interest in ethnographic studies and collecting during the last century, though antecedents can be found in previous centuries and in advanced civilizations of antiquity. Spain has moved within these same parameters, though sometimes trailing the achievements and efforts of European and American researchers. The first studies concentrated on more or less exotic foreign cultures, related to European colonial expansion. Landmarks along the way include the creation in Paris of the first Ethnological Society in 1839, followed by New York (1842), London (1843), and Madrid (1865). The next stage is represented by the great universal exhibitions, where colonized cultures and peoples were presented, giving rise to a number of ethnological/anthropological museums. One example is the Paris exhibition of 1878, with no less than sixteen million visitors, which was the basis for the Trocadero Museum, now the Musée de l'Homme, in the French capital. A decade later, in 1887, Spain held an exhibition on its possessions in the Pacific (Philippine, Mariana, and Caroline Islands), and after several vicissitudes (Overseas Library Museum, etc.) the collections exhibited eventually became the nucleus of the Museo Nacional de Etnografía, which was created in 1875 as the Museo de Antropología.

Museums dedicated to exhibiting collections from national or native cultures would appear somewhat later. The open-air Skansen Museum in Stockholm, founded by Arthur Hazelius in 1881, was the standard and model for a century. It was inspired by the reproductions of the traditional houses that were constructed at the great exhibitions to contain the objects displayed. Hazelius used them to re-create the rural life and customs being displaced by industrialization. As late as the 1960s, open-air museums were still being created in Eastern Europe. In Spain, the Museo del Pueblo Español did not open until 1934 (the Museum of Popular Arts and Traditions in Paris dates from 1937). That it was not laid out like the Skansen is due to economic factors, to the fact that Mediterranean Europe is more varied and complex than Scandinavia, and to the difficulties of attempting to reproduce traditional structures in rough stonework or adobe. Although our museum opened late, it should be noted that as early as 1885 Antonio Machado y Alvarez, one of the pioneers of Spanish folklore studies, had asked the Madrid City Council to create a folklore museum. Though the idea was accepted, it never came to fruition.

During the last quarter of the nineteenth century, a series of folklore societies began to spring up in Spain. Their purpose was to study the life and customs of the different Spanish regions, as opposed to the ethnological studies of foreign peoples, who were apparently judged to be backward. These societies, under a colorful variety of names, built up collections of popular objects that were falling into disuse. At this time a singular yet generalized phenomenon was occurring in Europe, in which national or regional differences and peculiarities were stressed and valued. In Spain, this phenomenon was double-sided: on the one hand leading to an idealization of the nation as a whole (for instance, by Joaquín Costa), and on the other, to the nascent nationalism of Galicia, Cataluña, and the

PLATE 5
Doña de la Rosa (Lady of the Rose) Figurehead
c. 1900
Barcelona, Spain
Polychromed wood
58 × 19 in. (148 × 47 cm)
Museu Marítim, Barcelona

The figureheads of ships have been popular in the Mediterranean region since the time of the ancient Egyptians and the Greeks and Romans who followed. Among the Vikings, menacing dragons were popular motifs. Other motifs related to national emblems, religious symbols, or figures symbolic of the ship's name. Many were thought to provide protection to the crew. During the nineteenth century, voluptuous females graced the prows of ships, and this example from Barcelona is an engaging one.

Basque Country. Because of this powerful flow of nationalism, it was in these regions (the most advanced in general and in the field of ethnographic studies) that museums and folklore centers would arise. Examples are the Museo de San Telmo in San Sebastián (1902), the Museo de Bilbao (1917), and the Archivo de Etnología y Folklore of Cataluña (1915).

Regarding universities, in the past we had only a single professorial chair (that of Don M. Antón) and a handful of experts of international standing, who had to complete their training in Paris, London, or Berlin. Nowadays, the situation has changed dramatically. From the bare half-dozen shared chairs of Prehistory and Ethnology that we had in the 1950s, there are now general anthropology studies in fourteen Spanish cities. In Madrid alone, apart from the Chair of Prehistory and Ethnology that still exists in the Complutense University, there are a further three chairs dedicated to different aspects of anthropology. Furthermore, we have the Department of Spanish and American Anthropology of the C.S.I.C. (Council for Higher Scientific Research), numerous publications, and scientific congresses and meetings.

There has also been a total turnaround in the area of museums, which grew up little by little and none too surely. The aim of state policy during the 1960s was for each of Spain's fifty-two provinces to have a museum containing, in addition to art and archeology, a third section on ethnography, so as to save a rural, craft-based world that was rapidly disappearing. However, it was with the political changes of the 1970s and the new division of Spain into seventeen autonomous regions that a veritable eclosion of museums occurred. Each region, and occasionally every district, wanted to have its own museum of memories and nostalgia, if possible with roots to differentiate it from the others. By 1990, there were 194 museums, and nowadays the figure is around 300. The latest issue of the *Anales,* the journal published by the Museo Nacional de Antropología, was devoted to this subject, and the conclusion we have drawn is both positive and dispiriting. There is insufficient technical staff for so many centers and not enough money to maintain them properly. Moreover, some of these "museums" are little more than hurriedly assembled collections of pots no longer in use, or sometimes the badly collected and atrociously exhibited work of a skillful craftsman.

As a footnote, let me mention that the Museo Nacional de Etnografía and the Museo del Pueblo Español (mentioned above) were merged by a Royal Decree in 1993 to form Spain's great Museo Nacional de Antropología. In this new center, which is now being created, we shall attempt to ensure that its Spanish collections do not present our regional differences as antagonisms, but as common spiritual riches.

Manuel Berges Soriano, Director
MUSEO NACIONAL DE ANTROPOLOGÍA
MADRID

Oviedo
ASTURIAS

Santiago de
Compostela

GALICIA

Santander Vitoria
CANTABRIA
BASQUE
COUNTRY

Pamplona

NAVARRA

Logroño
LA RIOJA

France

CASTILLA–LEÓN

Valladolid

Zaragoza

CATALUÑA

Barcelona

ARAGÓN

Madrid
✪
MADRID

Toledo

Portugal

EXTREMADURA

Mérida

CASTILLA–LA MANCHA

VALENCIA

Valencia

BALEARIC
ISLANDS

Palma

MURCIA

Murcia

ANDALUCÍA

Sevilla

Spain

(by Autonomous Community)

CANARY ISLANDS
Santa Cruz
de Tenerife

Las
Palmas

Ceuta

Melilla

Africa

N

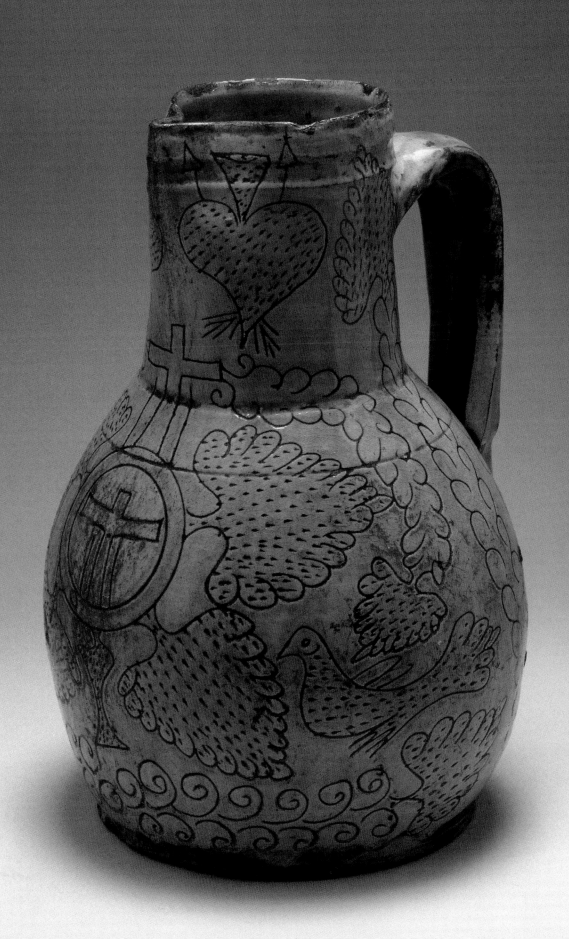

Marion Oettinger, Jr.

Introduction

All Spain flooded with light, stirring inside
my mind like a male peacock, its wings wide-
spread, slowly strutting between two seas.
—NIKOS KATZANTZAKIS, 1963[1]

Several years ago, I was asked to organize and
curate, under the auspices of the Museum of
American Folk Art, a major exhibition of folk art
from all over Latin America. This exhibition,
entitled *Visiones del Pueblo: The Folk Art of Latin
America,* opened in New York in 1992 and sub-
sequently traveled to ten other venues in the
United States and Latin America. *Visiones* was
very well received—the schedule was twice ex-
tended, the catalogue went into and sold out of
a second printing, and the exhibition prompted
numerous positive reviews in magazines and
newspapers here and abroad. The two main ob-
jectives of this exhibition were to remind Latinos
in the United States of the power and impor-
tance of their own folk artistic heritage, much of
which had not been previously celebrated in this
country, and to alert the rest of the United States
population to the richness of Latin American
culture.

Visiones clearly demonstrated a number of
important things. First, that the United States
public at large is shamefully ignorant of Latin
American culture and society but eager to ame-
liorate that situation and learn more. And sec-
ond, that folk art is alive and well in Latin
America and can be used to understand better
the nature of those societies that make and use
it. Prompted by the popularity of *Visiones* and
a demonstrated need to understand more fully
the origins of Latin American folk expression,

we decided to organize the present exhibition,
El Alma del Pueblo.

Spain has a long and rich tradition of folk art,
a tradition which continues to play an important
role in Spanish life and culture. Religion, poli-
tics, architecture, social organization, music,
dance, and regional cuisine manifest themselves
in distinctly vernacular forms throughout Spain.
Frequently, these folkways are so tightly woven
into the fabric of Spanish life that they are hardly
recognizable to those who use them on a daily
basis. Yet folk art is everywhere; it is rural and
urban, secular and religious. It is found in the
gigante (giant) figures periodically paraded
through the streets of Pamplona to honor San
Fermín, the votive offerings left by faithful pil-
grims en route to Santiago de Compostela, the
fallas, ephemeral satirical tableaux burned on
Saint Joseph's day in Valencia, the special breads
used to celebrate marriages and honor the dead,
and the spontaneous dancing of the *sardana* in
Barcelona. Folk art is a visual manifestation of
the spirit of Spain and a window onto her soul.

With the expansion of the Spanish Empire in
the sixteenth century and the subsequent coloni-
zation of the Americas, many Spanish folk forms
found expression in the New World. Although
Latino folk art has many roots—including Na-
tive American, African, and Asian—those which
stretch back to Spain are among the most direct
and enduring. Household altars of Puerto Ricans
in New York; glazed pottery of Mexico, Peru,
and Ecuador; votive offerings at Chimayó, New
Mexico; masked dance dramas in south Texas;
giant processional figures in Antigua, Guatemala;
and innumerable other forms of traditional folk

PLATE 6
*Pitcher with Symbols of
the Passion of Christ*
Early 20th c.
Palencia, Spain
Glazed and incised
earthenware
13 × 8½ in. (33 × 21 cm)
Museo Nacional de
Antropología, Madrid

This pitcher was probably
used for special celebrations
during Holy Week. The in-
cised designs provide a spe-
cial texture to the surface of
the vessel.

expression trace their origins to Spain, many as far back as the sixteenth century.

Contrary to popular opinion in this country, Spain is not a monolithic society with a singular artistic statement. Rather, it is a multicultural phenomenon with enormous variation from region to region. Although Spanish is the dominant language of the country, there are three other mutually unintelligible languages as well—Galician, Basque, and Catalan—each with its own dialectical variations. Ethnic divisions are even more diverse. Roughly speaking, Spain's seventeen autonomous communities follow cultural lines, and their inhabitants tend to share more cultural elements with each other than with people outside their community. Although it is estimated that approximately 99 percent of Spain's population is Roman Catholic, folk religious practices vary widely from community to community. For example, customs associated with the veneration of Zaragoza's Virgen del Pilar (Virgin of the Pillar) are quite different from those connected with the Virgen de la Consolación (Virgin of Consolation) just outside Sevilla. Pilgrimages to the shrines of Nuestra Señora de la Barca (Our Lady of the Boat) in Galicia and Nuestra Señora del Rocío (Our Lady of Rocío) in Andalucía manifest themselves in remarkably different ways. Votive offerings in maritime communities are different from those in areas where the economy is based on sheepherding, and these types are both different from those found in large urban areas. Great variation exists in utilitarian folk art as well. Pottery types, for example, vary enormously, from the richly glazed majolica of Puente del Arzobispo, Toledo, to the simple utilitarian ceramics of Mondoñedo, Lugo, to the delicate filigree style of Alba de Tormes, Salamanca. Each autonomous community, each province, each town, each village and, frequently, each neighborhood has its own distinctive artistic expressions that say, "This is who we are, this is what we believe."

Another misconception about Spain is that it is a cultural isolate. Located on a large peninsula, bordered by France on the north, Africa on the south, Portugal and the Atlantic Ocean on the west, and the Mediterranean Sea on the east, Spain has the appearance of a large appendage to southern Europe, set aside from the historical events which shaped that world. But its geographical position is one of the main determinants binding it to the rest of the region. Over several thousand years, Spain has been the cultural crossroads for peoples of Europe, North Africa, the Americas, and countries of the Mediterranean. Culturally, it has been at the confluence of many forces for over four thousand years, and these many ebbs and flows of humanity through time have shaped the cultural face of Spain and created the special complexion we see today.

Starting in the third millennium B.C. the Iberians, as they were called by the Greeks, set up sedentary tribal groups along the Río Ebro and elsewhere. They were soon joined by other emigrant groups, apparently originating from the eastern shores of the Mediterranean Sea. Predating the Iberians, another distinctive ethnic group settled in the isolated, rugged western Pyrenees, where their descendants have remained until the present. The origin of their pre-Indo-European language, known as Euskera, has perplexed historical linguists for generations. The Celts moved into Spain from southern France during the first millennium B.C., bringing with them such skills as metalworking and additional methods of farming and herding. About the same time, the Greeks set up colonies on the Mediterranean coast and established commercial ties with those around them.

Spain fell to the Romans toward the end of the first millennium B.C., and the entire area came under Roman colonial rule for approximately five hundred years. The wonderful new Museo Nacional de Arte Romana in Mérida bears witness to the splendors of the Roman period in Spanish history. Visigoths from northern Europe, principally from what is now Germany, were invited in by the Romans, and an uneasy coexistence was established between the Catholic Hispano-Romans and the Visigoths. In the sixth century, the Visigoths adopted Catholicism, establishing a tenuous religious unity in a sea of cultural diversity. In the early part of the eighth century, Islamic armies invaded southern Spain and did not leave for approximately eight hundred years. Al Andalus, as Islamic Spain was called, eventually dominated Spain as far north

as León, Zaragoza, and Barcelona and led to a Christian reaction known as *La Reconquista* (the Reconquest), which plunged Spain into ferocious warfare. This lasted, off and on, until the reign of the Catholic monarchs Ferdinand and Isabel, at the end of the fifteenth century. The last Arab stronghold fell at Granada in 1492, leading to the expulsion of all non-Christian peoples from Spain. That was also the year Christopher Columbus was sent by the Spanish monarchs in search of the Indies.[2] Spanish colonization, especially in the Americas, changed the societies of the Western Hemisphere forever, but it also brought back to Spain new people, different ideas and worldviews, new riches, and countless other discoveries, which changed, yet again, the nature of Spain.

The point of this tightly compacted history is to show that while Spain may appear to have been tangential to the action of Europe, other parts of the Mediterranean, and the wider world, in fact it has been at its center. Over the millennia, vastly different populations have entered Spain. Some moved on, others stayed. All left behind their genes, art, architecture, culinary habits, languages, and religious practices, which became new, dynamic ingredients in the Spanish cultural recipe of today. Among the most easily recognizable contributions were those left by the Arabs. Architecture, language, food, music and dance, ceramic forms and techniques, and a host of other distinctly Islamic styles eventually changed to hybrid forms over time. This Islamic expression, or *mudéjar,* as it is called, is among those many things which set Spain apart from her European neighbors.

One of the ways we have been able to appreciate the tremendously exciting story of Spain has been through her art. Every college sophomore recognizes the names and masterful works of such great Spanish artists as Velázquez, Zurbarán, and Goya, as well as those of modern artists such as Gaudí, Miró, Picasso, and Dalí. These artists stand with the most important painters in world art history. The Prado and the Reina Sofía are among the greatest of the fine-arts museums, and Spain is proud of these institutions and the collections contained therein. Spain is also very serious about the role these

collections play in the establishment and maintenance of national identity. The central role that the fine arts occupy in Spain was demonstrated in a loud public debate during the spring of 1996 over the attribution of an early nineteenth-century painting, first thought to have been executed by Goya. The debate raged for weeks on the evening news and the front pages of newspapers. Politicians commented, philosophers reflected, and social pundits speculated. Finally, the painting was shown to have been painted by another artist. Eventually, heads rolled, and the debate was concluded. The interesting aspect of this event was not that such a debate would take place in the first place, but that it occurred outside professional museum circles, in the "popular" arena. If only the United States public demanded such highbrow content for its news, instead of its daily diet of street violence and sexual scandal! Spain invests great money, energy, and emotion in its fine arts and is rightfully proud of its enormously rich artistic traditions. Because of this pride, the lives of all of us have been greatly enriched.

While Spain has been tremendously successful in introducing the world to her great academic artists and their works, the country has done little to alert the world to its other great artistic statement—*arte popular,* or folk art. Typically, folk-art museums in Spain are underfunded and underappreciated. Several of her main collections of popular art, such as those in Madrid's Museo Nacional de Antropología and Barcelona's Museu d'Arts, Industries i Tradicions Populars have been inaccessible to the public for years, owing mainly to lack of installation and programming funds but also because of a lack of national commitment to promote better understanding of popular art and to invest in its preservation and research. Perhaps because folk art is so pervasive in Spanish society, so much a part of her national fabric, it is seldom set aside for special consideration, certainly not for the rarefied treatment afforded precious academic paintings and sculpture. But the majority of the artistic expression of any time and place is its folk art, and for the world to understand the full range of Spanish artistic expression, attention must be given to popular as well as academic art.

Spanish folk art is made by Spaniards for Spaniards and is integrated into virtually every part of Spanish life. For hundreds of years, it has been used by the Spanish to express their fears and dreams, court their lovers, amuse their children, and honor their ancestors. In modern times, it continues to be an important device for relating to the physical, social, and spiritual worlds. Most Spanish folk art, like folk art everywhere, is ephemeral, frequently lasting no longer than the feast day or other specific task for which it is designed. It is eaten, exploded, burned, used, worn out, and discarded. From a museological perspective, this is lamentable, and most of what we now have to study from times past is determined as much by the materials from which it was made as by the important role it may have played in the lives of those who made and used it.

Through this exhibition, we are interested in bringing to the attention of the United States public an art that has come down through the centuries, passed on from generation to generation, parent to child, mentor to protégé. It is an art which represents a collective spirit, a communal rather than an idiosyncratic expression. Spanish folk art does not seek to be avant-garde but instead strives to be in the mainstream of the beliefs, tastes, and values of the community in which it is made and used. Instead of being international, it is very local, responding to the needs of the people it serves. The community sets the standards to which folk art must adhere and, in the end, serves as its most strident critic.

Spanish folk art, like folk art everywhere, serves as a buffer between the individual or the community and the greater social, physical, and spiritual environments. It is a cultural response to demands of these environments, allowing individuals and communities to cope. House types, clothing, and farming implements, for example, are cultural responses to demands arising from the physical environment. Wedding costumes, gifts exchanged between neighbors, dolls which socialize children into adult roles, village and regional banners setting one group apart from another, are integrating elements and serve as cultural responses to the demands of the social environment. Finally, devotional images found on home altars, votive art hanging on the walls of rural chapels testifying to the efficacy of the power of a saint, and small amulets placed around the neck of an infant to ward off evil

spirits are cultural responses to challenges emanating in the spiritual environment. All assist the individual and, by extension, his or her community, in coping with the persistent demands of the world.

The primary goals of *El Alma del Pueblo* are two. First, because this is the first major exhibition of Spanish folk art presented in the United States, and because our understanding of the subject is practically nonexistent, we hope to provide an overview of Spanish folk art through time and space. The paintings and objects presented here span approximately five hundred years and are drawn from most of the autonomous communities of Spain. In addition, we have tried to assemble a representative sample of works from every major category of folk expression, i.e., utilitarian, ceremonial, recreational, and decorative. This introductory overview to Spanish folk art should, at the very least, alert the public in this country to the richness of Spanish folk art and provide a point from which to begin to understand Spanish folk expression and the central role it has played in Spanish society.

By its very nature, art in general and folk art in particular is malleable, always changing to meet the needs and requirements of new times and places. Such is the case with Spanish folk art introduced to the Americas during the sixteenth century and for three centuries thereafter. Thus, this exhibition will also examine a selection of Latin American folk items that are of Spanish derivation.

Within the first hundred years of the first European contact the majority of the indigenous population in the Americas had died due to disease and warfare, and tremendous deculturalization resulted. In this vacuum, the culture of the vanquished was replaced, to a large extent, by the culture of the victors. But new forms required modification in order to appeal to new audiences, mostly mestizo (of mixed Indian and Spanish blood) and creole (American-born Spaniards). Transformation was needed and transformation occurred. Indigenous values of color and form, different perspectives, and new and more relevant content were players in the creation of this new hybrid expression. Catholic churches, often built on sites of important Native American shrines, took on new looks, basically Spanish, but tempered by new settings, materials, architects, and artists. Glazed pottery, unknown

prior to the arrival of the Spanish, was introduced to Mexico during the middle of the sixteenth century, but it quickly took on a different flavor from that of its parents in Triana, Puente del Arzobispo, and Talavera de la Reina. From the great majolica centers of Mexico, such as Puebla and Guanajuato, further diffusion took this new method of pottery production into Guatemala, Peru, and Ecuador. In each instance, it became a new child of the Spanish parent and grandparent, with its own distinctive look and personality.

Unfortunately, there is a dearth of information about the Spanish origins of Latin American folkways. In the United States, this omission is partly due to an overemphasis on Anglo folkways, frequently to the detriment of other expressions, including Spanish. In Latin America, this exclusion goes back to the period of Latin American independence, when newly formed American republics sought to establish their own identities by rejecting Spanish and European models. Instead they looked inward, to their pre-Columbian origins and local indigenous folk traditions, for nation building. In Mexico, this was twice expressed—first, following independence from Spain and, second, a hundred years later, in the early twentieth century, after the fall of the dictator Porfirio Díaz, whose interest was in European, rather than indigenous, art.

The Mexican Revolution of 1910–20 expelled Díaz and his regime and, at the same time, rejected Spanish, French, and other European artistic models in favor of pre-Columbian and Indian folk art. In 1922, this perspective was clearly stated in an exhibition of Indian arts organized by the Mexican Secretariat of Industry, Commerce, and Labor. The catalogue, written by the American novelist Katherine Anne Porter and entitled *Outline of Mexican Arts and Crafts*,[3] vigorously applauded indigenous art, while taking potshots at anything with a hint of European, especially Spanish, influence. A similarly inspired exhibition was organized by René d'Harnoncourt under the auspices of the Carnegie Foundation. This 1930 exhibition, entitled *Mexican Arts*,[4] rejected the importance of anything Spanish in building twentieth-century Mexican artistic expression. Like feelings prevailed throughout most of the first half of the century. It was not until exhibitions such as *Spain and New Spain*,[5] curated by Marcus Burke and Linda Bantel in 1979, and *Mexico: Splendors of Thirty Centuries*,[6]

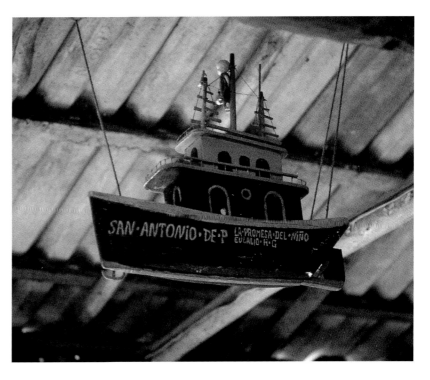

FIGURE I
Boat Ex-voto, c. 1950,
Tabasco, Mexico

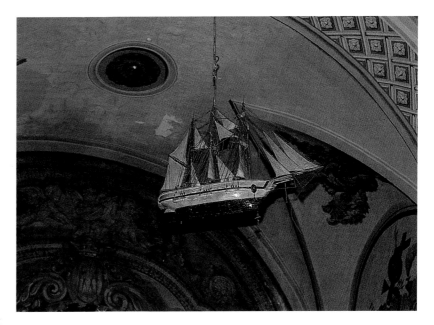

FIGURE 2
Boat Ex-voto, early 19th c.,
Sitges, Spain

organized in 1990 by the Metropolitan Museum of Art, New York, and the Mexican government, that the Spanish presence in Mexican art was seriously mentioned.

Similar omissions by other disciplines should also be noted. Anthropological studies discussing the enormity of Spanish influence in the formation of Latin American culture are greatly lacking. George Foster's pioneering study of America's Spanish heritage, *Culture and Conquest*,[7] is one of the few exceptions, and his important 1960 publication represents the first systematic comparison of Spanish and American cultural forms. In the area of folk art, the omission is blatant. Not only has there never been an exhibition of Spanish folk art in this country prior to this endeavor, but publications on subjects of obvious Spanish derivation are rare. Martha Egan's two fine publications on *milagros* and *relicarios* (votive offerings and reliquaries) are exceptions, since they explore the Spanish influence on these subjects in Latin America.[8] Books dealing with votive paintings in Mexico, for example, hardly mention the connection with Spain, and the same is true of the dozens of otherwise fine publications on religious art of the southwestern United States. One is left with the feeling that such forms of Latin American folk art emerged full-blown, independently, when clear evidence to the contrary is often right before our eyes.

One need only visit Spain to see the connection—not the Spain of the Prado, but the Spain of regional museums and provincial shrines. Furniture, farming implements, objects of personal adornment, and devotional art show remarkable similarities to what is found in the Americas. This relationship was first brought home to me most clearly in the area of maritime votive art. In 1988, while working in rural Tabasco, Mexico, I happened upon a small church dedicated to San Francisco (Saint Francis) that was filled with wooden model ships hanging from the ceiling of the nave (fig. 1). These delightful carvings were votive offerings left by sailors and fishermen in appreciation for safe delivery from storms. The earliest was from the late eighteenth century, and the most recent was dated 1969. Subsequently, I found similar *ex-votos* (votive offerings) in Colombia, Peru, Venezuela,

and Oaxaca, Mexico. Nothing had been published on these charming testaments to the power of the saints to save endangered sailors, much less on the origin of the custom. I was about to assign them to independent Latin American genius, when a colleague, Judith Sobré, suggested that I visit the Chapel of Nuestra Señora de Vignet (Our Lady of Vignet) in Sitges, south of Barcelona. I took her advice and was delighted to find the nave filled with boats hanging from the ceiling (fig. 2).

The earliest represented a square-rigged galleon from the sixteenth century and the most recent an oil tanker from the 1980s. I later discovered dozens of other chapels all over Spain with similar offerings, and found that the custom goes back to the fifteenth century or earlier. Hundreds of similar examples demonstrating the relationship between Spanish and Latin American folkways could be cited. It is our hope that, through this exhibition, we will learn more about the Spanish roots of Latin American folk art and, consequently, develop a richer appreciation for the hybridization that took place.

The present publication is designed to be a supplement to the *Alma del Pueblo* exhibition, as well as an independent overview of Spanish folk art. We have invited specialists from both sides of the Atlantic to write broad introductory articles on key aspects of Spanish folkways, in order to provide a general context for the objects in the exhibition. Although the articles appear in close proximity to plates of objects in the exhibition, the objects are not necessarily referenced by the authors. We are keenly interested in having this publication provide a worthy introduction to Spanish folk art and in its having a useful life long after the exhibition has been dismantled and the objects returned to their proper homes.

For me, this project has been enormously exciting and rewarding, but it has not been without its difficulties. Having worked as an anthropologist and folklorist in Latin America for over twenty-five years, I had developed a certain understanding of the rhythms of that part of the world. These rhythms, while similar to those of Spain, are, in fact, quite different in most respects, and I needed a tremendous amount of adjustment to work comfortably in

Spain. I might add, however, that the process of adjustment was enjoyable and illuminating.

Language was also a problem. Although I am fluent in Spanish, my knowledge of Galician (Gallego), Basque (Vasco), and Catalan (Catalán) is negligible. Unfortunately for me, the communities in which these languages are spoken are among Spain's richest in terms of folk art. Most of the publications produced by the Museo do Pobo Galego in Santiago de Compostela, for example, are in Galician, and I really had to struggle to glean what was needed from these valuable contributions. Much to my dismay, most of the magnificent books by Joan Amades on Catalan customs and folkways were published only in Catalan, and this project has suffered as a result of my inability to take full advantage of Amades's brilliant insight.[9]

Difficulties are inherent in all research, especially cross-cultural research, and I have learned to accept the notion that they "come with the territory." Selecting appropriate objects, making the necessary petitions, arranging for crating, insurance, and shipping, and a host of other "challenges" added special spice to the project and sent me more than once to the antacid bottle. But the project was blessed with excellent cooperation from colleagues whose contributions are too numerous to list here.

Finally, *El Alma del Pueblo* does not seek to present the absolute truth on Spanish folkways.

Rather, like all exhibitions, it represents the curator's perspective on the way things are. The perspective expressed through this exhibition is largely the result of my own personal, but educated, take on the folk art of Spain, a view tempered by my own upbringing, training, and research as an anthropologist/folklorist in the United States, Latin America, and, to a lesser degree, Spain. In order to make this publication more inclusive of different perspectives, I have elicited the contributions of others, all grounded differently than I in the area of Spanish folkways. Undoubtedly there are many perspectives on the materials presented here, each one with value, none absolute. A Salamancan devotional image, for example, would be seen and interpreted differently by someone from the community in which it was made and used than by a visiting priest from the outside or by a learned folklorist from Madrid, or by a serious collector of Spanish folk art from Paris. Each would approach this object with different eyes, and each appraisal would have value.

El Alma del Pueblo is the result of the collaboration of many, but the choice of objects, the interpretation of materials, and the order in which they are presented have passed mainly through my own cultural and professional filters. Any errors or misinterpretations that might have occurred are exclusively mine.

NOTES

1. Nikos Katzantzakis, *Spain* (New York: Simon and Schuster, 1963), 15.

2. Eric Solsten and Sandra W. Meditz, eds., *Spain: A Country Study* (Washington, D.C.: Library of Congress, 1990), 3–64.

3. Katherine Anne Porter, *Outline of Mexican Arts and Crafts* (Los Angeles: Young and McCallister, 1922).

4. René d'Harnoncourt, *Mexican Arts* (Portland, Maine: Southworth Press, 1930).

5. Linda Bantel and Marcus Burke, *Spain and New Spain: Mexican Colonial Arts in Their European Context* (Corpus Christi: Art Museum of South Texas, 1979).

6. *Mexico: Splendors of Thirty Centuries* (New York: Metropolitan Museum of Art, 1990).

7. George M. Foster, *Culture and Conquest: America's Spanish Heritage* (New York: Wenner-Gren Foundation, 1960).

8. Martha Egan, *Milagros: Votive Offerings from the Americas* (Santa Fe: Museum of New Mexico Press, 1991), and *Relicarios: Devotional Miniatures from the Americas* (Santa Fe: Museum of New Mexico Press, 1991).

9. Joan Amades, *Gegants, Nans, i Altres Entremesos* (Barcelona: Imprenta La Neotípia, 1934).

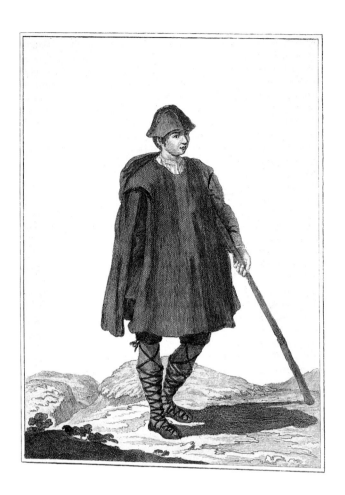

PLATE 7
Juan de la Cruz Cano
Man from Aragón, late 18th c.
Madrid
Etching, 17 × 11 in. (43 × 28 cm), unframed
San Antonio Museum of Art

PLATE 8
Juan de la Cruz Cano
Woman from Aragón, late 18th c.
Madrid
Etching, 17 × 11 in. (43 × 28 cm), unframed
San Antonio Museum of Art

Juan de la Cruz was a well-known artist/engraver who
worked during the second half of the eighteenth century.
Among his most popular works was *Colección de trajes de
España, tanto antiguos como modernos (A Collection of Spanish
Costumes, Both Old and New),* published between 1777 and
1788. Prints such as these give us an idea of regional dress
and local customs and are invaluable tools for a better under-
standing of the folk art of the times they represent.

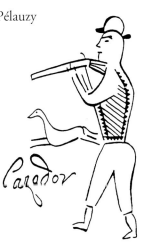

María Antònia Pélauzy

Common Themes
and Regional Variations

Spain is a mosaic of peoples and cultures, a country in which the different regions have maintained strong individual identities right up to the present day. Four languages are spoken: Castilian throughout the country; Galician in Galicia; Catalan in Cataluña, Valencia, and the Balearic Islands; and Basque in the Basque Country.

Spain is the third largest country in Europe. In addition to its size, geographical and historical factors have contributed to its enormous variety. Because of its location, the Iberian Peninsula is a site of encounter and collision between two continents, a bridge between Europe and Africa. Peoples and cultures from both sides have co-existed there over the centuries: Celts, Iberians, Greeks, Carthaginians, Romans, Visigoths, and for eight centuries in a considerable part of its territory, Arabs or Spaniards of Arab culture, with a religion and culture alien to Christian Europe. Finally, the country's profound relationship with the New World gave a unique configuration to its population.

Besides Spain's cultural diversity, the difficult geography of its land helps to make it extremely fragmented. High mountain chains running parallel to each other prevent the confluence of rivers and isolate areas from each other. The northern part of the Peninsula bathed by the Atlantic Ocean comprises the lands known as "humid" Spain, while the other two-thirds of the country make up "dry" Spain, which includes a desert area, unique in Europe, and coastal areas bordered by the Mediterranean Sea.

While the country's geography and history made it open to all types of influences, they also ensured that archaic forms and models were perpetuated. Eighteenth-century European travelers found Spain picturesque and wrote about customs they considered strange, attributing characteristics to the Spanish which were sharply different from their own. Even today it strikes foreigners as a country of unique characteristics and enormous contrasts.

Despite the influence of the mass media and a migration to the cities from the countryside, Spanish traditions have adopted new forms but maintained the same spirit. A good example is traditional festivities. One of these is Carnaval, which varies greatly from one region to another: archaic in Galicia, cosmopolitan in the Canary Islands. The feast days of the old patron saints are celebrated with dancing in the public squares of towns and villages. There are children's festivities, with processions of Giants and Big-Heads, as well as the running of bulls and cows, and the *romerías,* or pilgrimages, which include feasting and dancing. There are bonfires on Saint John's Eve and the *fallas* in the streets of Valencia on the night of Saint Joseph's day, when the inhabitants of the city burn sculptural compositions made of papier-mâché that are symbolic representations of current events.

In contrast to the general tendency to be passive observers of everything from culture to politics, during these times of celebration the citizens make the streets and open spaces their own, using them as a festive space in which everyone is an actor and a spectator at the same time.

It is important to stress that the transformation of the rural, agricultural, and stock-raising Spain into the present-day nation, where the way of life is fairly similar in both town and country,

has only recently occurred and is even still under way. This transformation has been particularly pronounced since the 1980s, as a result of political changes (the achievement of democracy after the death of the dictator Franco) and economic ones (the incorporation of Spain into the European community and great improvements in communications).

Thus, the natural regions of Spain, isolated and closed in on themselves, until well into the present century maintained traditional atavistic ways of life, using ancient techniques to make what they needed. And even though these traditional crafts no longer form part of the world of production and consumption or solve the daily needs of the community, they continue to exist. Our older artisans continue to make objects designed to recall traditions and people's origins, for use as festive items, as tourist souvenirs, or as decorations.

Some of the techniques we discuss here have fallen completely out of use, and others have been incorporated into modern times.

Shepherds' Art

The humble objects in wood and horn made by shepherds or by country folk in their leisure time integrated ancient ornamental elements similar to those used in decorative medieval stonework.

Shepherds made a number of objects from the horns of their animals: snuff boxes, eating utensils, drinking cups, powderhorns, and milking horns (pls. 24–26). They are all richly ornamented with animal or mythic motifs such as Adam and Eve before the tree of Paradise, around which is coiled the serpent or the representation of a siren. Some show local churches and monuments or heraldic motifs, for which the original models were almost certainly the coins in common use.

The shepherds also worked in wood, but in this case geometrical decoration predominated. The items included distaffs, walking sticks, boxes, mortars, and stamps for marking bread (pls. 19, 30). Most of these objects were made for the girl with whom the shepherd was in love and so were considered an offering or gift, rather than a functional item. On occasion these pieces achieve the status of important works of art, so finely and delicately are they made.

The manner in which the horn or wood was incised is simple: Sometimes the shepherd used the point of his razor, which was heated until red-hot in order to burn the design into the object; in other cases he would mark the wood with a sharp point and then carve it with a handmade tool. The shepherds carved as they kept watch on the livestock, making gifts for friends.

This ancient pastoral tradition has survived to our day, as a few shepherds from the grazing lands of Extremadura and León still make mortars and castanets to sell as souvenirs.

Artistic Ironwork

From very ancient times, the art of ironworking enjoyed great prestige in the Peninsula; in Roman times, the indigenous Celtiberian peoples used materials mined in Spain to make highly prized weapons.

More artistic forms of ironwork occur in both Gothic and Renaissance styles. They include *rejas* (grilles or screens), balconies, door knockers, weather vanes, and locks for chests. Much of the delicate ornamental ironwork from churches and grand buildings is now to be found in museums (pls. 20, 21, 23).

An unforgettable feature of southern and southeastern Spanish houses is the highly attractive ironwork of their balconies, railings, and wellheads, which stands out against the white walls. These items were made in local forges, but with their light, graceful shapes they appear to be made of malleable materials. Such work is amazing, taking into account the lengthy and tedious technical process of shaping the iron ingots until they could be made to adopt these complex forms of stylized vegetation or fluttering birds. Equally celebrated and popular are the wrought-iron crosses in the center of so many Andalusian squares, well-remembered by travelers.

Ironwork centers could be found throughout Spain. The areas of Extremadura and Andalucía produced ironwork mainly for use as an architectural feature. Aragón, Navarra, and Cataluña produced more functional grilles and balconies and an infinite number of objects for domestic use, especially in the large kitchens that were at the center of peasant family life.

The ironworking tradition continued well into the present century, and the *modernista* (art nouveau) architects made ironwork a prominent feature of their characteristic works.

Pottery and Ceramics

The diversity of pottery still produced today, the variety of throwing techniques, and the richness of the decorative motifs make this one of the most widespread, lively, and interesting of all crafts.

Primitive pots produced exclusively by women, without a potter's wheel, have great expressive vigor. Despite their simplicity, they have survived into our own time. Three or four centers of such production still exist in the Peninsula, and one in the Canary Islands, a testimony to the fact that for centuries the old techniques have coexisted with the potter's wheel and with the vitreous ceramics of Arab origin.

The vitreous glazes left cheerful and unpretentious vestiges in the production of such centers as Manises (Valencia), Lorca (Murcia), Alfajalauza (Granada), and Puente del Arzobispo (Toledo). Their most characteristic products were plates, serving dishes, bowls, wine jars, and kitchen utensils (pls. 32–34).

All these objects are profusely adorned with floral or animal designs, or with primitive scenes in brilliant colors—blues, greens, ochers, and browns—on a background of marble-white varnish. Despite their humble origins, the older pieces have become highly sought after on the strength of their decorative motifs and the beauty of their glazes.

Ex-votos

Votive offerings can still be seen in city churches and innumerable rural chapels. Nowadays, the objects offered are highly personal: a bride's veil, a child's suit, a lame person's crutches, and even motorcycle keys and automobile steering wheels.

Beside these recent gifts are ex-votos, which can be considered folk art because of the simple iconography with which they relate the event being commemorated. These little altarpieces, painted on wood panels or glass, show the image or images of the saints invoked at the moment of making the promise, a scene describing the acci-

dent, and often a short explanation providing name, date, and information on the miracle achieved. The painting is rough and simple, but full of narrative vigor and rich in detail, showing interiors of homes, furniture, clothing, agricultural implements, maritime customs, landscapes, and storms. These scenes were painted by specialized artists, the official *pintasantos* (saint painters), who also made popular religious images.

The fine collection of the Museu d'Arts, Industries i Tradicions Populars in Barcelona contains ex-votos dating from the late seventeenth to the early twentieth century, most painted on wood (pls. 51, 56).

Such offerings have disappeared, to be replaced by more direct forms, such as the above-mentioned steering wheel.

Textiles and Embroidery

Spain has a long and rich textile tradition. The cultivation of flax and the use of silkworms, together with the quality of the sheep (the fame of merino wool is widespread), gave rise to important textile mills throughout Islamic Spain. The Arabs introduced silk cultivation and oriental techniques and designs that were unknown in medieval Europe, promoting the creation of workshops in the cities of Málaga, Almería, Granada, and Valencia.

The common people who worked in the manufacturing centers adopted the Islamic motifs, employing them for their homemade trousseaux and other clothing. Until well into the twentieth century, despite the introduction of industrial textiles, marvelous wools, fine linen, and carpets with oriental motifs survived. They may be considered the most genuine expression of national popular taste over the centuries.

The most expressive aspect of the textiles in the Iberian Peninsula is the embroidery and appliqués used to decorate fabrics, bedding, the best clothes of villagers, and even the caparisons of their horses and mules. The rich embroidery on popular regional dress was documented in the eighteenth century by Juan de la Cruz Cano and was still in use until the end of the nineteenth century.

Traditional embroidery used either religious designs, such as the symbols of Christ's Passion,

or oriental motifs, such as geometrical borders, birds facing each other, fountains with a spring of water, and trees and plants, which have their origin in the symbolic tree of life of Persian art.

The most important regions for embroidery, in terms of variety and fine quality, are Toledo, Salamanca, and Zamora, which still produce embroidered tablecloths and napkins. Other types of traditional embroidery were made with braid, sequins, and metal thread and used for small, precious objects such as reliquaries, frames for religious prints, and brides' purses.

This is also the type of decoration used for bullfighters' suits, a cross between embroidery and braidwork appliqué. Bullfighters' suits have evolved a great deal since the last century, becoming even more ostentatious and colorful. This type of garment requires specialized workshops and tailors, found mainly in Sevilla, Madrid, and Barcelona.

Traditional Dress

In the second half of the seventeenth century, traditional dress became separate from court dress and, eventually, urban dress. It tended to incorporate raw materials from other areas or of industrial origin, while maintaining the motifs and designs of local tradition.

In 1777 Juan de la Cruz Cano documented the variety of styles of dress in his *Collection of Spanish Costumes, Both Old and New* (pls. 7, 8). And foreign travelers testified to the local variations they found throughout the eighteenth and nineteenth centuries.

The two items of clothing most widely used were the *mantilla* for women and the cloak for men. These were considered characteristic Spanish dress to the extent that they became commonplace, appearing in all the typical illustrations relating to the common people.

The mantilla, which is found all over Spain, is used to cover the head in church and as part of formal dress to attend ceremonies and festivities. It consists of a semicircle of black fabric, which when placed over the head reaches down to the waist. It can have a fringe of velvet or decoration with local variations. The lace mantilla, nowadays considered the most typically Spanish, was

first used among the wealthy classes, and though in some cases it did form part of the regional dress, it never took root among the lower classes and was used still less in the colder parts of the country.

For men, the most widespread item of clothing was the cape. This was used not only to keep warm, but also as a sign of respect, for the cloak was worn to attend funerals or official ceremonies. It was made of black or brown cloth, with or without a shoulder cape, and sometimes with a hood. It was used all over Spain, but was essential in the North and in Central Spain.

Apart from these more generic items of dress, there are the priestly garments, recalling those of ancient divinities, and the light, graceful, flounced dresses of the Andalusian countryside, worn with a silk shawl and flowers in the hair.

Giants and Big-Heads

Giants and Big-Heads are monstrous characters with a medieval origin, who once added splendor to the religious processions of Corpus Christi. Nowadays, they can be found in small-town processions and in some areas of large cities, as relics which have been reincorporated into community celebrations (figs. 18, 19).

The head, torso, arms, and hands of the Giants are made of papier-mâché, and from the waist downward consist of a frame of basketwork or light wood, which is covered by garments that reach to the ground and conceal the person who is carrying the figure, making it walk and dance. They are two or three times the size of a person, and they move in a solemn, dignified manner.

This tradition is common to all the towns of southeastern Spain, and there are pronounced variations in terms of symbolism. The Giants are warriors, knights, kings, or, as in Mallorca, wealthy peasants. They always appear in couples, man and woman. The woman is dressed as an archaic lady or queen. During the nineteenth century, in some important cities such as Valencia and Barcelona, the Giants wore contemporary dress and modeled the fashion for the coming year.

Normally, Giants are owned by a parish, the municipal council, or an association of volun-

teers, which is responsible for looking after them, renovating and dressing them, bringing them out into the streets, and making them perform.

The Big-Heads, also made of papier-mâché, are companions of the Giants. They symbolize the people. Their features are crude caricatures, and the pantomime they perform around the dignified Giants is deliberately grotesque. Sometimes, as in Tortosa, they represent the various social classes, and the differentiation between gentlefolk and peasants is clearly defined and marked. Nowadays, popular local figures or regional or local politicians are represented. The pieces of molded papier-mâché are made by specialized workshops in Valencia, Barcelona, and Manresa, but orders are infrequent.

Apart from these humanlike characters, great monsters of papier-mâché also take part in some local festivities. These frightening, exotic animals from an ancient tradition are representations of evil. In Cataluña two popular monsters are the Cucafera in Tortosa and the Guita in the festivity known as Patum de Berga.

From the 1980s onward, during the festivities in honor of the patron of Barcelona, the Verge de la Merçé (the Virgin of Mercy), an encounter has taken place between all the mythical animals of the different towns, under the auspices of a municipal festivities commission. This gives rise to a street spectacle known as Correfoc, which is held every year, testifying to the participation of the Spanish people in popular traditions.

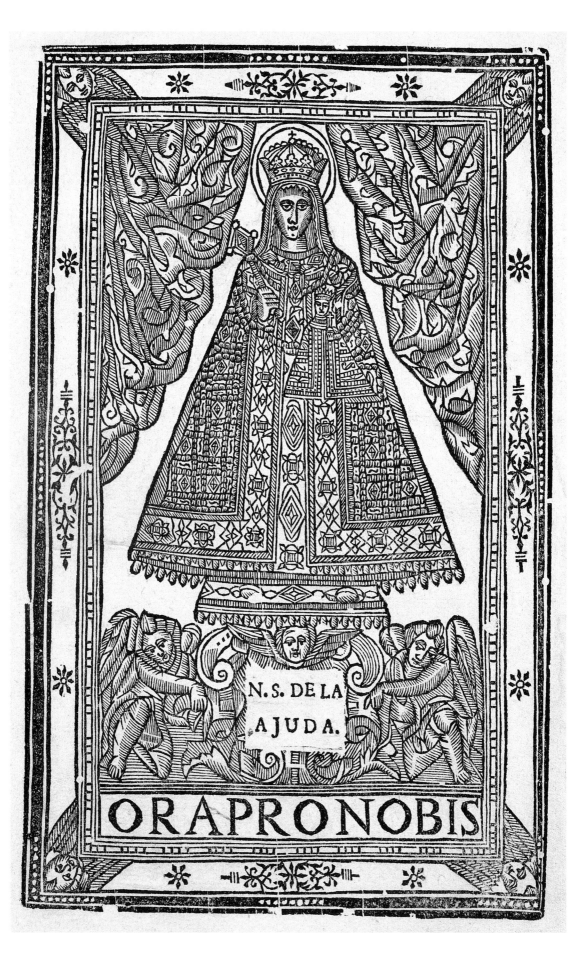

N.S. DE LA AJUDA.

ORAPRONOBIS

Vicente Ribes Iborra

Popular Prints: A Reflection of Society

Engraving is probably as old as mankind. However, engraving combined with print appeared in Spain toward the end of the fifteenth century. This was early compared to the rest of Europe, as Spain was one of the first countries to benefit from Gutenberg's invention, which led to the rapid reproduction and dissemination of the final product of the engraving process, the print. But unlike the book and the "cultured" print, which was almost always included in a book as an illustration, the print of a "popular" nature was produced independently, for its own intrinsic value, and was directed toward its own public, the vast majority of society. Printing popularized, or made accessible to ordinary people, everything from images of the most venerated saints of the celestial court to likenesses of human characters or festivities peculiar to each district. As decoration, curiosity, or object of devotion, the product's market success was assured.

Nonetheless, popular prints in Spain were not immediately successful. For this to happen more than a century would have to pass, until the advent of the baroque period and the Counter-Reformation, which fostered the dissemination of prints as propaganda. For five centuries engraving and the print were the only means of massive dissemination of images. For this reason prints soon became an important medium for spreading ideas, a use that surpassed their artistic function. In comparison with other arts, such as painting, the print excelled as a vehicle of social communication because it was easily reproduced.

From the time of the Counter-Reformation, the use of the popular print expanded enormously, to the point that from the mid-seventeenth to the mid-nineteenth century it enjoyed absolute supremacy as a means of social communication among the common people. For the following fifty years it shared its informational sovereignty with the written press, and only the spread of radio and television well into the twentieth century relegated the popular print to virtual oblivion.

For a long time, possibly until the eighteenth century, the creators of Spanish popular prints were mostly foreigners: Germans, Flemings, Italians, and the occasional Frenchman. It was not until the middle of the eighteenth century that the presence of foreign engravers in Spain could be considered incidental, coinciding with the first fruits of Bourbon "nationalism," one of which was the teaching of academic engraving techniques at the academies of San Fernando (Madrid) and San Carlos (Valencia). However, this account does not concern itself with the greater or lesser degree of native originality of engravers or their level of popularity (which are impossible to measure). This latter point leads us to the central figure of Spanish engraving, Francisco de Goya. His series of engravings *(Los Caprichos, Los Proverbios, Los Desastres de la Guerra,* and *La Tauromaquia)* not only represent the summit of Spanish engraving, but also show how tenuous is the line separating engravings considered "cultured" from those deemed "popular"—poor academic labels destroyed by the genius of an artist. In a country like Spain, where even the most renowned aristocrats have traditionally made a great showing of their affinity with the common people (and nobody

PLATE 9
Goigs de Nostra Senyora de la Ayuda (Praise Song to Our Lady of Aid), 1745
Barcelona, Spain
Woodcut
12½ × 17 in. (31.5 × 43 cm)
San Antonio Museum of Art

This exceptionally fine woodcut praise poem is in honor of La Virgen de la Ayuda. Note the finely executed scrollwork on the dress of the Virgin and the balance maintained throughout the print. Praise poems were usually sung during processions, in this case, a procession honoring the Virgin of Aid.

Núm. 9.

CONTESTACION

á Bernardo Lobo, por el Memorial que ha compuesto contra el bello y respetable sexo.

VERSO OCTASILABO.

PLATE 10
Contestación (Reply) (det.)
1822
Valencia, Spain
Woodcut
8½ × 6½ in. (22 × 16 cm)
San Antonio Museum of Art

This charming woodcut for a poem put to music was executed with typical popular characteristics. Note the distorted scale of the instruments and their flattened perspectives.

has portrayed this phenomenon as effectively as Goya), differences in taste between the "elites" and the "people" have scarcely existed. This is also indicated by "popular" reissues of prints that originally appeared in books which, because of their cost, reached a minority of the population.

Here we consider the straightforward print, with or without a caption, which was constantly in demand over the centuries, and the narrative strips known as *abecedarios* (alphabets), *gritos* (cries), and *aleluyas* or *romances,* which had their heyday in the eighteenth and nineteenth centuries. The *aleluya* is actually a print of the type we have just called straightforward, but it is also a kind of narrative strip, originally with a religious theme. An aleluya was originally a small print that was thrown to the people when the Alleluia was sung on Holy Saturday or when a procession passed. These little prints sometimes carried a text of verses from the Bible referring to the image depicted, and these verses went on to become moral reminders. Eventually the texts included a variety of subjects: biographies, customs, festivities, and so on. Meanwhile, the images became a series of pictures, like narrative strips, which were printed on a strip of paper with a written explanation at the foot of each picture, generally in rhyming verse. Each period saw the predominance of a certain type of aleluya:

those of a courtly or religious nature in the eighteenth century; documentary and biographical ones in the first half of the nineteenth; and genre and satirical-political themed ones in the second half. Because these prints were considered a minor art, or on occasion because their contents were vulgar, the engravers (particularly those of any renown) made efforts to conceal their authorship. This was not the case with the printers, however. The most prominent printers were Orga in Valencia; the heirs of Mares in Madrid; Escribano in Sevilla; and Estevill, Piferrer, Sierra, Bosch, and Llorens in Barcelona.

Popular prints can be classified according to their subject matter. At the risk of oversimplifying, they are grouped here in four categories: propagandistic, ludic, narrative, and genre.

Prints of a propagandistic nature, whether religious or political, were very possibly the first ones to appear. Religious prints traditionally served to encourage piety and devotion among the lower classes, to redeem their holders from purgatory, or to appeal for celestial protection from misfortunes and calamities, commending the holder to the appropriate saint. At the same time, other prints appeared with the aim of disseminating among the common people the sociopolitical ideology on which the ancien régime was based, showing the union of throne and

Núm. 42

MÓNICA Y SILVESTRE.

PLATE 11
Mónica y Silvestre (Monica and Sylvester) (det.), 1822
Valencia, Spain
Woodcut
8½ × 6 in. (22 × 16 cm)
San Antonio Museum of Art

This woodcut print and the one depicted in pl. 10 were illustrations for poems put to music and performed publicly or in private, usually between acts of theatrical productions.

altar, royal portraits, commemorations, festivities, and so on. Nineteenth-century versions of this type of print were of a satirical nature, implying a greater degree of political liberty.

Prints of a ludic, or playful, nature are also numerous, extending from playing cards to the game of *ocas* (or *aucas*), to flirtatious games, some showing risqué or daring scenes and others containing a nude figure or a scene considered indecent. Ludic prints are almost as old as the religious prints and, in view of their explicit nature, were from the start subject to strict controls by the authorities, both civil and ecclesiastical.

Before daily newspapers appeared, narrative publications known as *gazetillas, noticias,* or *avisos*—printed sheets which covered a wide diversity of subjects from assassinations to the appearance of monsters or the first aerostatic experiments—already existed. Their function of informing/forming public opinion was not lost on the authorities of the time.

Prints of a genre, or picturesque, nature are of several subtypes: collections of regional dress, gritos advertising merchandise sold in the markets, abecedarios linking each letter of the alphabet with a picture to help those learning to read, and so on. Though these prints were less propagandistic, not even they were always immune

from becoming a channel for expression of the dominant ideology.

Early Prints: Sixteenth and Seventeenth Centuries

Throughout the Renaissance, most prints were merely illustrations from serious books which, because of their academic level and price, were far removed from the intellectual and economic grasp of the common people. While some of the most successful engravings could be printed and sold separately, and their subject matter would be repeated in the following centuries, the single print was not highly developed in Spain until well into the seventeenth century. The most plausible theory for now associates the first major growth of the popular print with the enthusiasm of the Counter-Reformation for propaganda. And its success would not be far different from the rise of the votive image imposed by the Catholic Church to counteract the attacks of Protestantism.

The first prints of which we are aware deal more or less exclusively with religious subjects and date to the fifteenth century. They are usually of clean lines, simplistic, and almost schematic in style, produced with the etching technique: a Virgen del Rosario, a San Antonio, or the prints distributed by Fray Hernando de

EL SOLDADO,

ó SEA

EL HIMAN DE LA MILICIA.

TONADILLA Á DUO.

BARCELONA:
EN CASA JUAN LLORENS: CALLE DE LA PALMA DE SANTA CATALINA.
1858.

Talavera among the Moriscos (converted Moors) of the Alpujarras. Through the centuries, religious prints have evolved relatively little from these first examples to the contemporary prints distributed at religious centers. In all periods, prints were usually sold at the entrances to churches or in sacristies, and while less dexterous or well-reputed engravers would satisfy the demands of the popular classes and rural religious centers, the works of great masters were directed toward the wealthier and more enlightened classes. In any case, they all did no more than comply with one of the mandates of the Council of Trent, which specified that bishops should

by means of the stories of our Redemption, expressed in paintings and other copies, instruct and confirm the people, reminding

them of the articles of Faith and recapacitating continually on them; furthermore, all the sacred images are very fruitful not only due to the benefits and gifts that Christ has granted to them, but also because they exhibit before the eyes of the faithful the healthy examples of the saints and the miracles that God has worked in them.

According to Carrete Parrondo (1987), throughout history the religious print has fulfilled three essential functions:

To encourage piety and devotion among the lower classes. Prints were inexpensive and bore a simple message that allowed the spectator to identify immediately the subject represented: images of Christ, virgins, or saints

PLATE 13
La Entrada y Entierro del Carnabal en Barcelona (The Beginning and End of Carnival in Barcelona) (det.), late 19th c.
Barcelona, Spain
Relief print
17 × 12 in. (43.5 × 30 cm)
San Antonio Museum of Art

This broadside provides a comical peek into the celebration of carnival as it occurred in nineteenth-century Barcelona. Parading Roman soldiers, masked dancers, cigarette-smoking women, and dancing devils are some of the characters depicted. All scenes are accompanied by clever rhymed verses.

Convidando está á Paquita / á que tome una copita.

Empeña saya y mantilla / por echar otra copilla.

Ven del vino los fumillos / y la acosan los chiquillos.

Arremete á su compañera / con una nabaja fiera.

Por ser de tan mala vida / á la cárcel es conducida.

Para domar esta fiera / la encierran á la galera.

25 En la taberna beodo / gasta su dinero todo.

26 Maltrata á mas no poder, / al hijo y á la muger.

27 Bebidos como unas sopas, / aun quieren echar copas.

28 Pa los efectos del vino, / le hacen perder el tino.

29 Vá en casa el tio Tomás, / á echar un traguito mas.

30 Está perdido y beodo / tendido sobre del lodo.

31 Un compañero que pasa, / le conduce hasta su casa.

32 Cansado ya de beber, / de palos dá á su muger.

33 Es tanto lo que ha bedido, / que en el suelo se ha dormido.

34 Audáz, arrogante y fiero, / desafia al tabernero.

35 Del vino y su consecuencia, / sobrevino una pendencia.

36 Lleno ya de mojicones, / se le caen los calzones.

37 La borrachera de marras / le hace romper las jarras.

38 Para beber dos cuartillos / empeña los calzoncillos.

39 Tal escándolo ha movido / que ha prision es reducido.

40 En vez de ir con su muger, / vá á la taberna á beber.

41 Ven compañerita mia, / que tu eres mi alegria.

42 Se ha dado tal atracon, / que vacia el barrigon.

43 Echa otro vaso Colasa, / que así la vida se pasa.

44 Entre pinto y baldemoro / echa otra suertita al toro.

45 Pide mas vino á fiar / y se marcha sin pagar.

46 Llora ya su suerte impia, / que la bota está vacia.

47 Un trago tras otro trago, / de la bebida es esclavo.

48 Tal borrachera tomó / que nunca mas dispertó.

PLATE 14

Vida de la Mujer y Hombre Borrachos (Life of the Drunk Man and Woman) (det.)
Late 19th c.
Madrid
Relief print
17½ × 12½ in. (44 × 32 cm)
San Antonio Museum of Art

One of the main purposes of nineteenth-century broadsides such as this was to reinforce the community's ideas of right and wrong. In this amusing but tragic example, we see the destructive results of drunkenness. The top half of the broadside relates to the Life of a Drunk Woman. In the bottom half shown here, we see the Life of a Drunk Man. The lesson starts with scene 25, showing a man spending all of his money in the tavern, and ends at scene 48, with the same man passed out, never to reawaken.

venerated by the people to whom they were directed. Specialized variations of this type included the *gozos* or *goigs* (hymns of praise), which along with an image included prayers in praise of virgins or saints, and which were sung at the end of religious services. Other variations were the aleluyas, mentioned above, small leaflets referring to the Easter liturgy, and the *vanidades* (vanities), which recalled the fleeting nature of life and the omnipresence of death. The gozos were found mostly in the lands of the ancient Crown of Aragón; these are sets of popular couplets in praise of Christ, the Virgin, or the saints in their most diverse advocations and representations. They are usually printed on a folio-sized sheet, and their main feature is an image or allegorical engraving in the midst of the dedication, often with some additional decoration in the form of borders, allegories, and so on. The written part consists of a eulogy or prayer in ten or twelve stanzas with a refrain repeated at the end of each one. They are meant to be sung in chorus, for which reason they sometimes include a simple musical score in the lower part of the print. Each church, chapel, or sanctuary, no matter how small, and each patron of a town or a guild, came to have at least one gozo in its honor, which translates into many thousands of such prints spread over the areas of Valencia, Cataluña, Aragón, Mallorca, and Navarra.

To redeem the possessor or buyer of a print from the miseries of purgatory. These were the so-called indulgences, which generated many abuses.

To provide protection or cure from illness or calamity through the intercession of a saint. Examples of saints who specialized in particular ailments include San Gil (Saint Giles) for fevers, San Blas (Saint Blaise) for throat infections, San Vicente Ferrer (Saint Vincent Ferrer) as protector against earthquakes, and Santa Bárbara (Saint Barbara) against plagues of locusts.

In addition to the religious print, there was the propagandistic type. The basic message of these prints stressed the grandeur and splendor of the monarchy and the nobility, which together with the Church (the oft-mentioned "union of throne and altar") formed the pillars of contemporary society of the time. To this category belong the royal portraits and those of prominent personalities, the prints commemorating royal solemnities (births of *infantes* [the monarch's children], marriages, funeral rites) and public festivities (reproductions of decorations, triumphal arches, allegorical floats).

Engravings of a ludic nature, together with the propaganda prints, were among the first to be printed. They included the famous *naipes*, or playing cards, which are presumed to be of oriental origin and already had a long history in Spain by the time the printmaking process arrived. The Spanish deck consists of forty-eight cards, known as *cartas* or *naipes*, divided into four suits: *oros, copas, espadas,* and *bastos.* One set of playing cards can be dated to the late fifteenth century—the oros show the arms of the Crown of Aragón—and in all likelihood they were printed in the city of Valencia during the reign of Juan II. They may well be some of the first playing cards printed in Spain. For a long time cards were "manufactured" by means of wood engravings, later replaced by copper plates, then hand-colored with patterns and a brush, using the wash technique. For centuries, playing cards were produced mostly in Valencia, Barcelona, and Sevilla, until their manufacture was centralized at the Fournier firm, in Vitoria, during the nineteenth century.

Also very ancient is the game of *oca,* played with dice on a printed board with sixty-three numbered spaces forming a spiral. Players move their tokens forward or backward as indicated by the space to which their luck takes them, the winner being the first player to complete the course. No matter how ingenuous and inoffensive they may seem nowadays, the games of oca did not escape several prohibitions dictated by inquisitorial zeal.

Even after the appearance of newspapers, loose printed sheets passed from hand to hand would recount news items ranging from feats of arms (such as the reconquest of El Salvador in the seventeenth century), to a thorough study of monsters and deformed beings, to detailed accounts of catastrophes or reliable news of outstanding social events. Multiple prints, which dealt with important scientific or artistic subjects from anatomy to architecture, were addressed to the most educated sectors of the population, but on occasion could also prove of interest to some sectors of the common classes.

PLATE 15
*Nuestra Señora de la
Consolación (Our Lady of
Consolation),* 1762
Sevilla, Spain
Etching
9½ × 7 in. (24 × 18 cm)
San Antonio Museum of Art

The sanctuary of Nuestra Señora de la Consolación is
located in the town of Utrera, a short distance from Sevilla,
and is a popular pilgrimage site. Customarily, pilgrims bring
votive objects to express thanks for the Virgin's intercession
during times of crisis, and the sanctuary displays thousands
of ex-votos as witness to her power. Flanking the statue in
this etching are votive offerings representing miraculous
cures for eye problems, breast disease, broken legs, and other
afflictions. Etchings such as this were either part of larger
printed works related to the Virgin or were displayed by
themselves in the homes of devotees.

PLATE 16
Mare de Deu de La Cisa
(Mother of God of La Cisa)
(det.), 1924
Barcelona, Spain
Relief print
12 × 8½ in. (31 × 22 cm)
San Antonio Museum of Art

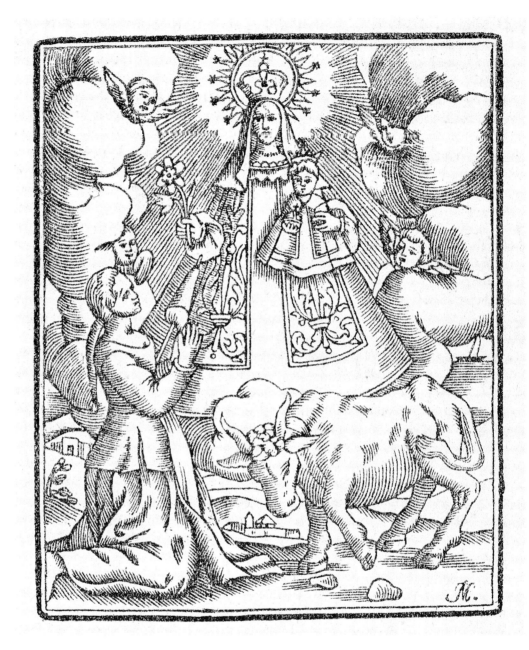

Marian praise poems such as this were popular throughout
Spain and continued to be used well into the twentieth
century. This print relates to a miraculous apparition of the
Virgin to a cowherd from a small town just north of Barce-
lona. The behavior of the bull drew her attention to a spot
where she discovered the long-lost image. Similar apparition
motifs are common throughout Spain and the Americas.

PLATE 17

San Isidro Labrador
(Saint Isidore the Farmer)
Late 18th c.
Madrid
Etching
12 × 9 in. (30 × 22 cm)
San Antonio Museum of Art

Graphic works such as this were widely used to teach the lives of saints. This etching shows miraculous events in the life of San Isidro Labrador, the patron saint of Madrid and of farmers.

And all of this took place within the tight controls over printed material imposed by the Holy Inquisition. By 1612 the Index of censorship already condemned

> any portraits, figures, coins, prints, large printed letters and printed books, inventions, masks, medals, or any materials that are printed, figured or made, which are in derision or disrespect of the Holy Sacraments, or of the Saints, their images, relics, miracles, habit, profession or life, or of the Holy Apostolic See and its State, and of the Roman pontiffs, cardinals, bishops and of their order, dignity, authority, keys and spiritual power, or of the ecclesiastical states and Sacred Orders approved by the Church

in addition to inscriptions propagating the rumor

> that those who pray such and such a prayer or perform such and such a devotion shall not die a sudden death, or in water, or in fire, or any other kind of violent or disastrous death, or that such a person shall know the hour of his/her death, or shall see Our Lady at that moment, or similar things.

And the list grew a great deal longer in subsequent centuries. The inquisitorial crusade against printed material fomenting impiety, heresy, false devotions, deviations from orthodoxy, scenes showing nude figures or provocative postures, obscenities, or material with a clear political intention (such as anything referring to the French Revolution or the independence of the American colonies, to mention a few cases) was to prove long and arduous.

Miscellaneous Prints: Eighteenth Century

The prolonged economic boom during most of the second half of the eighteenth century allowed for the development of "popular" culture, which bordered on the more refined tastes of the aristocracy, being far removed from the attention of the lowest classes, who were fully occupied by the struggle for survival. This situation resulted in an abundance of prints, traditional ones as well as new types. This growth and diversification of prints would continue throughout the nineteenth century, only starting to decline during the Restoration, in the last decades of the century, with the introduction of new printing techniques and the rise of journalism. It should

be remembered that the Spanish eighteenth century ended in 1800 from a chronological viewpoint only, as for all practical purposes it did not end until the Spanish War of Independence (Peninsular War) against Napoleon, or even, it could be argued, until the first half of the next century was well underway.

Several phenomena contributed to widen the scope of eighteenth-century prints. First came increased social freedom coupled with a greater preoccupation with people's external appearance. The rise of new styles of dress, the growing importance of adornment, and the evanescence of fashion all combined to create not only a series of novelties in design, but also a dialectical tension between old and new values. Both factors were reflected in popular images and therefore in prints. One example is the representation of the male figure: The *valientes, guapos,* or *espadachines* (dashing young men), who were the prototypes of masculinity in the seventeenth century, were replaced in this role by the *petimetres, pisaverdes,* and *majos* (dandies) of the following century, which almost invariably implied a greater affectation in dress. Only the portraits of *bandoleros* (highwaymen), which were common at the beginning of the nineteenth century and to some extent imposed a return to the previous masculine values, represented something of a bridge between the two centuries.

These two phenomena were at the root of a new type of print which proliferated in the following years, the genre print. The engraver Juan de la Cruz Cano, with his *Collection of Spanish Costumes* (1777), was a pioneer of this type of print (pls. 7, 8). His scenes are static and rigid, with heavy figures firmly grounded. These evident limitations in the prints of Juan de la Cruz were overcome by two later engravers, J. Camarín and Marcos Téllez, who illustrated animated popular dances and scenes from the lives of the highwaymen and smugglers who were to flourish in the Andalucía of the end of the century. Finally, the collection of regional dress prints by A. Rodríguez (who was from Valencia) united naturalism and moderation in movement with masterly portrayals of the costumes shown.

This type of genre print is related to other types of picturesque prints which attained great popularity in the first decades of the nineteenth century. These included the *juegos galantes* (flirting games), pastimes showing a scene below

EL MUNDO AL REVÉS

2 — SOL Y LUNA POR LA TIERA
3 — MALO ESTA EL ENFERMO
4 — I QUIETO BARBARO
5 — LA CRIADA ES LA SENDRA
8 — A GALOPE
9 — LOS OMBRES MANSOS
10 — EL CAPITAN Y EL RANCHERO
11 — EL PERRO ES QUILADOR
14 — VAMOS A RAILAR
15 — EL GATO EN LA RATONERA
16 — ROMPEME LAS COSTILLAS
17 — ABRE BURRO D UN LADRON
20 — MUERTE COCHINO
21 — PARA MANANA SERA BUENO
22 — PATAS ARIBA
23 — HOMBRES SALEN

PLATE 18
*El Mundo al Revés (The
World in Reverse)* (det.)
Late 19th c.
Madrid
Relief print
17½ × 12½ in. (44 × 32 cm)
San Antonio Museum of Art

Entertaining scenes showing the world's natural order in re-
verse go back as far as ancient Egypt. They were popular in
Germany and the low countries during the seventeenth and
eighteenth centuries. This print shows, among other things,
an animal treating a veterinarian (3), a horse riding a man
(8), a chair sitting atop a person (16), a fish catching a fisher-
man (23), and other entertaining reversals. One of the latent
functions of these prints was to remind people of the proper
order of things by showing them in reverse.

which was a short text appealing to the imagination or flirtatious wit of the player, or the series devoted to the gritos of the wandering peddlers in the cities, pioneering images of the urban proletariat, whose expressions reflect the wide idiomatic range of the Spanish people. Another curious example of the genre print is the abecedario, which related each letter of the alphabet to a specific scene, to help beginning readers. Another native of Valencia, Miguel Gamborino, was the undisputed master of this type of print.

Two further varieties of print experienced important innovations in the last years of the eighteenth and first years of the nineteenth century.

Descriptive or documentary prints. These depicted a scene (whether imaginary or real) and became more dramatic in the early years of the nineteenth century, sometimes to the point of foreshadowing the romantic flyer.

Grotesque prints, coming from a long tradition, and including all types of engraving. Baltasár Talamantes (from Valencia) saturated all types of prints with grotesque figures, from the aleluyas of Carnaval (pl. 13) to those of the "world turned upside down" (pl. 18). His work invites us to reflect on the grotesque aspects of the world, its loss of direction, and the announced reign of Satan, acting as a prelude to Spain's turbulent nineteenth century and difficult entry into modernity. Not by chance do Goya's *Caprichos* and *Disparates* point in the same direction.

Goya's Genius

Francisco de Goya, who lived in the late eighteenth and early nineteenth centuries, is essential to an understanding of Spanish engraving, and the influence of his work is evident in both the nineteenth and twentieth centuries. He was certainly not chronologically the first of the great Spanish engravers, as this distinction belongs to José de Ribera. However, none of Ribera's celebrated engravings could be included in the category of popular prints—neither his *Martyrdom of Saint Bartholomew* (engraved in Rome in 1624) nor his *Drunken Silenus* (printed in 1626). Though the former demands identification between the spectator and the martyr saint and was very popular in its time, its sophisticated

concept and execution distance it from the common people. The second of these works, a pagan theme produced on commission from a Flemish merchant, never even approached the aesthetic tastes of the Spanish people.

Goya's engravings are very different, possibly because the artist was born in a humble Aragonese village, was self-taught, and came late to the world of culture, always remaining very close to the taste of his people. Chronologically, *Los Caprichos* (whims or fancies) was the first set of Goya's etchings offered for sale, being advertised in the *Diario de Madrid* on 6 February 1799. This series, which led Valle Inclán to exclaim that "Goya had the idea for the *esperpento*" (theater of the grotesque), shows a series of grotesque beings, corrupt and with few personal charms, who personify the popular print, far removed from the neoclassical ideals of reason, serenity, and harmony that were in fashion among the wealthier and more educated classes.

The series *Los Desastres de la Guerra* was started in 1810, during the Spanish War of Independence, though it would not be published until 1863. In these works Goya rejects satire or sarcasm as a means of toning down the images of war he presents, practicing social criticism with scenes of great crudity. *La Tauromaquia* is a series of engravings that explains the origins of bullfighting and the prowess of the most famous bullfighters of the artist's time, and was probably executed between 1814 and 1816, when it was offered for sale. Though it was less important than Goya's other series, it had a stronger connection with the popular print of the genre or festive type. Finally, the documentary character of his work is evident in the series known as *Los Proverbios* (proverbs) or *Los Disparates* (foolishness), produced in the 1820s but not published until 1864. In these works Goya continued to find his inspiration in the Spanish people, in their old refrains, allegories, and symbols. Their meaning is difficult to interpret nowadays, though it was easily grasped by the people of the period.

Apotheosis of the Print: Nineteenth Century

The Spanish War of Independence ushered in a long period of political uncertainty—the first third of the nineteenth century, when the print seemed to hearken back to the previous century rather than look forward, much like absolutism, which has been Spain's most prevalent political

structure. Nevertheless, it would be an exaggeration to suggest that the print did not evolve in step with the times. Indeed, the war and political circumstances favored the proliferation of two types of print, those of a satirical-critical nature, which targeted the king, José I Bonaparte (Joseph Bonaparte), and those of a documentary-propagandistic type, which favored the cause of King Fernando (Ferdinand) VII and the anti-French party. The first type formed part of a general European trend toward anti-Napoleonic prints, and only certain Goyesque traits or specific reference to circumstances relating to the war in Spain confer a certain degree of originality to this group of works. The documentary prints portray feats exalting Fernando and promoting a visceral anti-French feeling. In this category we could include the enormous number of prints portraying diverse local and national heroes, although the common denominator of all the portraits is to exalt or glorify the person in question, from the king down to "heroes" of the lowest social extraction.

Toward the middle of the century, the popular print entered a clearly different phase. The two main blocks of products, straightforward prints and the narrative strips, abecedarios, gritos, and aleluyas or romances, suffered different fates. While the latter underwent few formal modifications, the prints became increasingly subordinated to the language of graphic expression, turning into mere illustrations, while their classic independent production began to diminish until it almost disappeared. This phenomenon was due to the wide acceptance of newspapers, illustrated books in installments, and booklets.

As Liberalism and the bourgeoisie grew gradually stronger in Spain, the written press expanded greatly, though interrupted or obstructed on occasion by certain restrictions on freedom of the press imposed by the political faction currently in power. In this environment of continual political change, prints or illustrations of a satirical nature found fertile ground for development. Any print emphasizing the grotesque, amusing, ridiculous, or corrupt aspects of the political enemy was well received. Criticism expressed in regular publications such

as *El Papagayo, Guindilla, El Matamoscas,* and later on *El Cencerro, La Flaca,* and *Fray Gerundio,* often took on a denigrating, violent, and excessive tone, much like the prints directed against José I Bonaparte and the French during the Spanish War of Independence. This type of print, and press, reached its zenith during the revolutionary six years from 1868 to 1874, when four different concepts of the Spanish State were tried out but failed, thus increasing the frustration of those in favor of each of the political options. During these six years there was ample press freedom, and the enormous number of satirical publications that appeared was equaled only by the violence of the attacks directed against the political enemies of each one of them. With the restoration of the Bourbon monarchy in 1874, the press was severely restricted, under a legislative framework that was to endure until the end of the Spanish Civil War.

Other prints demanded by newspaper publishing were the documentary, or genre, types used to illustrate the variety magazines of recent appearance, such as *El Semanario Pintoresco* and *El Museo de las Familias,* which went on to enjoy considerable growth during the remainder of the century. These were pleasant illustrations, directed to an urban bourgeoisie desirous of entertainment and pleasure while seeking a certain refinement in their prints, obliging the publishers to expunge any violent or disagreeable content.

In the midst of such a change in the concept of the simple print, the aleluyas or romances underwent few modifications compared to those of the previous century and enjoyed something of a boom. At the same time, they diversified their subject matter with new themes of a picturesque, lighthearted, political, religious, moral, didactic, descriptive, or historical type. How, in terms of the mentality of the period, to separate the historical objective from the political one, or the didactic, genre, or ludic aspect from the moral? In fact, aleluyas to a great extent continued, as in previous centuries, to concentrate on subjects referring to religion, lives of saints and virgins, descriptions of processions, and explanations of morality and doctrine.

Conclusion

The panorama we have been describing up to this point begins to change substantially in the twentieth century and more rapidly after the watershed of the Spanish Civil War. By the end of the war, the character of the popular print had changed. Several essential features differentiate the prints we have been examining from the modern ones. To begin with, the term itself, "popular," is now applied (when speaking of prints) only to those reflecting "popular" subjects, such as the life of the people, their customs, and environments. And though in this sense prints may indeed be related to the naturalistic, genre prints of previous centuries, they are no longer intended for the "people," but rather for educated elites, and their messages are often more elaborate. The artists of such prints, even the most famous ones such as Picasso and Miró, are far removed from popular taste. And this is the case even with those who express a desire to situate themselves close to the "popular" in its most classic sense, as happened with the artistic

movement *Estampa Popular* (Popular Print), a Communist-inspired group of engravers that appeared in the 1960s in the larger Spanish cities. Their basic proposal consisted of using the engraver's art as a sociopolitical medium, professing open admiration for the Mexican engraver José Guadalupe Posada. The Valencian group adopted the most radical position, choosing the language of comics as a vehicle for expression, and silk-screen printing as a technique. However, with the arrival of democracy in Spain, aesthetic and political evolution took its members along different paths.

And so the twentieth century, with its revolutionary changes in the fields of technology and communications, and accelerated processes of urbanization and demographic movement, has witnessed the end of the "popular" print, leaving traces only in the area of Catholic devotion. It is nothing if not paradoxical that, after a life of five centuries, both the beginning and the probable end of the popular print are associated with the religious arena.

BIBLIOGRAPHY

Blas, J., et al. *Goya, grabador y litógrafo: Repertorio bibliográfico.* Real Academia de Bellas Artes de San Fernando. Editorial de la Calcografía Nacional. Madrid, 1992.

Bloch, G. *Pablo Picasso. Catalogue de l'ouevre gravé et litographe. 1904–1967.* Berne, 1968.

Bozal, V. *La ilustración gráfica del XIX en España.* Comunicación. Madrid, 1974.

Carrete Parrondo, J. *Catálogo general de la Calcografía Nacional.* Real Academia de Bellas Artes de San Fernando. Editorial de la Calcografía Nacional. Madrid, 1987.

Carrete Parrondo, J., et al. *Estampas, cinco siglos de imagen impresa.* Exhibition catalogue. Madrid, 1981–82.

———. *El grabado en España (siglos XV al XVIII).* Summa Artis, vol. 31. Madrid: Espasa Calpe, 1987.

———. *El grabado en España (siglos XIX y XX).* Summa Artis, vol. 32. Madrid: Espasa Calpe, 1988.

Catala Gorgues, M. A. *Colección de grabados del Excmo. Ayuntamiento de Valencia.* Valencia, 1983.

Durán y Sanpere, A. *Grabados populares españoles.* Barcelona: Gustavo Gili, 1971.

Estampa popular. Exhibition catalogue. I.V.A.M. Valencia, 1996.

Gallego, A. *Historia del grabado en España.* Cuadernos Arte Cátedra. Madrid, 1979.

García Vega, B. *El grabado del libro español en los siglos XV, XVI, XVII.* Institución Cultural Simancas. Valladolid, 1984.

Garrido Sánchez, C. *Goya, de la pintura al grabado.* Universidad Complutense. Madrid, 1989.

Goya. *La década de los Caprichos. Dibujos y aguafuertes.* Exhibition in the Real Academia de Bellas Artes de San Fernando. Editorial de la Calcografía Nacional. Madrid, 1982.

———. *Caprichos y Disparates.* Carreño-Gómez Collection of the Museu de l'Almodí de Xàtiva. Generalitat Valenciana. Valencia, 1989.

LaFuente Ferrari, E. *Sobre la historia del grabado español.* Caja de Ahorros Vizcaina. Bilbao, 1989.

Páez Rios, E. *Antología del grabado español. 500 años de su arte en España.* Madrid, 1952.

———. *Repertorio de grabados españoles en la Biblioteca Nacional.* 4 vols. Ministerio de Cultura, 1981–85.

Tomás Sanmartín, A., and M. Silvestre Visa. *Museo de Bellas Artes de Valencia: Estampas y planchas de la Real Academia de San Carlos.* Ministerio de Cultura. Madrid, 1982.

Vega, J. *Museo del Prado: Catálogo de estampas.* Ministerio de Cultura. Madrid, 1992.

Marion Oettinger, Jr.

Utilitarian Folk Art

Watch me closely,
I am your food.
—SALAMANCAN BREAD STAMP[1]

As elsewhere in the world, most folk art in Spain is, first of all, utilitarian—made to satisfy the daily practical needs of those who produce and use it. For centuries, objects whose forms visibly reflect their functions have been made and used all over Spain. They are time-tested cultural responses to demands made by the environment and form buffers between the individual, the community, and the larger physical world. Pottery to hold wine or olive oil, chairs to rest in, wooden trunks to store prized textiles, implements carved by lonely shepherds, clothing for warmth, specialized cooking utensils, and thousands of other items in the Spanish home are examples of utilitarian folk art.

But seldom is a folk artist content to let his or her craft stop once it has satisfied a practical need. Most take their work a step further by embellishing objects in special ways. Sturdy walking sticks are entwined with serpents and vines or carved into voluptuous nudes, thereby venting the artistic talents of the carver or transforming his or her dreams into something closer to reality. Powderhorns are delicately incised to show frightening battle scenes, thereby transforming a simple container into a portable historical document. Andirons are beaten into zoomorphic figures which, by the light of a blazing fire, seem to spring to life. These transformations often serve as a folk artist's "signature" and identify his or her work for miles around and over many generations. Variation, however, usually

FIGURE 3
Drying Shed, 19th c.(?),
Galicia, Spain

occurs on a broader level. Galician *hórreos* (drying sheds) often appear identical within a village but vary considerably from one village to the next (fig. 3).

The two essays in this section point out variation as well as consistency. Andrés Carretero's excellent overview of Spanish folk pottery deals with one of Spain's most complex and persistent folk forms. Each community has experienced its own special evolution of ceramics, which has led to the tremendous variation of pottery forms still found throughout the country today. Carlos Piñel's superb essay on Spanish popular furniture provides us an exciting glimpse into a subject rarely addressed. Furniture, with its specialized functions, varies tremendously from the Basque Country to Andalucía, from Cataluña to Galicia, and it can serve as an excellent barometer of local cultural adaptation to special environmental demands.

NOTE
1. Luis Cortés Vázquez, *Arte popular Salmantino* (Salamanca: Centro de Estudios Salmantinos, 1992), 46.

PLATE 19
Three Walking Sticks
Early 20th c.
Asturias, Spain
Wood with metal tips
L. 31–34½ in. (78–89 cm)
Museo Nacional de
Antropología, Madrid

These walking sticks were probably carved as a leisure-time activity. Although those shown here are highly individualistic, others were carved in more generic forms all over Spain. Walking sticks may also be related to staffs of authority and shepherd's crooks.

PLATE 20
Pair of Andirons, 19th c.
Cáceres, Spain
Iron
8½ × 19 in. (21 × 48 cm)
Museo Nacional de
Antropología, Madrid

These andirons are yet
another example of the
Spanish folk artist's desire
to take his or her skills be-
yond the principal require-
ment to fill a utilitarian
need. By converting inani-
mate andirons into vital
zoomorphic forms, the
artist has breathed special
life into these objects.

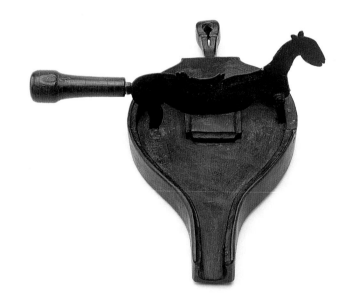

PLATE 21
Door Knocker, late 18th c.
Central Spain
Iron, 8½ × 2½ in. (21 × 6 cm), opened
San Antonio Museum of Art

This iron door knocker in the form of a lizard served to
announce the presence of a visitor. Its subtle lines are a
testament to the artistic skills of the ironsmith.

PLATE 22
Chocolate Cutter with Horse Motif, late 19th c.
Northern Spain
Wood and iron, 5 × 12 in. (13 × 30 cm)
Peter P. Cecere, Reston, Virginia

Chocolate has been a fashionable and popular drink in Spain
since it was brought to Europe from Mexico in the sixteenth
century. This charming chocolate cutter was used to shave
blocks of chocolate required in the preparation of cool des-
serts and warm drinks.

PLATE 23
Weather Vane, 19th c.
Origin unknown
Iron
H. approx. 84 in. (213.5 cm)
Museo Nacional de Artes
Decorativas, Madrid

Weather vanes have graced
the roofs of Spanish build-
ings for hundreds of years.
In addition to indicating
wind direction, these objects
are also highly decorative.
Some represent a village's
patron saint. Others indicate
the profession of the owner
of the house. In the sherry-
producing town of Jerez de
la Frontera, wineries often
display weather vanes
showing the logo of their
company. Still others are
designed simply to amuse.

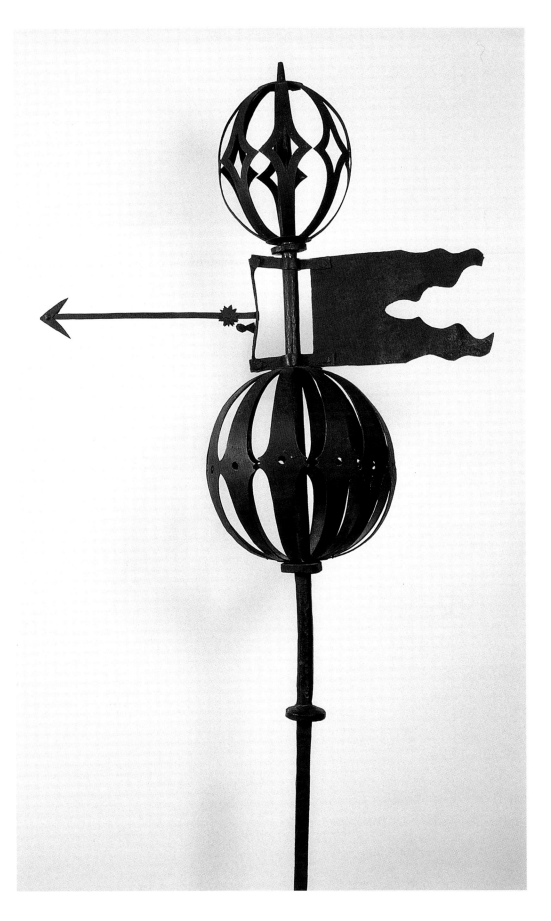

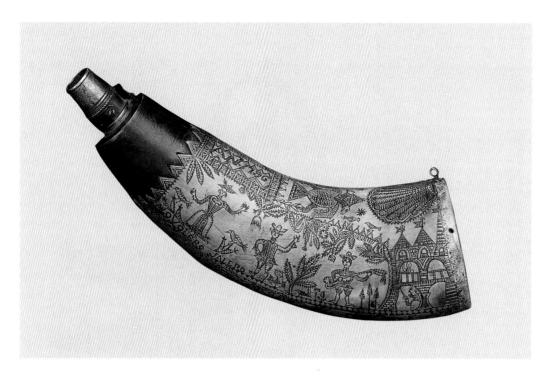

Powderhorn, 1796
Salamanca, Spain
Brass and horn
9½ in. (24 cm)
Martha Egan, Santa Fe,
New Mexico

Horn carving became very
popular in Spain during the
eighteenth and nineteenth
centuries. Powderhorns,
drinking cups, spoons, and
trumpets were favored
forms. Most of these items
were executed by shepherds
and soldiers with plenty of
free time. Often these pieces
were gifts for sweethearts
or friends and relatives.

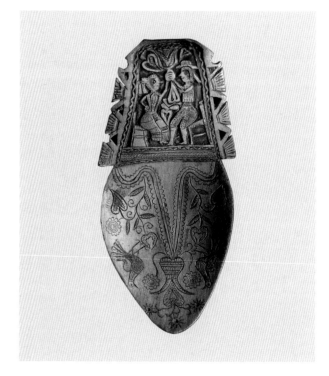

PLATE 25
Spoon and Fork with Flowers and Deer, early 20th c.
Salamanca, Spain
Horn, 8½ in. (21 cm), opened
Museo Nacional de Antropología, Madrid

Carved horn objects such as this spoon and fork often com-
bine utensils with specialized functions. These "proto–Swiss
Army knives" sometimes combine as many as six tools.

PLATE 26
Spoon with Couple, Flowers, and Birds, early 20th c.
Salamanca, Spain
Horn, 4 × 2 in. (10 × 5 cm)
Museo Nacional de Antropología, Madrid

Horn, like bone, lends itself to decoration. In addition, it is
somewhat durable, inexpensive, and available to the shepherds
who usually carved it. By incising designs into the base materi-
als and rubbing in charcoal or other pigment, the artist created
richly contrasting spaces with impressive results.

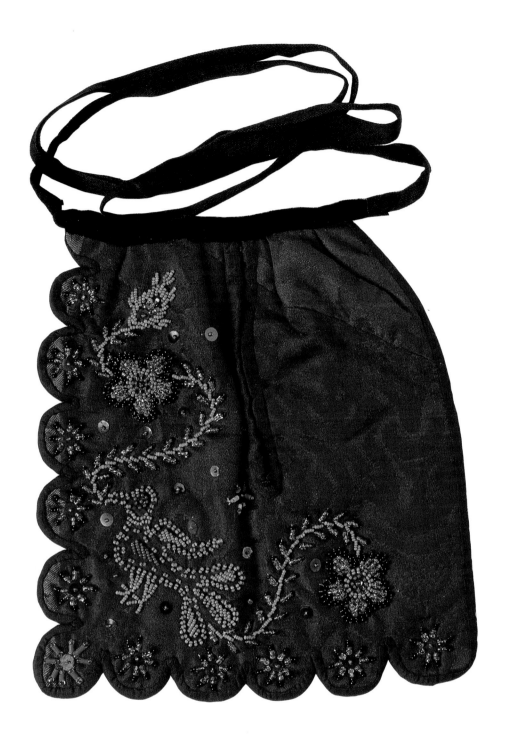

PLATE 27
Purse, c. 1780
Salamanca, Spain
Embroidered textile, 6½ × 6¾ in. (16 × 17 cm)
Museo Nacional de Antropología, Madrid

This purse was tied around the waist to hold objects of
worth. The beaded floral and bird designs stand out
boldly against the silk background.

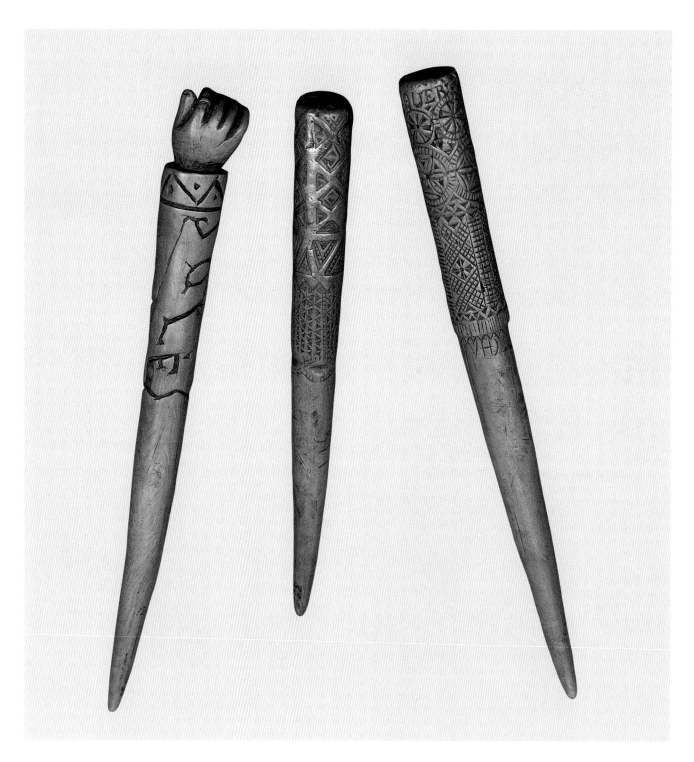

PLATE 28
Three Garrots, early 20th c.
Cataluña, Spain
Wood, metal inlay, L. approx. 10 in. (25 cm)
Museu d'Arts, Industries i Tradicions Populars, Barcelona

Garrots were used mainly by women to tighten the cord
used to tie bundles of wheat or hay. Frequently, the garrots
were individualized and given by husbands to their wives.

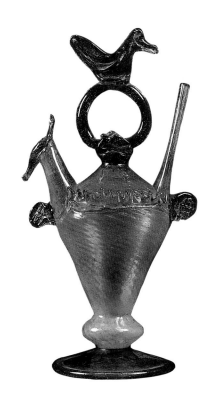

PLATE 29
Glass Pitcher, 18th c.
Cataluña, Spain
Glass
H. approx. 7½ in. (19 cm)
Museo Nacional de Artes
Decorativas, Madrid

Glass production in Spain is
ancient, and many regional
museums there have good
collections of glass objects
from Roman times and
earlier.

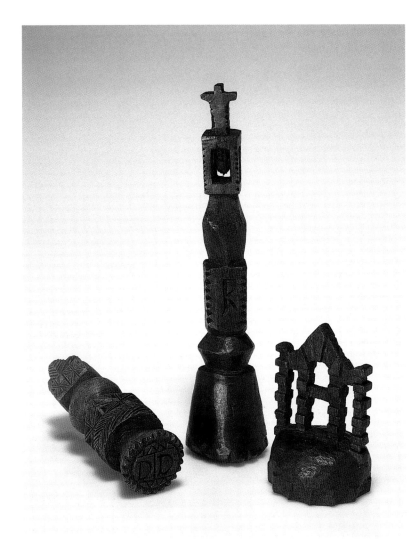

PLATE 30
Three Bread Stamps, late 19th c.
Northwestern Spain
Wood, H. 3–7 in. (8–17 cm)
San Antonio Museum of Art

Until relatively recently, the inhabitants of many Spanish
communities baked bread in communal ovens. To distin-
guish which loaf belonged to which family, bread stamps
such as these were used to press initials or other marks
into the dough.

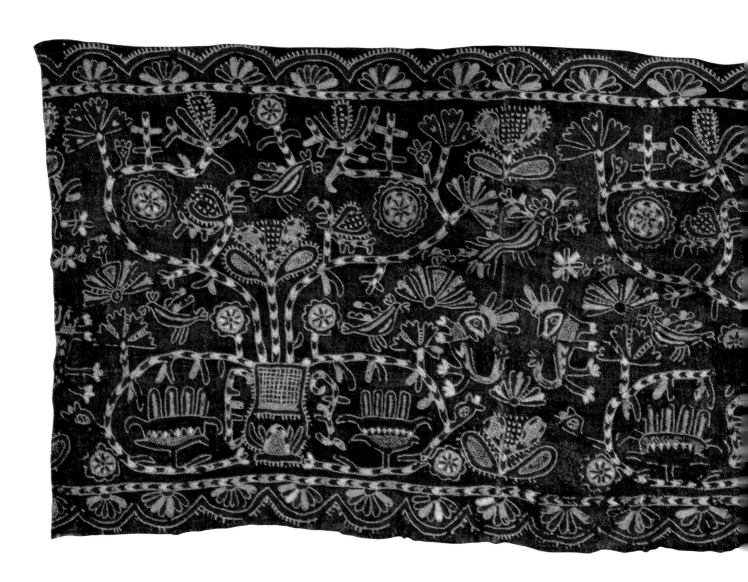

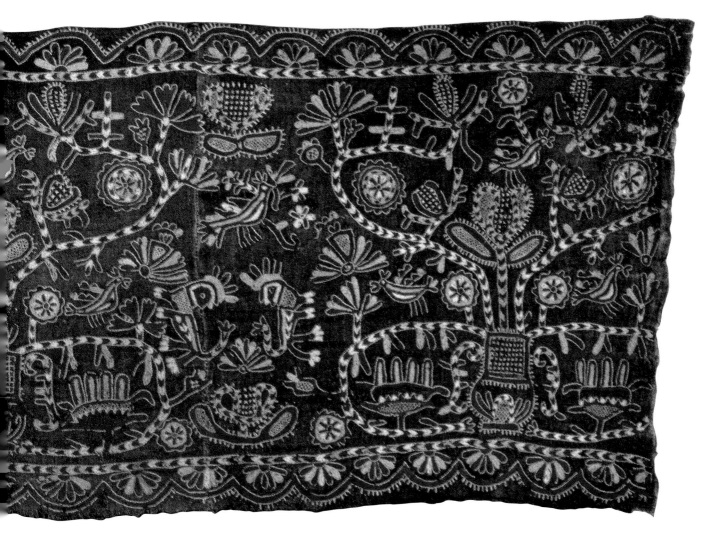

PLATE 31
Bed Covering, 18th c.
Salamanca, Spain
Embroidered wool, 26 × 78 in. (65 × 195 cm)
Museo Nacional de Antropología, Madrid

This elaborately embroidered textile covered the nuptial bed
of some lucky Salamancan couple. The three "trees of life"
are common motifs on Spanish folk textiles associated with
marriage rituals.

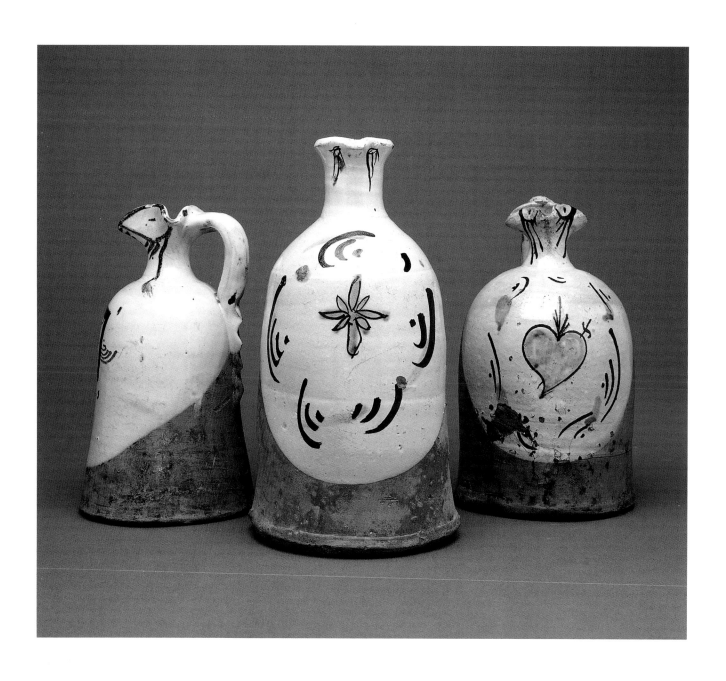

Andrés Carretero Pérez

Folk Ceramics

Pottery has been a silent companion to humanity throughout history. Now, the four basic elements (earth, air, fire, and water) that, according to the ancients, governed the world, and that have always governed ceramic production, have been superseded by technical advances. New synthetic materials have taken over our homes and our cities, so that a piece of handmade pottery is becoming a rarity in daily life.

Spain has an ancient pottery tradition, from the first Neolithic forms dating from around 5000 B.C., to the works of current ceramic artists that are to be found in the museums of contemporary art. Spanish ceramics have been influenced by other cultures, at times distant ones, throughout their history, resulting in the rich variety of techniques and shapes to be found in the twentieth century. Let us glance at some of the principal landmarks in this long history.

Following the Neolithic Era and the Bronze Age, in which ceramics were manually produced, Greek and Phoenician traders began to arrive on the Mediterranean coasts of the Iberian Peninsula around the tenth century B.C. With them came the stand-up potter's wheel, a revolutionary innovation, as well as new inspiration for shapes and decorative motifs. This influence is clearly reflected in the so-called Iberian ceramics, which are decorated with human figures, vegetable and geometrical motifs drawn with *almagra* (a reddish clay). The most complex pieces show the clear influence of the red-figure pottery of classical Greece.

With the expansion of the Roman Empire, a long and industrious period began in Hispania that saw the production of such characteristic

pottery as the *terra sigillata hispanica* (Hispanic Samian ware), fine ceramics with a red surface layer, for domestic use, and the large amphorae used to transport salted preserves, wine, and oil, thousands of which are to be found broken on Monte Testaccio in the city of Rome, near the old port on the Tiber River, which was the end of their journey.

When Islamic culture burst into Europe in the eighth century, it produced a further revolution in ceramics. With the Arabs came the technique of glazing, consisting of coating the pots with ground silica and lead sulphate to give an impermeable crystalline surface.

The technique is more complex than that used in Roman times—among other things, it requires a higher firing temperature—but it does open up a whole new range of decorative possibilities. Under the transparent surface, colored clays can be used for decoration (under-glaze decoration). If other metal oxides are added to the lead, a variety of colors can be achieved. And by mixing lead with tin oxide, a uniform white outer layer is obtained (white glaze) on which multiple decorations can be made with metal oxides in different colors (copper green, cobalt blue, manganese brown, and so on).

Though work with white glaze and polychrome decoration would achieve its greatest development in later centuries, during the Middle Ages a highly refined type appeared which has never since been replicated. This technique, known as metallic luster or gilded earthenware, produces a gold color, which is achieved by applying to the already-fired piece (which sometimes has already been decorated with other

PLATE 32
Three Oil Jars, 18th–19th c.
Teruel, Spain
Glazed earthenware
H. 9–11½ in. (23–29 cm)
San Antonio Museum of Art

Green and white glazed olive oil pitchers with pinched mouths are typical of the excellent pottery for which Teruel has been famous for hundreds of years. Today, potters still produce forms and glazes reminiscent of earlier seventeenth- and eighteenth-century ceramics. The partial glaze on these pitchers is referred to as an "apron design."

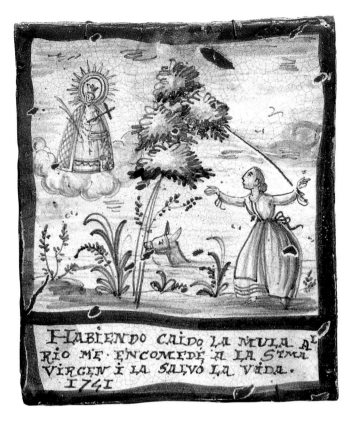

HABIENDO CAIDO LA MULA AL
RIO ME ENCOMEDÉ A LA STMA
VIRGEN I LA SALVO LA VIDA.
1741

colors) a mixture of silver, cinnabar, copper sulphate, iron oxide, and sulphur, dissolved in vinegar. The piece is then fired for a second time at a low temperature with very little oxygen.

Historic sources from the period mention places that continue to be production centers in the present day: Sevilla, Granada, Manises, Paterna, and Teruel. There are many others that cannot be recognized, for pottery with white glaze and simple decoration in cobalt blue or copper green appeared in hundreds of small workshops throughout the country, in both the Middle Ages and subsequent centuries.

The technical basis was firmly established, but Islamic art did not offer figurative decoration, which came, apparently, from Renaissance Italy. Because of the lack of historical documentation, we will summarize this process with a single name: Francisco Niculoso Pisano, an Italian who had worked in the majolica workshops of Faenza and Casteldurante, and who at the end of the fifteenth century installed a tile pottery in Sevilla. It was in the Triana district, which already had a long history of ceramic production, and there he reproduced grandiose pictorial themes in the Renaissance spirit.

A generation later, polychrome decoration with figurative subjects by the "disciples of Niculoso" according to the classic studies appeared in

various production centers, particularly Talavera de la Reina and Puente del Arzobispo (Toledo). In these towns major production began in the mid-sixteenth century, and there it has been maintained ever since.

Peddlers distributed their products all over Spain. Talavera became synonymous with "fine ceramics," first for the wealthier classes and later for the common people. For centuries, the ships departing from Sevilla and Cádiz for America were loaded with ceramics from Triana and Talavera. And along with the products, they must have carried more than one potter, as American production centers with a clear influence of Talavera soon appeared (fig. 4).

Meanwhile, on the Mediterranean coast, once-important centers such as Paterna and Manises were disappearing or producing less and less of the gilded luster pieces.

The best-known popular items from the coast in this period are the "craft tiles," which apparently were first produced in the seventeenth century. These tiles are marked by two characteristic lines in yellow and purple around the border, with a design of flowers, animals, or people. The most typical are those for which the tiles are named: scenes showing workers at their craft (a hunter, a spinner, a candlemaker, a shoemaker, a weaver). Though often considered Catalonian, they were also produced in great quantities in the potteries of Valencia.

In 1727 the Count of Aranda decided to establish a factory of fine china at Alcora (Castellón Province) like those already established in other European countries, and he brought in technical experts from France and Germany. The factory functioned throughout the eighteenth century without ever succeeding in its great ambition, the production of porcelain.

Despite this failure, the establishment of the factory did represent a rebirth for ceramics in eastern Spain, as most of the employees went on to create a number of small potteries where they applied and popularized the techniques and decorative motifs they had learned. Places such as Onda, Ribesalbes, Biar, and particularly Manises, entered the nineteenth century with their production renewed and trade prospering. Some of their craftsmen even moved to Talavera, which at that time was in decline.

The nineteenth century brought another short-lived innovation, namely, stamped

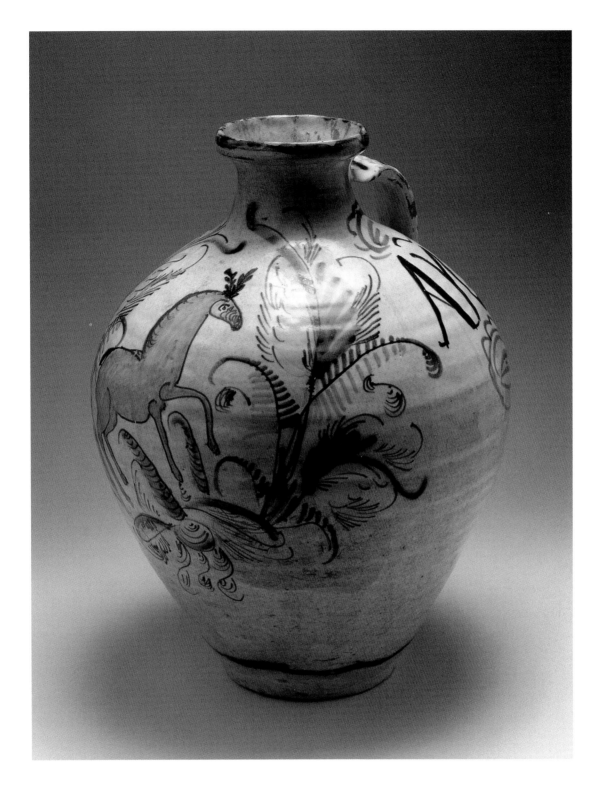

PLATE 33
Jar with Deer Motif, 1870
Puente del Arzobispo, Spain
Glazed earthenware
16 × 12 in. (40 × 30 cm)
Museo Nacional de
Antropología, Madrid

Puente del Arzobispo is in Toledo Province, near Talavera de
la Reina, a city well-known for glazed pottery. For centuries,
these two ceramic-producing communities enjoyed a symbi-
otic relationship. It seems probable that, throughout history,
potters from the two towns exchanged materials, ideas, and
products.

earthenware in the English style, which allowed designs to be reproduced with much greater detail and elegance than with the brush. The first such factory (1804) was Sargadelos (Lugo), and the most famous (the only one still surviving) that of Pickman (1834) in Sevilla. However, throughout the century others were established in Busturia (Vizcaya), Pasajes (Guipúzcoa), Gijón (Asturias), Valdemorillo (Madrid), and Cartagena (Murcia), though they had to close one by one.

Dinner services of Pickman (or La Cartuja, as it is popularly known) still decorate many Spanish homes, but the difficulty of the technique kept the smaller potteries from copying it. That was also the case with porcelain and hard china, as when Carlos III created the Royal Porcelain Factory of the Buen Retiro (1760), and Fernando VII the Royal Factory of La Moncloa (1817), both in Madrid. Except in its simplest forms (such as white plates and cups), porcelain hardly reached the people, and its *grand feu* (great fire) technique, which required very high firing temperatures, did not allow small potteries to produce this type of ceramic.

The last historic landmark is the appearance of Juan Ruiz de Luna in Talavera de la Reina in the early years of the twentieth century. He began to recreate the old local shapes and decorative motifs, many of them long forgotten. His work led to a rebirth of the workshops that remain to the present day, and his name has been given to the museum that tells the story of the local pottery industry.

A "Minor" History

Along with this grand history of the evolution of pottery techniques and major decorative styles runs a minor history that has never been recounted. This tells of the pitchers used to collect water from the springs, the drinking jars used to keep water cool in the summer, the bowls women used to wash clothes, the stewpots where food was prepared every day, the great jars for storing wine or oil, and many other vessels with shapes that might not have changed in centuries.

While art historians delve ever deeper into the "great history" of aesthetic creation, traditional, rural products have attracted considerable interest in recent times. For over three decades, many enthusiasts of folk art, surprised at its richness and variety of forms, have been visiting the most out-of-the-way places in search of potteries that are still operating, or the remains of those that have disappeared.

Many of these part-time researchers have limited themselves to forming collections and even promoting a certain trade that has helped to maintain the craft, but there is no dearth of pottery aficionados who publish reports (of highly variable quality and interest) on their journeys and findings. Considering that there are also a number of systematic studies by historians and anthropologists, pottery is one of the best-known and most-studied traditional crafts in Spain.

However, in the long run, this boom in popular ceramics has been a mirage. The "rustic-aesthetic" trade could not last, and even the collecting urge has reached its limit. Though the potters took advantage of the situation, they regarded this "urban" interest in their work with considerable astonishment and skepticism, because they had realized for some time that their trade was being ruined by plastic, steel, aluminum, and running water. While we were asking them to continue making water pitchers or cooking pots in the old way, some were giving up the craft, or at least directing their children toward other occupations, and others were starting a process of transition, seeking new customers, trying to modify their production toward decorative items, transforming pitchers into flower vases, wine jars into planters, painting the drinking jars, or putting "Souvenir from . . ." on the jugs.

A few potters, those with a truly creative spirit, have managed to make aesthetic capital from their new products without resorting to the "junk trade." However, only the oldest artisans, who are declining in number throughout Spain, have resisted change and have continued to produce those traditional pieces that we now like, but that find few commercial outlets.

After visiting hundreds of potteries over many years, the image that comes to mind most often is one of men who are kind but sad, who know that the interest they arouse is similar to that shown for species threatened by extinction. These are men who enjoy their memories, who

always talk in the past tense: "We used to be…" and "When this district was full of workshops…" But what interests me more than the pieces themselves is that these men can offer a great deal of accumulated cultural information on traditional life.

Potteries today are concentrated in the most economically depressed areas, though there are few provinces where no potters at all are to be found. However, more are closing down every day, and a center we had considered active might have seen its last workshop close a year, or even five years, ago.

Though some workshops produce all types of pieces, most specialize. The most typical distinction is between the *cantareros* or *obradores de blanco* (jug makers), who made containers for water (pitchers or drinking jars), and the *olleros* (pot makers), who used refractory clays and glazed their pieces with lead sulphate, making items for use on the fire (casseroles and stewpots).

A third field of specialization, which to some extent goes beyond the sphere of popular ceramics, is the use of tin-lead glazes with different polychrome decorations, which usually requires large factories and extensive areas of trade (Talavera, Sevilla, Manises, Lucena, and so on). In earlier times, when decorations were simpler, this technique was much more widespread among smaller workshops.

Two other types of work about which we have little information, probably due to their nonaesthetic nature, are those of the *tinajeros* (jar makers), who specialized in large water containers, and the *tejeros* (thatchers), who made solid bricks, roof tiles, and other building materials.

To illustrate this diversity, of the fifteen pottery centers in the Province of Córdoba, eight traditionally limited themselves to supplying the local market for water containers, while Puente Genil and Hinojosa del Duque also produced pots for use on the fire, and Lucena worked with tin-lead. La Rambla also produced various decorative items; Palma del Río, Posadas, Córdoba, and Benamejí supplied roof tiles and bricks; and Lucena had several workshops for large jars. Each specialty had its own sales area, which overlapped in most of the province and neighboring areas.

Most potteries were family-run, by father and sons (informal apprentices since childhood), and by wife and daughters, who helped decorate, knead clay, or sell the finished product. As each son married he would open a new pottery, while one of them would inherit the father's workshop. Formal apprentices or other hired help were needed only in exceptional cases. such as when children were lacking or business was especially good, in which case men would be taken on for piecework.

A variation on the family pottery was the workshop operated by women, which was quite rare in Spain and somewhat of a sideline to the many traditional female tasks. The husband had his own craft, through which he supported the family, and the wife, who had only minimal equipment, worked on her pottery when the domestic and agricultural chores were done.

Female potters were daughters of female potters, and if the husband was not the son of a potter, or was not prepared to help in tasks such as collecting firewood and firing the pots, the woman would often give up the craft on marrying.

Factory organization was more complex, with large installations and a marked division of labor: potters, kiln firers, sweepers, painters, and so on.

Another variation that appears from Asturias in the north to Cádiz in the south is the pottery-tile factory. Workmen there made bricks, floor tiles, and roof tiles, while others worked the wheel and made structural pieces, such as piping, gargoyles, or gutters, on demand. Occasionally, in slow periods, they also made household items such as pitchers or drinking jars. Most of these factories evolved into mechanized tileworks, but some were reduced to conventional potteries, rendering their great kilns inactive.

Modeling Methods

The most characteristic feature of the traditional pottery is the potter's wheel, a deceptively simple machine that requires years of practice to operate well. Children often start to handle the wheel by shaping tops and small toys. The most common type is the foot-wheel, composed of the *cabeza* (head), the surface on which the item is modeled, and the *volandera* (fly-wheel), which is

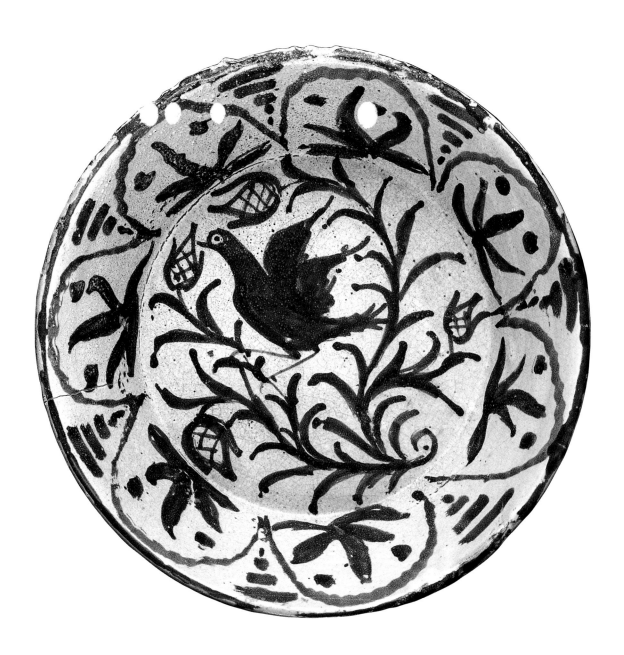

PLATE 34
Plate with Bird Motif, 19th c.
Granada, Spain
Glazed earthenware, DIAM. 11½ in. (29 cm)
Lent anonymously

Blue and white glazed dishes such as this are still being
produced in modified form in parts of Granada. Flowers
and birds are still among the preferred design motifs.

PLATE 35
Jar with Geometric Designs
16th c.
Andalucía, Spain(?)
Painted earthenware
H. approx. 28 in. (70 cm)
Lent anonymously

This jar shows strong influences of North African ceramics in form and decoration. It is either from North Africa itself or from southern Spain during a time of strong Islamic influence.

moved by the potter's foot; the two wheels are joined by a vertical axle set into a wood or masonry table.

Pot-throwing with small, hand-operated wheels is almost exclusively restricted to the areas where women potters work: in Pereruela, Moveros, and Carbellino (Zamora), and Mota del Cuervo (Cuenca). These machines, commonly known to archaeologists as slow-turning wheels, appeared in ancient times in some potteries operated by men, such as those in Faro (Asturias) and Zarzuela de Jadraque (Guadalajara).

But the simplest modeling technique of all is hand molding, which we find in all the *tinajería* potteries (where large storage jars are made), as the size of the jars does not allow the use of the wheel. The *tinajas* (jars) are constructed with rings made of long rolls of clay that are fixed and smoothed down with the hand and a trowel, often on scaffolding when the pieces are sufficiently large. Since the clay must harden slightly before the next roll is applied, the tinajeros commonly make eight, ten, or even twenty jars at a time. They take up space in the workshop for months, drying where they stand, as they cannot be moved while they are "green."

This method of building up pots is not often used for making household items, except in two areas: Aragón, where many small potters were not familiar with the wheel, and the Canary Islands, where pot-throwing by women really is a manual craft, to the extent that on occasion the potters do not even use a table for support.

Ornamentation

Decoration ranges from simple to complex. It can consist of straight or undulating lines marked in the fresh clay with an awl or sharpened stick while the wheel turns, and can be augmented with finger marks or other impressions. Another technique uses honeyed glaze, which contains lead sulphate. While it is functional, it also lends itself easily to the application of outer layers and motifs with clays in contrasting colors. Some examples of this are the well-known and widespread floral and geometrical motifs in white clay. Yet another technique consists of applying a variety of chemical products; the most frequently used are copper and cobalt oxides, which produce green and blue, under a lead covering or mixed with the lead to obtain different tones.

The next level of decoration is glazing with tin oxide and lead sulphate, which provides a uniform white covering and a surface layer on which, after firing, a variety of colors can be applied. This is a complex technique, generally beyond the reach of traditional ceramics.

Today it is relatively simple to recognize modern glazed products, because the use of lead sulphate (which led to numerous lung and skin complaints among potters) has been prohibited. It has been replaced by industrial pastes of minium (red lead oxide), which produce a more intense and uniform tone.

Firing

We conclude this section on techniques with a mention of firing, which requires at least as much experience as the shaping of the clay. Various types of kilns are used in this delicate and decisive task. They range from open cylinders (which are covered with rubble when loaded), very common in both Castillas, to those covered by domes, the most common type generally. The great rectangular kiln with a barrel-vault roof is particularly widespread in eastern Andalucía, though it is used in all the major pottery centers because of its large capacity and the precision with which it can be operated, due to its large number of air vents.

The Canary Islands, once again, have the most archaic technique: The pieces are placed in simple holes in the ground, then a large wood fire is lit just above. A similar solution is sometimes used for the large storage jars of the tinajeros: Either a kiln is virtually constructed around the jar, or an enormous pyre is made to fire it.

While modeling and decoration are matters of experience, firing is always subject to unforeseen risks. It is not uncommon for potters to commend themselves to God and the saints when firing pots, marking crosses beside the kiln mouths and reciting various prayers. They might well stay awake for twenty-four or even forty-eight hours at a stretch, concentrating on every sound, the whistling of the hot air, the color of the smoke from every vent, and any other indication of the progress of the firing. The work of an entire month, quarter, or even year is at stake.

Geographical Distribution

The Cantabrian geographical region (or "humid" Spain) is and always has been relatively poor in

pottery, and from ancient times wooden and metallic receptacles have predominated there.

GALICIA

In the province of La Coruña pottery activities are limited to the town of Buño, with products nowadays far removed from their traditional forms. In the province of Lugo pottery making is restricted to Bonxe and Gundivós. However, potteries are more plentiful in Pontevedra Province, which is more in contact with Portugal, and in Orense, which features outstanding pieces with yellowish glaze from Niñodaguia.

ASTURIAS

The only potteries still producing are at Llamas de Mouro, which is famous for its "black ceramics" in a bright gray color, obtained by reductive firing (closing all the air vents so as to limit the amount of oxygen used in combustion), a technique that appears at other Spanish centers; and in Faro, where the potters are experimenting with modern techniques and designs.

BASQUE COUNTRY

The maritime provinces (Guipúzcoa and Vizcaya) used methods similar to those of Asturias, but the potteries disappeared over a generation ago; the last Basque pottery was operating at Narvaja (in Alava Province) until some twenty years ago, though in its final period it did little more than sell (as "Basque jugs") pieces obtained from nearby potteries such as that of Navarrete, the last one in La Rioja.

NAVARRA

None of the potteries at Estella, Tafalla, Tudela, or Lumbier have been operative for at least twenty years.

CASTILLA—LEÓN

Here is a world of living potters, though they are ever fewer in number. With rare exceptions, most of the potters are of advanced age, and the production centers are disappearing rapidly.

Those particularly worthy of mention are Jiménez de Jamuz, in León Province, known for its barrels and *jarros de trampa* (trick jugs); Aranda de Duero, in Burgos; Tajueco, in Soria, a province which used to boast (at Quintana Redonda) the only ceramic center on the Meseta producing black pottery; Coca and Fresno de

Cantespino, in Segovia; Tiñosillos, in Avila; and Arrabal del Portillo, in Valladolid.

The remaining provinces of this region are also important. Palencia has lost its last pottery at Astudillo, famous throughout the country for its *botijos de Pasión* (Passion drinking jugs; pl. 6). Salamanca still has several centers in operation, the best known of which is Alba de Tormes, with its elaborate filigree decoration in white clay on drinking jugs and a variety of other pieces (fig. 5). Pride of place goes to Zamora, which at Moveros and Pereruela preserves one of the largest and most interesting centers of female-produced pottery, including until recently the small village of Muelas de Pan. The aesthetic quality of the forms and the shining mica particles in the clay make its output famous.

EXTREMADURA

This area can still boast of a rich variety, with some classic names. The principal ones are, in Cáceres Province, Arroyo de la Luz and Ceclavín, where pieces are decorated with white stone encrustations, very similar to those of Portugal; and, in southern Badajoz Province, Salvatierra de los Barros, an important center in many ways (fig. 6). It produces pots to contain water, for use on the fire and for decoration, and until recently most of the population lived from this activity, either directly as potters, or by working in the extraction and preparation of the clay, in the firing or decoration of the pots, or in the transporting of the wood. At the end of the chain were the peddlers who sold the finished products; at the beginning of the twentieth century, they took their beasts of burden and panniers full of pots by train as far afield as Paris and Amsterdam.

Salvatierra has also had a considerable influence on other production centers; since at least the nineteenth century some of its potters have moved to other areas of Extremadura and Andalucía.

CASTILLA—LA MANCHA

The towns of Talavera de la Reina and its inseparable Puente del Arzobispo have been noteworthy for over five centuries because of the quality of their products (pl. 33). This area, with Manises and Triana, probably produces the best-known "popularized" ceramics. Though some of its old patterns (particularly the polychrome ones) are clearly "refined," most of its output (which is

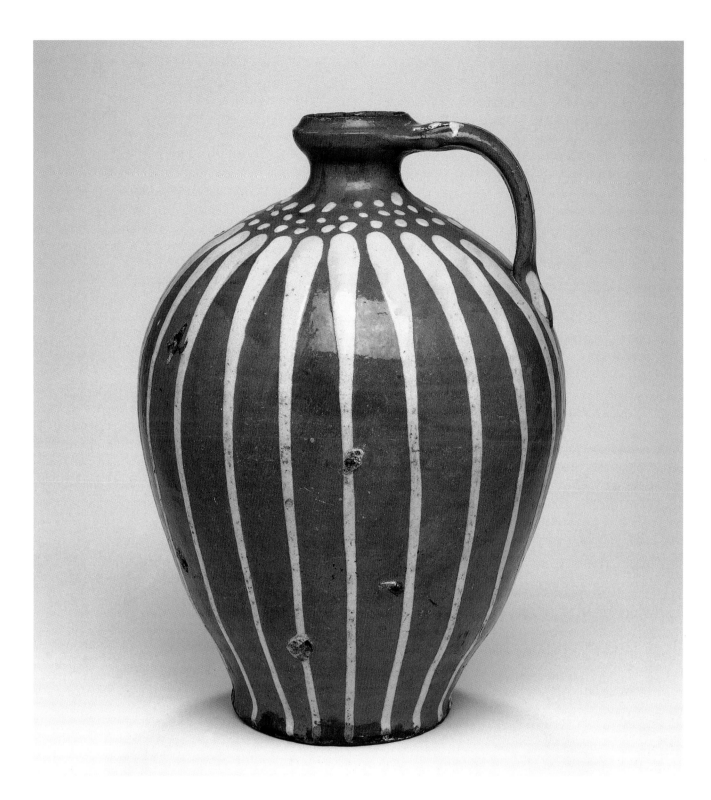

PLATE 36
Oil Jar with Drip Glaze, late 19th c.
Badajoz, Spain
Glazed earthenware, H. 14½ in. (37 cm)
San Antonio Museum of Art

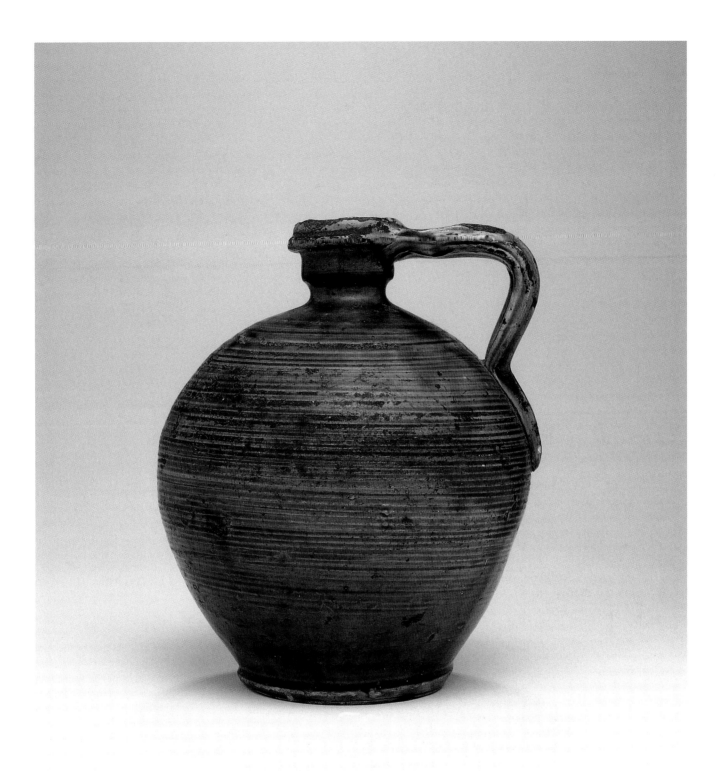

PLATE 37
Oil Jar, 19th c.
Triana, Spain
Glazed earthenware
H. 9 in. (23 cm)
San Antonio Museum of Art

Highly glazed ceramics are still made in the Triana area of
Sevilla. This olive-oil jar is typical of the rich greenware from
this location. During the colonial period, potters from Triana
moved to the Americas and played an important role in the
evolution of glazed ceramics there.

FIGURE 5
Filigree Jar, 20th c., Alba
de Tormes, Spain. Museo
Nacional de Antropología,
Madrid.

FIGURE 6
*"Enchinada" (Stone Inlay)
Jar,* 20th c., Ceclavín, Spain.
Museo Nacional de Antro-
pología, Madrid.

glazed with tin-lead) is intended for popular use.
Even today, plates and jugs from Talavera can be
seen on sideboards in half the towns and villages
of Spain. How sad, then, that some of the mod-
ern products do not maintain the charm of even
the poorest pieces of the nineteenth century and
do no more than debase classic patterns!

Little remains of the potteries of the Mancha
plain. In Toledo Province, some are still operat-
ing at Ocaña (which is famous for its drinking
jugs whitened with salt), Consuegra, and Cuerva,
where the most celebrated product is the *olla
maja,* a cooking pot highly decorated with designs
in white clay that used to form part of brides'
dowries. In the province of Ciudad Real, pots are
made at Castellar de Santiago, though they are
completely unlike traditional models; and in
Albacete, at Chinchilla. The potteries of Priego
and the city of Cuenca are still going strong,
though they increasingly cater to tourists, as do
the female-run potteries of Mota del Cuervo.

The province of Madrid, which to a great
extent can be included in the Castilla–La Mancha
area, still has potteries at Camporreal. Those that
used to make stewpots in Alcorcín no longer
exist, and the same is true of Colmenar de Oreja,
once the best-known (and the best-documented)
Spanish production center for the huge tinajas.

ARAGÓN

The pottery here is incomparable, but its pro-
duction is clearly being abandoned. In Huesca
Province the only center still operating is at
Fraga, where water pitchers are produced. In
Teruel several centers, including Calanda, make
pots by the system of clay rolls, and Huesa del
Común returned to activity as a result of the
high prices paid by collectors for its traditional
water pitchers. There is more activity in Zara-
goza Province, with long-established centers such
as Alhama de Aragón, Villafeliche, and Muel,
where (as in the city of Teruel) classic designs of
the seventeenth and eighteenth centuries are
being reproduced (fig. 7).

On the Mediterranean coast, ever-fewer
numbers of small potteries alternate with large
factories in industrial or tourist areas, which
cannot be said to produce traditional pieces.

CATALUÑA

The principal center is in Gerona Province at La
Bisbal, a major area for industrial ceramic manu-
facture that has successfully updated its tradi-
tional products and also supplies most of Spain's
potters with chemicals and even prepared clay.
The main traditional product, black ceramic
made by reductive firing, comes from the area
that includes La Bisbal, Quart (also in Gerona
Province), and Verúd (in Lérida).

VALENCIA

There are many well-known places, including
the potteries of Traiguera (Castellón Province),
which is famous for its water pitchers, and Agost
(Alicante Province), which specializes in myriad
forms of drinking jugs.

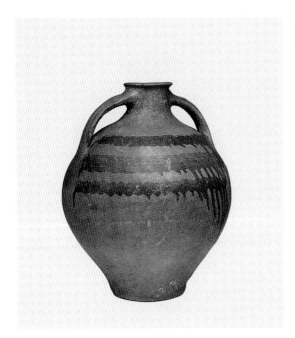

But, above all, there is Manises. Following a long history of pottery, today it has over two hundred completely industrialized factories, with thousands of employees. It also has an Official School of Ceramics as well as subsidiary industries supplying tools, pastes, and ceramic glazes to potteries all over Spain.

BALEARIC ISLANDS

The islands in many ways are closely related to Cataluña and Valencia, and this is true also of their pottery. Cooking pots are no longer made at Portol, nor are the "embroidered" pieces, with multiple appliqués and cutouts, made at Felanitx (Mallorca). Nowadays, the tourist market absorbs most of what is produced—from ashtrays to reproductions/falsifications of Roman amphorae, including the traditional hand-modeled *siurells* (whistles).

MURCIA

Halfway between Valencia and Andalucía, Murcia clearly shows the influence of the former. The water pitchers of Totana or Lorca are not very different from those of Alicante, and the polychrome designs of Manises are successfully imitated in Lorca and Mula, to the point that, unless one studies them carefully, it is not always easy to distinguish one from the other. A traditional industry in Murcia, today in decline, is the manufacture of highly realistic figures for nativity scenes, generally made from molds.

ANDALUCÍA

This is the last great pottery area of the Peninsula and, within the general process of decline, it is the region that maintains the greatest number of operational potteries, probably owing to its weak economic structure.

In general terms, it is possible to distinguish a line of potteries along the course of the Río Guadalquivir (with its abundant clay deposits), where pots for use with water are the main product, usually in shades of white or very light colors. There are two more approximately parallel lines, along the Sierra Morena and Sierra Nevada, where potteries have a varied output, but share in the style of glazing and in the production of refractory clay pots for use over fire.

For instance, in Huelva Province all the southern potters make vessels for holding water, and in the mountainous area water pitchers with a deep red surface layer appear, similar to those of Extremadura. Aracena and Cortegana concentrate on stewpots, cooking vessels, and plates decorated with metal oxides in various colors.

In Sevilla Province most of the rural potters used to make white pieces. The potters of Lora del Río and Osuna specialized in large *orzas* (jars) and *lebrillos* (bowls) with a diameter of over one meter; they can still be seen on country estates, but nowadays nobody feels capable of making them. However, the great center in this province is in the city of Sevilla itself, where the factories of Triana continue to produce painted tiles and other polychrome items.

Similar diversity is seen in the province of Córdoba, where a central strip (Palma del Río, Posadas, and Bujalance) concentrates on white pots, while to the north Hinojosa del Duque used to produce glazed pieces more closely related to those of Extremadura than to other Andalusian styles. In the south there are three important production centers: Puente Genil is known for its stewpots and casseroles (which are no longer made); Lucena produces large tinajas, or storage jars, and pieces glazed with tin-lead, which can be recognized by the cream color of the bottom; and La Rambla produces a variety of items, though it is famous for its *botijos* (drinking jars), which it has started to industrialize, modernizing the forms and adapting itself to market demands. This description applies equally to the three main centers in Jaén Province: Andújar, Bailén, and Ubeda.

FIGURE 7
Water Jar, 19th c., Calanda, Spain. Museo Nacional de Antropología, Madrid.

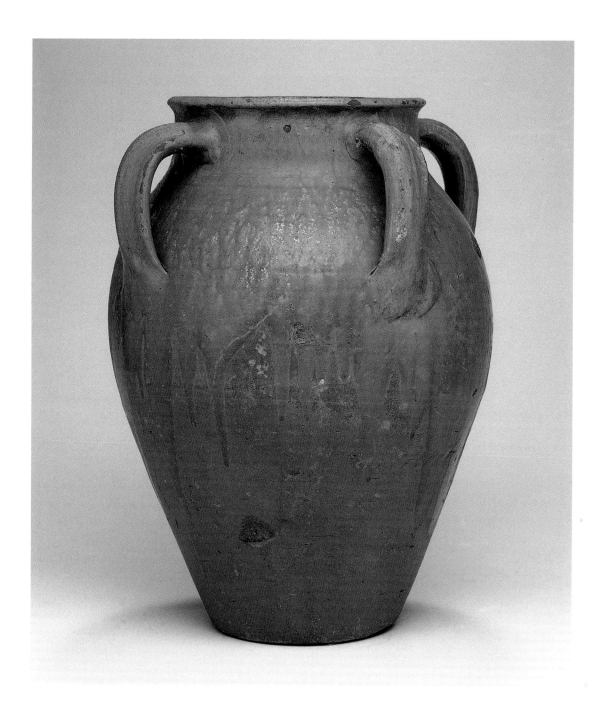

PLATE 38
Jar, 19th c.
Tarragona, Spain
Earthenware, H. 16½ in. (42 cm)
San Antonio Museum of Art

PLATE 39
Tile, 16th c.
Teruel, Spain
Glazed earthenware
8 × 7 in. (20 × 18 cm)
San Antonio Museum of Art

At one time, this hexagonal tile may have formed part of the
surface of a tower in Teruel. The decoration on this thick,
glazed tile presents an optical illusion and, together with
hundreds of others, must have provided an impressive sight.

Cádiz Province seems strongly influenced by Sevilla (indeed, the water pitchers of Lebrija were made at Conil and at Chiclana de la Frontera) and by Málaga, a province where nowadays almost no potters maintain the traditional output. The pots most similar to those of Málaga's mountain area can now be found at Jimena de la Frontera, in Cádiz Province. To find the pieces of Vélez-Málaga, which makes one of the most aesthetic and technically difficult styles of water pitcher known, it is necessary to go to Puente Genil (in Córdoba), where a potter from Vélez is still working and remembers the old forms.

Granada Province appears divided into two main zones: a central one around the city of Granada itself, which produces ceramics decorated in blue and green on a white or creamy background produced with tin-lead (known as Fajalauza ceramics after the district where the potteries are situated); and a mountain area, with Guadix and Cúllar Baza at the head.

In Almería, a province once rich in potters, the only remains are the cooking pots of Albox and the plates and cups of Níjar (which are lead glazed on surface layers of white clay with a variety of polychrome decorations).

CANARY ISLANDS

Apart from the activities of potters from the Peninsula, this is the third main nucleus of female potters. This pottery is undoubtedly the most archaic in techniques and forms, as the pieces have an almost prehistoric aspect. The only centers still operational are Hoya Pineda (on Grand Canary Island), La Victoria del Acentejo (on Tenerife), and Chipude (on Gomera).

The historic pieces mentioned at the beginning of this article are exhibited in museums all over the world. Outstanding collections include those of ancient ceramics in the Museo Arqueológico Nacional (Madrid), medieval ceramics at the Valencia de Don Juan Museum (Madrid) and the Hispanic Society of America (New York), and ceramics from the sixteenth to the nineteenth century in the Museo Nacional de Artes Decorativas (Madrid).

Popular twentieth-century ceramics are now also being collected systematically. Collections worthy of notice are in the Museo de Artes y Costumbres Populares (Sevilla), where some two thousand pieces offer a detailed panorama of the output of Andalucía; and in the Ethnographic Museum of Hamburg (Germany), with some ten thousand pieces. However, possibly the most representative collection from Spain as a whole is to be found at the Museo Nacional de Antropología (Madrid), with over sixty-five hundred pieces, which are interesting academically yet definitely functional.

Though a few pieces in the museum were purchased directly from the potters (particularly the recent Knetch-Drenth Donation, lovingly collected over years of visits to the potteries), the rest of the collection has been built up over time, since the establishment of the former Museo del Pueblo Español in 1934; it includes items that disappeared many years ago as well as utilitarian forms only to be found in a highly degenerate state in the 1960s and 1970s. The objects arrived gradually from the places where they were used, not made, and in their functional contexts: The water pitchers came with their stands and *aguaderas* (special mountings to allow them to be carried by mules or donkeys), and the stewpots with the rest of the household kitchen equipment.

This form of collecting has two advantages. First, pieces can be acquired that were made only occasionally, such as funnels or filters for the large storage jars. Second, more cultural information can be found about the way they were used and where they were distributed. Thus, three hundred Manises plates acquired by the museum in different parts of Spain make it possible to study the points reached by the sales networks of the Valencian potters. The same is true of pots made at Talavera de la Reina and Puente del Arzobispo.

BIBLIOGRAPHY

Albertos Solera, M. Dolores, Andrés Carretero Pérez, and Matilde Fernández Montes. *Estudio etnográfico de la alfarería conquense.* Cuenca: Diputación Provincial de Cuenca, 1978. 175 p. phot. and draw. (Etnología Conquense I).

Alvaro Zamora, María Isabel. *Alfarería popular aragonesa.* Zaragoza: Libros Pórtico, 1980. 411 p. col. and b.il. (Estudios 6).

Burillo Moñota, Francisco, and José Palomar Ros. *La alfarería de Huesa del Común.* Teruel: Ministerio de Cultura, 1983. 67 p. (Seminario de Arqueología y Etnología Turolense. Serie Etnología 14).

Cabezón Cuellar, Miguel, Ana Castello-Puig, and Tirso Ramón Olivan. *La alfarería en Huesca (Descripción y localización).* Zaragoza: Instituto Aragonés de Antropología, 1984. 123 p. (Monografías del Instituto Aragonés de Antropología 2).

Carretero Pérez, Andrés, and Carmen Ortíz Garcia. "Alfarería popular en la provincia de Córdoba," *Etnografía Española* 3 (1983):1–144.

———. "La tinajería de Lucena," *Etnografía Española* 8 (1991):247–63.

Carretero Pérez, Andrés, Matilde Fernández Montes, and Carmen Ortíz García. "Alfarería popular en Andalucía occidental: Sur de Badajoz y Huelva," *Etnografía Española* 1 (1980):101–265.

Carretero Pérez, Andrés, et al. *Cerámica popular en Andalucía.* Madrid: Editora Nacional, 1984. 167 p. phot. and draw.

Castellote Herrero, Eulalia. *Cerámica Popular: Camporreal.* Madrid: Servicios de Extensión Cultural de Divulgación. Diputación Provincial de Madrid, 1978. 330 p. phot. and draw.

———. *La alfarería en la provincia de Guadalajara.* Guadalajara: Institución Provincial de Cultura Marqués de Santillana, 1979. 216 p. fig. and plates.

Cortes y Vázquez, Luis L. *Alfarería popular del Reino de León.* Salamanca: n.p., 1987. 270 p. phot. and draw.

Delfín Val, José. *Alfares de Valladolid.* Valladolid: Caja de Ahorros Provincial de Valladolid, 1981. 115 p. phot.

Feito, José Manuel. *Cerámica tradicional Asturiana.* Madrid: Ministerio de Cultura, Instituto de la Juventud y Promoción Comunitaria, 1985. 324 p. phot. and draw.

Fernández Montes, Matilde, Andrés Carretero Pérez, and María Dolores Albertos Solera. *Museo Numantino. Alfarería popular de Tajueco.* Madrid: Ministerio de Cultura, Subdirección General de Museos, 1981. 110 p. pls. and draw.

Fernández Montes, Matilde, and M. Angeles Morcillo Pares. "Alfarería popular en la provincia de Jaén," *Etnografía Española* 3 (1983):147–264.

Fernández Montes, Matilde, Carmen Ortíz Garcia, and Andrés Carretero Pérez. "Técnicas alfareras andaluzas,"

Revista de Dialectología y Tradiciones Populares 42 (1987):241–59.

García Alen, Luciano, Alfredo García Alen, and Xosé Gomes Vilaso. *La alfarería de Galicia. Un estudio a través del testimonio cultural de las vasijas y de los alfareros-campesinos.* Coruña: Fundación Pedro Barrié de la Maza: 1983. 2 vols.

González Antón, Rafael, *La alfarería popular en Canarias.* Santa Cruz de Tenerife: Aula de Cultura de Tenerife, 1977. 103 p. III 14 phot.

Ibabe, Enrique. *Notas sobre la cerámica popular vasca.* Bilbao: Aurman S.A, 1980. 256 p. draw. and engr.

Lizarazu de Mesa, María Asunción. "Alfarería popular en la provincia de Albacete: Estudio etnográfico," *Etnografía Española* 3 (1983):267–384.

———. "Alfarería popular de Lanzarote y Fuerteventura," *Etnografía Española* 6 (1987):241–75.

Lorenzo Perera, Manuel J. *La cerámica popular de la isla de El Hierro (Canarias).* El Hierro: Excmo. Cabildo Insular de El Hierro. Colectivo Cultural Valle de Taoro, 1987. 63 p. phot.

Maestre de León, Beatríz. *La cartuja de Sevilla. Fábrica de cerámica.* Sevilla: Pickman S.A. La Cartuja de Sevilla, 1993. 286 p. col. ill.

Ortíz García, Carmen, Matilde Fernández Montes, and Andrés Carretero Pérez. "Alfarería popular en Andalucía Occidental II: Sevilla y Cádiz," *Etnografía Española* 2 (1981):41–185.

Paoletti Duarte, Celsa, and Angel Pérez Casas. "Estudio etnográfico de la cerámica popular de la provincia de Almería," *Etnografía Española* 5 (1985):135–271.

Pérez Vidal, José. *La cerámica popular española, zona norte, con noticias relativas a la influencia portuguesa en la cerámica gallega.* Barcelos: Cámara Municipal de Barcelos y Museo de Olaria, 1983. 105 p. ill. (Cuadernos de Olaria 1).

Sánchez Trujillano, María Teresa. *Alfarería popular en La Rioja. La colección del Museo de La Rioja.* Logroño: Museo de La Rioja and Gobierno de La Rioja, 1988. 50 p. phot. and draw. (Trabajos del Museo de La Rioja 5).

Seseya Díez, Natacha. *La cerámica popular en Castilla la Nueva.* Madrid: Editora Nacional, 1975. 273 p. phot. and draw.

———. *Barros y lozas de España.* Madrid: Editorial Prensa Española and Editorial Magisterio Español, 1976. 154 p. b. il. (Biblioteca Cultural 75).

Torres, Pablo, Carlos Laorden, and José María García Merino. *Alfarería de Avila.* Avila: Caja General de Ahorros y Monte de Piedad de Avila, Hogar de Avila en Madrid, 1983. 63 p. phot., map and draw.

Vossen, Rüdiger, Natacha Seseya Díez, and Wulf Köpke. *Guía de los alfares de España.* Madrid: Editora Nacional, 1981. 298 p.

Popular Furniture

Anyone who studies traditional, in this case Spanish, furniture, however briefly, will notice that each object carries certain spatial connotations (suggesting a geographical area of origin) as well as temporal ones (indicating a specific period of manufacture). In other words, the Iberian Peninsula contains defined areas that produce furniture that has its own specific historical features and that has evolved over time. Besides geographical factors, we must not overlook the economic and social status of the users of the furniture, or the prevailing culture.

Because of the numerous ways in which these factors may be combined, it is not difficult to explain what otherwise would seem a contradiction: There is a lack of prototypes in items of Spanish popular furniture, while at the same time there is great variety in such prototypes. Simple, humble forms appear next to others that are lavishly rich and colorful. There are great contrasts even within small geographical areas. Pieces of furniture corresponding to a specific period coexist with others that are timeless, often anachronistic. We shall attempt to address these apparent contradictions here.

Let us examine the history of Spain through furniture. However, before embarking on this exploration, it is important to bear in mind that historic evolution does not necessarily translate into higher quality work. To cite an extreme example, it is clear that the oldest furniture found in the Egyptian tombs is far more refined than items made twenty-five hundred years later, that is, in the present. The same proves true of marble or bronze Roman furniture that has survived to the present. Indeed, in the last century, two

thousand years after the pieces were made, they were copied and reinterpreted.

Spanish furniture evolved slowly at first, almost imperceptibly at times during the Middle Ages, and more visibly during the Renaissance, from the sixteenth century onward. However, major changes have taken place since the nineteenth century, particularly in the way furniture is manufactured, which affect its appearance.

The Dictionary of the Royal Academy of the Spanish Language tells us that a *mueble* (piece of furniture) is for "the comfort or decoration of houses." That definition refers to certain features of furniture which we shall discuss later.

Furniture is made to fulfill certain functions, sometimes very precise ones, such as containing objects, facilitating tasks, or satisfying needs. Its existence depends on uses and customs, as does the form it is given.

Spanish furniture closely followed the currents of fashion in the rest of Europe. However, the prototypes that arrived in Spain underwent a transformation as they were adapted to the national character. Spanish furniture forms are generally cruder and heavier, though not uninteresting, giving them a definite personality. On occasion, Spanish prototypes of shape, design, or decoration influenced furniture design elsewhere in Europe, though certainly to a lesser extent.

The succession of peoples that inhabited the Iberian Peninsula left their mark. In art we find a number of representations of Greek and Roman furniture, and almost intact pieces have been found in archaeological excavations comparable to the finds in Pompeii or Herculaneum. There are also examples of Iberian furniture made by

PLATE 40
Sailor's Chest, early 19th c.
Barcelona, Spain
Painted wood and metal
14 × 39 in. (35 × 100 cm)
Museu Marítim, Barcelona

Sailor's chests were given to women by their sailor-husbands to keep special letters and other objects during the sailor's absence. The interior lid decoration balances male (man/sun) with female (woman/moon) but joins them in the center.

ancient Hispanic peoples—chairs, tables, and couches—which are remarkably similar to the Roman models.

With the collapse of the Roman Empire, enormous political, sociocultural, and economic changes took place. Eventually, new people with strange customs, the so-called barbarians, settled in Europe. Their intermingling with the indigenous Hispano-Roman substratum and the Arab invasion in the year 711 were to be decisive for the purposes of our study. As we have already mentioned, a positive evolution of furniture in its technical, functional, and aesthetic aspects has not always come about. The use of classical Roman furniture dwindled and disappeared, even among the new elite. Nevertheless, the Goths left an important legacy in popular decoration, which, as it applies to furniture, continued to exist in Spain for centuries. Undoubtedly more important was the Islamic contribution which, evolving into the style we call *mudéjar,* would accompany Spanish furniture practically into the twentieth century.

As for popular furniture after the Roman era, it was almost nonexistent in most rural areas, where the economy was practically at subsistence levels. Some areas were more prosperous and therefore produced more objects of higher quality, including furniture. Nevertheless, there were few items of popular furniture in any one house, and for centuries, until quite recently, those pieces were often roughly made by local carpenters or cartwrights. The simplest items were often made in the home—if the householder was a handyman—with no tools other than the adze and the handsaw.

Furniture, like houses, was usually made from the nearest available material. The quality of the wood and the type of tree used are evidence of a scale of values—probably dating back to much earlier times—on which the most highly prized was walnut, followed by chestnut and oak, some fruit trees (cherry and pear), ash, and pine. The latter was used abundantly, while at the bottom of the scale came those of the worst quality, such as poplar, which were rarely employed. Naturally, the choice of material was determined by economic and social status.

Popular furniture can be classified in two categories. The first includes pieces that provide repose, or some degree of comfort, as in the case of seats and beds. We can also include tables in this section, as they provide a support on which work or other activities can be more comfortably carried out. The second category consists of containers, and includes chests, cabinets for plates or glasses, and cupboards, as well as desks or secretaries, kitchen racks, and other auxiliary items. Besides these two essential groups, there are certain exceptions with features common to both categories.

Furniture for Repose
SIMPLE SEATS

One of the most elementary yet most frequently used items of furniture in rural homes, often forming part of the architectural structure, was the *poyo* (bench), usually situated in the outer doorway at the entrance to the dwelling. It was found not only in homes but also in other buildings, such as mills or rural workshops. It is usually made of stone, either barely worked or elaborately carved; on occasion it is made of recycled material, such as carved building stone, remains of other buildings, or even fine ancient capitals, and some examples can still be seen today.

A very simple type of seat was the *tajo* (stool), made of whatever type of wood was easiest to obtain. Tajos are usually low, with a small seat, and very stable because of their three legs. Since they weigh little they could be carried around easily, even in one hand, to be used for a variety of purposes: to rest beside the fire or hearth where food was prepared, to sew, milk the cows and sheep, thresh grain, and many other activities. In shape they are usually round, oval, or rectangular, and sometimes triangular or heart-shaped.

Another type of tajo, closer in form to a chair, was a simple three-legged seat with a back. These usually consist of two thick, narrow planks, one curved or carved to an angle (so as to provide support for the back), and the other, cut into the shape of a T, fitted in horizontally, completing the seat. The legs are inserted at the ends of the horizontal cross. Some of these seats, which are very elementary in principle, were decorated with popular designs, armrests, or open handles on the horizontal plank. They could even be transformed into carved anthropomorphic figures, representing people dressed in the local costume. These last were actually popular art, in which decoration came to predominate over comfort, which in any case was never an outstanding feature of this type of furniture.

Though these basic seats are not of a specific style or historical period, they were made and used probably from the Middle Ages until well into the nineteenth century, and even into the first half of the twentieth century. Most examples that have come down to us are no older than the seventeenth or eighteenth century; the majority are from central Spain and the Castilian Meseta (plains) and date from the nineteenth century.

CHAIRS

Sillas (chairs) and *sillones* (armchairs) are to some extent rural imitations of elegant furniture, though this by no means implies any lack of originality or creativity. Rather, each successive artistic style would eventually leave its traces in popular chairs.

We are not aware of any examples of popular chairs predating the sixteenth or seventeenth century. From 1600 forward, certain prototypes were established, in which a square or rectangular shape predominates. Vertical-turned pieces also appeared, forming arches in the backrest and balustraded shapes on the back, front, and sides of the chair. Other ornamental details in the backrest and lower part of the chair front were made by cutting symmetrical and geometrical shapes. We also find decorative motifs consisting of repeated gouge marks on any part of the structure, including the legs. In some cases small carved details, such as beveling or grooving, or simple geometrical or floral designs completed the decoration (fig. 8).

The few chairs or armchairs found in each house were highly diverse; the material used to a large extent determined their shape, while the construction techniques varied little. The main differences were in the nonessential aspects, such as decoration.

In addition to chairs of conventional height (16–18 in., or 40–45 cm), lower chairs were made that were more comfortable than stools, but also used for household chores, such as preparing food at the hearth.

In both types the material used was whatever came most easily to hand: pine, ash, chestnut, oak, and even poplar occasionally. Sometimes two or three different types of wood were used in a single chair.

One of the quintessential pieces of Spanish furniture was the so-called *sillón frailero* (friar's chair, known in Latin America as *sillón misional*

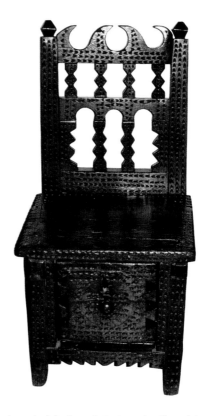

or mission chair). Its origin is to be found in Italian prototypes, but it was modified in the sixteenth century and given its own proportions and characteristics. This design was so successful that its use expanded, and it evolved over space and time while maintaining its essence. Its use did not extend to all social classes (hence the name), but numerous examples were found in wealthier rooms in both urban and rural settings. Thus, while it was created in the larger cities, its provincial or rural reflection was the work of local carpenters and craftsmen copying and interpreting the most popular models of the time.

One characteristic feature of the *frailero* is its simplicity and relative comfort, as both the seat and back are made of leather or strong fabrics that conform to the body and are fastened to the wood with broad-headed nails. Its overall shape is square and rectilinear; even the arms form a right angle with the legs. It is held together by *chambranas* (crosspieces), the front one being much wider and often decorated with carvings or geometrical incisions, the style of which can be an indication of date. As time passed, in the seventeenth and particularly the eighteenth century, the rectilinear forms moved gradually toward curved ones, first in the arms and later in all its elements, including legs and chambranas, with baroque crests appearing on the backrest.

These backrests and the chambranas became especially exuberant in Andalucía.

In later times turned pieces were commonly used for the legs, supports, and crosspieces, but the resulting chair could no longer be considered a sillón frailero.

During the eighteenth and nineteenth centuries, some chairs and armchairs incorporated turned pieces, while in others carpenters and artisans interpreted a specific style in elegant furniture, creating designs that were sometimes quite unusual. Generally, decoration in these centuries was limited to simple tops on the backrest, carvings with vegetable or geometrical motifs, or even letters (initials or whole names of the owner or maker).

In the nineteenth century large numbers of *sillas mallorquinas* (Mallorca chairs) were made. The structure was turned, the back was high, and the chairs were completely covered in painted decoration. The seat was usually made of a vegetable fiber (palm-sacking or rushes). Similar models were also widespread in Andalucía. Turned chairs with lower backs and without the colored decoration became the most common type of seat throughout the Peninsula. They were produced in batches by preindustrial methods and are of little interest to us, having no features identifying them with any specific rural group.

BENCHES AND SETTLES

This category of furniture includes a variety of benches. Early medieval ones shown in illuminated manuscripts and codices are stalls or thrones indicating the high social position of the person sitting on them. It may seem inappropriate to mention such pieces in an article on popular and traditional furniture, but in fact these pieces were the origin of the large number of benches used over the centuries.

In a category of its own is a magnificent example from the Catalonian Pyrenees, known as the Tahll bench. Originally belonging to the Church of San Clemente, where it stood in the sanctuary, it is now displayed in the Museo Nacional de Arte de Cataluña in Barcelona. It is a clerics' choir stall, with three seats under arches, enclosed, and surmounted by canopies. The style is highly architectural—with small simulated columns and capitals—and fine Romanesque decoration covers the piece entirely. The designs clearly correspond to the period during which the bench was presumably made (c. 1200) and may be considered entirely popular. The decorative motifs are carved in some cases or form intricate lattices in others, reproducing geometrical elements (small panels, tiny arches, circles, rhombuses, triangles, and stars) and little designs taken from architecture (bell towers with their bells, horseshoe arches, and battlements) in an exuberant composition synthesising the purely Romanesque and geometrical with an undoubtedly mudéjar spirit, at once spontaneous and rural.

Ordinary benches that resulted from the ancient tradition of the choir stall hardly evolved for centuries in rural areas. We will not even glance at the Gothic and sixteenth-century benches, which followed the prevailing fashions and were exclusive to the nobility: Their decoration and ornamental styles were usually not followed by the people (for example, the vegetable designs such as "thistle leaves" of the Gothic style, or the architectural features of the period, or the Renaissance "parchment" or "linen-fold" carvings). However, after the Middle Ages, for centuries some disparate elements (such as the use of the ogee arch in decoration) were to be found in the popular tradition right up to the nineteenth century. Simple symbolic geometrical motifs also survived, and when the rural artisan was talented enough, he would even carve fabulous mythological animals. Thus, we find gables with outlined ogee arches, rose carvings, spoked disks, and simple geometrical objects, together with the much less common dragons and sirens, which are harder to carve.

Nevertheless, the great majority of rural benches from the sixteenth, seventeenth, and eighteenth centuries are very plain and crude, this crudeness being a specifically Spanish feature in furniture. These benches can be categorized into two types in terms of construction and function.

The first group of benches is relatively homogeneous and could be considered directly related to the ancient thrones or medieval choir stalls, though in the rural environment they did not serve to demonstrate social differences but simply

to provide a seat. This group, known in some areas such as the Meseta as *escaños* (settles), have very wide seats, high backs, and closed sides at a right angle to the back. Although they were intended for sitting, they were in fact used for a variety of functions, including sleeping.

There are two types of escaños, as with the medieval prototypes from which they descend directly. The first, or "closed" type, has solid sides and back, which are very high in order to provide protection from drafts. The second, or "open" type, has lighter sides and back, with a balustrade-type arrangement of turned or carved wooden struts, and in some cases the sides are no more than simple armrests.

Interestingly, the predecessors of both types are shown frequently in fifteenth-century paintings, though the medieval examples are high-quality pieces finely carved with religious scenes (the Annunciation, scenes of the life of a saint, and so on).

Both types were made and used in one form or another in various areas depending on the preferences of the inhabitants. Economic differences also had an effect, as some were clearly made by carpenters who used good materials, while others were made by their owners with whatever tools were available (often only a saw and an adze) and, in many cases, the cheapest available materials.

Examples of the latter type have continued in use until relatively recent times in isolated areas including the western edge of the Meseta, in the provinces of Zamora (Aliste and Sayago) and Salamanca (Los Arribes and the Sierra de Francia), the mountainous area between León, Galicia, and Zamora (La Cabrera, El Bierzo and Sanabria), and the neighboring Portuguese region of Trás-os-Montes. No nails or tacks were used in the rough-hewn pieces; the wood was planed with the adze, assembled in the peg-and-box system, and it then acquired a black patina from the fire in the hearth. The backs are very high and sometimes have a cover. The adze was often used to decorate the top part by cutting away geometrical shapes. In both appearance and manner of construction, these pieces could well be classified as medieval, yet they were probably made continuously following similar patterns

from the fourteenth to the nineteenth century. When one wore out, it was replaced by another in the same style. Most of the surviving examples date from the second half of the eighteenth to the twentieth century, as indicated by those bearing a date.

In more prosperous areas all over the Peninsula, more refined escaños with large backs and seats were made, often by skillful carpenters using sophisticated techniques and tools. From the seventeenth and eighteenth centuries they achieved harmonious geometrical and rectilinear surfaces, with the doors known as "*de cuarterones*" (paneled). Good-quality wood was used (chestnut, walnut, knot-free pine), and the pieces were completed by carved designs and sometimes painted decoration on the backrest.

More complex escaños also exist, containing a drawer or larder in which to store bread, a panel that could be lowered to serve as a table, and even a mobile support, or *palomilla,* to hold an oil lamp.

The second category of benches is made up of pieces with a long and usually narrow seat, four legs (or six if it is very long), and a simple flat back. They are generally simple in construction and plain in style. Nevertheless, considerable variations exist. Some were made of walnut, when this could be afforded, and had carved legs in imitation of elegant furniture in style at the time. In the sixteenth century the legs could have been carved in the form of a fluted column, while in the seventeenth and eighteenth centuries the legs would be straight or carved into undulating lyre-shaped forms. Some pieces had folding backs on iron hinges and wrought-iron catches. Though such pieces are exceptional, they can still be found in rural areas. However, it was more common to imitate urban or aristocratic benches, which in some areas were decorated with elaborate carving on the backrests: These designs vary from simple vegetable or geometrical patterns to crosses, spoked disks, or roses, linking up with the ancient traditions mentioned above. Others show animals—real or imaginary —which almost always correspond to specific cultural areas and their preferred schemes of decoration.

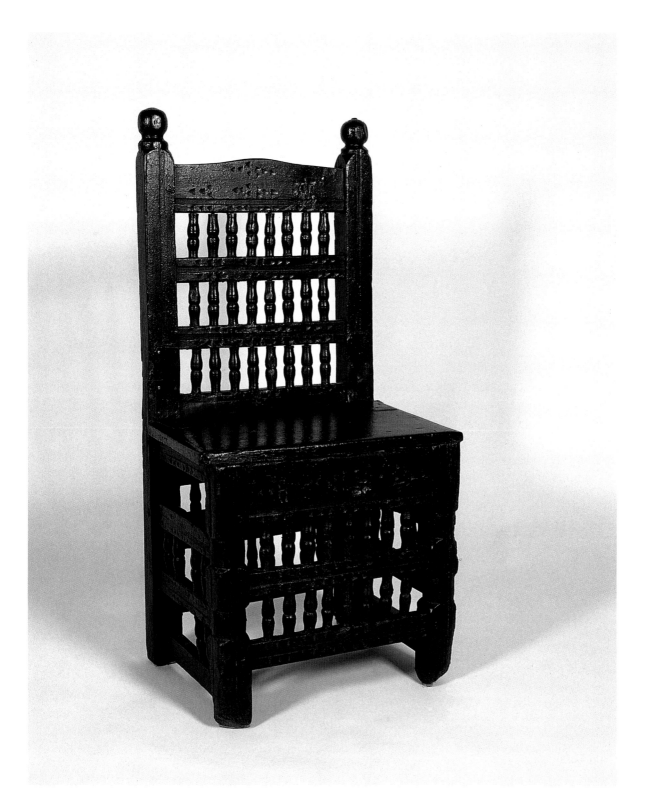

PLATE 41
Chair, 18th c.
Origin unknown
Wood, H. approx. 39 in. (100 cm)
Museo Nacional de Artes Decorativas,
Madrid

Chairs meant for the common folk are rarely found
from the sixteenth and seventeenth centuries but they
became widespread in Spain during the eighteenth
and nineteenth centuries. Often, they were popular
expressions of types used by wealthier classes.

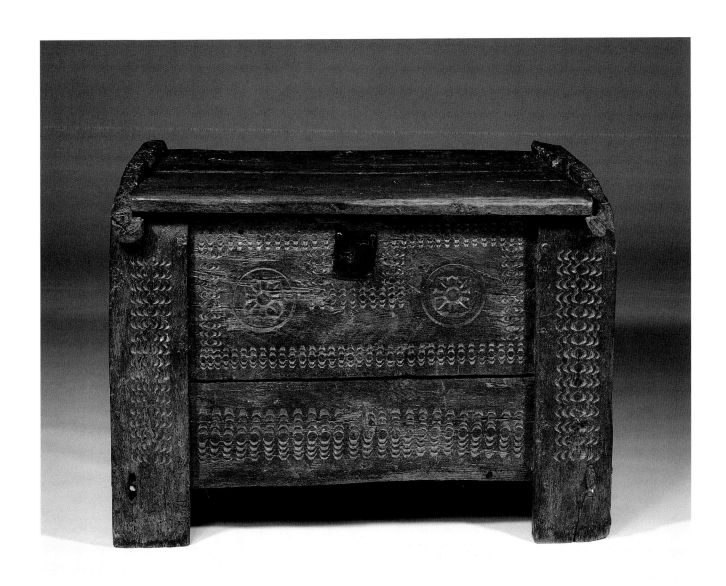

PLATE 42
Grain Box, 17th c.
Logroño, Spain
Wood and iron, 27 × 38 in. (69 × 97 cm)
Lent anonymously

This sturdy lidded box was probably used to store grain. The repeated gouge marks are characteristic of post-sixteenth-century furniture. Note how the legs raise the box above the ground to protect the contents from water, dirt, and animals.

The piece of furniture most clearly dedicated to repose is, of course, the bed. Its use in earlier times is confirmed by examples from the tombs of the pharaohs in ancient Egypt, and by those existing in the Etruscan and Roman world before the Christian era. However, in these cases beds would have belonged to the nobility and high dignitaries.

In Spain, there are two types of rural bed, with different origins. The first type has longer legs (which are a prolongation of the head- and footboards) linked by side beams and follows the long tradition mentioned above. The second, or "dressed" type, stands on a dais, sometimes with a frame, and its supports are covered by curtains. This type corresponds to the fashion of the Middle Ages and sixteenth century, when much of the furniture and even the walls of the house were covered with rich fabrics or tapestries.

The first type, similar to the normal modern bed, is very straightforward. Two square-cut horizontal poles are joined with vertical head and footboards, which can be decorated with carving or popular painted designs, or cut out in geometrical shapes. These cut-out shapes can form curves and square or triangular battlements, and sometimes have fretwork crosses, hearts, or other symbolic designs such as swastikas. Some are painted with simple monochrome decoration such as flowers and hearts. This type of bed is often erroneously known as a "nun's bed." Occasional examples may have indeed been preserved in monastic cells, taken there by novices as part of their humble dowry, but these beds were normally used in rural homes.

An unusual type of bed is found in Cataluña and the Valencia region. These beds have great curved headboards, with a baroque ancestry, carved, gilded, and painted in colors, with religious subjects in the central part and pairs of cherubs and curves in the manner of cornucopias. Sometimes the decoration consists only of flowers, and the later ones from Olot have gentler lines and colors. The footboard almost always has colored decoration and curved forms.

Painted designs on beds appear almost everywhere. Simple rectangular headboards and footboards were often painted with a uniform background, garlands, and bright flowers, possibly following the neoclassical style. We are familiar with examples of this type from Burgos, Palencia, and La Rioja.

As always in popular furniture, there is an exception to the rule. An unusual bed in a private collection has a carved, fitted headboard, painted yellow, red, and green on a black background. Primitive Christian motifs represent a monstrance, angels' heads, a central cross with inscription, and fretwork vegetable designs. On the highest part there is a statue of an angel, with wings and a sword. However, the footboard, though more restrained, is decorated with swan heads and necks, recalling the late Empire style. It probably comes from León.

"Dressed" beds were usually placed lengthwise against a wall or at a corner, and fine embroidery or lace was often hung over the front. We find the richest popular embroidery, in multicolored silk and wool with floral and animal designs, in the Sierra de Francia, the Campo Charro, and the Abadengo in Salamanca Province. Attractive handmade bed covers completed the whole, and as in the case of the frontals and other bed linen, the different types reveal their geographical origin.

TABLES

The table provided repose as it supported the hands and the objects being used and facilitated various activities, including eating and sitting down together.

Tables were found in certain geographical areas, while in others they were relatively unknown. The little "bacon table" *(tocinera)* was used in most rural households in the kitchen or near the hearth. The high table was considered unnecessary in many homes, particularly in the poorest areas where the people made do with only the essentials.

Most traditional tables trace their origin to the styles of elegant society, with the exception of the above-mentioned bacon tables found only in peasant homes. These can be found over most of the Peninsula: Thousands were used in Castilla–León, Extremadura, Andalucía, and La Mancha, as well as the mountainous areas of the Northeast and North. Though specific features

can be seen in some areas, their construction and, where it exists, decoration are basically similar. They are normally low, with a top that extends beyond the legs, and have a drawer. In most cases they are made out of pine, though chestnut, ash, and fruit-tree wood are also found. The origin of the name is unknown, as the drawer was not necessarily used to store bacon, but rather to keep bread, small utensils, or cutlery, as well as leftovers, which could have included bacon. One possibility is that the term *cocinera* (cook or stove) may have become confused with *tocinera,* as the table was certainly used for a variety of purposes, including cutting, preparing food, and eating.

Though some simple carved decoration is not unusual, this is not a piece of furniture that lends itself to embellishment. Sometimes one can find a rose design drawn with a compass, gouge marks, and an occasional ogee arch from the late fifteenth century, which continued to be used in popular art until well into the nineteenth century.

With regard to larger tables, there are two types, with and without drawers. Both types have clearly been influenced by elegant designs, and the rectangular top at least is almost always made of fine wood (chestnut or walnut).

The simplest type is called "*de San Antonio*" (Saint Anthony's table) by furniture enthusiasts and antique dealers, as it was a very common design and is seen in a well-known painting of the saint by Murillo. It has square-cut legs, flared at the bottom, with simple iron bolts connecting the crosspieces to the base of the top. Many such tables, from the simplest types to the most baroque, were made, particularly in the seventeenth and eighteenth centuries; the shape of the legs and the style of the ironwork can indicate their approximate age. This was a functional table, used for writing, eating, and other activities.

In contrast, the second variety of large table has one to three drawers, or even more depending on its length. The height and width did not vary greatly, and certain proportions were always respected. This type has a heavier appearance than the former one, as the top, legs, and structure are usually thicker. It is also more likely to be decorated with carvings on the drawers, sides,

or rear panel. It can be difficult to distinguish the popular rural version from the refined city one, except in the more rustic finish and construction of the latter, and possibly in the decorative motifs, which may be of a clearly popular nature. Both types of larger tables tended to be found in wealthier homes over a wide range of rural areas.

Tables with circular tops were also used. They are generally simple and rustic, and, again, were imitations of the urban models supported by a single central column and three legs, so frequent in refined nineteenth-century furniture.

A characteristic type in the mountain region of Salamanca Province (Béjar, Sierra de Francia) and the north of Cáceres are the *bufetes* (buffet tables), heavy though not very large walnut tables with thick planking, two drawers, and sturdy legs carved in curvilinear shapes.

Furniture to Contain Objects
CHESTS

The *arca* or *arcón* (chest) was the classic moveable container until quite recently in both town and country, and chests are still used in some isolated areas, particularly in the western strip bordering on Portugal and some mountain regions. They were used to store textiles and clothes (the hanging wardrobe was unknown), but also cereals and other food, agricultural implements, and tools (pls. 42, 43).

Chests of this type are remembered by anyone in Spain over a certain age. They have a lid, and are often raised above the floor on legs or some other type of base, to protect the contents from animals, water, and dirt, and they often have a locking mechanism. They can have one or more locks, which were usually decorated in the style of contemporary models when they were made by the local blacksmith, or with traditional motifs specific to the area. Blacksmiths also made the long hinges fitted inside the lid, the handles used to carry the chest, and in some cases iron cornerpieces.

A few Gothic examples from the fourteenth century still exist. These were usually pious gifts to churches, made of holm oak, deciduous oak, or walnut, and employing a simple yet durable system of peg-and-box construction. They stood on wide, flat supports achieved simply by

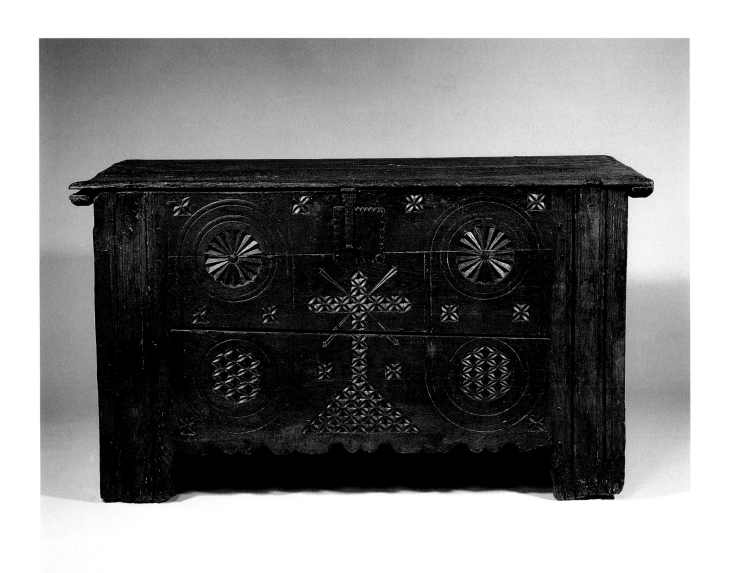

PLATE 43
Trunk with Geometric Cross, early 17th c.
Basque Country, Spain
Wood and iron, 35 × 62 in. (89 × 157 cm)
Lent anonymously

This massive trunk, called a *kutxa* in the Basque language, is
typical of the excellent utilitarian wooden furniture produced
in northern Spain beginning as early as the fifteenth century.
Northern Spain, particularly the Basque Country, is known
for its large-scale furniture, often decorated with geometrical,
anthropomorphic, and zoomorphic designs. This trunk was
probably a wedding gift and used to store clothing belonging
to the bride.

extending the vertical planks forming the corners. Some have architectural or "gable" tops (the oldest ones), allowing water and dirt to run off, and the fronts and sides are decorated with carvings in an architectural vein.

Their shape hardly varied from the Middle Ages onward, except for the introduction of a flat top. They are raised above the ground by horizontal bases, turned legs, or surrounds, none of which form part of the structure of the chest (as in the Gothic examples). However, the system of construction did change, as the different parts were attached by dovetail joints. These features provide clues on area and date of origin, as well as the economic status of the clients for whom they were made.

The date can be established with considerable accuracy in the case of quality items, but in the area of popular furniture the dates for specific fashions will often be later, as rural makers tended to imitate urban fashion. When the two are contemporary, the popular decoration will be rougher, or the front of the chest might be carved with specifically popular designs, which can be very interesting in certain areas. In any case, this genuinely rural item of furniture was a constant presence, especially in the sixteenth, seventeenth, eighteenth, and most of the nineteenth centuries. Similar chests can be found in different sizes, from small ones with legs or surrounds to huge ones (taller than a person) used to store cereals.

The finest was undoubtedly the nuptial chest (which did not necessarily belong to the bride, as sometimes erroneously supposed), which often had carved or painted decoration. Some very fine examples from noble or wealthy families of the Middle Ages still exist. Popular decoration (geometrical or floral designs in general) finds its most lovely expression in the chests of the Sierra de Francia in Salamanca Province. These are made of walnut or chestnut, with long carved legs sometimes recalling those of a quadruped. The carved decoration includes the floral bouquets, trees, birds, lions, dogs, and other animals of the popular repertoire.

TRUNKS

Lighter than the chest and easier to transport, the *baúl* (trunk) was not found frequently in rural areas, except among the wealthiest inhabitants, and in recent periods, when they were mostly mass produced. However, there are baroque examples of trunks covered with leather or skins (usually goatskins with hair), and decorated with iron or bronze tacks forming shields, names, or other motifs.

The *bargueño,* though equivalent to other similar European bureaus or secretaries, does have characteristic features making it an unambiguously Spanish piece of furniture. Because the bargueño was used by the nobility, it cannot be considered a truly popular item, though it could be found in wealthy rural circles as well. Some examples are midway between the elegant world of the nobility and that of the peasantry, due either to their simple, rough construction or to their decoration (fig. 9).

Both the origin and name of this piece of furniture are obscure. The name can be written with either a *b* or a *v,* but we prefer the form *bargueño* and believe that it might well be related to the town of Bargas (in Toledo Province).

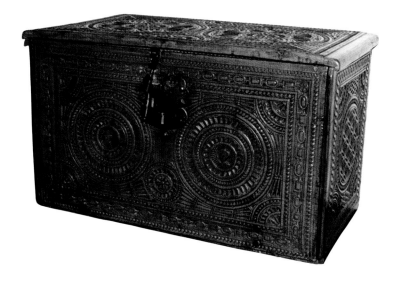

FIGURE 9
Portable Desk (Bargueño), 18th c., Andalucía, Spain. Museo Nacional de Artes Decorativas, Madrid.

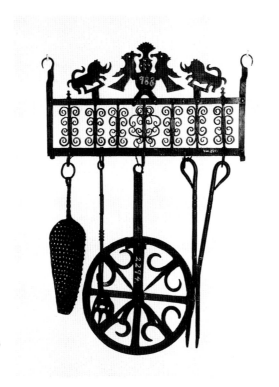

This piece evolved from the sixteenth to the eighteenth century into a rectangular trunk with a front-opening flap and numerous small drawers. The use of gilded appliqué ironwork and highly varied decoration make it without parallel in Western Europe.

Decoration can consist of carving and gilding, with colored painting, architectural features (a pediment and small columns), and inlays of bone and different woods, clearly a mudéjar feature. Wrought ironwork is also important: a large frontal lock, cornerpieces and bolts, side handles, little fretwork plaques, and so on.

The bargueño was always placed on top of another piece, which could be a simple table with wrought-iron supports, or the so-called *pie de puente* (bridge base). A third type of support which, though a separate unit, really forms part of the bargueño, is the *taquillón,* or cupboard with doors, on which the first unit stands; both have the same decoration.

HUTCHES

Pieces of furniture variously known as *vasares* (glass holders), *plateros* (plate holders), or *coperos* (cup holders), were used to hold crockery, specifically glasses or plates, as the names imply. In the more prosperous areas of Castilla–León, attractive china from distant production centers such as Manises (Valencia), Ribesalbes (Castellón), and Talavera de la Reina and Puente del Arzobispo (Toledo) would be displayed on these shelves. China was bought from these centers in surprising amounts, and in return the lands of the Meseta sold wheat and wool.

These cabinets are simply constructed, with two sides and a variable number of shelves resting on wooden pegs. The back can be open or closed. Nevertheless, there are many variations in form and decoration, which was quite common with these pieces. Some show a strong medieval Gothic influence right up to the eighteenth century, with a gable and cross on the top and circular shapes in the upper part of the side panels. It is still possible to find the cabinets in poor, isolated areas such as the western part of the Meseta adjoining Portugal. They are widespread in Zamora Province, where some of these dressers have a double-angled top and central cross, and plentiful carving in curvilinear forms.

This type of repetitive symmetrical (and usually geometrical) shape is often found in Galicia and Extremadura and in Trás-os-Montes, Portugal, but local systems of construction and especially decoration can identify the area of origin. Thus, the designs used in the lovely embroidery and ironwork of Salamanca Province are also reflected in the decoration of its hutches.

CUPBOARDS

The *alacenas* (pantries) used in country homes were derived from the cupboards used from the Middle Ages onward to store vestments and liturgical objects in churches and monasteries, and together with chests and benches made up the majority of rural furniture.

They were used to store crockery and domestic tools as well as food, for which ventilation was often provided by open latticework. They have doors with iron hinges, and one or two drawers. They are raised above the ground by short square-cut or turned legs, or by horizontal bases. Alacenas were also often built into a straight wall or a corner.

Alacenas were widespread in the Iberian Peninsula, in different shapes and styles depending on cultural or local influences. The use of latticework can be an indication of mudéjar influence. In other cases ventilation is achieved with vertical turned or balustrade-type bars, and with symmetrical openings in the upper doors. Entirely

solid doors were not unusual, however, and they could be plain or decorated by the straight lines of the paneled structure so often used from the sixteenth to the nineteenth century.

This genuinely popular item of furniture was occasionally decorated with a diversity of techniques and motifs, with carving, painting, and appliqué in designs adapted from more sophisticated pieces or in the regional tradition.

In Salamanca Province there is a simpler variation on the alacena, which does not have the usual tall, narrow rectangular shape. Some of these go back to the sixteenth century, and their solid doors and drawers are often wider than they are high. They are somewhat heavy and very robust pieces of great quality, indicating an early origin, though they continued to be made until the seventeenth and possibly the eighteenth century. Of the few examples we have been able to find, some have good popular carving in fine wood.

A model derived from the bargueño has a taquillón, or supporting cupboard, below, and an upper unit with doors that may have latticework. The upper part is sometimes in an architectural style. The fusion of these models with the simple two-door cupboard probably resulted in the alacena that appeared in Spain.

There are many examples of mixed types of furniture, such as alacenas with open shelves or plateros with two doors; on occasion these were small enough to be hung on the wall, and below some of them was a stand for water pitchers.

Cantareras, or stands for two or three pitchers, can also be found. Small hanging cuchareros (spoon holders) were made to hold cutlery in horizontal grooves; they were often decorated with symmetrical fretwork on the sides, their construction and shape varying with their place of origin.

Also made to be hung on the wall were the wooden espeteras (utensil racks) with numerous iron hooks from which different objects or household utensils could be suspended. Though little more than simple planks, they were oftentimes decorated with popular carving or painting, the aesthetic results of which would depend on the skill of the artist (fig. 10).

A final item of furniture hung from the wall was a small bracket on which a drinking glass (often with a handle) was placed; in some provinces it was decorated, sometimes profusely.

Mass-produced items of industrial origin have been deliberately excluded from this study, despite their widespread use in country areas. They include turned chairs with rush seats; beds of brass and wrought iron, which were very common in the villages; mesas camillas (round tables with hot coals underneath and a heavy fabric tablecloth, around which a family could gather to get warm); and certain types of trunks and chests of drawers that from the 1800s to the 1960s invaded so many homes, from the richest to the most humble, in many cases bringing to an end the ancient traditions of construction by artisans.

BIBLIOGRAPHY

de Lozoya, Marqués, and J. Claret Rubira. *Muebles de estilo español.* Barcelona: Editorial Gustavo Gili S.A., 1968.

Feduchi, Luis M. *Antología de la silla española.* Madrid: Editorial Afrodisio Aguado S.A., 1957.

Klatt, Erich. *Die Konstruktion alter M'bel.* Stuttgart: Julius Hoffmann, 1961.

Lucie-Smith, E. *Breve historia del mueble.* Barcelona: Editorial del Serbal, 1980.

El mueble español. Barcelona: Editorial Polígrafa S.A., 1969.

Piñel, Carlos. *La Zamora que se va: Colección de etnografía Castellano-Leonesa de Caja España.* Barcelona: Editorial Prensa Ibérica, 1993.

Schmitz, Hermann. *Historia del mueble.* Translated by José Ontañón. Barcelona: Editorial Gustavo Gili S.A., 1971.

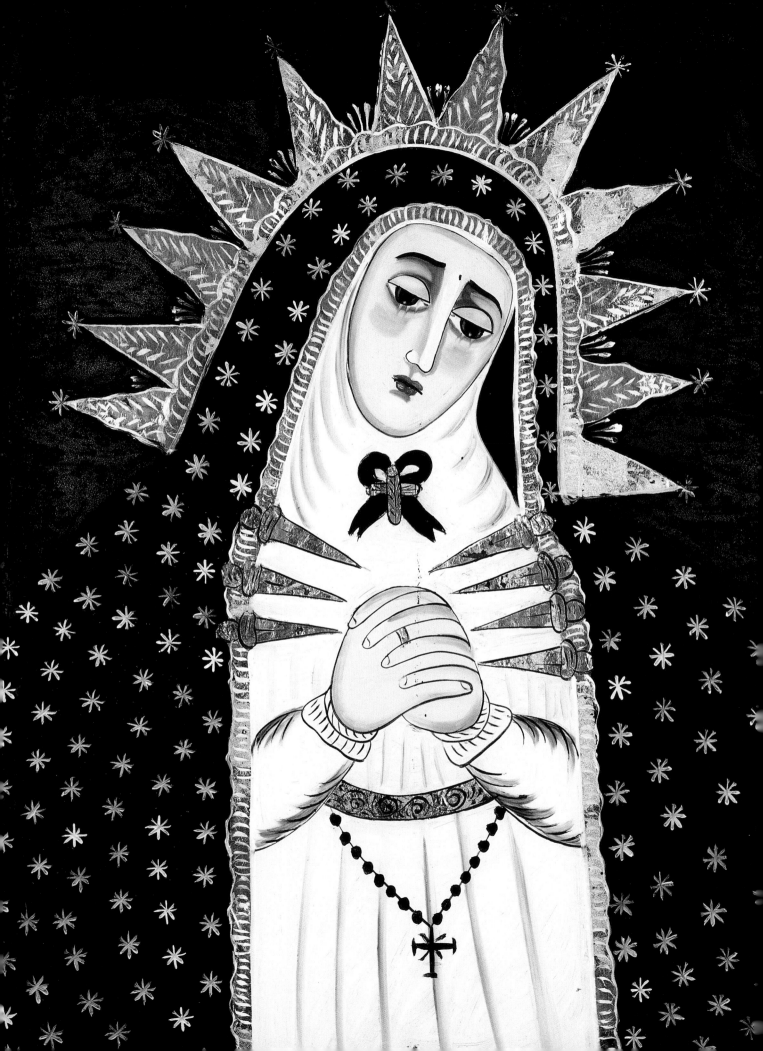

Ceremonial Folk Art

It's the Virgen de la Peña
Who has the most altars,
There's no son of La Puebla,
Who does not guard her
 in his breast.
—FOLK SONG, HUELVA, ANDALUCÍA[1]

As in many parts of the world, the most visible and dramatic form of Spanish folk expression is that associated with ceremony—religious and secular. Using time-tested traditional objects—some rooted in the pre-Christian past, and others of more recent manufacture—the Spanish commune with their saints, maintain continuity between the living and the dead, celebrate the passage of the seasons, acknowledge life's transitions, and strengthen ties with family, community, and nation.

The institutional framework for most religious ceremonial folk art is the Catholic Church. Throughout Spain, the Church occupies a central role in the community, both physically and figuratively. Not only do churches (the structures themselves) stand at the geographical center of a village, town, or city, but the Catholic Church also provides the ritual calendar, which determines the schedule for the year's ceremonial activity. While the Church calendar provides the temporal framework for local religious events, a community's particular history and circumstances provide the shape and texture of each celebration. Cristina García Rodero's powerful photographic study of contemporary Spanish celebration, *Festivals and Rituals of Spain,* bears witness to the richness and variety of modern Spanish ceremonial folkways.[2]

Religious celebrations have varying degrees of size and importance. Annual events, such as the celebrations of Semana Santa (Holy Week) in Sevilla and Corpus Christi in Valencia, Toledo, and Barcelona, are real "happenings" and draw millions of people from all over Spain and elsewhere. These intensely devotional events become spectacles as impressive as any public events in the world, involving thousands of participants and requiring enormous expenditures of time, money, and energy. Other celebrations are more modest and personal in nature, such as the annual celebrations in honor of San Blas (Saint Blaise) in Cambados, Galicia, the celebration for San Pedro (Saint Peter) and San Pablo (Saint Paul) in Extremadura, and thousands of other local celebrations in towns and villages throughout Spain.

Among the most popular and widespread religious celebrations are those associated with the cult of the Virgin Mary. Frequently, each region, each village, and each neighborhood has its own vernacular version, usually recalling a local miraculous apparition. The apparition story related to the Virgen de la Peña (Virgin of the Hill) in Huelva is somewhat typical:

In 1460, Alonso Gómez, a humble shepherd and devotee of La Inmaculada (the Virgin of the Immaculate Conception), noticed a brilliant aurora surrounding her image. When he approached, he found not one but two images of the Virgin. They spoke to him, saying, "We are from Ayamonte. When Spain was lost to the Moors, we were hidden here by devotees. Carry one of us to the Cerro del

PLATE 44
Nuestra Señora de los Dolores (Our Lady of Sorrows)
Late 19th c.
Andalucía, Spain
Oil on glass, 26 × 22 in. (65 × 55 cm), unframed
San Antonio Museum of Art

Images of the Virgin Mary are among the most popular religious folk forms in Spain. In this mournful depiction of the Virgin, we see seven swords piercing her heart, symbolic of her "seven sorrows," the first of which was her son's circumcision.

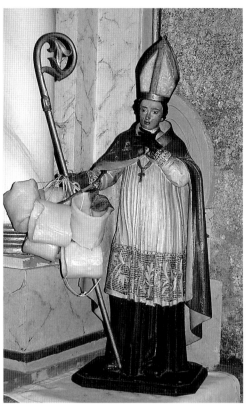

FIGURE 11 (left)
Boat Rock, 1996,
Muxia, Spain

FIGURE 12 (right)
*Saint Blaise with Wax
Votive Offerings,* 1996,
Cambados, Spain

Aguila, and leave the other here for the protection of this land." The shepherd did as he was told and left an image in its original place, which today is the site of a hermitage. He carried the other to a spot on the top of a high hill known as the Hill of the Eagle. There, he and other pious devotees built another hermitage in honor of the Virgen de la Peña.[3]

Pilgrimages to sacred shrines honoring the Virgin are very special and often involve prescribed behavior known only to the faithful, such as gathering up special earth from the site, or collecting water considered to have curative powers. Pilgrims to the shrine of Nuestra Señora de la Barca (Our Lady of the Boat) in Muxia, Galicia, have their faith tested by trying to lift an enormous boulder. According to local tradition, those who successfully meet the challenge are among the few who will receive special blessings from the Virgin (fig. 11).[4]

According to folk belief, the saints (second in importance only to the Virgin Mary) are intercessors between man and God. Each town and city has a patron saint: Madrid has San Isidro Labrador (Saint Isidore the Farmer); Barcelona, Santa Eulalia (Saint Eulalie); and Pamplona, San Fermín (Saint Fermin). During each town's saint's day celebration, life reorganizes itself around ritual time. Towns are decorated with flowers, bunting, and other ephemeral hangings.

Masses are said, processions held, and special public performances are staged in honor of the patron of the community. It is a time when those who have left town return, and a time for those who have remained to reestablish bonds with their friends and neighbors. Perhaps most importantly, it is a time for the community to come together in an event which is commonly cherished as an act of solidarity and shared faith.

Certain saints are associated with professions and occupations, and their feast days are also a cause for celebration. San Ramón Nonato (Saint Raymond Nonatus) is the patron saint of midwives (pl. 51); San Isidro Labrador, of farmers; and San Antonio de Padua (Saint Anthony of Padua), of masons and bricklayers. In addition, some saints are petitioned for special needs. San Blas's assistance is sought when one has throat problems (fig. 12); Santa Lucia's (Saint Lucy's) help is asked for eye disease and blindness; and Santa Apolonia (Saint Apollonia) is appealed to for dental problems. Seemingly, every place and circumstance has a saint whose special qualities ameliorate suffering during times of need and crisis.

Throughout Spain, religious imagery associated with the important personages in the Catholic Church abounds, and these images

PLATE 45
Nuestra Señora de Guadalupe
(Our Lady of Guadalupe)
18th c.
Madrid
Oil on copper, 14 × 11 in.
(35 × 28 cm), unframed
San Antonio Museum of Art

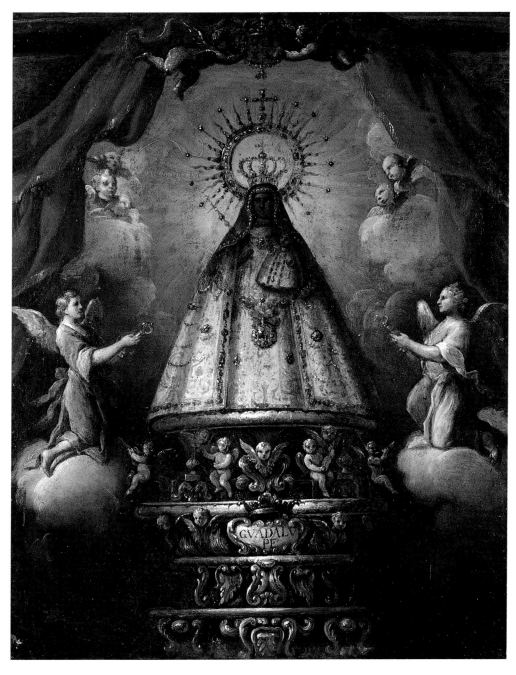

The Virgen de Guadalupe, from the hills of Extremadura, is one of the most popular images in Spain. Venerated for hundreds of years by people from all walks of life, the black-faced Guadalupe has had an enormous influence throughout the Hispanic world. Her shrine, established by Jeronimites and maintained today by the Franciscans, has been a popular pilgrimage destination since the Middle Ages. Both Christopher Columbus and Hernán Cortés made pilgrimages there upon returning from the Americas to give thanks for miracles they attributed to the Virgin.

According to tradition, this image, like that of Montserrat, was originally carved by Saint Luke and sent to Spain hundreds of years later. During the Islamic rule of Spain, the image was hidden for over six hundred years.

In 1325, a cowherd named Gil Cordero was looking for a lost cow near the banks of an isolated river when he came upon the long-hidden statue. A shrine was erected there in the Virgin's honor.

That Extremadura's Guadalupe was transformed into Mexico's Virgen de Guadalupe seems indisputable. Iconographically, however, Mexico's Virgen de Guadalupe looks like Spanish representations of La Inmaculada (Our Lady of the Immaculate Conception) and bears little resemblance to the image shown here. However, in the choir wall of the Spanish monastery, there is an image strongly resembling the Guadalupe of Mexico. This image is believed to have been carved in 1499, over thirty years before the apparition of the Virgen de Guadalupe in Mexico.

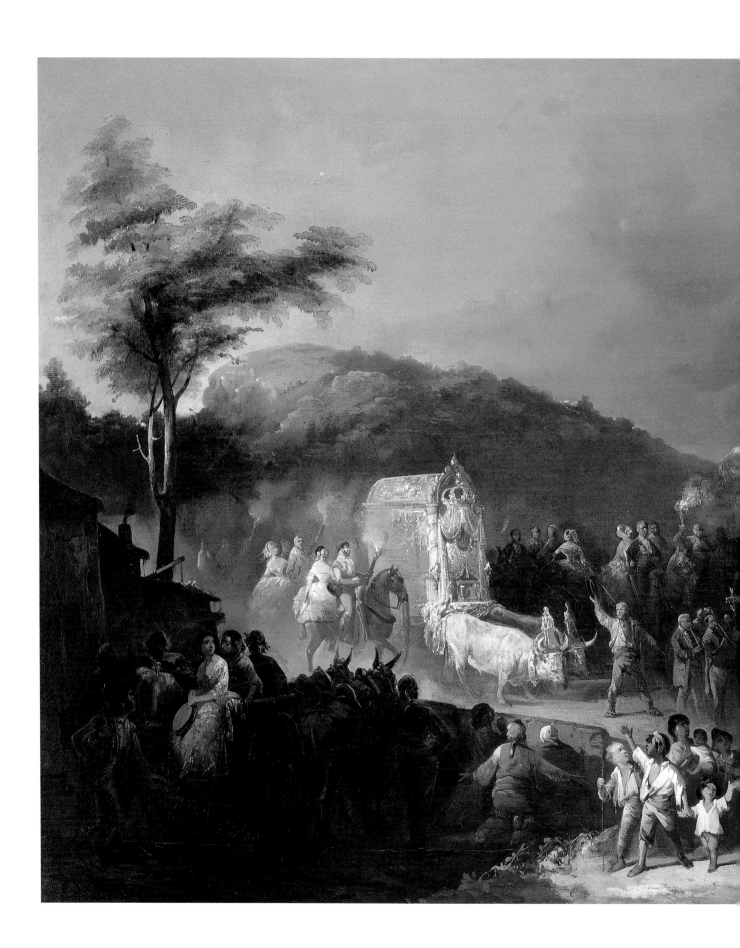

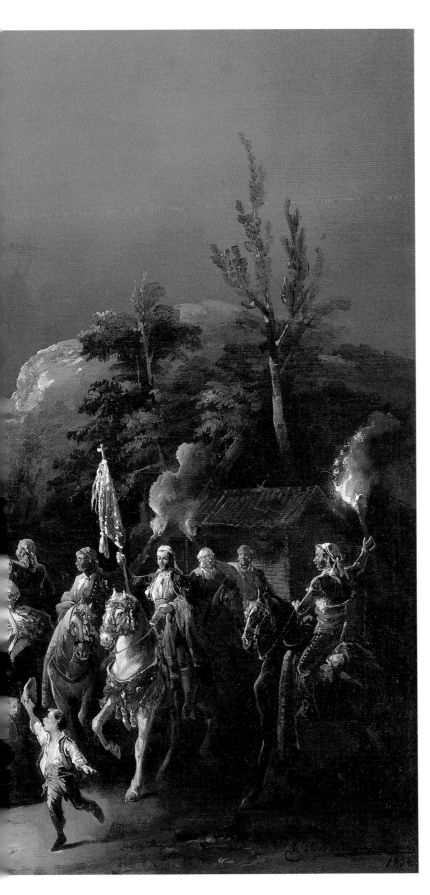

PLATE 46

M. Rodríguez de Guzmán, 1818–1867
Folk Festival: Romería del Rocío (Pilgrimage to the Shrine of Our Lady of Rocío), 1856
Sevilla, Spain
Oil on canvas, 26 × 37 in. (65.5 × 94 cm)
Meadows Museum, Southern Methodist University, Dallas;
Algur H. Meadows Collection

This interesting painting depicts the annual spring pilgrimage to the shrine of Nuestra Señora del Rocío, located near the Andalusian town of Huelva. All classes of Spaniards participated in this pilgrimage, which often lasted several weeks. Some went on foot, others astride elegantly dressed horses, still others in elaborate carts drawn by decorated oxen similar to those shown here. Great stories of romance and adventure are associated with this popular event. Romerías could be considered performance votive art, since they are usually done in thanks for a miracle from the Virgin or in anticipation of a favor to be received.

FIGURE 13
Votive Offerings, 1993,
Sanctuary of Saint Amaro,
Burgos, Spain

offerings, referred to generally as ex-votos, take many shapes and sizes. Since Roman times in Spain, people have offered votive objects in wood, wax, bone, and metals as testaments to the efficacy of the power of a specific saint or other member of the spirit world. Eyes, legs, arms, breasts, and other body parts testify to a return to health following a grave illness or serious accident. Sheep, horses, cows, and other domesticated animals attest that these creatures have been saved from disease or injury (fig. 13). These interesting expressions of devotion and gratitude are usually pinned to the hem of the religious statue or close by for all to see. Less standard votive objects are more varied still and include such things as wedding dresses offered by appreciative brides, a matador's *traje de luces* (suit of lights) in thanks for surviving a bullfight, or hand-knitted booties presented by a grateful mother whose child was gravely ill.

For hundreds of years in Spain, seafarers, upon returning from difficult voyages, have offered ships and other items in appreciation of the miraculous intervention of a saint (pl. 52). On 14 February 1493, Christopher Columbus vowed to make a pilgrimage to the Shrine of Nuestra Señora de Guadalupe (Our Lady of Guadalupe) in Extremadura if the Virgin would protect him and his crew from a violent storm encountered near the Azores. As part of his vow, he promised to carry a five-pound wax votive candle to offer to Nuestra Señora.[5] Several decades later, Hernán Cortés made a similar vow to Nuestra Señora de Guadalupe (pl. 45). In appreciation for her protective intervention following a near-fatal scorpion sting, Cortés vowed to make a pilgrimage to the Extremadura shrine, a pledge that he fulfilled. As a testament to the efficacy of the Virgin, he offered a bejeweled likeness of the scorpion that stung him.[6]

Appreciation for favors received is also expressed in paintings found throughout Spain and other parts of Europe, many dating back to the Renaissance or earlier. These votive paintings show in vivid detail crises overcome through the miraculous intervention of a saint (pls. 54–58). Intensely personal, they are often accompanied by textual explanations giving the exact date and time the event took place. "Santísima Virgen de la Consolación (Holiest Virgin of Consolation), I give thanks for your help during a grave illness," reads one. "I give thanks to San Ramón Nonato

represent a broad range of styles, often spanning five or six hundred years. It is not rare for provincial churches to have on display religious statues dating from Romanesque times to the present, many of which are splendid examples of local and regional folk expression. They are made of a variety of materials—from wooden, metal, or plastic statues, to paintings on glass, canvas, wood, and metal, to popular images printed onto paper.

Among the most interesting ceremonial folk art is votive art. Throughout much of the Christian world, devout men and women use votive offerings to mark their continuing devotion to a saint and to give thanks for favors received or in anticipation of future assistance. The contract leading to these gifts is usually established between the believer and a member of the spiritual world during a time of crisis. Throughout Spain, from large pilgrimage centers such as the shrine of Montserrat near Barcelona to small *ermitas* (hermitages) in the countryside, walls are filled with such gestures of appreciation. These votive

PLATE 47
Octagonal Reliquary with Face of Christ, 18th c.
Castilla, Spain
Silver, glass, hand-colored paper, 3 × 3 in. (8 × 7.5 cm)
Museo Nacional de Antropología, Madrid

This hand-colored image on paper represents Cristo de
Medinaceli, a popular manifestation of Jesus in Madrid.
Not shown here is a red cross on the reverse.

PLATE 48
Necklace, 19th c.
Salamanca, Spain
Coral, paper, glass, silver
L. 16 in. (40 cm)
Museo Nacional de
Antropología, Madrid

Necklaces such as this were usually part of a Salmantina woman's attire during religious festivals such as weddings and saint's day celebrations. Coral—imported and expensive—had a reputation for warding off evil spirits. Attached to this necklace are two medallions representing the Virgin and a pendant frame containing a small image of the head of Christ.

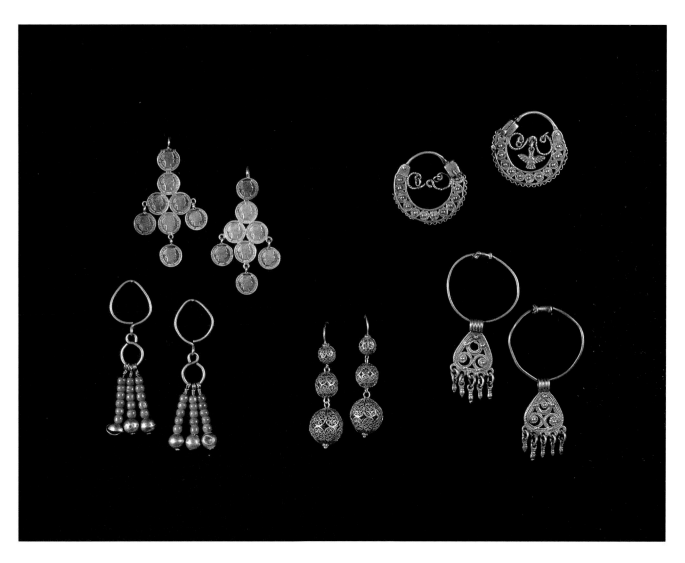

PLATE 49
Five Pairs of Earrings, 19th c.
Santandér, León, Córdoba, Madrid, León, all in Spain
Silver, glass, coral
Museo Nacional de Antropología, Madrid

Earrings have been worn by women in Spain since at least
Roman times. This small collection suggests their variation
in terms of style, material, and technique.

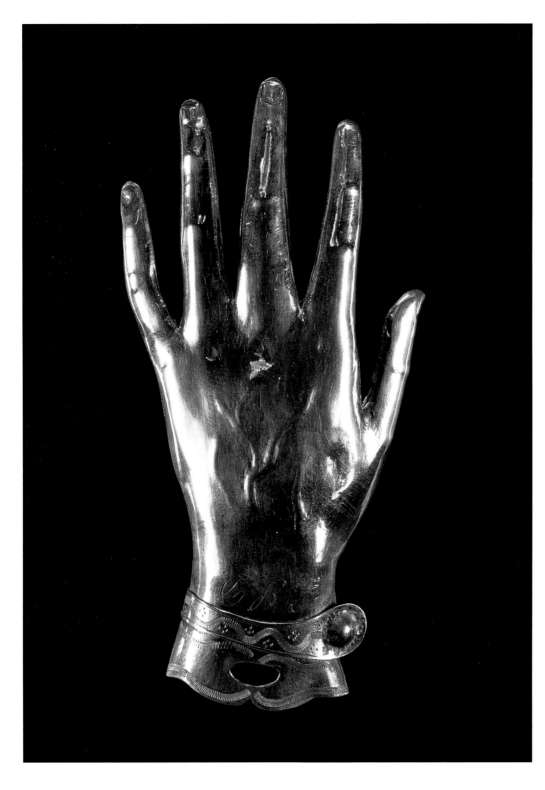

PLATE 50
Ex-voto in Form of Hand
19th c.
Toledo, Spain
Silver
4½ × 2½ in. (11 × 6 cm)
Museo Nacional de
Antropología, Madrid

Votive objects such as this,
which acknowledge a mir-
acle received from a saint
during a time of need, have
a very long tradition in
Spain, going back to pre-
Christian Roman times.
The donor of this ex-voto
probably invoked the aid of
a saint to cure a problem
with his or her hand. Once
cured, the appreciative pa-
tient commissioned this
object and offered it as a
testament to the power of
the saint. Today, similarly
shaped votive offerings can
be found all over Spain,
but they are usually made
of wax.

for assisting me during a difficult delivery," reads another (fig. 14). María del Carmen Medina San Román's excellent essay in this volume provides a interesting overview of votive art through time and space in Spain and is itself a testament to the continuing importance of this centuries-old tradition. Votive art, with its honest directness, clear sentiment, and lack of pretension, is among the most powerful manifestations of ceremonial folk art in Spain.

Among other forms of religious folk art are amulets and charms. Particularly interesting are amulets worn by children as protection from the evil eye and other threats. These amulets come in many shapes and are made of silver, gold, jet, wax, cloth, bone, and many other materials. Some also serve as symbols of continuing devotion to a particular saint, such as those representing Santiago (Saint James).

Spanish ceremonial folk art also includes objects related to the secular world. Often these things are used to contrast with the religious. Carnival dramas depicting the profane, groups dressed as Moors and Christians reenacting the Christian reconquest of Spain from the Arabs, and thousands of other folk forms are used annually in villages and towns all over Spain, providing local versions of the constant battle between good and evil. Giants and Big-Heads parade through the streets of Barcelona, Zaragoza, Olite, and elsewhere, behaving in worldly ways, sometimes approaching the sacrilegious, and are counterpoints to the more important solemn processions that follow (pl. 64). Stanley Brandes's contribution to this volume provides an intelligent overview of this and other forms of popular theater, based on many years of anthropological fieldwork in Spain and elsewhere.

Ceremonial folk art associated with rites of passage can still be found in every province

of Spain. Marriage is one rite of passage acknowledged and reinforced with folk art (pl. 60). Special dresses, bed linens, furniture, and other things are exchanged to cement the vows spoken during marriage ceremonies. Pregnancy and birth are anxious, often difficult, times in all parts of the world, and Spain is no exception. To better cope with these difficulties, Spaniards call upon traditional folkways to see them through. Special amulets, tested through time by mothers and grandmothers, are still used by young women giving birth for the first time. Finally, death is marked with traditional folk objects. Burial cloths, breads, and tombstones assist in this final transition and provide focal points for continuing recognition of the deceased (pl. 62).

Ceremonial folk art is among Spain's strongest connection to traditions of the past and probably of the future. It is her boldest, often most boisterous, voice. It conveys her hopes, fears, loves, and hates and speaks proudly of her faith and values.

FIGURE 14
Votive Painting, 19th c., Sanctuary of Our Lady of Consolation, Utrera, Spain

NOTES

1. George M. Foster, *Culture and Conquest: America's Spanish Heritage* (New York: Wenner-Gren Foundation, 1960), 218.

2. Cristina García Rodero, *Festivals and Rituals of Spain* (New York: Harry N. Abrams, 1994).

3. Foster, *Culture and Conquest*, 214.

4. Ruth Matilda Anderson, *Pontevedra and La Coruña* (New York: The Hispanic Society of America, 1939).

5. John Cummins, *The Voyage of Christopher Columbus: Columbus' Own Journal of Discovery* (New York: St. Martin's Press, 1992), 180.

6. Letizia Arbeteta Mira, "El Ex-voto de Hernán Cortés," in *Dones y Promesas: 500 Años de Arte Ofrenda* (Mexico City: Centro Cultural/Arte Contemporáneo, 1996), 234–40.

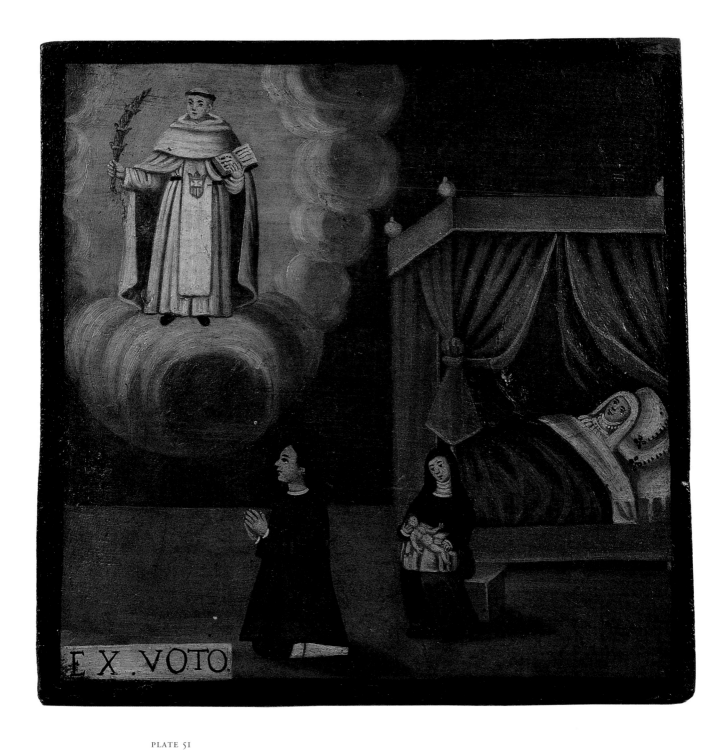

PLATE 51
Ex-voto to San Ramón Nonato (Saint Raymond Nonatus)
Early 19th c.
Cataluña, Spain
Oil on wood, 12½ × 12½ in. (32 × 32 cm)
Museu d'Arts, Industries i Tradicions Populars, Barcelona

This votive painting was offered in thanks to San Ramón
Nonato, patron saint of midwives and of women who give
birth by caesarean section. Paintings such as these attest to
the faith of the times and people shown. In addition, they
provide valuable information on typical dress, furniture,
and medical crises.

María del Carmen Medina San Román

Votive Art: Miracles of Two Thousand Years

Concept and History

The concept of votive art refers directly to the existence of a relationship between mankind and the divinity: We call this relationship "religiosity." This cultural phenomenon should not be viewed from only the theological perspective, but also from psychological, anthropological, aesthetic, and sociological angles, within the framework of the culture of a people.

We consider votive art to be an artistic manifestation characterized by being dedicated to God, to the Virgin, or to a saint, in payment of a benefit received. This payment can be expressed in a multitude of ways, and in all facets of popular art, which Carvalho-Neto (1965) calls an "expression of the culture of the people with elements specific to artistic creation." If we apply this definition, then votive art begins to emerge with the first appearance of man, as the feeling of dependence in relation to a superior being has been a constant feature in the history of humanity.

In Spain, some of the first examples of votive art are the Celtic ex-votos found in Mérida (Badajoz): a collection of bone offerings, feminine figures with necklaces and incipient arms, with square heads and pedestals and spindle-shaped bodies. This type of small figure can also be found at other Celtiberian sites on the Spanish Meseta (plain); they are made of bronze and date from the fourth to the third century B.C. (Camón Aznar 1954). Offerings to the gods continued over time, and thousands of ex-votos accumulated in the places dedicated to a particular devotion. A series of these items dating from the fifth to the first century B.C. were found at

various sanctuaries: Cigarralejo, Cerro de los Santos, Llano de la Consolación, Elche, and Osuna, among others.

Two types of ex-votos appear at Cigarralejo: more than two hundred naturalistic representations of horses, in which it is clear that the offerer is presenting the god with an image of a specific horse, and eighteen schematic human figures. The ex-votos at the Cerro de los Santos and on the Llano de la Consolación, within the municipal district of Montealegre in the southwest of Albacete Province, are solemn figures in a humble attitude of making an offering before the presence of the divinity. There are over three hundred such figures, in some cases in the form of a couple, both offering a single vase. The Elche (Murcia) finds, centered around the Lady of Elche, can be considered votive art according to the theory of Camón Aznar (1954), who believes the figures represent a person making a religious offering.

In the sanctuary of La Serreta, at Alcoy (Valencia), remains have been found of a temple containing very rough ex-votos in terra-cotta; they are almost grotesque, with a Punic feel, and are of uncertain date.

The strong religious impulse of the Hispanic peoples is manifested in the collection of over four thousand bronze ex-votos displayed in the Museo Arqueológico Nacional in Madrid. These ex-votos were not intended as representations but rather as figurative allusions by the believers, a characteristic common to the ex-votos still being offered today in our sanctuaries. They are crude figures, of a strictly religious character, with no intended aesthetic value. To summarize, bronze

ex-votos from before the fourth century are considered Celtic: They were cast using the lost-wax technique, in which a figure is shaped in wax and coated with a layer of clay to form a mold with a hole into which the hot bronze is poured as the wax melts. When the metal cools the clay is removed, and the metal figure appears; the roughly indicated features are reworked and any depressions erased.

At the sanctuary of La Luz, in Murcia, free-style ex-votos from the third and second centuries B.C. have been found. In a temple dating to the fifth century B.C., at the sanctuary of Collado de los Jardines in Sierra Morena, some tiny and very simple ex-votos were discovered. And at Castellar de Santisteban (Jaén), on a hill some sixty meters square, a deposit of ex-votos was found near two springs. Over fifteen hundred items were discovered, their design varying depending on the economic situation of the faithful. They ranged from carefully modeled pieces to a simple nail considered to be an anthropomorphic offering. Some archaeologists date this site between the fifth century B.C. and the later Roman Empire.

What all ex-votos of this type have in common is that they were offered to a specific divinity, as a gesture of hope in the face of adversity or of gratitude for a favorable response by the divinity. This applies to the small bronze offerings as well as the large stone sculptures, whose generic characteristics express the symbolism of what is offered.

By the seventh century A.D. the Hispano-Visigoths were on the scene. Their contribution to votive art consists mainly of a crown offered to Saint Felix, a martyr from Gerona, according to Saint Julian's narration in his History of Wan Wa. Other examples of this type of offering include the crown and votive lamps in the treasures of Guarrazar (Toledo) and Torredonjimeno (Córdoba). Both cases are an expression of votive art that cannot, perhaps, be considered among the popular arts with regard to their manufacture, as they are highly elaborate works of great richness. However they are offerings to the divinity as a request for protection, which situates them in this category.

Northern Spain in the seventh century A.D.

had specific cultural characteristics, mainly due to the area's geographical structure. The art known as pre-Romanesque appeared in Asturias, with precious metalwork that seems to have a connection with the artistic currents of northern Italy and the Franco-Carolingians. It is a sumptuary art manifested in such works as the Cross of the Angels, made in 808 on the orders of King Alfonso II, with an inscription stating, ". . . MAY THIS THAT IS OFFERED BY DON ALFONSO, humble servant of Christ, remain in honor of God. With this sign, he shall vanquish the enemy." In the year 874 another cross was donated by Alfonso III to Santiago in Galicia; the Cross of Victory, which dates from 890, was given by the same king and is still kept in the Cathedral of Oviedo.

The period from the eleventh to the fifteenth century witnessed a flourishing of art in ivory, which was brought to Spain by the Arabs and redirected from the workshops of Córdoba to the rest of Spain. Though no items specifically classified as votive offerings have been preserved, it is quite probable that they existed, particularly because the religious orders and pilgrimages were flourishing at this time and both these elements were of major importance for the existence of ex-votos.

We have literary evidence that from the Middle Ages onward the wax ex-voto was quite common in Christian societies. The *Cantigas* of Alfonso X speak of the offering of a goshawk made of wax to Santa María de Sirga (Saint Mary of Sirga) in Palencia Province, and of others relating to Santa María de Salas (Saint Mary of Salas). In later years, texts of Lope de Vega refer to this type of ex-voto in a more or less jocular fashion:

> It comes closer. If I can escape
> from this gentle beast
> I WILL GIVE A WAX GALICIAN
> to the Virgin of the Pillar
> (*La boda entre dos maridos.* ACT I)

The oldest dated ex-voto we have been able to find is in Cataluña; it dates from 1323 and is dedicated by a mariner from Mallorca to the Virgen de Montserrat (Virgin of Montserrat).

From the fourteenth century onward, votive art appears very frequently, now definitively in the form of ex-votos. Those of a "pictorial" nature

especially were most widespread in the eighteenth and nineteenth centuries. Nowadays, when popular religious culture still continues, though to a lesser degree, we continue to have this form of relationship with the supernatural being.

Votive art appears across Spain throughout each civilization that has existed in the country. Now we shall examine how votive art manifests itself as popular art, that is, in ex-votos.

The Ex-voto as a Popular Manifestation of Votive Art

The word *ex-voto* is from the Latin, meaning "according to a vow"; it designates an article offered to God, to the Virgin, or to the saints as the result of a promise for a favor received. In other words, it is a promise materialized in an object. To be classified as such, an ex-voto has to possess the following differentiating features: Above all, it has to be public, to announce the favor received, or the beneficial action worked by a supernatural being. The texts that often accompany the votive panels are expressed in such terms as "to commemorate," "in thanksgiving I offered to place this memorial," "this picture testifies to what happened," and so on, but the intention to publicize the offering is already implicit in the use to which it is destined. The offerings are designed to be displayed on the altars and in the antechambers of the benefactors' images, as well as on the walls and ceilings of chapels and sanctuaries, so that all devotees may recognize the miraculous actions.

The ex-voto should also have some relationship with the person who has received the favor and the portentous event that motivates it. Thus, the ex-voto is a description of the miraculous deed and the personal details of the beneficiary, or a replica of the limb or part of the body healed, or an object belonging to the offerer, or even a portrait of the beneficiary. In any case, the votive offering has a representational character that differentiates it from monetary offerings or other types, such as oil lamps, candles, and especially, those sacrificial gifts destined to be consumed. Thus follows the third characteristic, which is the desire for permanence, for perpetual announcement of the supernatural powers of a specific image.

Therefore, an ex-voto is any object offered publicly to a supernatural being as a response to a favor received, the giving of which was promised beforehand. The gift always has a close relationship with the person and/or event. As such, there is an enormous diversity of ex-votos: replicas of organs and limbs in tin, silver, or wax, made industrially or by a craftsman; orthopedic equipment and prostheses; objects of personal use such as clothing, eyeglasses, or walking sticks; parts of the person's own body after they were removed; photographs, letters, pictures; and any object related to the situation motivating the offering. For the mariner, a miniature of the boat in which he feared he would drown (some captains have offered the figurehead from the bowsprit, or the sails), for the craftsman the tool that injured him, for the prisoner the chains that deprived him of liberty, for the driver the wheel of a car he was driving, for the soldier a piece of uniform, for the bride the bridal gown; the list is as extensive as human activity itself.

The promise arises from the being with the need, is directed to the divinity, and concludes in the human being who will fulfill the promise once the requested favor has been received. Fulfillment of the promise is ensured by socially admitted sanctions of a natural or supernatural type. In this way an attempt is made to attract attention and exercise influence on the one with the power to divert or direct human events, that is to say God, the Virgin, or the saints. The relationship might be broken, though possibly only temporarily, if the favor requested is not received. The action of the supernatural beings expected by mankind is frequently of a miraculous nature; therefore, it exceeds the limit of human capacity and annuls the logical development of natural laws. Acceptance of an event as miraculous is subjective and does not imply that the Church recognizes it as such.

The material nature of ex-votos and, therefore, the possibility of their permanence over time, allows them to fulfill the function of a link between generations. Many votive offerings are made of materials that in normal circumstances can survive for several centuries. This permanence gives them historic and cultural value, insofar as they reflect and symbolize

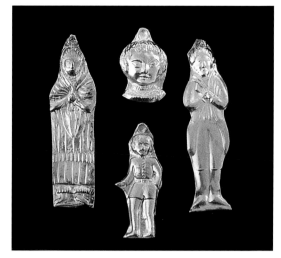

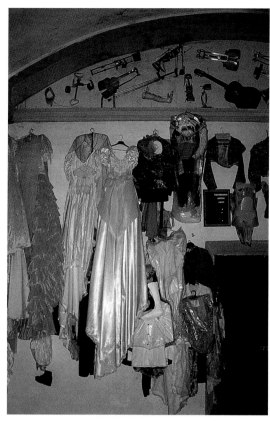

FIGURE 15 (left)
Silver Votive Offerings,
c. 1995, Andalucía, Spain

FIGURE 16 (right)
Votive Offerings, 20th c.,
Sanctuary of Our Lady of
Consolation, Utrera, Spain

attitudes, events, and customs of human groups past and present. Ex-votos are particularly valuable as sources of knowledge for a culture's beliefs and values, though they are a source of knowledge (and in some cases, the only one) about the material culture as well.

For purposes of their evaluation as a historical and cultural source, ex-votos can be classified into two types:

Narrative. Pictures or documents patently showing the relationship between the beneficiary and the sacred symbol.

Symbolic. Objects belonging to the person who offers them (hair, suits of clothing, etc.) or representations in different materials (mostly metal) of limbs of the body on which the miracle was performed. These objects have a symbolic value linking the offerer to the gift; by offering one of these objects to the image, the superiority of the sacred symbol is recognized and, at the same time, a reciprocal relationship is sought: give-receive-return.

The types of ex-voto still to be found today in Spanish chapels, sanctuaries, and churches may be grouped into the following categories:

Industrial ex-votos. Known in some areas as *milagritos* (little miracles), these ex-votos reproduce the part of the body affected by the miracle. They are generally made of wax or thin die-cast metal sheets (fig. 15). They are usually 4–6 inches long, with a ring on one end for hanging. Sometimes they carry a text identifying them with the donor.

Objects directly related to the malady to be cured. These can include all types of orthopedic equipment: crutches, collars, and so forth. They are displayed in the "room of the miracles." Often they are accompanied by a piece of paper with a handwritten explanation of the motive for the donation. Generally, the preserved ex-votos of this type are very recent.

Personal objects and objects from the donor's body. The most common offerings in this category are suits of clothing, particularly those related to rites of passage for which special protection is requested (fig. 16).

Pictorial ex-votos. These describe situations in life, in which the subject believes divine intervention to be essential for a favorable resolution of the problem. Therefore, they tend to reflect customs, furnishings, power structures, and sociological situations of the historical period when these events occurred (fig. 17).

The most commonly used technique for painted ex-votos is oil on canvas or wood panel. Also found are watercolor on paper and painting

on glass. Toward the middle of the nineteenth century, as religious prints became more widespread, the left side of pictorial ex-votos usually had a disclaimer from the artist, declaring his unworthiness to create the image.

The subjects are illnesses and accidents of all types, and a variety of life situations. Cases of assistance to women during childbirth are frequent, as are assorted illnesses, converting the ex-voto into a source of information on sicknesses of the period, which in some cases can be confirmed from historical references. The highest percentage deal with unexplained illnesses, or those specific to the place or time, such as *tabardillo,* now known as sunstroke.

The historical, ethnographic, and anthropological value of votive painting is considerable, insofar as it gives witness to daily events. The ex-voto painter bases his work on the information provided by the donor. Thus, when inventing the context he reflects whatever is most characteristic of the moment, in terms of furnishings, clothes, situations, power structure, and so on, providing a record of general events on the basis of one particular happening.

Power structure is sometimes reflected, particularly as it refers to the religious power to which human efforts are subjected. The priest is shown in his vestments for administering the sacraments; he is close to the physician and expresses the donor's lack of confidence in the latter. The relationship of dependence with respect to the supernatural being manifested in the sacred symbol is clear in view of the overwhelming size of the sacred figure in comparison to all the other figures. Social structures are differentiated not only by paintings of interiors, but also in the texts, which in the case of donors with a high social position do not as a rule specify the malady, as it was often something considered "shameful." Ninety percent of the time the intermediary is a woman. Men usually appear as beneficiaries but may be intermediaries in cases where the request is made on behalf of children.

Present-Day Geographical Distribution

The attention given in recent decades to studies of popular religiosity has brought to light a large number of sanctuaries and chapels in which ex-votos are still preserved, despite the ongoing disappearance of this example of popular religiosity, particularly since the 1940s. The destruction

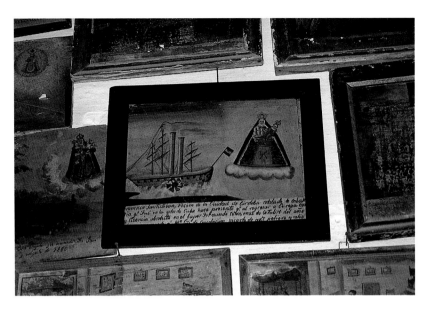

FIGURE 17
Votive Painting, 19th c., Sanctuary of Our Lady of Consolation, Utrera, Spain

and chaos wrought by the Spanish Civil War, followed some years later by the disdain of one sector of the Church toward this manifestation of popular religiosity, have led to the disappearance of entire collections of ex-votos across the length and breadth of Spain. Nevertheless, some places with a great ex-voto tradition remain. We list some of them below.

ANDALUCÍA

Ex-votos in Andalucía were studied extensively by Prof. Rodríguez Becerra, who in turn has encouraged the study of this subject through the Fundación Machado. In 1980 he published, jointly with Vázquez Soto, a study considered basic to understanding Andalusian ex-votos. In recent years more studies have been published on this subject, among which those of J. Cobo and F. Luque in the province of Córdoba stand out.

In the present day, many sanctuaries and chapels preserve ex-votos, which vary considerably in typology. In some locations, such as the Sanctuary of the Virgen de Consolación (Virgin of Consolation) at Utrera (Sevilla), large collections of pictorial ex-votos exist. Below we mention some of the holy places where ex-votos are still kept, without attempting to provide an exhaustive list.

Province of Almería: Albox, Virgen del Saliente; Gador, Nuestra Señora de Gador; Olula del Río, Virgen de los Dolores; Vélez Rubio, Cristo de la Yedra; and Ugíjar, Virgen del Martirio.

Province of Cádiz: Chipiona, Sanctuary of the Virgen de Regla; Alcalá de los Gazules, Nuestra Señora de los Santos; Trebujena, Virgen de Palomares; and Olvera, Virgen de los Remedios.

Province of Córdoba: The oldest ex-voto in existence here dates from 1553 and is dedicated to the Virgen de la Fuensanta. Córdoba, Santo Domingo de Scala Coeli, Nuestra Señora de Linares, and Virgen de la Fuensanta; Espiel, Virgen de la Estrella; Obejo, San Benito; Villanueva del Duque, Virgen de Guía; Dos Torres, Santo Cristo (almost two hundred wax ex-votos); Villa del Río, Virgen de la Estrella; Santaella, Nuestra Señora del Valle; Carcabuey, Virgen del Castillo; and Cabra, Virgen de la Sierra.

Province of Granada: Granada, Virgen de las Angustias and Cristo del Cementerio; and Valle del Zalabí, Virgen del Valle.

Province of Huelva: Almonte, Virgen del Rocío; Manzanilla, Virgen del Valle; Villalbadel Alcor, Santa Agueda; and Beas, Virgen de Clarines.

Province of Jaén: Jaén, Cristo del Calvario; Baeza, Cristo de la Yedra; and Andújar, Virgen de la Cabeza.

Province of Málaga: Archidona, Virgen de Gracia; and Mijas, Virgen de la Peña.

Province of Sevilla: Marchena, Jesús Nazareno; Castilblanco de los Arroyos, San Benito; Lora del Río, Virgen de Setefilla; Sevilla, El Salvador; Utrera, Virgen de Consolación; Estepa, Virgen de los Almendros; and Valencina, Cristo de Torrijos.

These are some examples of the great wealth of ex-votos existing in the sanctuaries and chapels of Andalucía. Despite losses, in most of the chapels housing the saints and virgins honored as patrons of the different districts there are some ex-votos of varied typology.

ARAGÓN

Specialists such as Ansón Navarro have studied the pictorial ex-voto in particular in this autonomous community. These are generally small pictures, oil paintings on panels that follow the general lines of this category of votive art. Mention may be made of those existing at Caminreal (Teruel) in the chapel of the Virgen de las Cuevas (Virgin of the Caves); at Blancas (Teruel), chapel of the Virgen de la Carrasca (Virgin of Carrasca); at Yebra de Basa, Santa Orosia (Saint Orosia); at Albaracín (Teruel), chapel of the Santo Cristo de la Vega (Blessed Christ of the Lowlands); at Egea de los Caballeros (Zaragoza), where in 1804 the painter Luis Muñoz painted four large canvases decorating the side walls of the Capilla del Voto (Chapel of the Vow); at Mezalocha (Zaragoza), the chapel of San Antonio de Padua (Saint Anthony of Padua); at Acered (Zaragoza), chapel of the Virgen de Semón (Virgin of Semón); at Lanzuela (Teruel), the sanctuaries of Nuestra Señora de Cillas (Our Lady of Cillas) and Nuestra Señora de Salas (Our Lady of Salas), close to the city of Huesca, and many others.

There is documentary evidence that León Abadías, a nineteenth-century ex-voto painter, produced a small reredos in honor of Santa Orosia (Saint Orosia) and another for Santa Elena (Saint Helen). The former is now in the custody of the Hermandad de Romeros (Pilgrims' Brotherhood) of Jaca.

The wax ex-voto is nowadays not very common. Some interesting descriptions were written by Father Facci in the eighteenth century, and by Rafael Leante in the nineteenth of the wax ex-votos at the Virgen de Ubieto (Virgin of Ubieto).

ASTURIAS

A feature of Asturian ex-votos is that most are made of wax, while pictorial ones are rare and metal offerings practically unknown. In some cases instruments are preserved, as are personal objects such as military caps, crutches, and so on. As this is cattle country, ex-votos in the shape of animals (particularly cows) are common. In Cangas de Narcea there is currently a shop where ex-votos are made to order. Sanctuaries still preserving this type of demonstration of popular religiosity include the Sanctuary of the Virgen de Acebo (Virgin of Acebo) in the *concejo* (district) of Cangas de Narcea, which contains possibly the most complete collection of ex-votos; the

Sanctuary of the Virgen de Pastur (Virgin of Pastur) at Llanes, though in recent times its collection has practically disappeared; the Sanctuary of the Cristo de Candés (Christ of Candés) in the concejo of Cereño; the Sanctuary of the Virgen de Llugar (Virgin of Llugar) at Villaviciosa; the Sanctuary of the Virgen de la Providencia (Virgin of Providence) in Gijón; and others.

There are a large number of chapels and sanctuaries where we know that ex-votos could once be found. However, nowadays few holy places still preserve them.

CASTILLA–LA MANCHA

The few studies undertaken on ex-votos in this region make us suspect that many more exist than is known. Those worthy of mention include, in the province of Guadalajara, the Sanctuary of the Virgen de la Salud (Virgin of Health) at Barbatona; in Toledo, the different ex-votos in the retrochoir of the Cathedral and the Sanctuary of El Cristo (The Christ) at Urdas; in Ciudad Real Province, in addition to the Virgen de Alarcos (Virgin of Alarcos) and the Virgen de la Encarnación (Virgin of the Incarnation) at Carrión de Calatrava, and the Monastery of Discalced Carmelites of Santa Teresa at Malagón (with wax ex-votos), special mention should be made of Daimiel, where numerous ex-votos have been found at Nuestra Señora de las Cruces (Our Lady of the Crosses), patron of the town. In the antechamber of the Virgin, photographic ex-votos are displayed on two walls, while a third has personal objects and wax representations of different body parts. Characteristic of this sanctuary is the ex-voto known as *el pináculo* (the pinnacle): a conical cylinder some five feet high, along which appear twenty-one lines on alternate bands, with different flags. Each line is marked with studs, between which appear in ascending order Nuestra Señora de las Cruces (Our Lady of the Crosses), Nuestro Padre Jesús Nazareno (Our Father Jesus of Nazareth), the Virgen de los Dolores, and Santa Gema (Saint Gemma). Beside them are photographs of the townspeople of all ages, sexes, and social stations. The ex-voto symbolizes the entire life of the town offered up to its patron. In the province of Albacete, we have evidence of the existence, at least in earlier

times, of ex-votos made of bread, but possibly due to the difficulty of preserving them, we have not been able to locate any examples.

CASTILLA–LEÓN

The general comments in the preceding section also apply to this region. In most places people say that ex-votos used to exist, but their existence cannot be documented. Regarding typology, pictorial ex-votos predominate, followed by objects of personal use. Parts of the human body also appear, particularly plaited hair, as do wax figures referring to the miracle produced and photographs of the donor.

In Zamora Province, pride of place goes to the Sanctuary of the Virgen Peregrina (Pilgrim's Virgin) of Donado, which is rich in wax ex-votos, and San Pedro de la Viña and Navianos de Valverde with the Sanctuary of the Virgen del Carmen, where many ex-votos are also to be found.

In the area of Astorga, pictorial ex-votos are abundant in Santiagonillas, Quintanilla, and Filiel. At Rabanal del Camino there are many wax ex-votos in the chapel of the Cristo de la Vera Cruz (Christ of the True Cross). In the Sanctuaries of Castrotierra and of La Merced (Mercy) at Priaranza de la Valduerna we can find many photographic ex-votos, not only from the present day but going back to the nineteenth century.

In the Bierzo district, the Sanctuary of La Quinta Angustia (The Fifth Anguish) and its narrative ex-votos are of great interest. In the Ribera del Duero, in Burgos Province, there is evidence that ex-votos once existed, mainly in chapels and sanctuaries, though nowadays they are not preserved. Isolated exceptions include the Virgen de los Olmos (Virgin of the Elms) in Quintana del Pidio, Nuestra Señora de la Vega (Our Lady of the Lowlands) in Roa de Duero, the Virgen del Prado (Virgin of the Meadow) in Villalba del Duero, Nuestra Señora de la Vega in San Juan del Monte, the Virgen del Juncal (Virgin of the Rushes) in Valdeande, and others. Oral testimony suggests that sometimes donations were made by persons occupying very prominent social positions, as in the case of the mantle presented by Queen Margarita to the Virgen de las

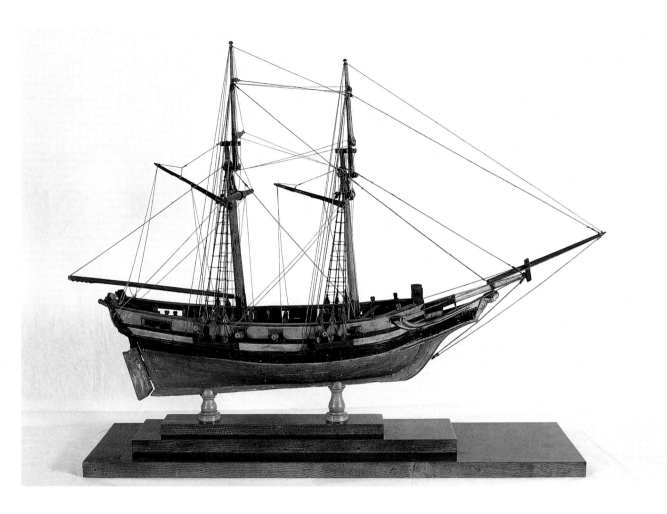

PLATE 52
Model Ship Ex-voto, late 18th c.
Cataluña, Spain
Polychromed wood, string, metal, 31 × 9 in. (78 × 23 cm)
Museu Marítim, Barcelona

Model boats such as this were made to be used as votive
offerings to thank a saint for rescue during storms at sea. In
chapels all over coastal Spain, ships similar to those shown
here hang from the ceilings of church naves or in nearby dis-
play rooms. One can see an excellent display of votive ships
hanging in the ancient chapel of Nuestra Señora de Vignet
(Our Lady of Vignet) in Sitges, south of Barcelona (fig. 2).
The Sitges boats range from seventeenth-century galleons
to oil tankers from the 1980s. In the shrine to Nuestra Señora
de la Barca (Our Lady of the Boat) in Galicia, votive boats
include a sporting sailboat from the 1990s.

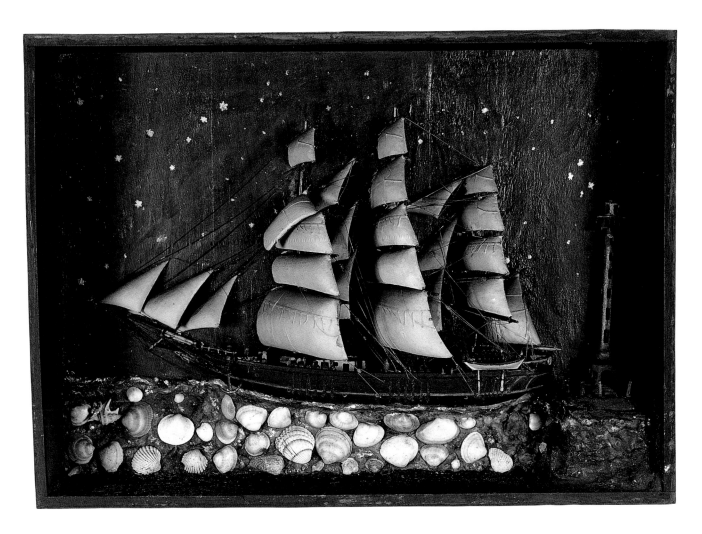

PLATE 53
Model Ship Ex-voto, 19th c.
Cataluña, Spain
Polychromed wood, cloth, shell, 22½ × 31 in. (57 × 79 cm)
Museu Marítim, Barcelona

This unusual model ship ex-voto is an assemblage of shells,
sailcloth, wood, and paint set against a starry sky.

Viñas (Virgin of the Vines), in thanks for a cure experienced by her son, Felipe IV. In other cases, the ex-votos reflected the piety of anonymous persons who wished to leave a testimony of their gratitude for the favor granted. Other places where ex-votos may be seen nowadays include: Santa Cruz de Salceda (Burgos), Villafranca del Bierzo (León), El Congosto (León), Valdejimena (Salamanca), Virgen del Compasco (Virgin of Compasco) at Aldeamayor de San Martín (Valladolid), Virgen de la Fuente (Virgin of the Fountain), Villalón (Valladolid), and Ecce Homo at Villagarcía de Campos.

Apart from many other places of worship which preserve their ex-votos, special mention should be made of the important Fontaneda Collection in the Castle of Ampudia, which contains a large number of expressions of popular religiosity from this area.

CATALUÑA

Ex-votos from Cataluña have been studied thoroughly by various experts (Amades [1952], Parés [1989], etc.) According to Parés, the oldest ex-voto preserved in Cataluña belongs to the Sanctuary of the Mare de Deu del Miracle (Mother of God of the Miracle) in the district of Solsona and dates from 1595. Unlike the situation in other parts of Spain, the tradition of ex-votos in Cataluña is not only based on oral testimonies, but also appears to be fully documented, as numerous registers of miracles are preserved in different sanctuaries, in addition to inventories in places of worship. Thus, written evidence refers to offerings to the Virgen de Montserrat in 1079, and to the votive lamp which in 1134 the lord of the castle of Montcada ordered burned in the chapel.

Regarding specific terminology, Amades (1952) distinguishes between *retaulons* (painted ex-votos) and *presentelles* (all others). Traditionally, ex-votos have also been called *taulets pintade,* and *miracles.* Most of the ex-votos that have been preserved are the pictorial type, and according to Parés number close on two thousand, spread across Cataluña. The general characteristics of ex-votos in this area are as follows:

➤ Most are pictorial or made of wax.

➤ They have little material value.

➤ Certain types predominate at specific chapels and sanctuaries: San José de la Montaña (Saint Joseph of the Mountain) and its metallic ex-votos, for example.

➤ They make frequent allusion to a saint, in addition to the Virgin: for example, San Ramón (Saint Raymond), San Antonio (Saint Anthony), San Narciso (Saint Narcissus), San José (Saint Joseph), San Miguel (Saint Michael).

A large number of marine ex-votos exist at the Sanctuary of the Mare de Deu de Vignet (Mother of God of Vignet) in Sitges, among others.

Museums specialize in various types of ex-votos: Museu Marés, Barcelona (metallic ex-votos); Museu d'Arts, Industries i Tradicions Populars, Barcelona (ex-votos from the Sanctuary of San Ramón Nonato at Portell); Museu Folklbric of Ripoll (wax ex-votos); Museu Municipal of Badalona; Museu d'Art of Girona; Museu Comarcal of Olot; Museu d'Art Modern of Barcelona; and the Museu Episcopal of Vic, among others.

Ex-votos are particularly to be found in the central-eastern area, in the districts of Alt Empordá, Garrotxa, Gironés, Ripollés, Selva, Osona, Maresme, Bages, Solsonés, Segarra, and Baix Camp.

Good collections of ex-votos are currently preserved at the Sanctuary of the Mare de Deu de Montserrat (Mother of God of Montserrat), Monistrol, Bages; Sanctuary of the Mare de Deu des Angels (Mother of God of the Angels), Sant Martí Vell; Sanctuary of the Mare de Deu del Camí (Mother of God of the Roads), Granyena de Segarra; Chapel of Nuestra Señora de Farnés (Our Lady of Farnés), Santa Coloma de Farnés; Sanctuary of El Miracle (The Miracle), Riner; Sanctuary of the Mare de Deu de la Misericordia, (Mother of God of Mercy), Canet de Mar; and the Sanctuary of Nuria.

VALENCIA

In the province of Valencia, the Chapel of the Virgen del Remedio at Utiel is a good exponent of the existence of ex-votos in this autonomous

community. It has an important room with an exhibition of all types of ex-votos: wax figures, crutches, costumes, plaits, and pictures, which represent popular devotion from at least the eighteenth century onward. Of particular note among the pictorial panels is one known as the ex-voto of the bulls. Dated 1783, it is nearly three feet high and represents an accident that took place in the bullring when the seating terraces collapsed and, miraculously, the bulls did not attack the people. Its ethnographic and historical value is considerable, as it situates the bullfight in this place since at least the late eighteenth century. The collection at this sanctuary is of great importance because of its state of conservation, which makes it possible to study specific data of the period when the ex-votos were painted, such as the clothing of the late nineteenth century shown in the so-called *exvoto del privado*.

In the northern part of Castellón Province, in the municipal district of Zorita, is Nuestra Señora de La Balma (Our Lady of La Balma), with wax ex-votos and some photographs. These ex-votos are given not only by people from the district, but also by those of the entire province and even neighboring Teruel: Iglesuela, Las Parras, Aguaviva, Castellote, Morella, and Chiva.

EXTREMADURA

Not all sanctuaries, chapels, and monasteries in Extremadura preserve this type of offering. This is due to a number of reasons including the presence or absence of consolidated brotherhoods, the attitude of the bishops, and the presence of religious orders. The *mudéjar* (Islamic-influenced) cloister of the Monastery of Nuestra Señora de Guadalupe in Cáceres Province preserves a large collection of paintings narrating miracles performed by the Virgin, though they are not really ex-votos since most of them were painted in the eighteenth century by Fray Juan de Santamaría. The artist painted the events in which some of the pilgrims to the sanctuary had participated or about which they had spoken. He took the subject matter for others from the medieval codices (fourteenth and fifteenth centuries) preserved in the monastic archives. Also in Cáceres Province, wax ex-votos are offered to the patron of the capital, the Virgen de las Montañas

(Virgin of the Mountains), and then regularly collected by the caretaker of the sanctuary. In the same province, in the Chapel of San Lázaro (Saint Lazarus), Trujillo, wax ex-votos hang in the entrance; ex-votos can also be found in Nuestra Señora de La Antigua (Our Lady of La Antigua) in Valverde de Burguillos and the Chapel of the Cristo de la Paz (Christ of Peace) in Santibañez el Bajo, among other places.

In Badajoz Province, some forty places still display ex-votos in chapels, sanctuaries, and parish churches. They include the Virgen de Carrión (Virgin of Carrión) in Albuquerque, where two ex-votos apparently by the same painter can be admired (they are in a sophisticated style, with careful perspective); the Virgen del Soterraño (Virgin of the Underground) at Barcarrota; Nuestra Señora del Ara (Our Lady of the Altar) at Fuente del Arco, where so-called bedroom ex-votos predominate, showing the sick person in bed accompanied by family members; Nuestra Señora de Piedraescrita (Our Lady of Piedraescrita) in Campanario; the Santísimo Cristo de la Teja (Most Blessed Christ of la Teja) in Segura de León; and Santa Eulalia in Mérida.

Two cases in particular, the multiple ex-voto of the Cristo del Humilladero (Christ of the Shrine) at Azuaga and the set of pictorial ex-votos of the Virgen de los Remedios (Virgin of Remedies) at Fregenal de la Sierra, are particularly noteworthy. The latter are located in a room of the *ermita* (hermitage chapel) known as *la hospedería* (the hospice), near a portrait gallery of local personalities. Of special interest in this set of nineteenth-century ex-votos are the ten pictures situated to the right and left on the walls of the hospice. All but two are oil paintings on canvas, one is painted on glass, and the other is painted on paper, with the figure of the Virgin usually in the upper left-hand corner, and all in a generally primitive style.

The Ermita del Cristo del Humilladero is now a parish church and preserves a small collection of ex-votos, six paintings and one engraving. All but one are hardly worth mentioning. This one is an unusually large panel (45 × 75 in.; 113 × 175 cm) with eighteen miraculous scenes arranged in three rows. All the scenes except the first three are ex-votos. The unitary conception

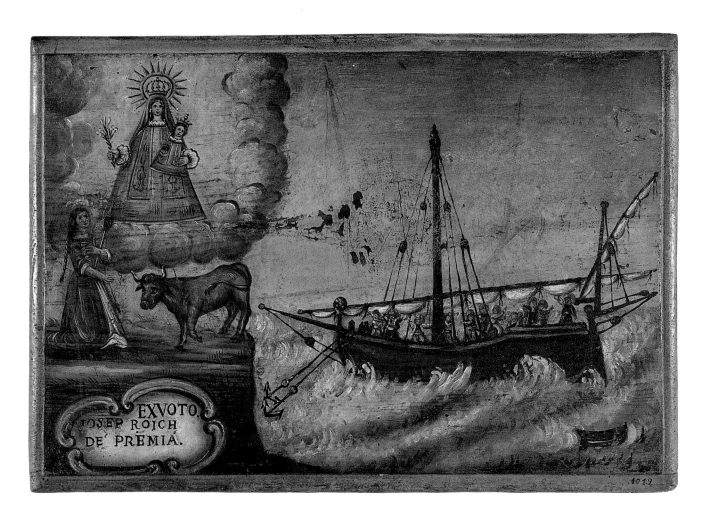

PLATE 54
*Maritime Votive Painting to Nuestra Señora de Cisa
(Our Lady of Cisa),* 19th c.
Cataluña, Spain
Oil on wood, 19 × 13 in. (49 × 33 cm)
Museu Marítim, Barcelona

Maritime votive paintings are found in most parts of coastal
Spain. This charming painting attests to the miraculous in-
tervention of Nuestra Señora de Cisa during a crisis at sea.

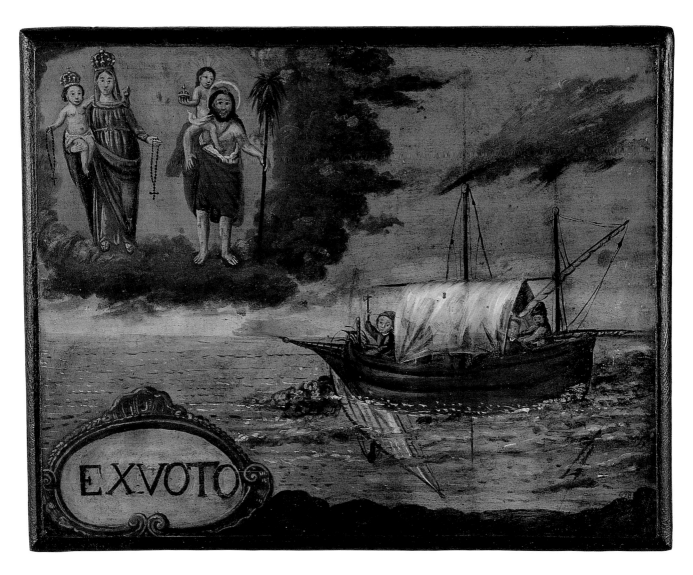

PLATE 55
Maritime Votive Painting to San Cristóbal (Saint Christopher)
and La Virgen (The Virgin), 19th c.
Cataluña, Spain
Oil on wood, 19 × 15 in. (48 × 38 cm)
Museu Marítim, Barcelona

This painting shows the miraculous intervention by
San Cristóbal and La Virgen, which ameliorated a crisis
at sea stemming from a broken mast.

of the picture and its style have led it to be considered a single piece, under the denomination of multiple ex-voto. Two chronological and artistic phases may be identified. The scenes are arranged more or less chronologically from 1739 to 1802; in each square a different person is shown, and the figure of Christ occupies a prominent position in a central semi-circle in the form of a canopy. In addition to its originality (research suggests it is one of a kind), it is equally exceptional in that it is not the result of a single will, but rather the product of a well-designed project to record the miracles performed by the Cristo del Humilladero. More of the ex-votos deal with accidents than with illness. With regard to its historical and ethnographic value, the work offers a good deal of valuable information about Azuaga—especially the daily life of its people—which would be difficult to find in other documents. However, the iconographic richness of the scenes is relatively poor compared to that of other series of ex-votos.

GALICIA

The study of ex-votos in the Autonomous Community of Galicia has been greatly encouraged in recent years, particularly by the Museo de Pontevedra, where the researcher José Fuentes is working on this subject.

Many places in this region are known to have ex-votos of all types. In some cases coffins appear as ex-votos, as in the case of Santa María de Ribarteme (Saint Mary of Ribarteme) in As Neves; Nuestra Señora de los Milagros del Monte Medio (Our Lady of the Miracles of Monte Medio) in Maceda; El Nazareno (The Nazarene) in Puebla del Caramiñal; and San Andrés de Teixido (Saint Andrew of Teixido) in Cedeira.

As this region has many kilometers of coastline, with a large population dedicated to fishing, ex-votos of model boats are numerous, as are items related to boats, such as rudders, sails, and so forth. This is the case with Nuestra Señora de Grela (Our Lady of Grela) in A Estrada; Santa Minia (Saint Minia) in Brios; Nuestra Señora del Remedio in Lira-Carnota; and San Juan (Saint John) de Espasante in Ortigueira, to name a few.

The wax ex-voto reflecting the cure of a part of the body is also well represented in the sanctuaries of Galicia and, indeed, throughout the north of Spain.

LA RIOJA

At Grañón, near Santo Domingo de la Calzada, ex-votos exist in the Chapel of the Virgen de Carrasquedo (Virgin of Carrasquedo), patron of the village: The oldest is dated 1673 and was offered by María de Aguilar from Laguardia, who was cured by the Virgin that year. There are several more, including one of a boy being cured in 1675, and one presented by Martín de Parabo and Magdalena de Segura after the latter was cured by the Virgin in 1679. There are references to other ex-votos of hair and wax, but these have disappeared. Ex-votos may also exist in different sanctuaries and chapels in this region, including San Estéban (Saint Stephen) in Canales de la Sierra, Santa Catalina (Saint Catherine) in Mansilla de la Sierra, Santa María de Soregana (Saint Mary of Soregana) in Ochandurri, and, particularly, the Sanctuary of the Virgen de Valvanera (Virgin of Valvanera), patron of La Rioja.

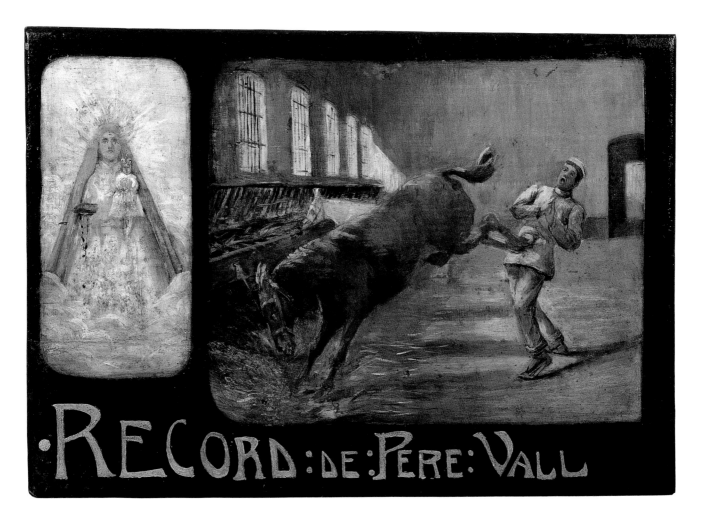

·RECORD : DE : PERE : VALL

PLATE 56
Ex-voto of Soldier Being Kicked by a Mule, late 19th c.
Cataluña, Spain
Oil on wood, 12½ × 18 in. (32 × 46 cm)
Museu d'Arts, Industries i Tradicions Populars, Barcelona

In this action-filled votive painting we see a uniformed man
probably regretting that he walked behind a mule. Appar-
ently, he was saved from serious injury by the miraculous
intervention of the Virgen del Rosario (Virgin of the
Rosary).

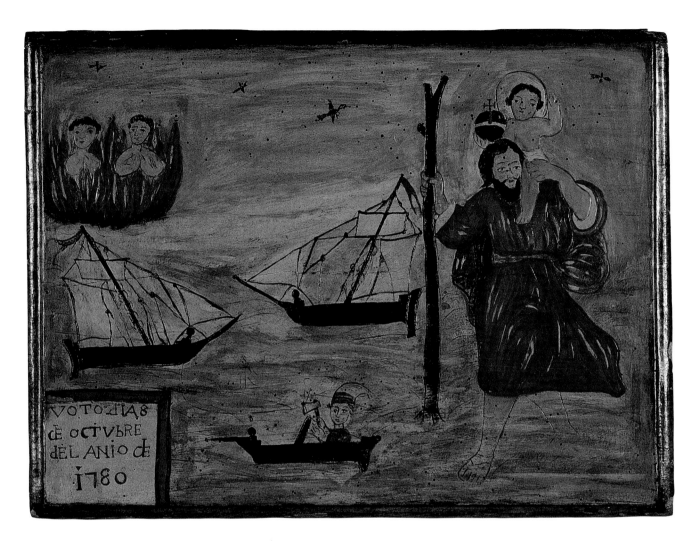

PLATE 57
Maritime Votive Painting to San Cristobal (Saint Christopher)
1780
Cataluña, Spain
Oil on wood, 16½ × 12 in. (42 × 31 cm)
Museu Marítim, Barcelona

San Cristobal is the patron saint of travelers throughout the
Catholic world and is still very popular in Spain. Here, a
man in a small boat is saved from death after his ship collides
with another. In the upper-left-hand corner of the painting
is a representation of souls in purgatory.

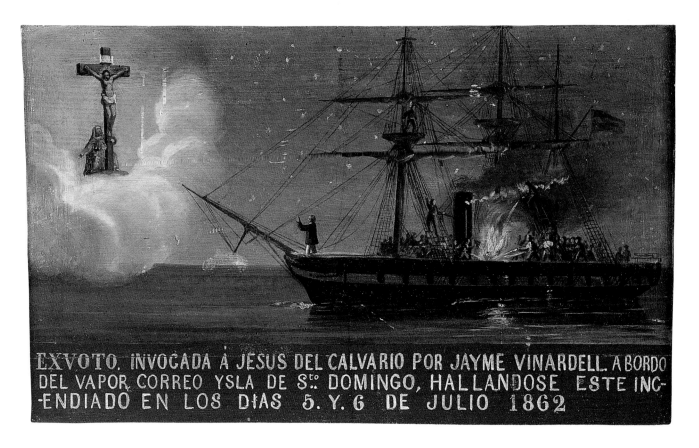

EXVOTO, INVOCADA À JESUS DEL CALVARIO POR JAYME VINARDELL, A BORDO DEL VAPOR, CORREO YSLA DE S.to DOMINGO, HALLANDOSE ESTE INC--ENDIADO EN LOS DIAS 5. Y. 6 DE JULIO 1862

PLATE 58
Maritime Votive Painting to El Señor del Calvario
(Lord of Calvary), 1862–63
Cataluña, Spain
Oil on wood, 23 × 15 in. (58 × 38 cm)
Museu Marítim, Barcelona

In this terrifying votive painting, we see a steam-driven mailboat ablaze off the coast of the Caribbean island of Santo Domingo. Kneeling on deck is a man appealing to El Señor del Calvario for help.

BIBLIOGRAPHY

Aguilár García, María Dolores. "Exvotos de pintura ingenua." *Baética*. Estudios de Arte, Geografía e Historia, no. 11 (1978):5–30. Facultad de Filosofía y Letras. Universidad de Málaga.

Alvarez Santalo, Carlos, María Jesús Buxo, and Salvador Rodríguez Becerra, eds. *La religiosidad popular,* 3 vols. Barcelona: Antropos–Fundación Machado, 1989.

Amades, Joan. *Els Ex-vots.* Barcelona: Editorial Orbis, 1952.

Amich Bert, Julián. *Mascarones de Proa y exvotos marineros.* Barcelona: Editorial Argos, 1949.

Ansón Navarro, Arturo. "Los exvotos pictóricos y su utilización como fuente de investigación." In *Actas de las II Jornadas.* Jaca, 1986.

Bakker, Nicolau. "Romerías: Interrogantes a partir de una encuesta." In *Religiosidad Popular* (Equipo Seladoc, eds.) Salamanca: Editorial Sígueme, 1976.

Camón Aznar, J. *Las artes y los pueblos de la España primitiva.* Madrid: Editorial Espasa Calpe, 1954.

Cano Herrera, M. "Exvotos y promesas en Castilla-León." In *La religiosidad popular,* vol. 3. Barcelona: Antropos–Fundación Machado, 1989.

Carvalho-Neto, Paolo de, *Arte Popular en Ecuador.* Quito: 1965.

Castillo Lucas, Antonio. "Exvotos pictóricos populares," *Arte Español* 22 (1958):211–14.

Cavestany, J. "Exvotos náuticos," *Arte Español* 8 (1926): 211–14.

Centro Provincial de Etnología y Folklore Leonés. *Catálogo exposición exvotos.* Astorga, 1991.

Christian, William. "De los Santos a María: Panorama de las devociones a santuarios españoles desde el principio de la Edad Media hasta nuestros días." In *Temas de Antropología Española* (C. Lisón, ed.) Madrid: Akal Editor, 1976.

Cobo Ruíz de Adana, J., and F. Luque Romero. *Exvotos de Córdoba.* Córdoba: Fundación Machado and Diputación Provincial de Córdoba, 1990.

Equipo Seladoc. *Religiosidad Popular.* Salamanca: Editorial Sígueme, 1976.

García Román, C. "Religiosidad popular: exvotos y subastas." In *La religiosidad popular,* vol 3. Barcelona: Antropos–Fundación Machado, 1989.

Gaya Nuño, J. Antonio. "Sobre los exvotos." *Diario de Barcelona,* 15 August 1964.

Gómez Teruel, José María. *El convento de las nieves.* Jábega. Revista de la Diputación Provincial de Málaga (1975) no. 11, pp. 57–59.

Llompart, Gabriel. "Las tablillas votivas del Puig Pollensa (Mallorca)." *Revista Dialectología y Tradiciones Populares* 28 (1972) nos. 1 and 2, pp. 39–54.

López Pérez, Manuel. *La ermita del Calvario, atalaya de espiritualidad.* Boletín del Instituto de Estudios Giennenses 23 (1977) no. 92, pp. 87–110.

Maldonado, Luis. *Religiosidad Popular.* Madrid: Editorial Cristiandad, 1976.

Montoto y Rutenstrauch, Luis. *Desde Chipiona (artículos de verano),* vol. 4 of the *Obras completas.* Sevilla, 1914.

Parés, F. "Exvotos pintados de Cataluña." In *La religiosidad popular,* vol. 3. Barcelona: Antropos–Fundación Machado, 1989.

Piñuel y Raigada, José Luis. "Un análisis de contenido de devociones populares." *Revista Española de Investigaciones Sociológicas* (1978) no. 3. Centro de Investigaciones Sociológicas, Madrid.

Rodríguez Becerra, Salvador, and José María Vázquez Soto. *Exvotos de Andalucía.* Sevilla: Editorial Argantonio, 1980.

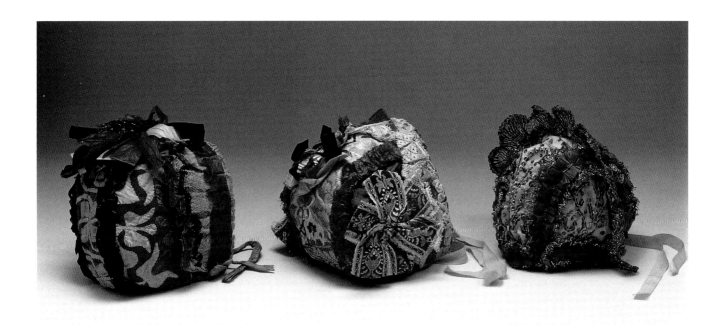

PLATE 59
Three Christening Caps, 18th c.
Toledo, Spain
Silk, cotton, lace
Museo Nacional de Antropología, Madrid

Folk art often plays an important role in a community's rites of passage. Throughout Spain, baptism is an important occasion in the life cycle, and folk art reinforces its importance. Ornate bottles for holy water, special foods for the feast to follow, and special clothing worn by the child are examples of this type of ceremonial folk art. These christening caps were probably made and presented to the child by his or her baptismal godparents.

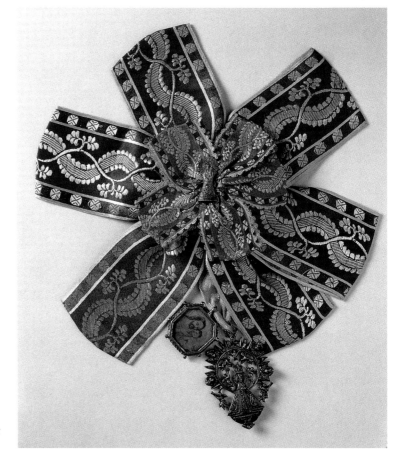

PLATE 60
Bridal Bow with Reliquary and Medallions, 18th c.
Toledo, Spain
Silk, silver, glass
Museo Nacional de Antropología, Madrid

This bow was worn by a bride at her wedding and is another example of how folk art reinforces rites of passage.

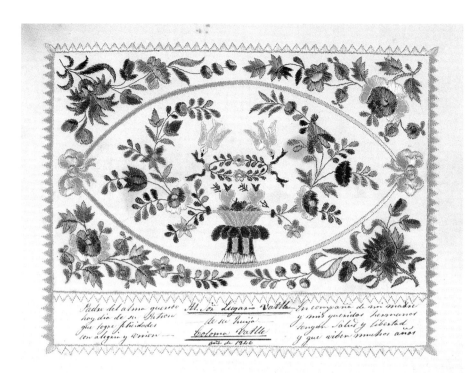

PLATE 61
Coloma Battle (Vattle), n.d.
Greeting Cards, 1843, 1846
Northeastern Spain
Embroidered and painted
paper, 18 × 14 in. (45 × 35 cm)
Peter P. Cecere, Reston,
Virginia

Birthday celebrations are
important rites of passage, as
these cards attest. These two
greeting cards were crafted
to honor the saint's day of
the artist's father (top) and
another person close to her
(below). Work similar to
this was often done by nuns
in convents, but these cards
probably were made by
secular hands.

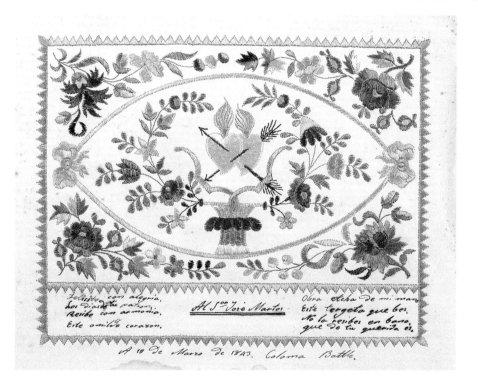

PLATE 62
Burial Plaque, 1834
Toledo, Spain
Glazed earthenware
7½ × 7½ in. (19 × 18.5 cm)
San Antonio Museum of Art

Throughout Spain, folk art is used to bolster the final stage in the life cycle: death. Paraphernalia associated with death and burial, such as mourning attire, candles, floral arrangements, and other things, demonstrate the grieving process through visual symbols. This majolica-type ceramic burial plaque is typical of those popular in various parts of Spain during the nineteenth century. The inscription reads, "Here lies Doña Juana Pascual, wife of Don José Ramón who valiantly died on the 13th day of August, 1834. RIP."

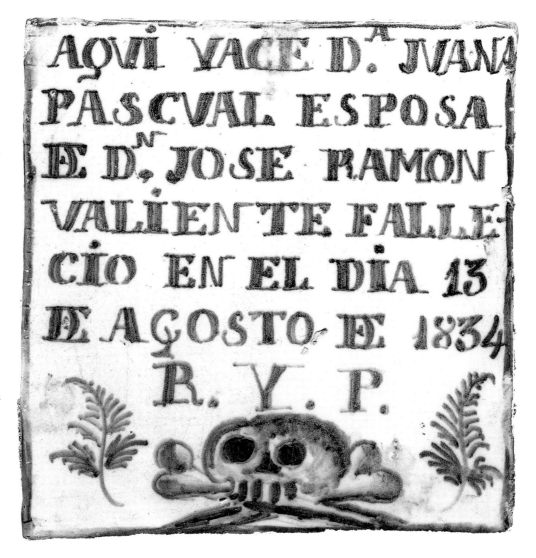

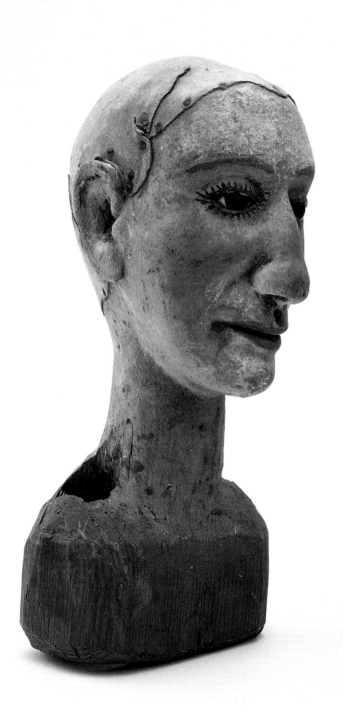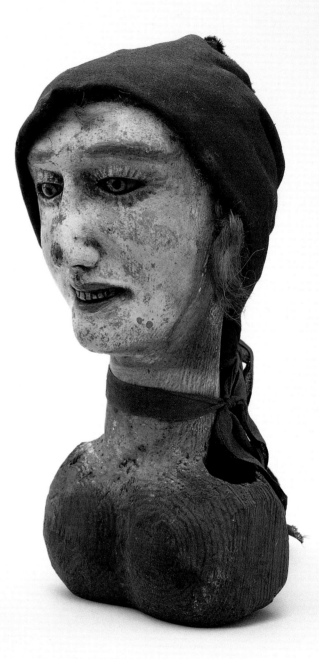

Stanley Brandes

Popular Performance in Traditional Spain

To speak of popular performance, whether in Spain or elsewhere, is to invoke the widest possible range of regularized social behavior, everything from meals to Mass. According to some theorists, all human interaction is performative in the sense that we are constantly acting in conformity with the image that we wish to project or that others impose upon us. For our purposes, however, it is useful to limit the concept of performance to self-conscious behavior with a clear theatrical component, that is, that distinguishes between actors and audience. Moreover, these performances are delineated in time and space; they take place at a given moment and in a given locale, both usually announced in advance.

Applying even this relatively limited sense of performance, traditional Spain provides a rich variety of religious ritual and popular theater. A basic distinction must be drawn, however, between two fundamentally different types of popular performance: religious performance, endowed with sacred significance, and secular performance, with no necessary supernatural meaning or consequence. Between the two extremes falls the vast majority of popular performances in traditional Spain, including those which have no sacred significance but are nonetheless associated with key festivals in the Catholic liturgy. Spain has been an overwhelmingly Catholic country for centuries. It is not surprising, then, that the bulk of ritual life, including both sacred and secular rituals, has centered around the celebration of the abundant religious holidays which punctuate the yearly calendar. It is these holidays, above all, which provide occasions for Spanish popular performance, although,

as explained below, there are popular theatrical performances that have no religious associations whatsoever.

In this brief overview, we consider an example from each major category: first, secular performance; second, performance that straddles the line between the two extremes in that it is devoid of intrinsic religious meaning and yet is clearly associated with the Catholic ceremonial calendar; and finally, sacred performance.

Secular Popular Performance: *Juegos de Cortijo*

Throughout Andalucía, which comprises the eight southernmost provinces of Spain, festive occasions were traditionally accompanied by brief skits, known as *juegos de cortijo* (farmhouse games) or simply as *los juegos* (the games). These skits were performed exclusively by and for poorly educated, working-class people in agricultural towns and villages. Whenever there was a joyful gathering, whether for a christening, wedding, or the annual family pig slaughter, juegos were performed as a form of popular entertainment. They were never planned or rehearsed. Nonetheless, they formed a predictable and integral part of life-cycle festivities and other happy occasions.

Juegos were also performed on the final day of harvest. In the province of Jaén, for example, the employer would provide food and drink on the last day of the olive harvest for a celebration known as the *botijuela,* an event sponsored by grove owners. Because of rising labor costs, the botijuela is now a thing of the past. The disappearance of the botijuela, along with a rise in

PLATE 63
Hand Puppets, 19th c.
Cataluña, Spain
Polychromed wood,
human hair, cloth, glass
H. 10 in. (25 cm)
Peter P. Cecere, Reston,
Virginia

Puppets and marionettes have been popular in Spain since the Middle Ages. Covarrubias's *Tesoro de la lengua castellana* (1611) mentions that puppet shows were held on little stages with special sound effects. Frequently, they were performed in small villages by itinerant puppeteers. During the fifteenth and sixteenth centuries, puppet shows were used to teach biblical stories and to instruct on moral matters. The identity of the maker of these two puppets is unknown, but he or she was obviously an artist of considerable talent.

worldliness and sophistication throughout the Andalusian countryside, have contributed to the nearly complete obliteration of juegos de cortijo as a form of popular theater. The juegos are now a distant memory. "Men dressed up in ridiculous costumes and made fools of themselves," stated one Andalusian who was asked for his recollections of this form of popular theater. "That's all there was to it."

It is significant that the skits are termed games, for they, like most folk drama, may be viewed as a form of play. Johan Huizinga's classic conception of play, as expressed in *Homo Ludens,* can be applied to the juegos in that they were formed voluntarily within distinct spatial and temporal boundaries; in other words, they could be initiated or suspended at will.[1] They were unserious in goals and intent. In fact, they were meant to be humorous, and yet they were seriously executed. Like all play forms, too, the skits existed independent of the immediate satisfaction of biological wants or needs. They were not concerned with the moral issues of truth and falsehood, good and evil, or vice and virtue; but in their day they were enchanting, captivating, and absorbing, probably because they dramatized issues that were of immediate psychological and cultural concern to audience and actors alike.

Juegos de cortijo were exclusively a male dramatic form. Neither women nor children were directly involved as actors. However, as members of the audience, they could be drawn unknowingly into the show. As folk drama expert Arcadio de Larrea Palacín declares, "The distinctive thing about folk theater consists in its intention to convert the audience into actors, to make it participate in the action."[2] In the case of Andalusian juegos de cortijo, not only did the audience remain ignorant of the potential role they would play in the skits once they began, but the actors also found themselves, on occasion, participating in dramatic actions that they could never have predicted. These skits were temporally and spatially discrete; but in most cases it would be difficult to define clearly who was the actor and who the audience. In fact, it has been said that the point of these skits—their ultimate goal—was to perpetuate a hoax. They incorporated practical jokes leveled against one or more

spectators, who were immediately converted into actors. In some skits, the entire audience became victimized and was thereby drawn unknowingly and spontaneously into the drama.[3]

The skits themselves typically began with a slapstick prelude, usually a risqué sequence of humorous insults executed by a pair of actors and designed to call to attention all the people present. The prelude framed the action and announced that the play was about to begin. One of the most famous skits in the province of Jaén, for example, was called *La Zorra* (The Fox). It began exactly as the prelude ended, that is, with six men's caps, symbolizing hens, placed on the ground. One of the two actors leaves the scene. The other, playing the role of a guard, remains. The guard begins to watch over the hens, but within a few seconds becomes distracted, looking in the opposite direction and periodically nodding off. At this point, a man dressed as the fox —he wears *alpargatas* (esparto-grass sandals) on his ears and a long cord as a tail—enters and steals off with one of the caps. The owner of the hens enters the scene and asks the guard why one of his fowls is missing. "She's just laying eggs," responds the guard. With this, the owner cautions, "You'd better take good care of her. If not, the fox will get her."

This action is repeated four more times. On each occasion a "hen" is removed and the guard invents an excuse to explain the disappearance. When only one cap remains on the ground, the guard declares emphatically, "Now, I have to catch that fox because she's robbing all the hens. What will remain for me to show the owner?" The fox then appears, the guard pretends to shoot her, and she falls to the ground. To end the skit, the guard announces, "Va. La zorra está mata'o. El juego ha termina'o" ([There] you go. The fox is killed. The skit is over).

A second popular skit also portrayed theft as its main theme. As with *The Fox,* it begins with two men speaking in an agitated tone of voice:

CHARACTER A: *¡Este hombre me ha robado a mí!* (This guy has robbed me!)
CHARACTER B: *¡Hombre! ¿Cómo que te ha robado?* (Man! What do you mean he robbed you?)

A: *¡Sí, sí! A mí me ha robado no sé cuanto, no sé qué.*
(Yes, yes, he's robbed me of I don't know what all.)
B: *Este hombre. Ya llego y lo mato.*
(This guy. I've arrived and I'm going to kill him.)

At this point, the two actors engage in a mock struggle to subdue the alleged robber, who tries to flee. They finally push him down on the floor, and the dialogue continues:

A: *Bueno, este hombre ya esta mata'o.*
(Fine, this guy is killed.)
B: *¿Y ahora qué vamos a hacer? Si lo dejamos aquí todo el mundo lo ve y nos puede llamar la atención o nos [en]cierran.*
(And now what are we going to do? If we leave him here, everyone will see him and he'll draw attention to us or they'll lock us up.)
A: *Total. Este hombre, tenemos que desaparecerlo.*
(In short, we have to get rid of this guy.)
B: *Bueno pues. ¿Qué vamos hacer?*
(Well, OK. What shall we do?)
A: *Nada. Partirlo.*
(Nothing. Just cut him up.)

One of the actors then removes the victim's jacket while he is still lying on the floor and playing dead. The jacket is casually handed to an unsuspecting woman in the audience, who accepts it merely with the expectation of allowing the main plot, presumably including only the three actors already introduced, to develop. One of the men bends down and with his hand slices an imaginary line across the victim's body. The action is accompanied by the following interchange, with which the skit concludes.

A: *De aquí pa' arriba pa' mi.*
(From here and above is for me.)
B: *¿Y de la bragueta?*
(And [what about the part of the body with] the trouser fly?)
A: *¡Pa él que tiene la chaqueta!*
(For the one who's holding the jacket!)

The punch line, of course, derives its effect from the implication that the man's fly—or rather what lies inside it—belongs to the unfortunate woman in the audience who was caught holding the jacket. The punch line presumably caused the innocent woman a good deal of embarrassment, which she probably deflected in the theatrical moment through nervous laughter. The rest of the audience would reportedly howl with enjoyment at the unexpected sexual twist to the action. The audience also responds with laughter at the fate of the female victim in the audience, who is transformed into the actual victim of the drama, as distinguished from the assassinated robber, who is written into the improvisational script.

This drama, like most juegos de cortijo, is humorous but ends with a biting twist. It portrays domination and victimization: One man is robbed by another, who is then himself overcome by force and murdered. But it is the woman spectator, at the last moment pulled against her will into the plot, who is the real object of the male players' cunning deceit. Another salient message of the juegos echoes a theme that has been portrayed in Spanish drama since the Middle Ages, beginning with *La Celestina*,[4] that is, the unpredictability of the world and the preeminence of appearances as opposed to reality. Like the woman duped into holding the man's coat, we must all beware of whatever is openly placed before us, for it certainly holds a hidden and often hurtful meaning.

These dramas also implicitly advise people, for their own protection, to assume façades. The juego portraying the fox and hens is a case in point. The guard cannot admit his neglect to the owner. Repeatedly, when the owner asks him to explain each chicken's disappearance, he invents a false excuse. This strategy amounts to deceit for self-preservation, which is not unknown in rural parts of Andalucía in everyday affairs. Andalusians from the countryside say, for example, "There are no bad horses in Andalucía." How can that be, one might legitimately inquire. If you own a horse, you never know when you might want to sell him. Hence, it is best to maintain the horse's reputation in the best possible light, despite any observed defects. If you manage to sell a defective horse at a good price, the new owner is obliged to follow the same policy of lauding the animal, should he ever hope to recoup his losses. Andalusian juegos de cortijo incorporate a message of skepticism; they tell

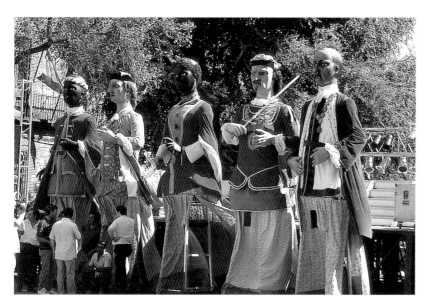

FIGURE 18
Corpus Christi Giant Figures,
1996, Toledo, Spain

have been converted into occasions for conspicuous leisure-time activities and consumption.[5]

Popular performances such as bullfights do not always follow a sacred celebration. They might also be cause for initiation of religious celebrations. Such is the case with the parade of *gigantes y cabezudos* (Giants and Big-Heads), as celebrated in the Andalusian town of Monteros.[6] The pageant of Giants and Big-Heads has a long history and wide distribution throughout western Europe. The first processional Giants and Big-Heads probably appeared in early-fifteenth-century Flanders, shortly thereafter diffusing to the Iberian Peninsula. We know that Giants and Big-Heads have existed in Spain at least throughout the past four hundred years, during which time they have been associated with both Corpus Christi and pre-Lenten Carnival celebrations.[7] In Monteros, a town of about five thousand inhabitants nestled in the olive-clad hills of eastern Andalucía, the parade of Giants and Big-Heads takes place each September on the first of four days devoted to the feast in honor of Our Lord of Consolation.

Giants and Big-Heads are masked figures. They appear at noon, amidst the joyful tolling of church bells. They file out from the town hall, located just off the main village square. First come two Giants, one masculine and one feminine figure, known respectively as King and Queen, dressed in crowns and simple tunics reminiscent of the garb of medieval monarchs. Each figure is about twelve feet tall, its clothing and papier-mâché head suspended from a wooden frame that is borne by a young man. The man is anonymous, his entire body from the knees up enveloped by the flowing gown of the towering image (fig. 18).

Immediately following the Giants appear some fourteen or fifteen Big-Heads, whose oversized papier-mâché heads and necks rest directly on the shoulders of young townsmen. In the case of the Big-Heads, the human body becomes part of the figure itself. However, thanks to the baggy, clownlike costumes and especially the head masks, the actors remain anonymous. No two Big-Heads are identical. Some, like Popeye, the Devil, a Witch, an Asian, and an African, are readily identified. Others, like the anthropomorphic Ape and Cow-Goat, are purely fanciful figures. A number of the Big-Heads represent men, both young and old, but there is one with

people to watch out for the supposedly fine horse that belongs to others, while presenting their own, no matter how defective, as of impeccable quality.

Andalusian skits are rarely performed nowadays. Simple and unsophisticated on the surface, they were deeply attached to the culture and society in which they once thrived. It is also likely that the skits provided an important socialization function; children watching these performances could not help but be affected by them. The skits therefore operated not only as cultural metaphors but also as agents of instruction. In their day, they must have exerted a profound influence as agencies of prevailing norms and values.

Secular Performance in the Service of Religious Devotion

Spanish popular theater for centuries has been associated with Catholic ritual and liturgy. It is mainly in the sacred celebration of saints' days and major holidays such as Holy Week and Corpus Christi that theatrical performances, both sacred and secular, have been mounted. The bullfight is a case in point. Bullfights, which are seemingly devoid of religious meaning, are usually associated with principal religious festivities, normally *ferias,* or fairs, which follow anywhere from a few days to a few weeks after a sacred saint's-day celebration. Ferias originated as occasions of economic exchange in the countryside, usually the buying and selling of livestock. However, with the rationalization and internationalization of large-scale commodity exchange, fairs

clean-shaven face and long hair that is hermaphroditic. The Witch, Devil, and Ape wear specially designed costumes appropriate to their images. The others don the loud, brightly colored garb of jesters. Aside from the Witch with her broom and the Devil with his blunt wooden spear, the Big-Heads all carry sausage-shaped cloths, about a foot long, stuffed stiff with sawdust and attached loosely to a short stick.

The pageant of Giants and Big-Heads takes these masked figures through the streets of Monteros, with crowds of children looking on and following the procession. The Giants, tall and domineering, walk together at a slow, even, dignified pace. The Big-Heads swarm around them, skipping, running, and jumping erratically; they seem intrusive and disruptive, thereby adding a chaotic element to the otherwise stately scene. The Big-Heads pause at several plazas where townspeople are gathered, and they rush around unpredictably, attacking children with their stuffed cloths. The Devil and Witch use their spear and broom for the same purpose. Adults and teenagers are amused, but little children seem frightened (fig. 19).

Meanwhile, a large crowd gathers in the main town plaza where the pageant began. From the second-story window of the town hall, skyrockets shoot out over the plaza carrying bags of candy and toys, which shower down on the throng of onlookers below. With every blast, the predominantly youthful spectators compete frantically for the spoils. Teenage boys, because of their size, aggressivity, and presence en masse, catch most of the flying objects. But they are usually content merely to win the contest, and prefer to distribute the goodies to unsuccessful girls and younger children rather than eat them themselves. The skyrocket display goes on for some quarter of an hour. By one o'clock P.M., an hour after the pageant began, the church bells and cannon fire cease, the Giants and Big-Heads reenter the town hall, and the crowd disperses.

If we examine the Giants and Big-Heads from a symbolic point of view, they bear the following contrasting qualities: The Giants are few, the Big-Heads many; Giants are tall, Big-Heads short; Giants dignified and graceful; Big-Heads foolish and clumsy; Giants unified and controlled; Big-Heads disorganized and spontaneous. Posters that announce the pageant of Giants and Big-Heads clearly represent the

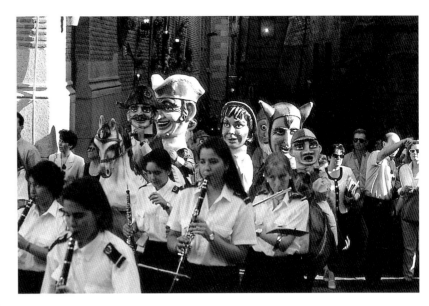

FIGURE 19
Corpus Christi Big-Heads,
1996, Toledo, Spain

Giants as king and queen, holding hands as husband and wife. Hovering below them at less than half their height are the bouncy Big-Head children. In fact, the parade of Giants and Big-Heads, directed as it is toward a mainly youthful audience, would seem to be a symbolic projection of a child's image of parents and children. The two Giants, haughty and remote crowned male and female figures, stand tall and erect and move smoothly through the crowds, exhibiting nearly complete bodily control, a control that anthropologist Mary Douglas points to as an indication of conformity to the wider society.[8] Within the family, it is the parents who, from a child's viewpoint, exhibit this kind of behavior based on learned and internalized social norms. Children, on the other hand, are still incompletely socialized and therefore manifest spontaneous, unpredictable, clumsy movements, which are characteristic of the Big-Heads. There can be no clearer example of Douglas's contention that "the social body constrains the way the physical body is perceived."[9] "Socialization," she states, "teaches the child to bring organic processes under control."[10] Likewise, the graceful Giants of our pageant have already grown up, while the erratic, playful, overtly aggressive Big-Heads represent immaturity.

At a deeper level, it is possible that the pageant of Giants and Big-Heads, which is associated with a Catholic festival, speaks symbolically to issues of dominance and control. The pageant is an extra-official celebration. To that extent, it challenges Church authority and demonstrates

popular initiative in the celebration of religious holidays. The aggressivity of the Big-Heads, the complete absence of clerical personnel, the fact that lower-class and largely anticlerical townspeople, who provide the vast majority of the celebrants, essentially take over the main public spaces throughout the duration of the pageant—all these circumstances and more add up to a ritualized rebelliousness. Of course, the rebelliousness is framed within the context of predictable ceremonial events. It is a tamed rebellion, an occasion for letting off steam, a folkloristic form of what elsewhere I have called a peaceful protest.[11]

At a deep psychic level, too, the parade of Giants and Big-Heads represents two conflicting tendencies inside everyone. There is a universal need for conformity and control, the desire to take charge of one's own affairs as well as to exert influence over others. That is, we yearn to emulate the behavior and attitude of the stately, monarchical Giants. At the same time, men and women everywhere are possessed, albeit occasionally, by internal forces demanding loss of control, chaotic abandon, and the display of anger and hostility. These characteristics are addressed by the Big-Heads. Giants and Big-Heads sort out opposing aspects that reside simultaneously within each human being. It may be for this reason above any other that the figures have received such widespread acceptance wherever they have been introduced.

The Religious Drama: Autos Sacramentales

Autos sacramentales, which are also known as *autos religiosos,* are dramatic enactments of biblical stories and scenes put on by and for the common people. They are almost always tied to some date in the liturgical calendar: Christmas, Easter, or the saint's day for a patron of a given locale. Unlike the pageant of Giants and Big-Heads, which is also related to religious celebration, these dramas are in their essence sacred. Townspeople dress in costumes that represent religious figures such as Jesus, Mary, and the apostles, and enact the religious roles; moreover, these roles correspond thematically to the liturgical date upon which the play is performed, whether it be Christmas, Holy Week, or the name day of a

specific saint. Autos sacramentales run the gamut from highbrow literature written by Lope de Vega and Pedro Calderón de la Barca,[12] to largely improvised skits in which the actors follow a predetermined story line but spontaneously compose their own dialogue.

Autos sacramentales are believed to have originated as a way for the Church to teach Christian doctrine to uneducated subjects. José Luis Alonso Ponga dates these dramas back to the fourth century A.D., when early Christians in Jerusalem reenacted the Passion and death of Jesus in the very spots where they were supposed to have occurred.[13] By the twelfth century, autos had spread throughout Europe.[14] Popular religious dramas have functioned throughout much of Latin America since the time of the Conquest, first as a means of religious education and later as sacred celebration and popular entertainment. Among the most famous contemporary examples are the Christmas *posadas* celebrated in Mexico and the southwestern United States.[15]

The Assumption play of Elche figures high on the list of autos thriving in Spain today. Elche is a medium-sized city located near the Mediterranean coast in the province of Alicante. The play takes place on 14 and 15 August, the Feast of the Assumption of the Virgin. It is performed in honor of Our Lady of Elche, patroness of the city, who is said to have appeared off the nearby coast, floating in a large chest. The legend's story line follows that of numerous patron saints' legends in Spain. George Foster has outlined the general pattern of these miracle legends:

> The common tradition is that during the Visigothic era a multitude of images were paid homage by the Goths and that, with the rapid Moorish advance, these images were quickly hidden in caves, canyons, and other out-of-the-way places, to be lost and forgotten for hundreds of years. Then, as the reconquest rolled back the Moors, the images were rediscovered, one by one. Almost invariably the image appears and speaks to a humble person, usually a shepherd but occasionally a shepherdess, who advises the unbelieving townspeople. At last they come, and convinced of the authenticity of the miracle, carry the image to their village, where they

immediately set about erecting a chapel. But the next day the image has disappeared, and after long search it is found at the spot where it first appeared. Often the image is carried a second and third time to the village before the villagers realize that the Virgin has taken this way to show that she wishes her chapel to be built where she was found. In other stories, the image floats to shore in a box which, when the Christians try to carry it beyond a certain point, becomes so heavy that it cannot be moved. Thus the people know where the chapel is to be built.[16]

<p style="text-align:center">⊰⇠⇢⊱</p>

All of these legends are designed to explain why the image in question came to be associated with a particular place. In the Elche version, a coastal guard named Francisco Canto centuries ago spied an unidentified object floating off the coast. The object washed on shore and turned out to be a chest. When Francisco Canto opened the chest he found an image of the Virgin Mary. He ran back to town to inform the villagers, who all ran to the beach to see the miracle for themselves. When they arrived, they found a note lying beside the image written in the Valencian language native to the region. It read *"Soc pera Elig"* (I belong to Elche). Accompanying the note was a manuscript of the play, which according to written instructions was to be performed every year on the feast day of the Assumption of the Virgin, 15 August. According to one version of this legend,

> The image was borne in triumph to the city and was first placed in the hermitage of San Sebastián (Saint Sebastian) before being taken to the parish church of Santa María and anointed patron of Elche. The lady, however, seems to have preferred the humble hermitage of San Sebastián for she is said to have returned to it on two occasions; each time she was carried back to Santa María and, after the clergy and people had implored her to remain there, "the gracious queen finally consented to do so," in the words of the local chronicler.[17]

For centuries, as the Virgin requested, the Assumption play has been performed every year in mid-August. The play is divided into two acts, the first of which is given on 14 August, the second on the next day. The play, which takes place on a stage especially erected for the occasion in front of the altar of the Church of the Virgin of the Assumption, is sung in thirteenth-century Valencian. Above the stage a blue canvas cloth is suspended to represent the sky. This space becomes important during the performance. Through a technologically simple arrangement of pulleys, several men, poised on a wooden platform, release a trap door through which a little boy, dressed as an angel and encased within a large model pomegranate, is lowered from "heaven"—the region above the blue canvas— to the stage below.[18]

The Assumption play begins late in the afternoon, when the actors, representing the Virgin, María Salomé, angel escorts, and the twelve apostles, march solemnly to church. The Virgin and her escort are the first to advance through the threshold. The Virgin opens the performance, singing variously in front of spots on stage labeled as Gethsemane, Calvary, and the Holy Sepulchre. She declares that she wants to die and join her son in heaven. On that cue, "heaven" opens and the angel in the pomegranate descends to the stage. As sections of the pomegranate peel away, the angel ascends to heaven. With this, act one of the play concludes.

On 15 August, the play concludes with the Apostles entering the stage, surrounding the Virgin in her deathbed, and preparing to bury her. Before this act can be concluded, a raucous band of Jews enters the stage and tries to steal the Virgin away. They are fought off by the Apostles, who win in the end and even manage to convert the Jews to Christianity. In unison, all the actors, Apostles and Jewish converts alike, proceed to bury the Virgin, after which they sing psalms in her honor. Four guitar-strumming angels descend on a platform from heaven to accompany the Virgin on her ascent. Midway along the journey, still suspended in air, they pause as Saint Thomas bursts late on the scene. He explains that he has been far away proselytizing for Jesus and begs the Virgin's pardon for his tardy arrival.

When he concludes his aria, the Virgin and her angel escorts continue their ascent. They are greeted by men representing God and two angels. In one final scene, in which all the characters are suspended from heaven, God crowns the Virgin, and she enters heaven. The Apostles file out of church to jubilant organ playing, bell ringing, and the wild applause of onlookers who all cry out "¡Viva la Virgen!"

After the play concludes, the carved image of the Virgin is placed to rest in front of the altar in a magnificent eighteenth-century bed with intricately embroidered sheets and coverlet. The image, accompanied by the Apostles, is carried in procession through the streets of Elche the next day.[19]

When folklorist Nina Epton observed this play in the 1960s, the actors were all male. (This situation does not always apply. The popular dramas of Castilla and León known as ramos are almost always sung by women.[20]) Young boys played the roles of the Virgin and María Salomé, and the Apostles were adult men whose real-life occupations were not so different from those of their biblical counterparts—carpenters, shoemakers, artisans, and the like. The parish priest played the part of God.

Nowadays, few priests would assume such a role. As Maximiano Trapero has pointed out, "Modern times are not very propitious for the preservation of 'ancient traditions,' and are even less so if these traditions are religious." Many modern priests, he says, are responsible for the suppression of traditional autos religiosos, an act that they justify on the grounds that rustic plays like these only serve to distance parishioners from expressions of true faith.[21] Clerics declare the plays superstitious and extraneous. They accuse the people of mythologizing the Bible by elaborating sacred stories to the point that they are barely recognizable. This is the clerical attitude that I observed and analyzed nearly a generation ago, when Spanish priests reacted to the Second Vatican Council and summarily eradicated popular religious forms that had long been part of local custom.[22] With that, priests contributed to the very process of secularization that they attempted to arrest.

On the other hand, as Trapero also points out, there are numerous examples of autos religiosos that were not performed for long periods and have recently been revived. The autonomous communities of today's Spain are largely responsible for revitalizing local customs that had long remained in abeyance. An example is the popular theatrical representation of the Assumption of the Madona Santa María (Saint Mary Madonna), which was revived and has been faithfully celebrated since 1980 in the Tarragona town of La Selva del Camp, in the comarca of Baix Camp. After centuries of silence, this play, incorporating one of the most ancient texts of Catalan theater, is now enacted yearly.[23] So, too, are the Pastoradas, traditional plays performed throughout the Kingdom of León that long ago fell out of the annual repertoire and have been reinstated.[24]

The Revival of Popular Theater

Popular theater, like most forms of ritualized entertainment, experiences alternating periods of florescence and quiescence. Performances, be they religious or secular, are a kind of cultural capital and as such may be promoted or suppressed as political and socioeconomic circumstances change. Now, on the eve of the twenty-first century, two especially potent forces seem to be working toward the revival of Spanish popular theater. One is the quest for national and ethnic identity, a quest which elevates folklore and traditional forms of entertainment to a pivotal position. This movement explains why, in a rapidly secularizing environment, Spaniards seem to be commemorating sacred calendrical rites with increasing cost and elaboration. Religious ceremony is not only of religious significance to them; it also reaffirms their sense of belonging to a group or, as Benedict Anderson puts it, to the imagined community that contributes to a sense of ethnic or regional identity.[25] Spanish popular performance, allied as it mostly is to religious events, currently flourishes. It provides people a sense of who they are as well as a connection to a common past, be it presumed or real. Popular performance also encodes particular norms and values which, if not necessarily intrinsic to the group, are at least treasured by it.

The second social force contributing to the revival and propagation of Spanish popular performance today is tourism, one of Spain's most lucrative industries. Governmental agencies, from local municipalities to the central state apparatus, have not lost sight of the economic possibilities that religious ritual and popular theater present. Hence, as a means of attracting

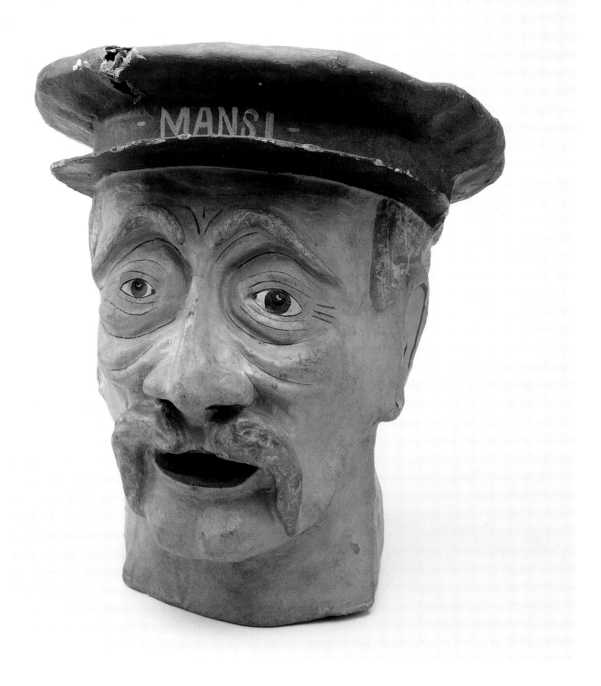

PLATE 64
*Viejo Cabezudo
(Old "Big-Head")*
Early 20th c.
Zaragoza, Spain
Painted papier mâché
17 × 15 in. (43 × 38 cm)
Peter P. Cecere, Reston,
Virginia

Cabezudos (Big-Heads) are large-headed, often grotesque,
dwarfs who run about mischievously during processions and
other events. They seem to appear most frequently during
the celebrations of Corpus Christi. Their roots go back to the
Middle Ages in Spain. Usually, they serve as counterpoints
to the more staid *gigantes* (Giants). Cabezudos are found
throughout Spain and vary tremendously from region to
region. Many represent local personalities or international
celebrities. In Zaragoza, cabezudo groups include personalities
from the eighteenth century as well as a local torch singer
from the 1920s. Each year, the village of Olite, not far from
Pamplona, parades a cabezudo representing Groucho Marx.

tourist income, they have propped up locally significant theatrical performances where they might otherwise have faltered and died. The impact of tourism on popular performance has been significant throughout Spain. Luis Díaz Viana has analyzed the process in Castilla;[26] Davydd Greenwood has shown how it has affected ceremonials in the Basque Country;[27] and other studies have chronicled the same circumstance elsewhere in the world.[28] Popular performance in Spain as elsewhere is no longer a matter, as Clifford Geertz once had it, of people putting on a show by and for themselves, thereby unselfconsciously dramatizing collective feelings about social norms, values, conflict, and cohesion.[29] National and international tourism has produced a much greater degree of self-consciousness in popular performance, as local communities and regional and ethnic groups vie for the attention of outsiders.

Unintentionally amusing and incongruous juxtapositions in Spanish popular performance are now becoming commonplace. Imagine the Dance of Moors and Christians as enacted throughout the province of Alicante, among other places. We have townspeople dressed variously as Moors and Christians, in a ritualized celebration of the Reconquest. The people playing Christians wear relatively drab garb, while those representing Moors are decked out in lavish finery—flowing robes; large, high, colorful, fancifully knotted turbans; and heavy, showy necklaces, earrings, and other jewelry. Meanwhile, the townspeople who are not acting in the drama promenade through the streets in the fancy modern clothing appropriate to fiesta celebrations in most provincial locales. The men wear suits and ties, the women and children their Sunday best. On the sidelines, watching the parading of Moors and Christians as well as the social drama provided by the nonperforming townspeople, sit North African migrant laborers, the Moors of today, dressed not in the finery of the Spaniards who represent their ancestors but rather in the ordinary garb of contemporary Western working people.

Spanish popular performances always incorporate themes of local significance; they regularly draw upon actors from the municipality or region in which the drama takes place. The reinforcement of ethnic and/or regional identity is usually a byproduct of such performances as well. But globalization must be taken into account in order to understand why these performances exist and how they have been transformed. The international movement of people and of goods and services on a large scale is intrinsic to whatever occurs at the local level in Spain today.

NOTES

1. Johan Huizinga, *Homo Ludens: A Study of the Play Element in Culture* (Boston, 1955).

2. Arcadio de Larrea Palacín, "El teatro popular en España," in José Manuel Gómez-Tabanera, ed., *El Folklore Español,* (Madrid, 1968), 339–52.

3. Ibid., 352.

4. *La Celestina: A Fifteenth-Century Spanish Novel in Dialogue,* trans. Lesley Byrd Simpson (Berkeley, Calif., 1958).

5. Gary Marvin, *Bullfight* (Urbana, Ill., 1994), 74–84.

6. Stanley Brandes, *Metaphors of Masculinity: Sex and Status in Andalusian Folklore* (Philadelphia, 1980), 17–36.

7. Giants and Big-Heads, though distributed throughout the Iberian Peninsula, seem to have their most impressive presence in Cataluña, Valencia, and throughout eastern Mediterranean Spain in general. For accounts of Giants and Big-Heads in Cataluña, where these figures have always been of enormous importance during the feast of Corpus Christi, see Joan Amades, *Gegants, Nans, i Altres Entremesos* (Barcelona, Spain, 1983) as well as the anonymously edited anthology *Gegants: Aportacio de Matadepera al nostre folklore* (Terrassa, Spain, 1982).

8. Mary Douglas, *Natural Symbols: Explorations in Cosmology* (New York, 1973), 99–100.

9. Ibid., 93.

10. Ibid., 101.

11. Stanley Brandes, "Peaceful Protest: Spanish Political Humor in a Time of Crisis," *Western Folklore* 36 (1977): 331–46.

12. For a collection of highbrow autos sacramentales, which are integral to Spanish literary history, see Eduardo González Pedroso, *Autos sacramentales desde su origen hasta fines del siglo XVII* (Madrid, 1964). The plays of Lope de Vega and Pedro Calderón de la Barca are included in this anthology.

13. José Luis Alonso Ponga, *Religiosidad popular navideña en Castilla y León: Manifestaciones de carácter dramático* (Salamanca, Spain, 1986), 9.

14. Ibid.

15. For information on *posadas* in Mexico and the southwestern United States, see Stanley Brandes, *Power and Persuasion: Fiestas and Social Control in Rural Mexico,* ch. 8 (Philadelphia, 1988); Salvador Carranza, *Posadas y Navidad* (Mexico City, 1973); Jesús C. Romero, *Nuestras posadas* (Mexico City,

1952); Socorro Sala González, "Cantos de posadas y Navidad en Santa Rosa, Veracruz, hoy Ciudad Caminero Mendoza," *Anuario de La Sociedad Folklórica de México* 9 (1954):25–79. For the history of the posadas and accounts of the European equivalents, see Esteve Albert, *El Pessebre vivent d'engordany* (Barcelona, Spain, 1958); Joan Amades, *El Pessebre: Tradicio popular i art pessebrista* (Barcelona, Spain, n.d.); Mariano Carcer, "Posibles orígenes de las típicas posadas mexicanas," *Anuario de La Sociedad Folklorica de Mexico* 4 (1943):287–97; Mary MacGregor Villareal, "Celebrating the Posadas in Los Angeles," *Western Folklore* 39 (1980):71–105; S. Margetson, "Medieval Nativity Plays," *History Today* 22 (1972):850–57.

16. George M. Foster, *Culture and Conquest: America's Spanish Heritage* (New York: Wenner-Gren Foundation, 1960), 161.

17. Nina Epton, *Spanish Fiestas* (London, 1968), 166.

18. Ibid., 168–69.

19. This account of the Assumption play of Elche comes mainly from Epton, *Spanish Fiestas,* 164–71.

20. Ponga, *Religiosidad popular navideña,* 43.

21. Maximiano Trapero, *El auto religioso en España* (Madrid, 1991), 19.

22. Stanley Brandes, "The Priest as Agent of Secularization in Rural Spain," in Edward C. Hansen, Joseph B. Aceves, and Gloria Levitas, eds., *Economic Transformation and Steady-State Values: Essays in the Ethnography of Spain* (New York, 1976), 22–29.

23. Trapero, *El auto religioso,* 19.

24. Ibid.

25. Benedict Anderson, *Imagined Communities,* rev. ed. (London, 1991).

26. Luís Díaz Viana, "El paso de fuego en San Pedro Manrique (el rito y su interpretación)," *Revista de Folklore* 12 (1981):3–9.

27. Davydd Greenwood, "Culture by the Pound: An Anthropological Perspective on Tourism as Cultural Commoditization," in Valene L. Smith, ed., *Hosts and Guests: The Anthropology of Tourism* (Philadelphia, 1977), 129–38.

28. See, for example, ch. 5 in Brandes, *Power and Persuasion.*

29. Clifford Geertz, *The Interpretation of Cultures* (New York, 1973).

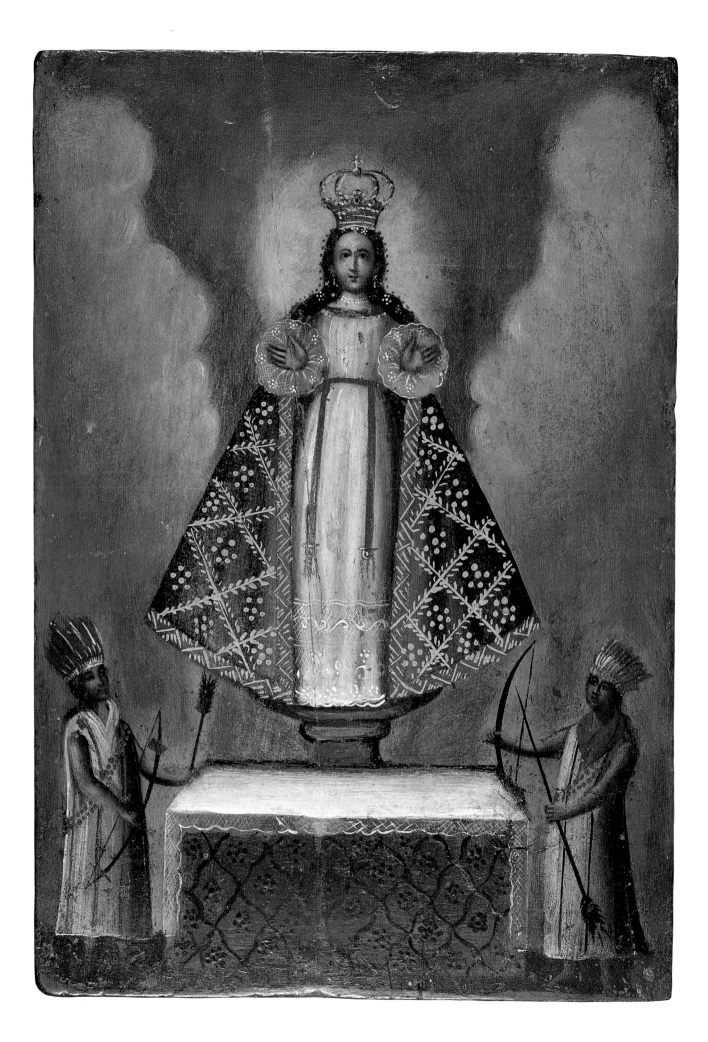

Marion Oettinger, Jr.

The Transformation of Spanish Folk Art in The Americas

The first encounter between the craftwork of the two cultures took place in Santa María de la Victoria, Tabasco, in 1519. . . . Cortés ordered two carpenters to make a tall, wooden cross, and he made the Indians "raise a fine and well-built altar." The Spanish and Indian workers, as if in a double rite, thus gave birth to the new craft with a double origin: that which was Spanish, rich in European influences, and that which was Indian.

—SALVADOR NOVO[1]

Throughout the world, folk art dies and is born each day. Like all art, folk art is always evolving. It is malleable, responding to new times, new faces, and new needs. Spanish folk art is certainly no exception; it has evolved, shifted, abandoned old materials and techniques, and adopted new ones. It has assumed the forms required by time and place. In the transformation that occurred when Spanish folk art traveled to the Americas, we see its remarkable ability to meet the challenges of new social, physical, and spiritual environments.

Latin American folk art is at the confluence of many forces—including African, Native American, and Asian—here we explore its European or, more specifically, Spanish, roots. In travels throughout Latin America, one quickly notices a shared cultural veneer, a variety of elements that all places seem to hold in common. One of those elements is *hispanidad,* or "Spanishness." Although each community has its own unique character, ancient history, and long-held cultural traditions, most parts of Latin America share a large number of cultural traits that can be traced directly back to Spain. The language,

religious music, architecture, belief systems, social organizations, and art all have Spanish antecedents. Despite their origin, these are vernacular expressions, tailor-made to meet the needs of new people and communities. Latin American folk-art forms are visual manifestations of the values and perspectives of the new creole and mestizo populations that produced and used them. And they change, often dramatically, through time and space.

For example, Spanish pottery, which was introduced in the early sixteenth century, made a tremendous impact on the Americas, and Spanish forms often changed to meet the needs and requirements of new environments (pls. 66, 70–74). Glazed pottery was not produced in Latin America prior to the arrival of the Spanish. Early majolica-type potteries were established in Puebla, Guanajuato, and other towns of New Spain, based on examples from Talavera de la Reina, Puente del Arzobispo, and other ceramic centers in Spain. These forms thrived in their new homes and soon diffused throughout the Americas. Twice-fired glazed tiles, household plates, flowerpots, water jugs, wash basins, and other objects were made in great quantities. Unlike the indigenous pottery of Latin America, these new ceramics were made on a potter's wheel. Examples shown here are from Mexico, Guatemala, Peru, and Ecuador, each of which molded Spanish-style ceramics into new hybrid forms unique in feel and appearance. Indigenous clays, design motifs, and local traditions helped shape this new pottery (fig. 20).

New economic activities, unknown prior to the arrival of the Europeans, also led to new folk

PLATE 65
Virgin with Peruvian Indians, late 18th–early 19th c.
Peru
Oil on wood
11½ × 8 in. (29 × 20 cm)
Jonathan Williams, Austin, Texas

One way Spanish Christian images were Americanized was by showing them in the company of Native American people. In this depiction of the Virgin Mary, we see two lowland Peruvian Indians dressed in feathered regalia standing at the base of the pedestal. They hold bows and arrows, perhaps to portray them as recent converts to Christianity and defenders of the faith.

FIGURE 20
Glazed Tile, 18th c., Cuzco, Peru. Jonathan Williams, Austin, Texas.

forms. By-products of the cattle business are good examples. Cattle-horn carving, popular in Spain and the rest of Europe for centuries, quickly caught on in Mexico and other places (pl. 68). The carving of wild animal and human bones was a highly developed art among indigenous people, and no doubt these skills came into play with cattle-horn carving.

Perhaps the most dramatic examples of the transformation can be seen in religious folk art. For the most part, non-Christian religious folk art was destroyed by the colonists. Manufacture of any religious art considered a threat to Catholicism was strictly prohibited. Pre-Columbian religious painting and sculpture, quickly destroyed by overzealous priests from the earliest days of colonization, was soon replaced by images of the new faith. Almost as quickly as these Spanish Christian art forms were introduced, they began to change in order to adapt to new populations and circumstances. Churches were built on the foundations of pre-Columbian temples, and miraculous apparitions of the Virgin Mary and Christ were reported to have occurred on or near sites previously thought sacred by Aztec, Maya, and Inca people. Catholic painting and sculptural forms evolved in ways distinct from the forms known in Spain. Saints were depicted dressed in native costume, against local backgrounds, and often physically resembled those indigenous people who made and worshiped them.

Images of the Virgin, widely revered in Spain for centuries, were brought to the Americas by Spanish soldiers, colonists, and priests, and they supplanted old pre-Christian images. Others miraculously appeared to ordinary farmers and newly converted Christians. In some accounts, the Virgin herself appeared, as in the case of Mexico's Virgen de Guadalupe. Other accounts relate the apparition of the carved image of the Virgin, as in the case of Nuestra Señora de los Remedios (Our Lady of Remedies) in Mexico (pl. 89) and the Virgen de Cocharcas (Virgin of Cocharcas) in Peru (pl. 90). These images, long-believed to be imbued with special curative powers in Spain, took on new relevance in the Americas, where many are honored to this day.

Latin-American apparition accounts are remarkably similar to Spanish accounts. Almost invariably, they involve ordinary, often humble, citizens, whom the Virgin charges with building a chapel on the spot where the apparition occurred. Frequently, doubt by the local citizenry requires that multiple apparitions take place before the miracle is deemed authentic and the chapel is built. Of course, in America the apparitions take place in American settings, before American people, making them especially relevant to local populations. As in Spain, American believers embraced the custom of wearing "reliquaries" showing images of the Virgin as a symbol of continuing devotion to her or as an expression of thanks for her intervention during a time of crisis.

Figures of Christ also play an important role in the religious folk art of the Americas. Images of the cross assumed new, hybrid forms as early as 1519, and they have been changing continually since. From the earliest days of European contact, the Passion of Christ was taught to indigenous people with paintings. A fascinating example of folk art at the service of the new order is Valadés's important sixteenth-century woodcut showing Fray Pedro de Gante, the early Franciscan mendicant, teaching Mexican indigenous people the story of Christ's Passion via paintings of the Fourteen Stations of the Cross (fig. 21, pl. 98). Very probably, the paintings used in the Americas, while inspired by Spanish prototypes, were tailored to appeal to new populations. The colorful nineteenth-century Peruvian *Adoration of the Magi* (pl. 94), for example, was painted against a background of snow-capped Andean peaks, with shepherds wearing ponchos and other indigenous garb.

Christ figures miraculously appeared on spots previously considered sacred by pre-Columbian

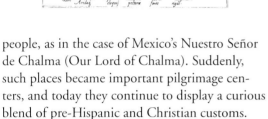

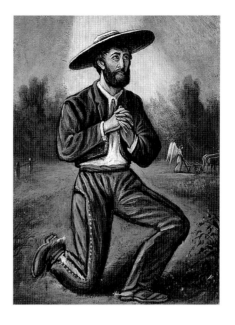

FIGURE 21 (left)
D. Valadés, *Fray Pedro de Gante Instructing Indians,* 1579. From *Handbook of Middle American Indians,* vol 15

FIGURE 22 (right)
Saint Isidore the Farmer, 19th c., Mexico. Fred Kline, Santa Fe, New Mexico.

people, as in the case of Mexico's Nuestro Señor de Chalma (Our Lord of Chalma). Suddenly, such places became important pilgrimage centers, and today they continue to display a curious blend of pre-Hispanic and Christian customs.

Almost immediately after contact, Spanish missionaries introduced saints important to their specific orders as a way of teaching exemplary life and the importance of individual sacrifice for the good of the community. Franciscans introduced their founder, San Francisco de Asís (Saint Francis of Assisi), and San Antonio de Padua (Saint Anthony of Padua) to indigenous communities; Dominicans named towns after their founding leader, Santo Domingo (Saint Dominic); and Augustinians established churches bearing the names of important members of their order, such as San Agustín (Saint Augustine). The clerics also introduced biblical figures, such as San José (Saint Joseph), San Pedro (Saint Peter), and numerous other New Testament personalities. In Mexico, towns founded before the arrival of the Spanish kept their original Nahuatl or Mayan names but were often given Christian prefixes, such as San Juan Teotihuacán and San Gabriel Chilac.

Among the most interesting and successful images brought to the Americas was that of San Isidro Labrador (Saint Isidore the Farmer), patron saint of Madrid and of farmers. Because much of the Americas was agrarian, San Isidro's assistance was highly prized. Today, his images occupy central devotional positions from Mexico to Bolivia and Paraguay, from Puerto Rico to

New Mexico. In each place San Isidro has adapted to meet new times and populations. Instead of maintaining his original eleventh-century Spanish appearance, he is shown as a member of the local community. In Castañon's painting (pl. 81), he appears as a nineteenth-century Bolivian *hacendado* (hacienda owner) amidst local flora and fauna, surrounded by scenes of Andean festivity. In fig. 22, San Isidro appears in Mexican *charro* (horseman) dress.

Excellent articles by William Wroth and María Concepción García Sáiz carry this discussion further and prod us to consider both the subtle and the powerful ways Spanish folk art was transformed in the Americas.

NOTE
1. Salvador Novo, "Nuestras artes populares," in *Antología de textos sobre arte popular* (Mexico City: Fonart-Fonapas, 1982). Editor's translation.

"El primer encuentro entre las artesanías de dos culturas tuvo lugar en Santa María de la Victoria en Tabasco, en 1519. . . . Cortés ordenó a dos carpinteros que hicieran una cruz de madera muy alta e hizo que los indios 'alzaran un buen altar y bien logrado.' Los trabajadores españoles y los indígenas, como en un doble rito, dieron así nacimiento a la nueva artesanía con su doble origen: el español, rico de influencias europeas, y el indígena."

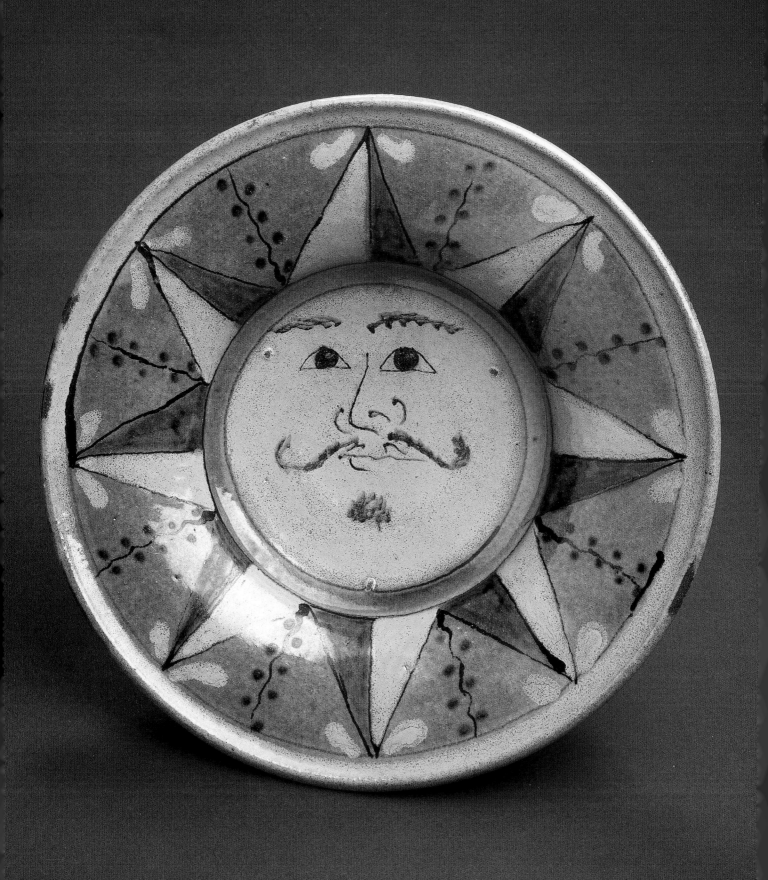

María Concepción García Sáiz

Constructing a Tradition

Today the inhabitants of Tinta, a settlement in the mountains of Peru close to Cuzco, looked on as the images of the saints venerated in the village were returned to their altars after being paraded around the streets accompanied by the entire community. Martín was one of the men who shouldered the platform bearing the equestrian figure of Nuestro Señor Santiago (Our Lord Saint James) in the Corpus Christi procession this year. His bones are still aching from the effort, but he is satisfied. He has been taking part in the annual festivity with the rest of his family for a long time now, and he does not need to delve too deeply into his memories to recall his father or one of his other relations carrying out the same task. Indeed, only last year a foreigner brought out a postcard with a reproduction of a photograph taken in the 1930s during the same procession, and Martín's father could recognize some of those taking part. They all appear very serious, hat in hand, befitting the importance of the celebration; some firmly clutch their ceremonial staffs, and all look fixedly ahead. Above their heads appear San Pedro (Saint Peter), Santiago (Saint James), San Blas (Saint Blaise), and La Almudena (Our Lady of Almudena) wearing their new costumes and surrounded by flowers and mirrors.

Several years ago, some of Martín's friends were in Cuzco around this season, and they have told him in detail about the numerous processions held there during the nine long days the celebration lasts. And about the many drunken feasts that almost always follow the dancing. One day he also will have to go to Cuzco. The processions begin on Whit Sunday (Pentecost), when the Virgen de Belén (the Virgin of Bethlehem), patron of the city, is transferred to the Church of Santa Clara. The other images are placed opposite the Virgin on the eve of Corpus Christi; from there they proceed together to the Plaza de Armas and directly into the cathedral. There people mill around on Thursday morning, the church packed with the faithful, and the authorities ready to hear the Mass of Te Deum and to accompany the Blessed Sacrament in procession. Actually, everyone pays the most attention to the images from their own parish churches, which they attend, decorate, and accompany on the procession around the square throughout the eight days the images remain in the cathedral before returning to their parishes. On this occasion Martín's friends met people who had also come to Cuzco from elsewhere; some had come a long way, from the coast or the *altiplano* (high plains of the Andes). None of them seemed to feel alienated, as everyone participated actively in all the festivities. Many moved ceaselessly in dances which those recently arrived from Tinta had never witnessed before, and most of them were wearing strange, fine clothing.

His friends also told him that they enjoyed the Corpus Chico (little Corpus) of some of the parishes even more. This event is celebrated when all the images return to their churches after holding their meetings, their private "assemblies," in the cathedral with the Cristo de los Temblores (Christ of the Earthquakes) presiding, and after taking leave of all their companions, among good wishes for the next year. For the saints are not just those wooden figures that strangers examine with curiosity. They participate in the life of the

PLATE 66
Montiel Family, act. early 20th c.–present
Dish with Sun Motif, c. 1900
Antigua, Guatemala
Glazed earthenware,
DIAM. 9½ in. (24 cm)
San Antonio Museum of Art

Majolica-type pottery was introduced to Guatemala during the early colonial period. Potteries flourished in Totonicapán, Antigua, and other towns. This piece, with its traditional mustachioed sun, is a fine example of the glazed earthenware produced by the Montiel family of Antigua during the early part of this century. This family still runs a pottery shop today, but the quality of its products has diminished.

people, and like the gods of classical mythology, they have their own life, which is halfway between the celestial realm and this world, in which they experience almost human joys and sorrows.

‑‑‑❖‑‑‑

The foreigner who spoke with Martín was one of those *limeños* (natives or inhabitants of Lima) who ask ceaseless questions. Listening to them, it seems as though people in cities have lost their memory of important things and need to visit small places and delve into the lives of their inhabitants to recover it. Then they forget everything again, returning to their homes believing they have understood something. In their living room, beside the television set, they place the altar ornament they bargained for, convinced thereby that they have managed to trap the past and, with it, tradition. They presume themselves connoisseurs and talk with their friends about the authenticity of popular culture, which they recognize at first sight. On occasion—the limeño tells his cronies—he has complained bitterly to some craftsman or other about his lack of commercial vision, reminding him that in Ayacucho the *sanmarcos,* those boxes which since the 1940s have been called *retablos,* are now selling much better because they were adapted to urban tastes. Many people buy them nowadays, though there are few who, like Francisco Stastny, consider them to be "the most complex and complete known expression of the syncretic ideology of the Peruvian Indian peasantry." They are no longer *huacas* related to the protection of livestock and agriculture, so important to the Andean mythical world, into which were incorporated the Christian saints who arrived with the Spaniards. Since they were discovered by civilization, they have become backdrops for attractive genre scenes ever more removed from custom and tradition.

These gatherings of limeños always break out in dispute. Some question whether the market should be allowed to dictate the path of traditional popular arts, yet recognize that craftsmen need to find a commercial outlet for their products beyond their own immediate surroundings as their only way of improving their standard of living. Some even allude to the role that official

entities should play, to the obligation of governments to protect this craftwork, to encourage it, open up foreign markets, award prizes to the best craftsmen, and so ensure that these crafts are not abandoned. Indeed, all of this *has* been done, with mixed success, over the past fifty years, as indigenist policies that identified the Indian with the craftsman were carried out, or even since the last century, when the Asociaciones de Amigos del País (Associations of Friends of the Country) began to take an interest in preserving traditional crafts. Yet always underlying the discussion is the apparently widely accepted definition of popular art as an art of the people for the people, made by anonymous authors and with a known function shared by the entire community. So if we entertain the notion of craftsmen being recognized as individuals, of modifications imposed by the tastes of an external market, and of radical changes in function, what then?

We all have our own definition of what popular art is, and we offer widely disparate examples to support that view. Some consider that many of the objects circulating in the trade or exhibited in museums as popular art are in fact unworthy of this description; they consider these objects to be, at the most, more or less successful reproductions of true examples of popular art.

Once again the city dweller yearns for the country, the "real" life. In Latin America this yearning includes identifying the indigenous peoples with the peasants. This idea is nothing new, having already been expressed with the exaltation of Nature during the Renaissance. In Spain this sentiment found one of its best expressions in a work by Antonio de Guevara, *Menosprecio de Corte y alabanza de aldea* (Contempt for the Court and Praise for the Village) (1539). Similarly, in another of his works, *Marco Aurelio,* primitive man is considered superior to civilized man. This concept has endured for centuries, as evidenced by the periodic revivals of the myth of the "noble savage."

From this point onward, the rhythm of the conversation becomes more complicated. The indigenous world has been identified with the rural world, in which the creations of popular art have been situated. This world has been defined as authentic, as depository of the national essences.

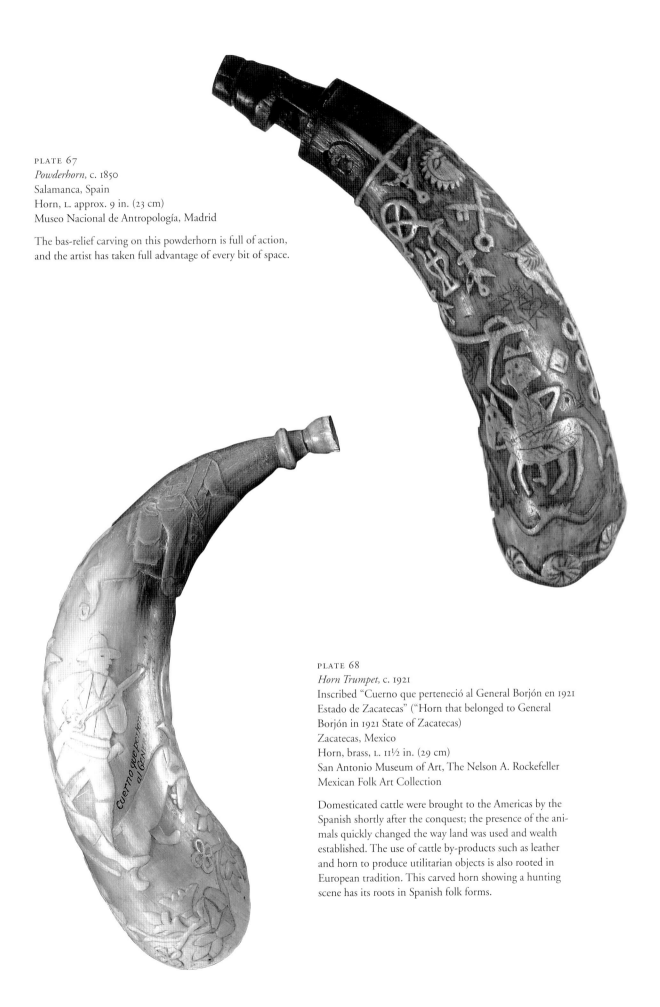

PLATE 67
Powderhorn, c. 1850
Salamanca, Spain
Horn, L. approx. 9 in. (23 cm)
Museo Nacional de Antropología, Madrid

The bas-relief carving on this powderhorn is full of action,
and the artist has taken full advantage of every bit of space.

PLATE 68
Horn Trumpet, c. 1921
Inscribed "Cuerno que perteneció al General Borjón en 1921
Estado de Zacatecas" ("Horn that belonged to General
Borjón in 1921 State of Zacatecas)
Zacatecas, Mexico
Horn, brass, L. 11½ in. (29 cm)
San Antonio Museum of Art, The Nelson A. Rockefeller
Mexican Folk Art Collection

Domesticated cattle were brought to the Americas by the
Spanish shortly after the conquest; the presence of the ani-
mals quickly changed the way land was used and wealth
established. The use of cattle by-products such as leather
and horn to produce utilitarian objects is also rooted in
European tradition. This carved horn showing a hunting
scene has its roots in Spanish folk forms.

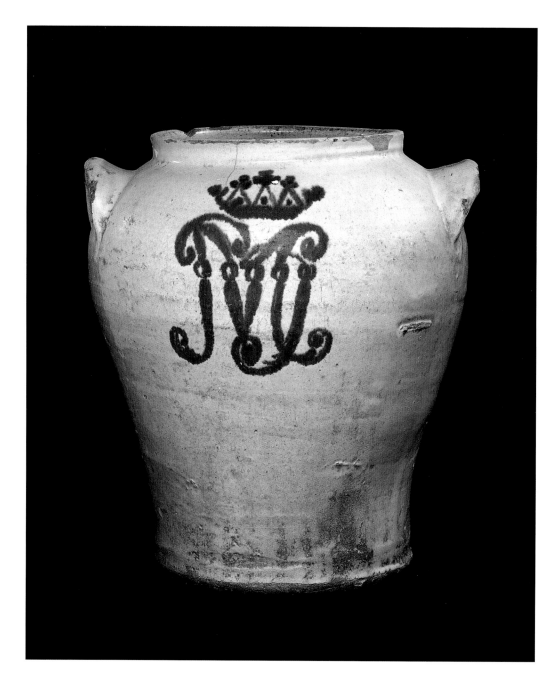

PLATE 69
*Jar with Anagram and
Crown,* 18th c.
Toledo, Spain
Glazed earthenware
13 × 11 in. (33 × 28 cm)
Lent anonymously

Majolica-type ceramics
have a long history in Spain,
and their production con-
tinues into modern times.
Thrown on a potter's wheel
and twice-fired in high-
temperature kilns, this pot-
tery became very influential
in transforming American
ceramic production. Glazed
ceramics such as this were
commonly found in con-
vents and monasteries. This
jar bears the anagram of
the Virgin Mary and was
probably used for storage
in a convent.

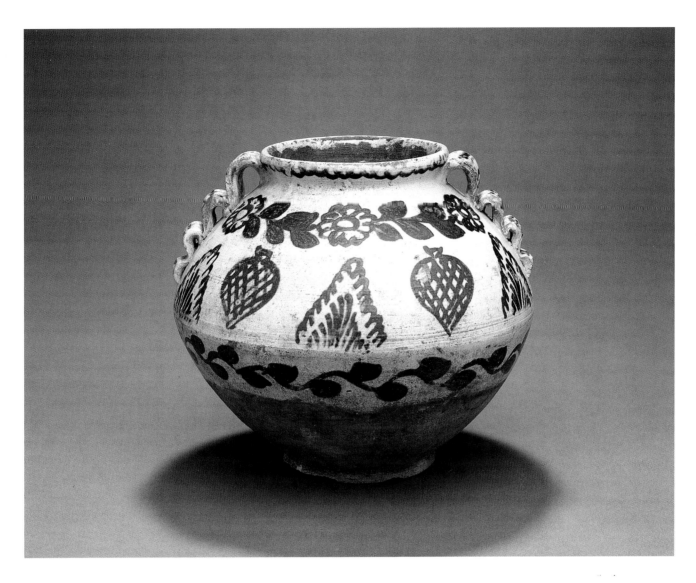

PLATE 70
Pot, c. 1900
Chorteleg, Ecuador
Glazed earthenware, H. approx. 9 in. (22 cm)
San Antonio Museum of Art

Majolica-type pottery was introduced into Ecuador during
the early Spanish colonial period. One of the centers of pro-
duction for this type of glazed pottery was Chorteleg, a small
community outside of Cuenca, where potters continue to pro-
duce ceramics similar to the pot shown here. The heavy use of
green glazed decoration is characteristic of Ecuadorian pottery.

The die has already been cast, and accepting the importance of popular art on the basis of these premises leads inevitably to an attempt to define these national essences. When the conversation reaches this point, a silence always occurs, followed by attempts to find the most exact definition, which never comes. This subject has to be followed up on another occasion, because many points need to be made and everyone is rather tired. Moreover, someone has started to launch questions into the air, such as why has indigenism always used popular art as a banner, and is the tradition of Latin America only indigenous?

Though a few friends have already left the gathering, the most enthusiastic sit down again, and intertwining opinions reanimate the discussion. There is always someone who tries to answer the questions left outstanding when it seems as though the group will finally break up. Someone tries to introduce a degree of order.

Such a person points out that the arrival of the Spaniards on the American continent in the sixteenth century and their definitive establishment in what they called the New World precipitated a cultural transformation of enormous dimensions, which affected both power structures and daily behavior. Everyone agrees to this and the following: What is known generically as Hispano-America, which today makes up the major part of Latin America, soon acquired an appearance of uniformity on becoming part of an empire that from the first imposed its Spanish language and its Catholic religion as determining elements of its culture.

At this point, one of the more attentive members of the group calls everyone's attention to this "apparent uniformity" which has just been mentioned. Indeed, it was this diversity of American cultures, which incorporated multiple native experiences, that modified the initial propositions of the new society dictated from the metropolis, on both the official level and that of daily life. And even though the peoples occupying the continent spoke a great variety of languages and possessed different cultural traditions, in the eyes of strangers they would seem to be similar. The vocabulary of the conquistadores soon became impregnated with Americanisms, taken indiscriminately from the cultures of the

Caribbean, Mesoamerica, or the Andes; their eating habits were transformed and with them those of hungry, rich Europe, which rapidly forgot the places of origin of many products and simply took them over. Who could imagine the popular cuisine of Germany or Spain without the potato? Who can think of Italian pasta without the accompanying tomato? American dyes colored the dull clothing of most inhabitants of the Old World with luminous hues, and all of these products became so entrenched in many areas of daily life that any modern European looks surprised when someone recalls the American origin of so many of them.

Someone mentions that the diversity is not only American, which people don't always recall. When Spain began to incorporate the American continent into her cultural sphere, Spain herself was constructing her own identity, based on important foreign contributions throughout her history, that formed what would subsequently be defined as Spanish culture. Up to 1492 the Iberian Peninsula was fertilized by a series of cultures that became more uniform under the Judaeo-Christian mantle, but which survive in a substratum that often develops on the margins of official culture and in competition with it. Some, like the Phoenicians, Greeks, Romans, Jews, and Arabs, came from the Mediterranean area, while others, like the Celts, arrived from Northern Europe. Cults related to the agrarian world, which basically originated in the east, were fully installed in Spain as in the rest of Europe when Christianity arrived, so that the great celebrations of the Christian liturgical year—Christmas, the Passion and Resurrection, and the feast of Saint John—are directly linked to pagan feasts related to the seasons and agricultural tasks. And it is from this multiple Spain that most of the new migration to America came.

Once colonization had begun, the two clearly differentiated undertakings of evangelization of the indigenous population and commercial exploitation of the riches of the continent would open the door to persons from other areas of European culture and from different parts of Africa. The religious orders, with the blessing of the Spanish crown, sent to America those individuals they considered the best prepared to

support the dissemination of the gospel, notwithstanding their specific origins. They needed more than dialectical skill or exemplary behavior, because since they regulated all communal activities, they acted as the most decisive element in the transculturization of the indigenous population. Not all of the clerics were members of the cultural elite. Not all of them were Fray Pedro de Gante or Bishop Vasco de Quiroga; on the contrary, many of them were men of the people. They shared the popular religiosity practiced in their places of origin, and they transmitted it easily, thus probably contributing more than anyone else to spreading specific devotions and speeding the syncretism of two rural communities with many points in common, though separated by a continent and an ocean.

The African population, which was tranplanted against its will and made up of individuals incorporated as slaves into the new society, also had diverse cultural origins. It forms another complex nucleus which, depending on its social mobility, was able to maintain a strong link with its traditions or abandon them rapidly to join the dominant society. We tend to recognize that culture's importance only in areas where Africans have traditionally been in the majority, such as the Caribbean, Brazil, or some areas on the coast of Colombia or Ecuador. However, the presence of African culture may be detected over much wider areas throughout America, and we should not overlook the importance of the runaway-slave societies that emerged in response to slavery.

To all of this we must add the arrival of the oriental world, which occurred mainly by way of the route established in 1565 linking the ports of Cavite in the Philippines with Acapulco in Mexico, in accordance with the Spanish trade monopoly. This opened up a route to America for the Chinese and Japanese, as well as other Asians with no officially defined origin but with clearly differentiated cultural roots.

By the end of the sixteenth century America was already occupied by this cultural mosaic, controlled from the spheres of power, yet alive and in a constant process of transformation in those urban and rural spaces where the majority population was of indigenous and mestizo extraction. Evangelical efforts were concentrated there to annul the individual beliefs of communities, which in most cases had been formed by *reducciones,* the forced union of different groups to facilitate control and to ease their incorporation into the new way of life. These reducciones into "Indian villages," are the origin of many present-day settlements.

‹‹›

Now the conversation turns back on itself. Some one observes that the subject has turned into a river that is overflowing its banks, threatening to submerge all those present. Is it possible that a discussion on how to recognize the popular character of our festivities and the work of our craftsmen has become a forum on the cultural roots of several continents? Evidently, the conversation has led us a long way, so far that it forces us to acknowledge that in a historically very short period of time, not more than fifty years, between 1530 and 1580, the indigenous peoples of the American continent established contacts that in other parts of the world took centuries to occur. The material cultures of Europe, Africa, and Asia flowed into America and took on new life by participating in an unparalleled process of cultural creation.

The power of the great historical events that culminated in the establishment of Western culture in the American continent, by means of the colonization undertaken basically by Spain, has thrust into the background the individuals who anonymously constructed a pattern of daily life. Those thousands of individuals, by acting in accordance with the standards of their places of origin, were in many cases the true protagonists of the introduction into America of the specific craft techniques, functional objects, and ritual behavior that today are found all over the continent and make up what we commonly know as popular culture.

‹‹›

Fortunately, and invariably, the gathering ends with an amusing recollection shared by all those present. All of them laugh when they recall the Spaniard who arrived some years ago and whom several of them accompanied to different villages in the Andes and on the coast, trying to time the

PLATE 71
Apothecary Jar, 18th c.
Puebla, Mexico
Glazed earthenware
H. 9½ in. (24 cm)
San Antonio Museum of Art

Glazed, wheel-turned pottery did not exist in the Americas prior to the arrival of the Spanish. The earliest potteries that produced majolica-type ceramics in Mexico were established in Puebla, during the mid-sixteenth century. Others grew up in Guanajuato, Mexico, and Guatemala. Originally, the potters adhered strictly to the forms and designs of Spain but the pieces later took on looks unique to each new ceramic community. In shape and color, this piece is typical of apothecary jars of eighteenth-century Puebla, but its roots are clearly Spanish.

visits to coincide with local festivities and markets. In the sanctuaries, he rapidly claimed as his own the ex-votos made of wax or other materials that were piled up on walls and altars. Before any of his traveling companions could ask why, he would tell them how these same forms of popular expression could still be found in the most remote rural Spanish chapels and churches, and even in some larger cities. And you should have seen him when his visit coincided with a local festivity, in which the noise of rockets and fireworks resounded along the village streets! The way he talked they imagined the whole of Spain in flames several times a year due to the efforts of her pyrotechnic experts. And how to describe the day he discovered that *mazapanes* (marzipan) and *alfajores* (sweet, filled pastries), together with other Arabic sweets, are eaten in different parts of the Andes.

When he went into the markets and saw the women busily setting out their wares, their *polleras* (the wide, gathered skirts many of them wear) always attracted his attention. They are the same, he would assure his companions, as those traditionally worn by the women of Extremadura, in Spain, where they are known as *refajos*. On some occasions, to accompany him on his visits was to take part in a fascinating game. Many of the features that attracted the Spaniard's attention have formed part of Peruvian traditions for centuries, and are so clearly identified with them that it is futile to isolate them and consider them alien to popular culture. Nonetheless, it does help a great deal in understanding the creative capacity of Andean man to learn the process by which essential elements of Spanish culture have been assimilated and converted into key features of Peruvian culture.

Of course, there were times when the visitor's enthusiasm led him into curious traps, such as when he tried to link the *serenero,* the head-covering used by the women of Candelario in the Gredos Mountains (Avila, Spain), with the *lliclla* or *uncuña,* those small shawls of clearly indigenous origin and described as such by sixteenth-century chroniclers. In the face of everyone's protests, he always had a reply in the form of a question, which introduced new elements into the argument. On this occasion the question was about the name given by the Salasacas from the Ecuadorian province of Tungurahua to a very similar article of clothing they call *varaimedia.*

This comes from the Spanish "vara y media," a Castilian unit of length.

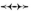

Martín probably does not realize that those who best understand his feeling of pride every time he feels the weight of the image of the saint are many kilometers distant. They are separated from him by the Andes, several countries of the American continent, and an entire ocean. Almost certainly nobody has ever told him that in many Spanish towns, for an entire week the inhabitants devote themselves (and have done so for many centuries) to adorning the streets, raising altars, and organizing the course of a procession which incorporates the most official aspects of religion and society as well as the interests of the people. And they continue to do so. The Blessed Sacrament—resplendent in its monstrance like the sun, like Inti—is solemnly accompanied by the authorities. The virgins and saints are joined in closer union by the entire community, which understands and shares their feelings, because as we know, saints also have their good and bad moments, form relationships, and even give way to excesses of displeasure.

This close communication with the patron saints was always viewed with misgiving by the Church, which perceived that each offering, each prayer, each dance, was more than it appeared. This is why the extirpators of idolatry and remains of paganism searched for "idols behind the altars," as Anita Brenner titled her book of 1929. These remains are as plentiful and clear as those which, in Spain, give life to the popular religiosity that rewards and punishes its saints, praising them or showing them the greatest indifference depending on the favors received, and which abducts its virgins, adorning them and carrying them through the streets among acclamations and praises that would make many strangers blush.

The celebration of Corpus Christi, which Martín helps to organize year after year, is firmly rooted in the popular tradition of Peru and many other Spanish-speaking countries. It was brought to the Andes by the principal figures of the new civil and ecclesiastical power generated by the conquest. Francisco Pizarro himself presided over the procession in Lima as early as 1541, and soon the guilds took over, covering the costs and organizing many of the events. Starting in 1574, each

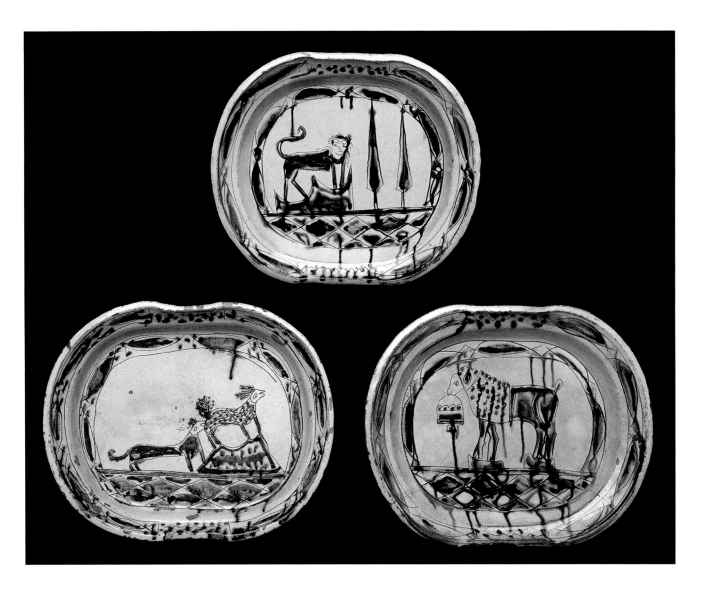

PLATE 72
Three Oval Dishes with Animal Motifs, 19th c.
Guanajuato, Mexico
Glazed and incised earthenware
Each approx. 7 × 8½ in. (18 × 22 cm)
San Antonio Museum of Art, The Nelson A. Rockefeller
Mexican Folk Art Collection

These three glazed dishes are representative of popular ceram-
ics from the region of Dolores Hidalgo. Their shape and
method of production are mainly Spanish, but some of the
design motifs are uniquely Guanajuatan. The drip-glaze
decoration is reminiscent of early Chinese pottery and may
have come into Mexico via Spanish trade with Asia.

PLATE 73
Miguel Martínez,
act. 1900–1934
*Platter with Oriental/Willow
Motif,* c. 1900
Puebla, Mexico
Glazed earthenware
DIAM. 17 in. (43 cm)
San Antonio Museum of Art

This platter brings together
influences from various parts
of the world. The method of
manufacture and shape are
Spanish, the stepped-fret
motif on the outer rim is
Aztec/Mixtec, and, finally,
the "willow" pattern in the
central part of the platter
was probably inspired by
popular English oriental
designs of the nineteenth
century.

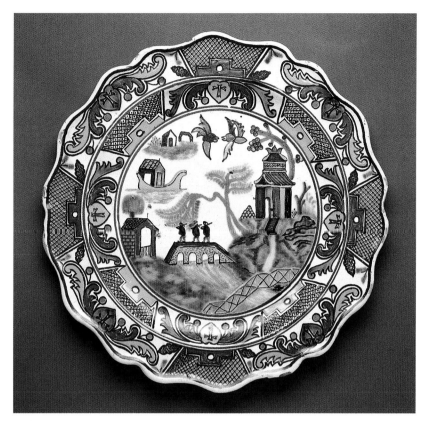

PLATE 74
*Jar with Seated Musician on
Top,* early 20th c.
Pupuja, Peru
Partly glazed earthenware
H. 16 in. (41 cm)
San Antonio Museum of Art

During the colonial period,
the Spanish introduced
glazed earthenware to the
Peruvian communities
around Lake Titicaca and
numerous other places. This
jar was probably used for
chicha, a corn beer favored
by Andean people. Near
the spout is an image of
an indigenous musician.

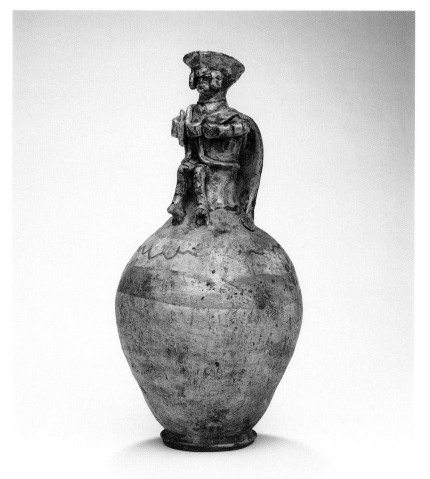

cofradía, or brotherhood, joined the procession together with its patron saint. The mixed composition of colonial society was reflected in the long procession. Virtually from the beginning, indigenous people took an active part in the processions, as did blacks and mulattos, with the images of their own brotherhoods, and with their dances and other performances.

Much closer to Tinta, in Cuzco, the same procession became as important as in the viceregal capital, and as in Lima, the authorities insisted that it should follow the Spanish model. Cuzco, as center of the Inca empire, attached special importance to indigenous presence in a festivity that, in the beginning, was the clearest expression of the essence of the Catholic religion and reflected the structure of society. The indigenous people were not limited to a purely testimonial appearance, nor did they play a secondary role. The parading *curacas* (chiefs) represented many of the regions that, like Quito, now made up the Viceroyalty. They were all obliged to display their joy, and indigenous canticles and dances played an important part, together with the masquerades featuring *gigantes y cabezudos* (Giants and Big-Heads). With their journey to Cuzco, Martín's friends were contributing to the maintenance of a tradition that goes back almost five centuries in America and more than seven in Spain.

Santiago, the image that Martín accompanies through the streets of Tinta, also traveled to Peru and all America in the baggage of the conquistadores, as so many authors have reminded us. In reality, Santiago made his entry by fire and the sword, and rarely dismounted from his horse to present himself in the humble attitude of the pilgrim; sometimes, even the pilgrim Santiago was shown holding a sword in his hand to ensure his defense of the faith. Thus, victorious, trampling on the heads of his enemies, he was installed on the facades of churches, on the altars and altarpieces of their interiors, and in places reserved for private prayer throughout the length and breadth of the viceroyalties. His warrior legend was forged in Spain, giving expression to mythical aspirations for a figure to oppose the Muslim invasion identified with a "holy war." To bring him to life, his appearance at a battle

against the Moors was invented, and so was the battle itself.

This figure always attracts attention, being portrayed in all artistic genres, in all types of material, and throughout the American continent, including settlements with a majority indigenous population, and was defined by the great Spanish thinker, Américo Castro, as one of the pillars of Spanish history. But Castro also reminds us that the figure embodies the pre-Christian myth of Castor and Pollux, the twin sons of Zeus and Leda. They were known as the Dioscuri, and were considered the protectors of the Roman army, on whose behalf they intervened on several occasions, riding spirited white chargers. Their most famous appearance was when they gave victory to Postumus in the battle at Lake Regilus. It was the year 449 B.C., and men were used to counting on the support of divinities to overcome their rivals.

Santiago, or Saint James the Greater, was brother of another Santiago, Saint James the Lesser, an apostle who was traditionally considered a relative or even brother of Christ. This close relationship accentuated Santiago's protagonism in a story that was built up as needed with a patchwork of pieces from here and there, without much regard for accuracy. Though Santiago's existence has been proven, his direct relationship with Spain and with evangelism—his sepulchre discovered in Galicia by means of signs appearing in the firmament—and his transformation into a warrior, are all a mythical elaboration.

And does not this biography clearly demonstrate Santiago's ability to adapt to the needs of every situation? Certainly it does. Thus it is not surprising that he should lend his image to Illapa, the god of thunder of the Peruvian mountain communities. Nor is it any more surprising that he should lend his support to these same mountain people against the Chunchos, their traditional enemies, nor even, no matter how paradoxical it may seem, that he should join with the American armies and appear in the nineteenth century against the Spaniards. Popular culture offers us many examples of all of this.

Certainly nobody stops to tell Martín that every year he carries a very special burden.

Santiago is no longer one of the pillars of Spanish history, but instead the clearest representation of one of the keys of Spanish culture, syncretism. The feast of Corpus Christi and the image of Santiago arrived in America as some of the most prominent symbols of the official culture imposed after the conquest. But in a short time they followed the opposite path to that pursued in the Peninsula centuries before, installing themselves fully in the popular culture—rural and urban, indigenous and mestizo—of the entire continent. There are many other examples of this same process.

In this return journey, Spanish culture is diluted in the American tradition of which it now forms part. Fortunately, it is already *aindiada,* or "Indianized," and like those Spanish soldiers who decided to remain in the indigenous communities, refusing to return with their own people, it clings to American soil resisting any attempt to question its nationality. And rightly so.

BIBLIOGRAPHY

Abellán, José Luis. *Historia crítica del pensamiento español.* Madrid: Espasa Calpe, 1988.

Alvarez Santaló, Carlos, María Jesús Buxo, and Salvador Rodriguez Becerra, eds. *La religiosidad popular,* vol. 1, *Antropologia e Historia.* Barcelona: Antropos—Fundación Machado, 1995.

Castro, Américo. *La realidad histórica de España.* Mexico City: Editorial Porrúa, 1963.

La fiesta en el arte. Exhibition catalogue. Texts by Guillermo Lohmann Villena and Jorge Flores Ochoa. Lima: Fondo Pro-recuperación del Patrimonio Cultural de la Nación, 1994.

Gisbert, Teresa. *Iconografía y mitos indígenas en el arte.* La Paz: Gisbert y Cía., 1980.

Majluf, Natalia. "El indigenismo en México y en Perú: Hacia una visión comparativa." In *Arte, historia e identidad en América: Visiones comparativas.* XVII Coloquio Internacional de Historia del Arte. Mexico City: Universidad Nacional Autónoma de Mexico, Instituto de Investigaciones Etnológicas, 1994.

Oettinger, Marion Jr. *The Folk Art of Latin America: Visiones del Pueblo.* New York: Dutton Studio Books and Museum of American Folk Art, 1992.

La procesión del Corpus en el Cuzco. Exhibition catalogue. Sevilla, 1996.

Stastny, Francisco. *Las artes populares del Perú.* Madrid: Ediciones Edubanco, 1981.

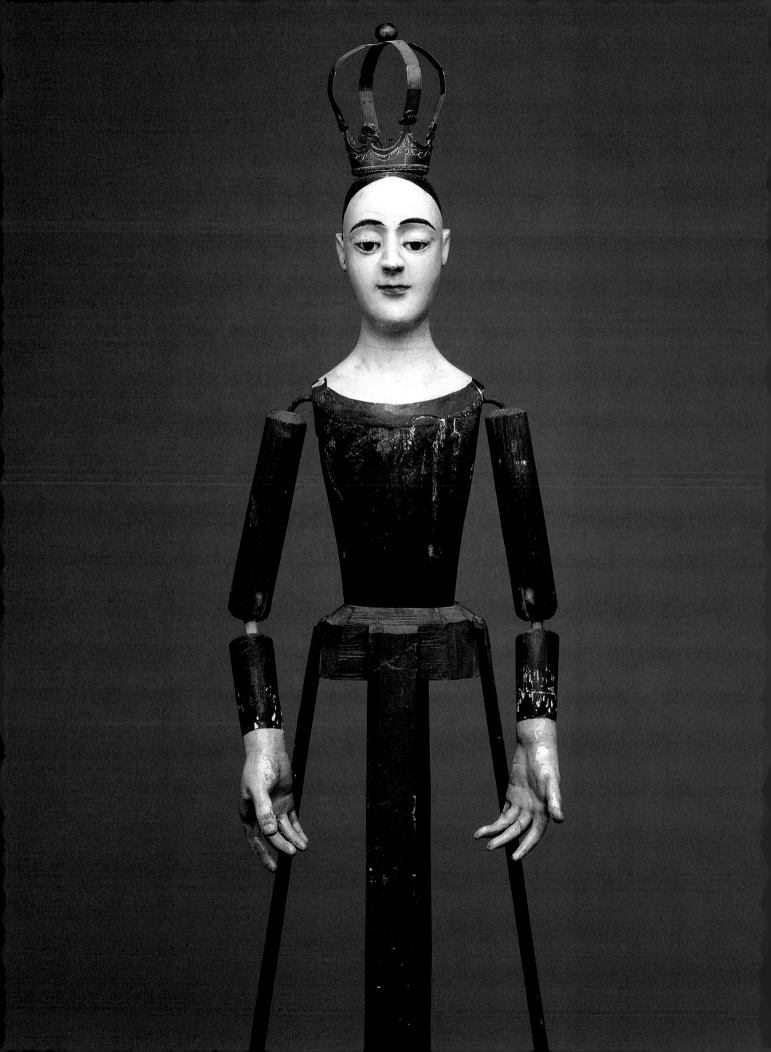

William Wroth

Miraculous Images and Living Saints in Mexican Folk Catholicism

A miracle is an event which breaks the normal order of things. Against all odds, all expectations, the miraculous event comes out of the blue and resolves an apparently hopeless situation. Thus, the miracle almost inevitably has a positive connotation; it is a beneficial occurrence, restoring harmony. The miracle escapes the bounds of rational expectations. We cannot pin it down, we cannot deconstruct it, for by definition its mode of action is beyond our comprehension.

In European and New World Catholicism, paintings and statues of holy personages are among the most important vehicles for miracles. In principle, all sacred images have a beneficial function for the believer. However, certain images have gained the reputation of being particularly efficacious in answering the needs of petitioners and solving apparently unsolvable problems. They gain this reputation in many ways. Some images may themselves be of miraculous origin. Such images in early Christian times were said to be "made without hands," that is, they were of superhuman origin.[1] Others have a miraculous history; they are rediscovered after centuries of loss, or survive calamitous events, or are miraculously renovated after a long period of neglect. A third possibility involves images that at a crucial moment are credited with working a miracle. Whatever its origin, the miraculous image soon becomes the focus of worship. Pilgrims come to seek the help and benediction of the holy personage represented by the image. The worshipers turn to the personage for intercession in spiritual or worldly problems and finally for salvation of the soul.

Not only is the miraculous image a focus for pilgrims, but so are certain places where sacred events have happened. With the emphasis upon sacred history in Christianity, it is not surprising that the earliest pilgrimage destination was the Holy Land. Other early sites include Rome—one word for pilgrim in Spanish is *romero,* one who travels to Rome. Europe is covered with pilgrimage shrines, some with pre-Christian roots, others dating to the first millennium of the Christian era. Important sites in Spain include Santiago de Compostela, where the apostle Saint James the Greater is said to have established the first Christian church on the Iberian peninsula. Other sites include places where a divine personage appeared, or simply mark the location of a miracle-working image. In Spain there are many such shrines dedicated to miraculous appearances and statues of the Blessed Virgin, such as Nuestra Señora de Montserrat (Our Lady of Montserrat), Nuestra Señora del Pilar (Our Lady of the Pillar), Nuestra Señora del Rocío (Our Lady of Rocío), and many others, as well as shrines dedicated to Christ and the saints. Thus the site of the apparition and the place where the image is located become a focus for the faithful and a destination for pilgrimage.[2]

Pilgrimage Shrines in New Spain

The Spanish conquerors brought the Catholic religion to the New World and with it the devotion to miraculous images. In New Spain by the end of the first century of the Conquest pilgrimage churches containing miraculous images were to be found all over the colony, from the northern frontier of Mexico (now the southwestern

PLATE 75
Standing Figure of the Virgin
18th c.
Mexico
Polychromed wood, glass
40 × 12 in. (102 × 31 cm)
Randy and Carol Jinkins,
San Antonio

As in Spain, American images of the Virgin Mary were often made to be dressed by women appointed to do so. In Mexico, New Mexico, and other places, it was customary to carve only the upper portion of the Virgin's body.

159

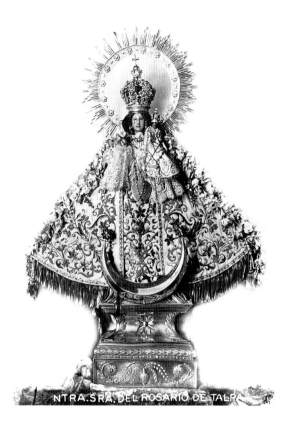

FIGURE 23
*Miraculous Image of Our
Lady of Talpa,* 17th c.,
Jalisco, Mexico

United States) to the southern reaches of today's Guatemala. The same advocations that were popular in Spain were revered in New Spain: The Blessed Virgin Mary, often as Nuestra Señora del Rosario (Our Lady of the Rosary) or La Inmaculada (Our Lady of the Immaculate Conception), and Christ in his suffering or Christ crucified were the most frequently found miraculous images. But in some cases popular saints, such as the Franciscan San Antonio (Saint Anthony) and the Jesuit San Francisco Javier (Saint Francis Xavier), gained reputations as miracle workers.

In the New World miraculous images and their shrines had the same kinds of origins as those of the Old World. The prime example of the image "made without hands" in Mexico is that of Nuestra Señora de Guadalupe (Our Lady of Guadalupe) who, according to tradition, in 1531 appeared to an Indian laborer, Juan Diego, at Tepeyac, a former shrine to the Aztec mother goddess Tonantzin. The miraculous painting of her appeared spontaneously on Juan Diego's cloak after the Blessed Virgin had filled his cloak with flowers to take to the bishop as a sign that the apparition was real.[3]

A typical example of an image miraculously restored is Nuestra Señora de Talpa (Our Lady of Talpa) in the remote Indian community of Talpa,

now in the state of Jalisco (fig. 23). The priest in the community, Pedro Rubio Felix, had ordered the destruction of several statues on the altar of the church because of their decayed condition. When the Indian woman who took care of the altar started to remove a small statue of Nuestra Señora del Rosario, "suddenly there was such a brilliant radiance issuing forth from the image that it dazzled and knocked [her] down." The decrepit statue was miraculously transformed into a newly radiant piece. The priest, duly notified, found further confirmation of the miracle in the candles he brought and placed before Our Lady, which did not burn down for many days. The site soon began to attract pilgrims, and in 1750 a larger church, still in use today, was built. By the early twentieth century, fifty to one hundred thousand pilgrims were making the difficult journey to Talpa every year.[4]

The third type of image that gains its reputation through miracles attributed to it is exemplified in Mexico by Nuestra Señora de San Juan de los Lagos (Our Lady of San Juan de los Lagos). In 1623 this small statue of La Inmaculada was on the altar in the hospital chapel in the Indian village of San Juan Bautista de Mezquititlán, now the city of San Juan de los Lagos, Jalisco. A family of acrobats was performing in the area and one of the daughters was apparently fatally injured during a performance by falling upon a dagger. She was wrapped in a burial shroud and her lifeless body was taken to the chapel, where many of the Indians gathered for the burial. There an elderly Indian woman said to the parents that

> *la Cihuapilli* [the Virgin] would give life to the girl . . . and she took this blessed image that today is so miraculous, and put it on the breast of the dead girl, with unwavering faith and resolution. And in a little while everyone present . . . saw the girl stir and move about. They quickly cut the ties of the winding sheet and took it off her, and she who was dead immediately got up fit and healthy, a rare marvel.[5]

This first miracle was soon followed by others, and the somewhat decrepit statue was restored and placed on the altar of the church, where it has remained ever since as one of the most popular images of the Virgin Mary in Mexico.

All three of the above examples involve

Indians, who made up the vast majority of the population of New Spain. Indians often played an important part in the origin of miraculous images, and veneration of these images and pilgrimages to the shrines still play a large role in the lives of many Mexican Indian groups. In the origin of some images, such as La Virgen de Guadalupe and La Virgen de Ocotlán, the Blessed Virgin appeared to a Christianized Indian at or near a former shrine dedicated to an indigenous goddess. Near the city of Tlaxcala, La Virgen de Ocotlán appeared to Juan Diego Bernardino on 12 May 1541, close to the ruins of the shrine of Xochiquetzalli, a beneficent mother goddess of the Tlaxcalan Indians. In both Guadalupe and Ocotlán, Our Lady asked that a church be built for her on the site of the former pagan shrine. These events may be interpreted in various ways, but from the point of view of the Christianized Indians, the miraculous appearance of Mary provided a continuation of the divine blessings granted them by the goddesses of the indigenous religion. Mary simply was the goddess appearing in another form. The often expressed idea that these events were engineered by the Catholic Church to bring more Indians into the fold overlooks the serious consequences and problems which miraculous cults had for the Church. To say the least, the miraculous appearances were a two-way street; the Indians utilized them for their own ends, perhaps more effectively than did the clergy.[6]

In the conversion of the indigenous populations to Christianity, the goal of the missionaries was to establish Catholic doctrine and practices and to stamp out every vestige of the native religions. While almost all of the sedentary groups in New Spain were converted to Christianity, it was not a simple matter to change the worldview of entire populations, and the indigenous worldview was decidedly different from the European; these differences had and still have a considerable impact upon the question of miraculous images.

The European Catholic view emphasizes the transcendent aspect of divinity: God the Father so totally transcends the world that the latter has no real existence of its own. This view downplays the participation of the divine in the world. The emphasis is upon the Revelation, especially the Incarnation of Christ, a historical event in which Heaven touched earth. While in principle the created world is sacred because it was made by God, in fact there is little interest in Christian doctrine in the sacredness of manifested phenomena. After the Incarnation, the major opportunity for God's presence to be felt in the world is through miracles in which Heaven acts directly, breaking through the natural order of things. But due to the Christian emphasis on transcendence, the Catholic Church has often reacted with ambivalence to miraculous images and places, especially in the New World, where the authorities were constantly vigilant against the return of pre-Christian practices. It was feared that the cult of saints and the enthusiasm among indigenous populations for miraculous images and shrines could lead to pantheism and the worship of images.

A typical example of this attitude in Mexico is that of the sixteenth-century Franciscan Fray Maturino Gilberti, who warned the Tarascan Indians:

> We do not worship any image, even though it be that of the Crucifix or St. Mary, for when we represent the Crucifix or St. Mary or the Saints [in an image] it is only to remind ourselves of the great mercy of God . . . although we kneel before the Crucifix in an attitude of worship, it is nevertheless not the Crucifix that we worship, for it is only made of wood, but God Himself, Our Lord who is in Heaven.[7]

Similar attitudes were expressed by Fray Francisco de Bustamante and other Franciscans in 1556 who attacked the Church's support of the new popular cult of La Virgen de Guadalupe. Bustamante stated that the painting of Our Lady was not miraculous but rather was painted by an Indian, and he criticized Archbishop Montúfar for fostering this dangerous cult that he felt was simply disguised idolatry. Fray Alonso de Santiago, in the same complaint, stated that the Indians believed the painting of La Virgen de Guadalupe was the Virgin herself and they worshiped her as an idol.[8]

This attitude indicates lack of understanding and fear of the religious concepts of the Indians. The emphasis in indigenous thought is upon divine immanence: The divinity is found within every created object, every occurrence, every action, every moment. Thus the sacred is not separated from everyday life. The indigenous view is immanentist and Platonic: It sees the

"metaphysical transparency of phenomena": Objects contain and transmit a divine reality. This attitude made it possible for the Indians to enthusiastically embrace aspects of Christianity without actually converting to it. Church authorities from the beginning have been confounded by the apparent conversion of the Indians, only to discover again and again that they are still practicing certain aspects of their old religion. Their worldview is not exclusive, and they can incorporate aspects of Christianity into their own religious practices. The spiritual power of Christian objects, such as images, is acknowledged, respected, and utilized.

The misunderstanding of the Christian missionaries was to think that the Indians, in their enthusiasm for miraculous images, were worshiping idols. The essence of what constitutes the miraculous image was well expressed in the Neoplatonic attitudes of the early Christian era. All sacred images embody to some extent the spiritual qualities of the personage depicted. The miraculous image is a particularly powerful embodiment of these qualities as evidenced by the miracles attributed to it. If the archetype that the image depicts is a source of spiritual power, then the image also shares in that power. To worship the image, then, is to worship the archetype in a specific material form. Thus the Indians were not worshiping pieces of wood, which would be a senseless activity, but rather had and still have a Platonic view (although they would not use this term) that clearly sees the archetype as such, but just as clearly sees that the archetype is truly present in the "piece of wood."

In Europe, by the late Middle Ages, Catholic thought had retreated from the Neoplatonic view. Sacred images were viewed primarily as objects of devotion and education. Devotional images provided a focus or means of visualization for the worshiper to direct prayers and petitions to the holy personage depicted, and didactic images were used in teaching the elements of Christian doctrine and the lives of Christ, Mary, and the saints. A third use of images combined the didactic and devotional: The processions in which statues and paintings were carried to celebrate important holy days, often commemorating events in the life of Christ.

In New Spain there was the constant fear that the plethora of Catholic saints were not seen by the Indians simply as intermediaries between human beings and God, but rather as a pantheon of deities similar to and perhaps in some sense replacing their indigenous deities. Thus in Tlaxcala the Indians could identify San Bernardino of Siena with their god Camaxtli, who is depicted holding a solar disc against his chest, because San Bernardino also holds a solar disc in which is inscribed the holy name of Jesus.[9] The missionaries, in acceding to this identification and perhaps even encouraging it, were hoping to use the saints to lead the Indians from pantheism to the Catholic belief in the preeminence of the Christian God. The supposed "sun worship" represented by the solar disc of Camaxtli would be replaced in time by worship of Christ, whose name is inscribed on the disc held by San Bernardino.

The extent to which the missionaries were successful in these endeavors was always in doubt by both Church authorities and outside observers and continues to be an open question to the present time. James Griffith reports that in the 1940s when a priest visited a sick child in a Tohono O'odham (Papago) home in Arizona he noticed a print of San Francisco Javier hanging in the room. San Francisco, patron of the pilgrimage church of Magdalena, Sonora, is the most revered saint among the O'odham because of his miracles. The priest asked whom the picture depicted and an elderly man replied, "God."[10] The Indians were not confused or too unintelligent to understand Christian concepts, but had a larger view, which saw God everywhere and in everything. This view continues to permeate Mexican Catholic practice in the present day: "We see God in the beauty around us. He is in the water, the mountains, and the smallest of the plants. We live with God while the Anglos lock him into Heaven."[11]

The continuum between idolatry at one extreme and iconoclasm at the other has a long history in Christianity because of the periodically raised apprehension that naive or newly Christianized people might be prone to idol worship. Throughout European history, although most of the peoples of western Europe were converted by the year 1000, pre-Christian elements continued to figure in practices in rural areas, and most importantly, a premodern Platonic worldview survived in which images were seen as containing the divine presence. In the Middle Ages, as Gurevich notes, Church spokesmen repeatedly

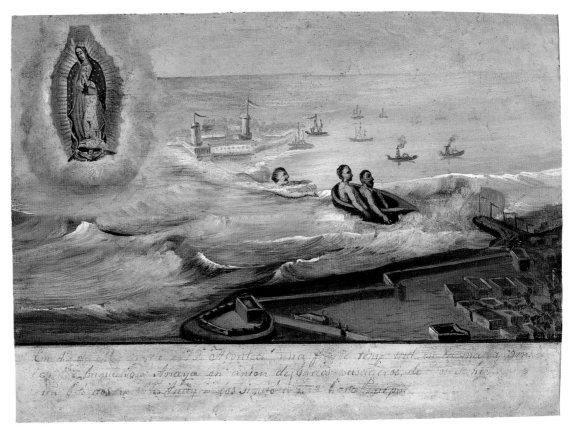

PLATE 76
Ex-voto to Nuestra Señora de Guadalupe (Our Lady of Guadalupe) Saving Sailors
1879
Mexico
Oil on tin
10 × 14 in. (25 × 35 cm)
August Uribe, New York

Votive paintings have been popular in Spain for over five hundred years. The tradition was brought to the Americas soon after the European contact and was immediately adapted to events and places in Mexico, and Central and South America. In this dramatic painting, sailors, ship-wrecked at sea, are saved off the coast of Veracruz by the miraculous intervention of the Virgen de Guadalupe.

PLATE 77
Ex-voto of Man Being Beaten, 19th c.
Mexico
Oil on tin, approx. 6 × 12 in. (15 × 30 cm)
August Uribe, New York

declared that the age of miracles was long past, and "various members of the clergy . . . spoke out against what they considered to be the excessive spread of the cult of the saints and the veneration of relics, seeing in them a rebirth of pagan idolatry, but these appeals had no serious effect."[12]

The Church in Europe was gradually able to cope with these survivals, often by allowing them to be informally incorporated into the body of Christian practice:

> In Spain "devils" dance in churches in some fiestas, devotees walk barefoot over live coals, maidens stick pins in images of the Virgin, a representation of a saint may be hung upside down in a well. . . . These, and other practices, must represent survivals from pre-Christian times, customs which the Church "captured" and brought within its own body of belief, as the most effective means of coping with the problem of conversions.[13]

Whether the Church actively "captured" these survivals or simply tolerated them because it had no choice is a matter of dispute, but in both Europe and the New World pre-Christian local practices survived. Some were hidden and caused consternation and scandal when exposed; others were open and became part of a syncretic religious practice that differed sometimes slightly, often markedly, from official Catholic doctrine.

The Indians of New Spain certainly added their own flavor to the Christian practices introduced by the Spaniards. We can trace indigenous elements such as music and dance forms performed on holy days at the churches, style and motifs in church decoration and images, and a certain familiarity with images, which includes their magical uses. In some isolated places where clerical supervision was sporadic or nonexistent for long periods of time, a syncretic religious form arose in which native and Christian elements were blended. However, what is essential in the miraculous occurrence is the presence of divine grace, defying all expectations and surface appearances. Miracles take the same form and have the same result in both the Old World and the New, unaffected by cultural differences. Similarly, with regard to the miraculous image, the indigenous response did not add anything new

but rather affirmed something old and something universal among traditional peoples, the early Christian and pre-Christian view that the image was efficacious because it truly reflected the essence and power of the archetype.

Mexican Folk Catholicism in the Twentieth Century

The syncretic or folk Catholicism which now permeates the religious practices of Mexico and the border regions of the United States embodies the indigenous and the pre-Christian view that "God is everywhere" and not just within the confines of the church and its canonical observances. For instance, as James Griffith has demonstrated, the Tohono O'odham (Papago), Yoeme (Yaqui), and other groups in the borderlands combine indigenous and Christian practices into one entity which permeates all aspects of their lives. The O'odham revere and make pilgrimages to natural sites made sacred in their traditional indigenous history. They also make pilgrimages to the miraculous statue of San Francisco Javier in Magdalena, Sonora, and to other representations of this saint in Chuwhiy Guwsk (San Francisquito), Sonora, and in the Church of San Xavier del Bac near Tucson. In their communities in Arizona they have their own chapels built in the 1800s, when they were not ministered to by the Catholic Church, where they practice a mixture of indigenous and Christian ceremonies. They also have a parallel series of churches built by Catholic missionaries in the early twentieth century, where more orthodox Catholic observances take place. In addition, many roadside, hilltop, backyard, and family shrines (often including a small image of San Francisco Javier) are to be found in active use throughout the O'odham landscape.[14]

The sacredness of natural features of the landscape has seldom played a role in official Catholic practice, and in fact has usually been treated as a negative aspect of indigenous and pre-Christian religions.[15] For indigenous groups in Mexico and elsewhere, the indwelling sacredness of natural phenomena has always been of central importance. In some cases, such as the shrine to La Virgen de Guadalupe on the hill of Tepeyac, the Church was able to transform

indigenous sacred places by building churches on them. But the missionaries' efforts to destroy "pagan" shrines could only affect images and man-made structures; thus natural features such as mountains, lakes, and springs continued to play a role in indigenous religious practices. As Coleman and Elsner point out (with regard to the Indians of Peru, but the observation is equally valid for Mexico): "Missionaries may have done their best to destroy pagan shrines but they did not take into account the fact that, according to indigenous cosmology, the sacred quality of the landscape was more important than mere effigies. By planting crosses on pagan shrines and sites, Christians merely succeeded in confirming the sacred status of these places in the eyes of the local people."[16]

Much of the fervor of the faithful in Mexico has focused upon the lives of past saints and divine personages represented by their images and the shrines dedicated to them, but spirituality is above all a living process involving the events of the present. Since the early Christian era, believers not only have worshiped before miraculous images of deceased saints and holy personages but also have sought the blessing of living saints. These individuals have gained a reputation for sanctity and for working miracles, and during their lifetimes they have often attracted vast numbers of pilgrims. They do not necessarily receive the official sanctification of the Church; if they do, it may be years, even centuries, after their death because the Church moves slowly and cautiously on issues of sanctification. For instance, Padre Pio, the Italian stigmatist and follower of Saint Francis of Assisi, died in 1968 and has not yet been canonized by the Church. During his lifetime he was considered by a large following to be a living saint, and his town of San Giovanni Rotondo remains an important destination for pilgrims. The living saint is a phenomenon that cannot be predicted or planned for, and he or she may exist in isolation or even opposition to the official practices of the Church:

> Pio thus represents a particular strand in popular religion (not only in Christianity, but also in other religious traditions such as the sufi strain of Islam or Hassidic Judaism)

whereby a charismatic and miracle-working individual proves a focus for devotion which by-passes and may even conflict with the authority of the hierarchy.[17]

In twentieth-century Mexico, pilgrims continue to visit the traditional miraculous shrines, but they are also attracted to the charisma of living saints. While some living saints may have been members of the church hierarchy, more often than not they are lay people who have developed a reputation for sanctity, often combined with an ability to heal spiritual and physical ills. Members of the clergy, in contrast to popular lay healers, are sometimes seen only as bureaucrats responsible for the official workings of the Church. Although they are respected, they are often viewed as being out of touch both with Heaven and with the daily concerns of the people:

> Take Doña Toribia, the curer. Where does she get her wisdom? Straight from God Himself. She can talk with God, so there is no need for her to read the inaccuracies of men's words. Therefore, she knows God's will better than the priest. When one wants help from God, one should go to some one who knows Him. The priest's duty is to say mass. He runs the machinery of the church. He does not see the trouble of one's soul.[18]

When a folk healer can talk with "God Himself," he or she may become a channel for divine grace and provide a form of healing that deals both with "the trouble of one's soul" and with physical ailments. This combination defines a living saint, for there are numerous healers—from professional doctors to lay practitioners—who heal only the body. Popular thought in Mexico and elsewhere makes less of a distinction between body and soul than does the rationalist modern world, so that healing the soul as well as the body is seen as a necessity for true health, and it raises the estimation of the healer in the eyes of followers. Individuals such as Teresita Urrea of Cabora, Sonora, and Niño Fidencio Constantino of Espinazo, Nuevo León, attracted followers not only for their healing miracles but also for the beneficial effect their sanctity had on the souls and bodies of those who sought them.

The Santa of Cabora, Teresita Urrea, at age seventeen, after twelve days in a comatose state in which she was thought to be dead, had a vision of the Blessed Virgin, who told her to use her nascent healing powers for the good of all who came to her. It was said that her eyes and voice and the touch of her hand all had a tremendous healing power, and that after her vision her body emitted a delicate fragrance with healing qualities. She was also said to have the power of prophecy. In a sense she was the living symbol of the blending of European and Indian in Mexico. Teresita was born in 1873; her father was a wealthy *hacendado* (landowner) of Spanish heritage and her mother an Indian of the region. But unlike most children of such a union she was raised by her father and after her vision continued to have his support.

The rural folk of northern Mexico, especially the Mayo and Yaqui Indians as well as countless mestizos, flocked to Teresita, who became, in a sense, their patroness. Pilgrims to her home in Sonora carried banners emblazoned with her name and wore large scapulars with "Hail Blessed Teresita" on one side and "The Great Power of God Rules the World" on the other. Broadsides were printed, similar to those for more orthodox Catholic saints, with prayers and petitions to "La Santa de Cabora." And like a traditional saint, Teresita humbly attributed all her powers to God: "I feel it [the power to heal] is given me from God. I believe God has placed me here as one of his instruments to do good." Her spiritual message was equally simple yet to the point: "I felt in me only the wish to do good in the world. I spoke much to the people about God—not about the church, or to tell them to go to church, but about God. I told them what I believe: that God is the spirit of love; that we who are in the world must love one another and live in peace; otherwise we offend God."[19]

Government officials soon became apprehensive because of the tremendous devotion Teresita inspired among the Indians and Mexican rural people. In 1892 the Mexican government decided she was responsible for stirring up the Mayos and Yaquis as well as the independent-minded people of the mestizo settlement of Tomochic, and they banished her to the United States, where she died in Clifton, Arizona, in 1906.

The life of Niño Fidencio Constantino connects the cult of the living saint with those of past saints worshiped through images. Born in 1898 in the state of Guanajuato, Fidencio came to Espinazo as a youth to work on a hacienda. Fidencio was a humble, unassuming young man who quickly became known for miraculous healings, attracting a huge following to his isolated home. He virtually wore himself out by healing everyone who came to him, night and day, dying in 1938 at the age of forty. According to Jacobo Dalevuelta, a journalist who met him shortly before his death,

> Fidencio has the character of a good man. His countenance is that of infinite goodness and of sweetness. He lives like a child, he speaks like a child. His body and his spirit are dedicated to the service of all the sick people.

A priest who knew him also wrote:

> Fidencio is a humble man. He applies his healing remedies simply, sincerely, without talking about them. He is not looking for money or fame. I have seen him refuse a large sum of money offered by one of his grateful patients. He takes the money he needs to live and prepare his medicines. That is why Fidencio is famous. I know that many poor people have received help from this extraordinary man.[20]

Fidencio's work has been kept alive by his followers throughout a large area of northern Mexico and the border regions of the United States. The isolated ranch at Espinazo where he lived and was buried is today an important pilgrimage shrine, especially in October, during the festival held there every year. Inspired by his purity of intention and selflessness, his followers act as mediums for his healing power, and in a variety of unorthodox practices they continue to effect cures. What has saved the Fidencistas from becoming an isolated cult of personality and has kept them active and expanding for fifty-nine years since the Niño's death is their purity of intention and the iron faith they have that God is the source of the good that they transmit. As one follower stated, "Understand first that it is

God that is doing everything, and [the] Niño is here because of God."[21]

Since the death of the Niño Fidencio, images have played an important part in the propagation of his cult. Photographs taken during his lifetime and upon his death are the prized possessions of every follower, and some of them replicate traditional Catholic devotional images depicting the Niño in poses reminiscent of Nuestra Señora de Guadalupe, the Sacred Heart of Jesus, Christ in His suffering, and even San Francisco Javier. One popular image is a photograph of the Niño posed in the traditional manner of Christ displaying His Sacred Heart and superimposed upon the aureole of rays which frames the figure of Nuestra Señora de Guadalupe. This remarkable combination not only identifies the Niño with the Sacred Heart of Jesus, but also depicts him as the child of Nuestra Señora de Guadalupe; indeed, he is called El Niño Guadalupano by his followers.[22]

While this essay has discussed specific transformations that have taken place in the transmission of European Catholicism to the New World, what is essential in miraculous pilgrimage sites and images has resisted transformation. The history and role of miraculous shrines are remarkably consistent the world over. Cross-cultural pilgrimage studies covering such diverse religions as ancient Greek, Hinduism, Buddhism, Islam, Judaism, and Christianity, as well as Native American, show very similar activities and attitudes in regard to miraculous shrines and their contents. The nature of the miracle is to break the bounds of time, space, and exterior conditions, including formal societal boundaries such as class, race, and economic status. In fact, in rigidly class- or caste-bound societies, the activities of pilgrims are often far more egalitarian than those of the populace at large. The miracle by its very nature demonstrates that what is essential in all religions—the divine presence acting in the human realm—is universal and transcends all the external differences amongst peoples.

NOTES

1. On miraculous early Christian images "made without hands," see William Wroth, *Christian Images in Hispanic New Mexico: The Taylor Museum Collection of Santos* (Colorado Springs: The Taylor Museum of the Colorado Springs Fine Arts Center, 1982), 6–7.

2. For a discussion of the varied origins of European pilgrimage shrines, see Mary Lee Nolan and Sidney Nolan, *Christian Pilgrimage in Modern Western Europe* (Chapel Hill: University of North Carolina Press, 1989), 216ff. The works of William A. Christian, Jr., are useful for pilgrimage and other expressions of popular religion in Spain. See especially, *Local Religion in Sixteenth-Century Spain* (Princeton: Princeton University Press, 1981), and his recent *Visionaries: The Spanish Republic and the Reign of Christ* (Berkeley: University of California Press, 1996).

3. The literature on Our Lady of Guadalupe is voluminous. A typical example, in which the earliest documents are transcribed and translated, is Samuel Martí, *The Virgen* [*sic*] *of Guadalupe and Juan Diego: Historical Guide to Guadalupe* (Mexico City: Ediciones Euroamericanas, 1973). For a recent revisionary study, see Stafford Poole, *Our Lady of Guadalupe: The Origins and Sources of a Mexican National Symbol, 1531–1797* (Tucson: University of Arizona Press, 1995).

4. The account of the miraculous restoration of the statue was written by the priest Pedro Rubio Felix in 1644 and is preserved at the church at Talpa. It is transcribed in Rubén Vargas Ugarte, *Historia del culto de María en Iberoamérica y de sus imágenes y santuarios más celebrados,* vol. 1 (Madrid:

1956), 286–88. It is translated in William Wroth, *The Chapel of Our Lady of Talpa* (Colorado Springs: The Taylor Museum of the Colorado Springs Fine Arts Center, 1979), 75–76.

5. Report of Lic. D. Juan Contreras Fuerte, commissioned in 1634 by Bishop D. Leonel Cervantes Carbajal to investigate the origin of the miraculous image of Our Lady of San Juan de los Lagos, transcribed in Presb. Fernando Vargas, *La Santísima Virgen de Sn. Juan de los Lagos y su Insigne Catedral Basílica: Su origen, su historia, su personal* (San Juan de los Lagos, Jalisco, Mexico, 1976), 3–4.

6. On Our Lady of Ocotlán, see Hugo G. Nutini, "Syncretism and Acculturation: The Historical Development of the Cult of the Patron Saint in Tlaxcala, Mexico (1519–1670)," *Ethnology* 15, no. 3 (July 1976):301–21. See also, N. Quirós y Gutiérrez, *Historia de la Aparición de Nuestra Señora de Ocotlán y su culto en cuatro siglos (1541–1941)* (Puebla, Mexico, 1941). The identification of Our Lady of Guadalupe with the mother goddess Tonantzin at Tepeyac was first discussed by Fray Bernardo de Sahagún writing in 1576. See his *Historia general de las cosas de la Nueva España,* vol. 3 (Mexico City: Editorial Porrúa, 1981), 352, cited by Poole, *Our Lady of Guadalupe,* 78.

7. Transcribed in *Libros y libreros en el siglo XVI* (Mexico City: Publicaciones del Archivo General de la Nación, no. 6, 1914), quoted in Robert Ricard, *The Spiritual Conquest of Mexico* (Berkeley: University of California Press, 1966), 103, a translation of his *Conquete Spirituelle du Mexique* of 1933. Gilberti, in stating that the sacred image is "only made of

wood," approaches the familiar iconoclastic Protestant criticism of Catholics that, in their devotion to Jesus, Mary, and the saints, they worshiped blocks of wood and thus were idolaters. Gilberti's view was too extreme for some Church authorities in New Spain who suspected him of Protestantism and brought him before the Inquisition, a trial which went on for seventeen years (Ricard, *Spiritual Conquest,* 59–60).

8. Ricard, *Spiritual Conquest,* 189.

9. Nutini, "Syncretism and Acculturation," 307–8, discusses the identification of San Bernardino with Camaxtli, but cannot account for it. San Bernardino holding the solar disc inscribed with the name of Jesus is illustrated and discussed in William Wroth, *Images of Penance, Images of Mercy: Southwestern Santos in the Late Nineteenth Century* (Norman: University of Oklahoma Press, 1991), 14. A painting of San Bernardino in the church of San Xavier del Bac near Tucson depicts him in a form quite similar to the Tlaxcalan image with the name of Jesus above a fiery solar disc painted on his chest. He points to the name with one hand and the disc with the other, thus symbolically identifying Christ with the sun (illustrated in Bernard Fontana, "Biography of a Desert Church: The Story of Mission San Xavier del Bac," *The Smoke Signal* [spring 1996], 60).

10. James S. Griffith, *Beliefs and Holy Places: A Spiritual Geography of the Pimería Alta* (Tucson: University of Arizona Press, 1992), 59–60. Charles Gibson describes missionary fears regarding the worship of saints in *The Aztecs Under Spanish Rule: A History of the Indians of the Valley of Mexico, 1519–1810* (Stanford: Stanford University Press, 1964), 100, and he notes that as late as 1803 "one entire town in the valley [of Mexico] was found to be worshiping idols in secret caves" (p. 101).

11. William Madsen, *The Mexican-Americans of South Texas* (New York: Holt, Rinehart and Winston, 1964), 17.

12. Aron Gurevich, *Medieval Popular Culture: Problems of Belief and Perception* (Cambridge: Cambridge University Press, 1990), 43.

13. George M. Foster, *Culture and Conquest: America's Spanish Heritage* (New York: Wenner-Gren Foundation, 1960), 165.

14. Griffith, *Beliefs and Holy Places,* 67–99. See also Henry F. Dobyns, "*Do-It-Yourself* Religion: The Diffusion of Folk Catholicism on Mexico's Northern Frontier 1821–46," in N. Ross Crumrine and Alan Morinis, eds., *Pilgrimage in Latin America* (New York: Greenwood Press, 1991), 53–68. The amalgam of indigenous and Christian elements has not always been readily recognized, especially in both popular and scholarly thinking concerning the American Southwest. Pueblo Indians in New Mexico are often characterized as practicing, in spite of four hundred years of Hispanic

presence, a fairly pure indigenous religion and only accepting Catholicism out of necessity, while Hispanic settlers are viewed as practicing a purely European Catholicism. To date there has been no in-depth study of Pueblo Indian Catholicism, and the Mexican and Indian influences on Hispanic practices are largely ignored.

15. The Irish were exceptional among early Christians in their sensitivity to the sacredness of nature. See Alwyn and Brinley Rees, *Celtic Heritage: Ancient Tradition in Ireland and Wales* (New York: Grove Press, 1961) and also Nolan and Nolan, *Christian Pilgrimage,* 291–92.

16. Simon Coleman and John Elsner, *Pilgrimage Past and Present in the World Religions* (Cambridge, Mass.: Harvard University Press, 1995), 127.

17. Coleman and Elsner, *Pilgrimage Past and Present,* 132. See also, among other works on Padre Pio, Clarice Bruno, *Roads to Padre Pio* (Rome: Citta Nuova, 1969).

18. Anonymous informant in south Texas quoted in Madsen, *The Mexican-Americans of South Texas,* 58.

19. Interview with Teresita Urrea by Helen Dare in the *San Francisco Examiner,* 27 July 1900, reprinted in William Curry Holden, *Teresita* (Owing Mills, Md.: Stemmer House, 1978). See also Barbara June Macklin and N. Ross Crumrine, "Three North Mexican Folk Saint Movements," in *Comparative Studies in Society and History* 15, no. 1, 89–105, and Mario Gill, "Teresa Urrea: La Santa de Cabora," *Historia Mexicana* (October 1956–June 1957), 626–44.

20. Quoted in Dore Gardner, *Niño Fidencio: A Heart Thrown Open* (Santa Fe: Museum of New Mexico Press, 1992), 67. See also Barbara June Macklin, "El Niño Fidencio: Un estudio del curanderismo en Nuevo Leon," in *Anuario Humánitas* (University of Nuevo Leon, 1967), and Macklin and Crumrine, "Three North Mexican Folk Saint Movements."

21. Gardner, *Niño Fidencio,* 105.

22. Kay F. Turner, "'Because of this Photography': The Making of a Mexican Folk Saint," in Gardner, *Niño Fidencio,* 120–34. Early in their careers both Teresita and Fidencio were eagerly embraced by the spiritist movement in Mexico, which no doubt had an effect on their lives and work as well as on how their actions and words have been reported. For instance, one of the few contemporary sources on Teresita is an article in the Mexican spiritist periodical, *La Ilustración Espirita* 13, no. 10 (1891), cited extensively and uncritically by Macklin and Crumrine, "Three North Mexican Folk Saint Movements." On the role of occultism in twentieth-century Mexican folk medicine, see Robert T. Trotter and Juan Antonio Chavira, *Curanderismo: Mexican American Folk Healing* (Athens: University of Georgia Press, 1981).

Throughout this plate section, examples of artwork show the transformation of objects and images as they were re-created in the Americas. In many instances, New World objects are paired with their Spanish prototypes to directly illustrate their similarities and innovations.

PLATE 78
Sant Isidro Llaurador (Saint Isidore the Farmer), 1877
Barcelona, Spain
Woodcut
12 × 8½ in. (31 × 21 cm)
San Antonio Museum of Art

San Isidro Labrador was a twelfth-century farmer from Madrid. A devout Christian, San Isidro spent long hours in service to the Church, much to the detriment of his work in the fields. His employer, Vargas, pressured him to attend to his employment. Miraculously, God sent an archangel to assist with his plowing. In the present example, we see San Isidro standing before a kneeling Vargas while his wife, María Cabeza, spins thread behind him. In the background, the archangel Michael plows the field.

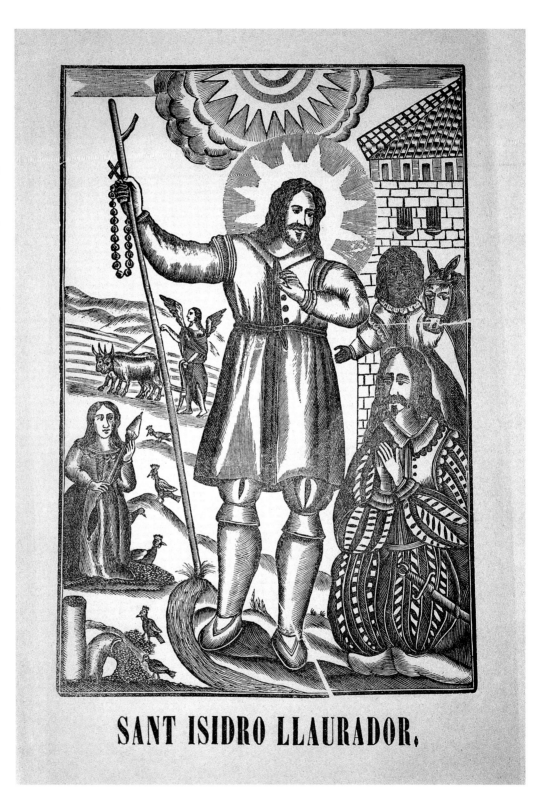

SANT ISIDRO LLAURADOR,

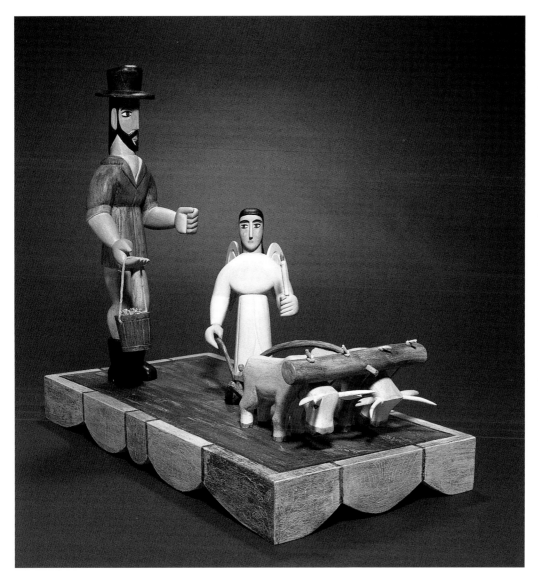

PLATE 79
Jerry Sandoval, b. 1955
*San Isidro Labrador (Saint
Isidore the Farmer),* 1994
New Mexico
Painted wood
19 × 23½ in. (48 × 60 cm)
San Antonio Museum of
Art, purchased with funds
from Friends of Latin
American Art in memory of
Ted Warmbold

San Isidro Labrador is still
very popular in strongly
agricultural northern New
Mexico, and his image is
found throughout the re-
gion. Villages such as San
Isidro Tezuque carry his
name and proudly celebrate
his feast day on 10 May.
Wooden religious statuary
in Hispanic New Mexico
has a look all its own, per-
haps due to its past isolation
from mainstream America
and resulting influence from
Native American popula-
tions of the region.

PLATE 80
*San Isidro Labrador
(Saint Isidore the Farmer)*
Early 20th c.
Paraguay
Painted wood, approx.
10 × 14 in. (25 × 35 cm)
Peter P. Cecere, Reston,
Virginia

PLATE 81
Joaquín Castañón,
act. late 19th c.
San Isidro Labrador (Saint Isidore the Farmer), 1866
Bolivia
Oil on canvas, 72 × 57 in.
(182 × 145 cm), unframed
San Antonio Museum of
Art, purchased with funds
from the Roy C. and Lillie
Cullen Endowment Fund

In this powerful painting of San Isidro Labrador, one can see how thoroughly images are transformed in the quest for local acceptance. Here, San Isidro is dressed, not as a twelfth-century Spanish farmer, but as a nineteenth-century Bolivian hacienda owner. Surrounding this imposing figure are scenes showing miracles attributed to San Isidro. In the space remaining, we are presented with a microcosm of nineteenth-century Bolivia —local ethnic groups, regional dress, jungle toucans and monkeys, high-altitude camelids, and dozens of other elements typical of the Bolivian landscape.

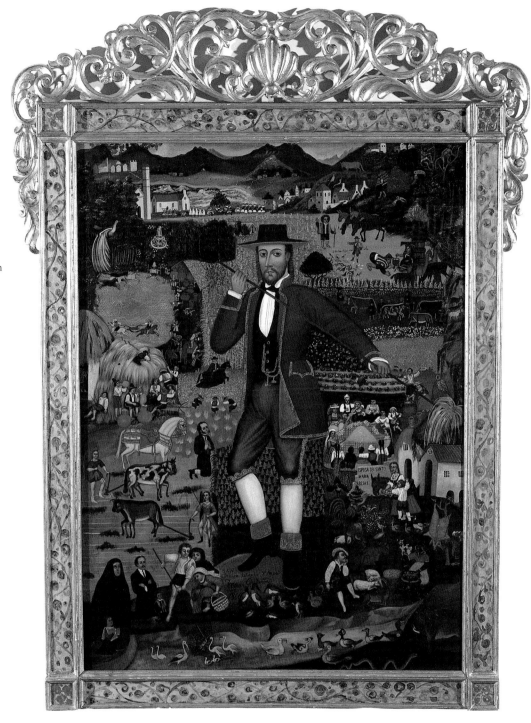

PLATE 82
La Inmaculada (Our Lady of the Immaculate Conception)
19th c.
Gerona, Spain
Polychromed wood, glass, wire, 36 × 14 in. (91 × 35 cm)
Peter P. Cecere, Reston, Virginia

This is an excellent example of an *imágen vestidera,* or dressed image. When the image is on display, the crudely finished parts of the Virgin are covered with clothing. All over Spain saints wear special attire, and the care and dressing of saints usually falls on the shoulders of members of *cofradías* (brotherhoods). Such a responsibility is always considered an honor. This image of La Inmaculada stands on a cloud, alluding to her heavenly domain. Her articulated arms are typical of Gerona's religious workshops.

PLATE 83
Standing Figure of the Virgin, early 19th c.
Bolivia
Polychromed wood, glass
35 × 14½ in. (89 × 37 cm)
Randy and Carol Jinkins,
San Antonio

Imágenes vestideras were also popular in the Americas, as seen in this example of the Virgin and in pl. 75. Although dressed religious figures were popular among pre-Columbian people, the custom as shown here is clearly rooted in Spanish tradition.

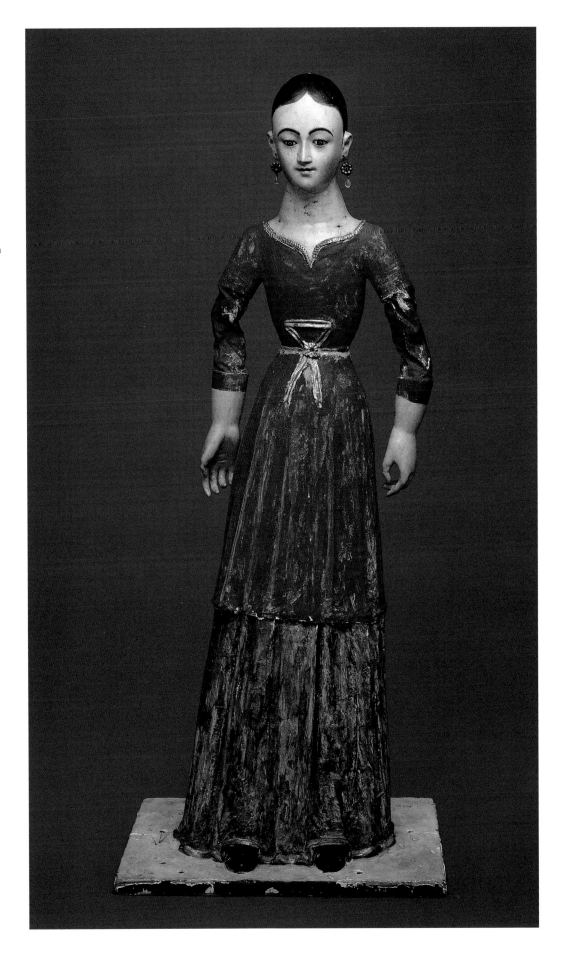

COLUMBA MEA IN ✝ FORAMINIBUS PETRÆ

Nª. Sª. DE LA CUEVA SANTA.

Rezando una salve ante esta Sᵗᵃ Imagen se ganan 160 dias de Indulgˢ concedidas por varios Señores Obispos.

B. Suñer la debº Fᵗᵒ Jordan la gᵒ

Se hallará en Valencia en casa de Franᶜᵒ Jordan.

PLATE 84
Nuestra Señora de La Cueva Santa (Our Lady of the Holy Grotto), 18th c.
Valencia, Spain
Engraving
11 × 7½ in. (27 × 18 cm)
San Antonio Museum of Art

Devotion to Nuestra Señora de la Cueva Santa has its origin in the province of Valencia, Spain. According to tradition, the original image was carved by a Carthusian monk who gave it to local shepherds. During a time of danger, the image was hidden in a cave and forgotten. Many generations later—in the fifteenth century—it was rediscovered when the image of the Virgin appeared to a shepherd and instructed him to establish a shrine in the cave.

PLATE 85
Nuestra Señora de La Cueva Santa (Our Lady of the Holy Grotto), early 19th c.
Mexico
Oil on canvas
16½ × 11½ in. (41 × 29 cm)
San Antonio Museum of Art, The Robert K. Winn Mexican Art Collection

The devotion to Nuestra Señora de la Cueva Santa was established in Mexico and Ecuador during the eighteenth century and arrived in Colombia the following century. The nineteenth-century image shown here is clearly a derivative of Spanish representations. As in the Spanish prototype, the mountain grotto in which the Virgin is located, crowned and framed with jewels, is quite abstract.

PLATE 86
Goigs de Ntra Sra de Montserrat (Praise Song to Our Lady of Montserrat) (det.), 1924
Barcelona, Spain
Relief print
12½ × 8 in. (32 × 20 cm)
San Antonio Museum of Art

In this detail from a twentieth-century praise song, we see a seated Virgin of Montserrat against a background of "sawtooth" mountains, where the Virgin miraculously appeared to a Catalan shepherd. Today the shrine is visited by thousands of pilgrims.

Manuel Gaban Hernández,
1884–1962
*Nuestra Señora de
Hormigueros (Our Lady
of Hormigueros),* c. 1930
Puerto Rico
Polychromed wood
25 × 14 in. (63 × 35 cm)
Alan Moss Reveron and
Robert Day Walsh,
New York

In Puerto Rico, the shrine
to the Virgen de Montserrat
is located in Hormigueros,
owing to a miracle that oc-
curred there in the sixteenth
century. According to
accounts, a farmer named
Gerardo González was
threatened by a rampant
bull, and he appealed to
the Virgin for help. She
miraculously appeared
and calmed the bull, which
dropped to its knees in sub-
mission and supplication.
This vernacular representa-
tion of the Virgen de Mont-
serrat, behind a scene of
local origin, has made her
special to Puerto Ricans.

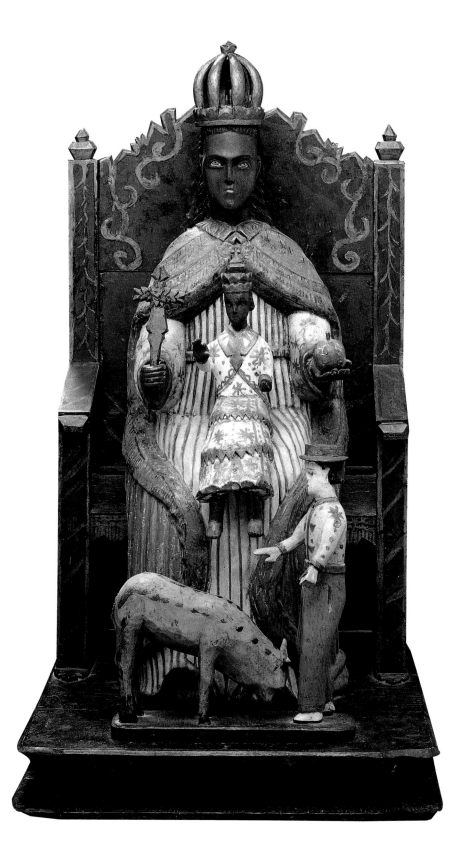

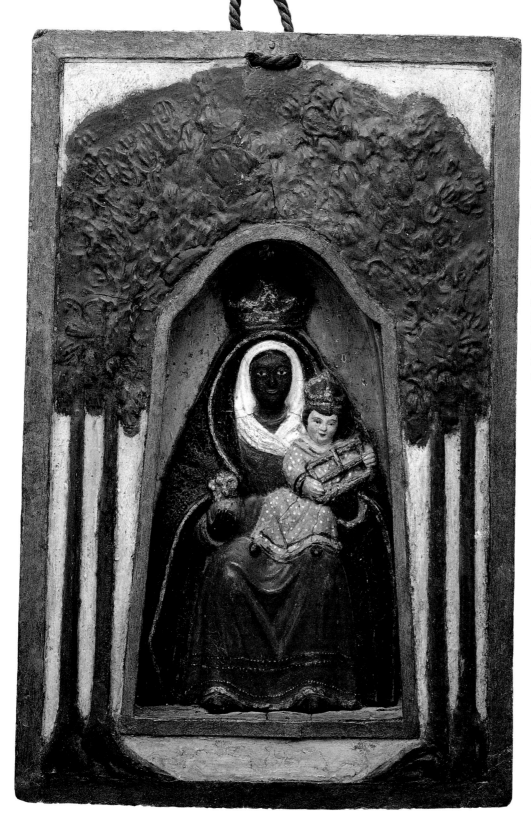

PLATE 88
Felipe de la Espada,
1754–1818
*Nuestra Señora de Montserrat
(Our Lady of Montserrat)*
c. 1810
Puerto Rico
Wood, paint, wax,
composition
11 × 8 in. (28 × 20 cm)
Alan Moss Reveron and
Robert Day Walsh,
New York

This Americanized version
of Nuestra Señora de
Montserrat shows her
beneath a canopy of ceiba
trees, commonly found
throughout the islands of
the Caribbean.

Nuestra Señora de los
Remedios was one of the
earliest marian images
brought to the Americas by
the Spanish in the sixteenth
century. As early as 1560,
a cult to honor her was
established in the area of
Puebla, Mexico. According
to tradition, the first image
of Nuestra Señora de los
Remedios was brought to
Mexico by one of Cortés's
soldiers. When the Spanish
were routed from Tenoch-
titlán on the Noche Triste
(Night of Sorrow), her im-
age was abandoned under a
maguey plant. Twenty years
later, she appeared to an In-
dian named Juan de Aguila
Tobar, who took the image
to his house. The next day,
the image reappeared under
the same maguey plant. This
was repeated three times.
Finally, a priest interpreted
this persistence as a signal
from the Virgin to build
her shrine on the site of
her apparition.

 The Virgin's apparition
in a maguey plant is part
of her Americanization
and strengthened her ap-
peal to Native American
populations.

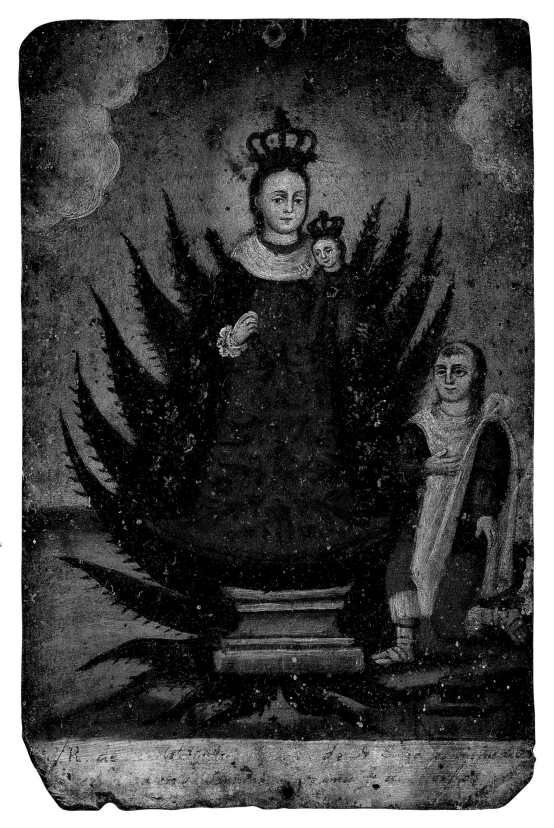

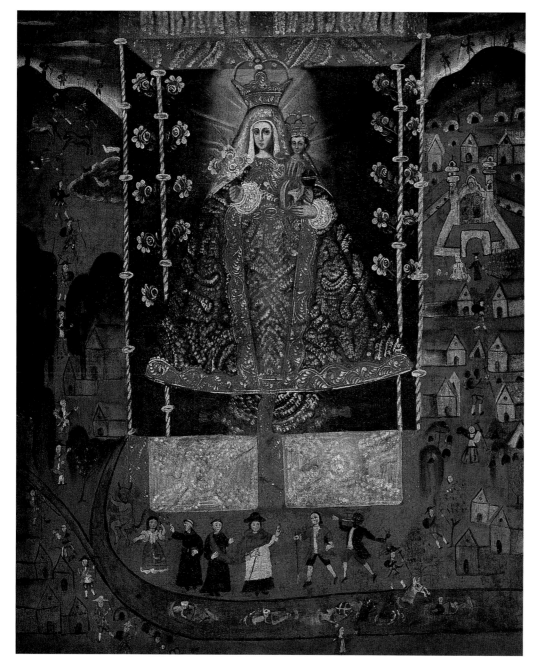

PLATE 90
Cuzco School
Nuestra Señora de Cocharcas
(Our Lady of Cocharcas)
18th c.
Peru
Oil on canvas
46 × 38 in. (117 × 96 cm)
New Orleans Museum
of Art

This painting alludes to a miraculous event that took place in highland Peru during the late sixteenth century. According to tradition, a young man named Sebastián Quimichi, from the village of Cocharcas, near Ayacucho, injured his arm and set out to find a cure through pilgrimage to the shrine of Nuestra Señora de Copacabana (Our Lady of Copacabana). His arm was healed, and in gratitude, he commissioned the carving of a replica of the Virgen de Copacabana, which he took back to his native village. This image was reportedly carved by Tito Yupanqui, the maker of the original. The new image became famous as a source of miracles, and a shrine was built to house it.

In this delightfully narrative painting, we see the Virgen de Cocharcas, under her processional *baldaquín* (canopy), being brought back to Cocharcas as local musicians and dancers celebrate her arrival. In the background are excellent examples of folk architecture, which give the viewer a valuable cultural context for this popular image.

Fray Miguel de Herrera,
act. 1729–1780
*Nuestra Señora de La Barca
(Our Lady of the Boat)*, 1755
Mexico
Oil on canvas
17 × 13 in. (43 × 33 cm)
Davenport Museum of Art,
Iowa

According to tradition,
Nuestra Señora de la Barca
appeared to Saint James and
encouraged him to preach
to heathens in Galicia.
Today, her shrine is still a
popular pilgrimage destina-
tion, and her feast day in
early September is attended
by thousands of devotees.
Because the Virgin appeared
in a boat, her assistance is
invoked by sailors and
fishermen. The nave of her
shrine is decorated with ship
model ex-votos.

In the Spanish version of
Nuestra Señora de la Barca,
the boat in which the Virgin
rides is a substantial skiff
with huge oars. In this
Mexican version by Fray
Miguel de Herrera, the boat
is an indigenous canoe
bedecked in flowers, remi-
niscent of lake vessels of
northwest Mexico and the
popular flowered boats of
Xochimilco.

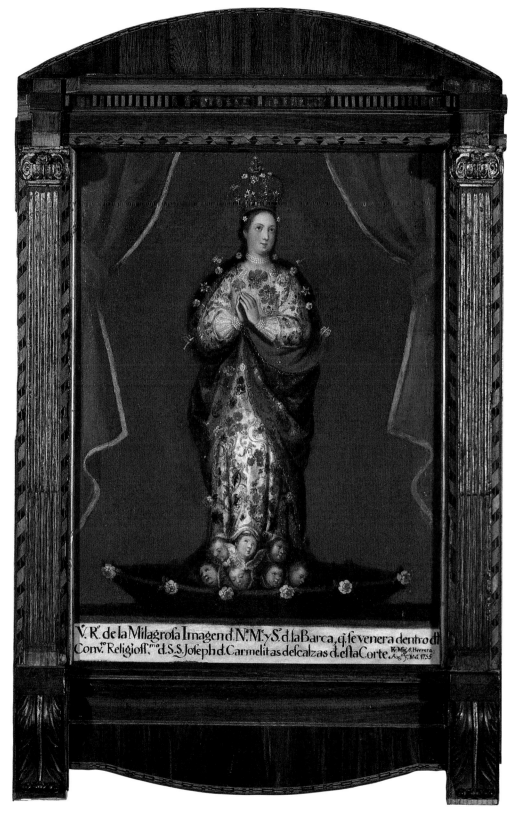

PLATE 92
*Miner's Lamp with Image of
Our Lady of the Mineshaft*
Late 18th c.
Bolivia
Silver alloy
10 × 3 in. (25 × 7 cm)
San Antonio Museum of Art

In some mines in Bolivia,
the Virgin Mary reigns over
an area from the surface
down to a certain depth,
and Spanish is spoken in
prayers to her. Below that
depth is the domain of
Pachamama, the Andean
earth goddess, to whom
llamas are offered and
prayers are said in Quechua.

This miner's lamp is
decorated with what is
probably an image of the
Virgin of the Mineshaft, a
Christian cross, and two
llamas. In this object sym-
bols important to Christian
and non-Christian religious
practices are joined.

PLATE 93
Virgen del Rosario de Chichinquira (Virgin of the Rosary of Chichinquira), 18th c.
Colombia
Oil on canvas, gold attachments, 32 × 33 in. (81 × 84 cm)
Alan Moss Reveron and Robert Day Walsh, New York

This extraordinary painting depicts the Virgen del Rosario as she appeared in the Colombian city of Chichinquira, near Bogotá. She is accompanied by San Antonio de Padua (Saint Anthony of Padua) and San Andrés (Saint Andrew). Of special interest is the application of gold objects to the painted canvas. In pre-Columbian times, gold ornaments were worn as jewelry and stitched to mummy bundles. Although the embellishment of paintings by nuns and others has a long history in Spain, the custom, when practiced in South America, must have been received sympathetically.

PLATE 94
The Adoration of the Magi, 19th c.
Peru
Oil on tin, approx. 19½ × 29½ in. (50 × 75 cm)
Valery Taylor Gallery, New York

This Americanized version of the Adoration of the Magi is
typical of the transformation that took place when Christian
art was brought to Peru. The nativity of Christ is shown
against an Andean backdrop of snow-capped mountains. A
shepherd in the distance is dressed in a Peruvian poncho,
and a woman holding a white dove is wearing a hat typical
of local headgear. Standing guard behind the Holy Family is
a black soldier similar to those seen in nineteenth-century
Peruvian *costumbrista* (genre) drawings.

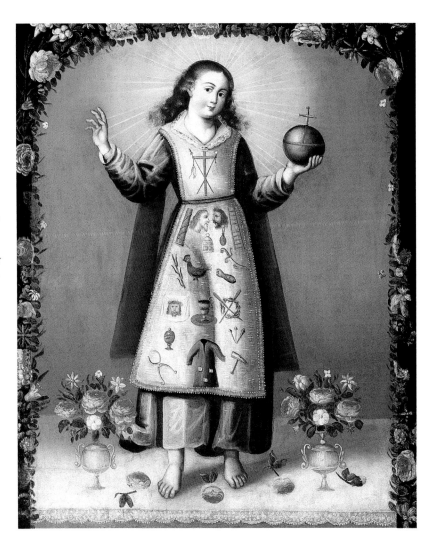

PLATE 95
Christ Child with Symbols of the Passion, late 17th c.
Peru
Oil on canvas
39 × 31 in. (99 × 79 cm)
The Brooklyn Museum, New York

This exquisite painting is typically Peruvian in style, but heavily Spanish in content. Note the strong similarities in iconography between this painting and the Spanish lusterware platter depicted in pl. 96.

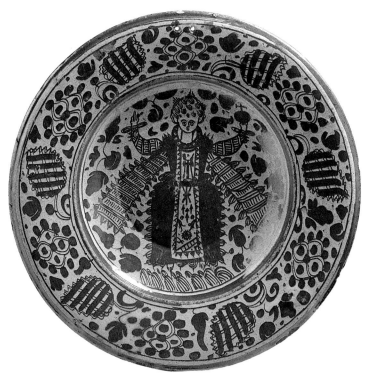

PLATE 96
Platter with Standing Christ Child, early 17th c.
Cataluña, Spain
Tin-enameled earthenware, DIAM. 14 in. (35 cm)
The Metropolitan Museum of Art, New York, The Cloisters Collection

This example of Spanish lusterware is decorated with a standing Christ Child in the center. In his left hand, Christ holds an orb symbolizing his sovereignty over sin through his crucifixion. His right hand is raised in blessing. On his apron are elements o᾽ the Passion: the cross, the ladder used to lower his body, the nails, the spear, etc. The six repeated motifs on the outer rim of the platter may be abstractions of the Hand of Fatima and could be survivals from earlier Islamic times. This platter was probably used in a convent or other religious institutional setting.

PLATE 97
The Judgment of Christ, late 18th c.
Central Spain
Oil on canvas, 17 × 22 in. (43 × 56 cm)
San Antonio Museum of Art

Stations of the Cross are indispensable didactic features of
Catholic churches in Spain and elsewhere. Their function
is to teach the story of the Passion of Christ. Totaling four-
teen episodes, the series always begins with Jesus being
condemned to death (shown here) and ends with his being
laid in the sepulchre. Early mendicant priests used these
paintings to teach Christianity to indigenous peoples in
Mexico and elsewhere (fig. 21).

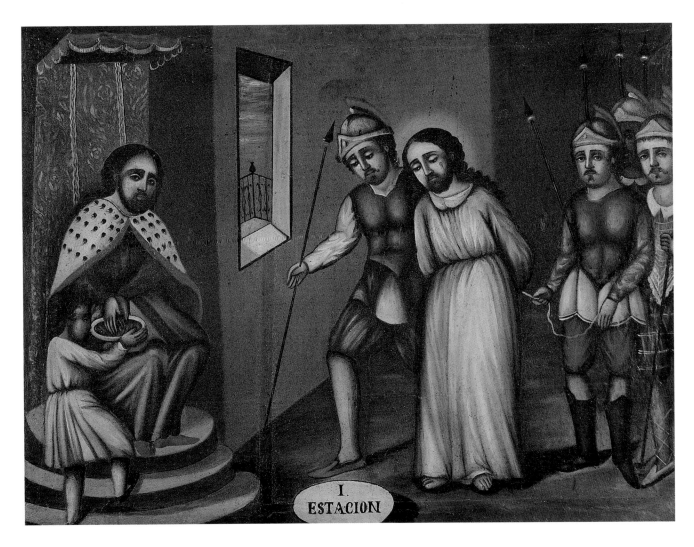

PLATE 98
The Judgment of Christ, c. 1850
Mexico
Oil on canvas, 19 × 24 in. (48 × 61 cm)
San Antonio Museum of Art, The Nelson A. Rockefeller
Mexican Folk Art Collection

Paintings such as these were used by early mendicants to
teach the Passion of Christ to Native American populations.
This nineteenth-century Station of the Cross, showing
Christ being sentenced to death, is inspired by Spanish
prototypes and was painted in a Mexican vernacular style.
Red-green-and-white banners and plumage seen in several
canvases in this series were probably inspired by the Mexican
national colors.

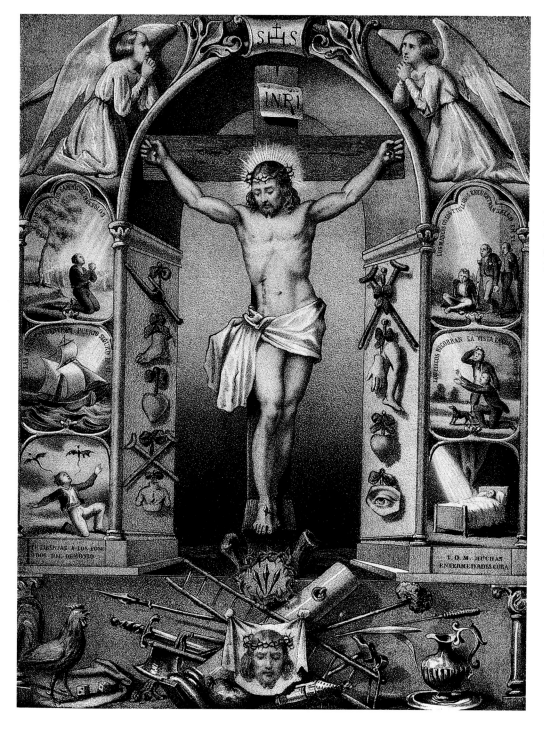

PLATE 99
*El Señor Cristo de Zalameda
(Lord Christ of Zalameda)*
19th c.
Paris
Lithograph
17 × 11½ in. (43 × 29 cm)
San Antonio Museum of Art

In this French lithograph
made for use in Spain, we
see a popular image of
Christ surrounded by votive
objects and symbols of the
Passion.

PLATE 100
Christ Crucified with Votive Offerings, 18th c.
Mexico
Oil on canvas, approx.
40 × 35 in. (101 × 89 cm)
Jonathan Williams, Austin, Texas

The custom of attaching votive *milagros* (offerings) to a religious image has its roots in Spain and continues today throughout Latin America.

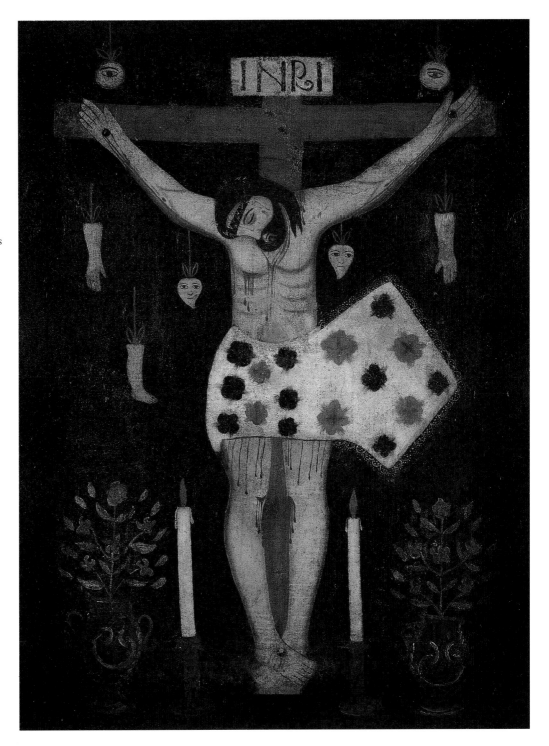

Illustrations

PLATES

1. *Cherub with Outstretched Arms,* 18th c., Central Spain frontispiece
2. José Cubero, *Genre Figures Showing Regional Attire,* early 19th c., Valencia, Spain 6–7
3. *Drawer with Facial Motif,* late 17th c., Segovia, Spain 10
4. *San Antonio de Padua (Saint Anthony of Padua),* late 19th c., Southern Spain 14
5. *Doña de la Rosa (Lady of the Rose) Figurehead,* c. 1900, Barcelona, Spain 18
6. *Pitcher with Symbols of the Passion of Christ,* early 20th c., Palencia, Spain 22
7. Juan de la Cruz Cano, *Man from Aragón,* late 18th c., Madrid 30
8. Juan de la Cruz Cano, *Woman from Aragón,* late 18th c., Madrid 30
9. *Goigs de Nostra Senyora de la Ayuda (Praise Song to Our Lady of Aid),* 1745, Barcelona, Spain 36
10. *Contestación (Reply),* 1822, Valencia, Spain 38
11. *Mónica y Silvestre (Monica and Sylvester),* 1822, Valencia, Spain 39
12. *El Soldado (The Soldier),* 1858, Madrid 40
13. *Carnival in Barcelona,* late 19th c., Barcelona, Spain 41
14. *Life of the Drunk Man and Woman,* late 19th c., Madrid 42
15. *Nuestra Señora de la Consolación (Our Lady of Consolation),* 1762, Sevilla, Spain 44
16. *Mare de Deu de La Cisa (Mother of God of La Cisa),* 1924, Barcelona, Spain 45
17. *San Isidro Labrador (Saint Isidore the Farmer),* late 18th c., Madrid 46
18. *El Mundo al Revés (The World in Reverse),* late 19th c., Madrid 48
19. *Three Walking Sticks,* early 20th c., Asturias, Spain 52
20. *Pair of Andirons,* 19th c., Cáceres, Spain 54
21. *Door Knocker,* late 18th c., Central Spain 54
22. *Chocolate Cutter with Horse Motif,* late 19th c., Northern Spain 54
23. *Weather Vane,* 19th c. (origin unknown) 55
24. *Powderhorn,* 1796, Salamanca, Spain 56
25. *Spoon and Fork with Flowers and Deer,* early 20th c., Salamanca, Spain 56
26. *Spoon with Couple, Flowers, and Birds,* early 20th c., Salamanca, Spain 56
27. *Purse,* c. 1780, Salamanca, Spain 57
28. *Three Garrots,* early 20th c., Cataluña, Spain 58
29. *Glass Pitcher,* 18th c., Cataluña, Spain 59
30. *Three Bread Stamps,* late 19th c., Northwestern Spain 59
31. *Bed Covering,* 18th c., Salamanca, Spain 60–61
32. *Three Oil Jars,* 18–19th c., Teruel, Spain 62

33. *Jar with Deer Motif,* 1870, Puente del Arzobispo, Spain 65

34. *Plate with Bird Motif,* late 19th c., Granada, Spain 68

35. *Jar with Geometric Designs,* 16th c., Andalucía, Spain(?) 69

36. *Oil Jar with Drip Glaze,* late 19th c., Badajoz, Spain 72

37. *Oil Jar,* 19th c., Triana, Spain 73

38. *Jar,* 19th c., Tarragona, Spain 76

39. *Tile,* 16th c., Teruel, Spain 77

40. *Sailor's Chest,* early 19th c., Barcelona, Spain 80

41. *Chair,* 18th c. (origin unknown) 86

42. *Grain Box,* 17th c., Logroño, Spain 87

43. *Trunk with Geometric Cross,* early 17th c., Basque Country, Spain 90

44. *Nuestra Señora de los Dolores (Our Lady of Sorrows),* late 19th c., Andalucía, Spain 94

45. *Nuestra Señora de Guadalupe (Our Lady of Guadalupe),* 18th c., Madrid 97

46. M. Rodríguez de Guzmán, *Folk Festival: Romería del Rocío,* 1856, Sevilla, Spain 98–99

47. *Octagonal Reliquary with Face of Christ,* 18th c., Castilla, Spain 101

48. *Necklace,* 19th c., Salamanca, Spain 102

49. *Five Pairs of Earrings,* 19th c., Spain 103

50. *Ex-voto in Form of Hand,* 19th c., Toledo, Spain 104

51. *Ex-voto to San Ramón Nonato (Saint Raymond Nonatus),* early 19th c., Cataluña, Spain 106

52. *Model Ship Ex-voto,* late 18th c., Cataluña, Spain 114

53. *Model Ship Ex-voto,* 19th c., Cataluña, Spain 115

54. *Maritime Votive Painting to Our Lady of Cisa,* 19th c., Cataluña, Spain 118

55. *Maritime Votive Painting to Saint Christopher and The Virgin,* 19th c., Cataluña, Spain 119

56. *Ex-voto of Soldier Being Kicked by a Mule,* late 19th c., Cataluña, Spain 121

57. *Maritime Votive Painting to Saint Christopher,* 1780, Cataluña, Spain 122

58. *Maritime Votive Painting to Lord of Calvary,* 1862–63, Cataluña, Spain 123

59. *Three Christening Caps,* 18th c., Toledo, Spain 125

60. *Bridal Bow with Reliquary and Medallions,* 18th c., Toledo, Spain 125

61. Coloma Battle (Vattle), *Greeting Cards,* 1843, 1846, Northeastern Spain 126

62. *Burial Plaque,* 1834, Toledo, Spain 127

63. *Hand Puppets,* 19th c., Cataluña, Spain 128

64. *Viejo Cabezudo (Old "Big-Head"),* early 20th c., Zaragoza, Spain 137

65. *Virgin with Peruvian Indians,* late 18th–early 19th c., Peru 140

66. Montiel Family, *Dish with Sun Motif,* c. 1900, Antigua, Guatemala 144

67. *Powderhorn,* c. 1850, Salamanca, Spain 147

68. *Horn Trumpet,* c. 1921, Zacatecas, Mexico 147

69. *Jar with Anagram and Crown,* 18th c., Toledo, Spain 148

70. *Pot,* c. 1900, Chorteleg, Ecuador 149

71. *Apothecary Jar,* 18th c., Puebla, Mexico 152

72. *Three Oval Dishes with Animal Motifs,* 19th c., Guanajuato, Mexico 154

73. Miguel Martínez, *Platter with Oriental/Willow Motif,* c. 1900, Puebla, Mexico 155

74. *Jar with Seated Musician on Top,* early 20th c., Pupuja, Peru 155

75. *Standing Figure of the Virgin,* 18th c., Mexico 158

76. *Ex-voto to Our Lady of Guadalupe Saving Sailors,* 1879, Mexico 163

77. *Ex-voto of Man Being Beaten,* 19th c., Mexico 163

78. *Saint Isidore the Farmer,* 1877, Barcelona, Spain 169

79. Jerry Sandoval, *Saint Isidore the Farmer,* 1994, New Mexico, United States 170

80. *Saint Isidore the Farmer,* early 20th c., Paraguay 170

81. Joaquín Castañón, *Saint Isidore the Farmer,* 1866, Bolivia ... 171

82. *Our Lady of the Immaculate Conception,* 19th c., Gerona, Spain ... 172

83. *Standing Figure of the Virgin,* early 19th c., Bolivia ... 173

84. *Our Lady of the Holy Grotto,* 18th c., Valencia, Spain ... 174

85. *Our Lady of the Holy Grotto,* early 19th c., Mexico ... 175

86. *Praise Song to Our Lady of Montserrat,* 1924, Barcelona, Spain ... 176

87. Manuel Gaban Hernández, *Our Lady of Hormigueros,* c. 1930, Puerto Rico ... 177

88. Felipe de la Espada, *Our Lady of Montserrat,* c. 1810, Puerto Rico ... 178

89. *Our Lady of Remedies,* 19th c., Mexico ... 179

90. Cuzco School, *Our Lady of Cocharcas,* 18th c., Peru ... 180

91. Fray Miguel de Herrera, *Our Lady of the Boat,* 1755, Mexico ... 181

92. *Miner's Lamp with Image of Our Lady of the Mineshaft,* late 18th c., Bolivia ... 182

93. *Virgin of the Rosary of Chichinquira,* 18th c., Colombia ... 183

94. *The Adoration of the Magi,* 19th c., Peru ... 184

95. *Christ Child with Symbols of the Passion,* late 17th c., Peru ... 185

96. *Platter with Standing Christ Child,* early 17th c., Cataluña, Spain ... 185

97. *The Judgment of Christ,* late 18th c., Central Spain ... 186

98. *The Judgment of Christ,* c. 1850, Mexico ... 187

99. *Lord Christ of Zalameda,* 19th c., Paris ... 188

100. *Christ Crucified with Votive Offerings,* 18th c., Mexico ... 189

FIGURES

1. *Boat Ex-voto,* c. 1950, Tabasco, Mexico ... 27

2. *Boat Ex-voto,* early 19th c., Sitges, Spain ... 27

3. *Drying Shed,* 19th c.(?), Galicia, Spain ... 53

4. *Tile Ex-voto,* 1741, Talavera de la Reina, Spain ... 64

5. *Filigree Jar,* 20th c., Alba de Tormes, Spain ... 74

6. *"Enchinada" (Stone Inlay) Jar,* 20th c., Ceclavín, Spain ... 74

7. *Water Jar,* 19th c., Calanda, Spain ... 75

8. *Chair with Drawer,* 17th c., Central Spain ... 83

9. *Portable Desk (Bargueño),* 18th c., Andalucía, Spain ... 91

10. *Utensil Rack,* 17th c., Northern Spain ... 92

11. *Boat Rock,* 1996, Muxia, Spain ... 96

12. *Saint Blaise with Wax Votive Offerings,* 1996, Cambados, Spain ... 96

13. *Votive Offerings,* 1993, Sanctuary of Saint Amaro, Burgos, Spain ... 100

14. *Votive Painting,* 19th c., Sanctuary of Our Lady of Consolation, Utrera, Spain ... 105

15. *Silver Votive Offerings,* c. 1995, Andalucía, Spain ... 110

16. *Votive Offerings,* 20th c., Sanctuary of Our Lady of Consolation, Utrera, Spain ... 110

17. *Votive Painting,* 19th c., Sanctuary of Our Lady of Consolation, Utrera, Spain ... 111

18. *Corpus Christi Giant Figures,* 1996, Toledo, Spain ... 132

19. *Corpus Christi Big-Heads,* 1996, Toledo, Spain ... 133

20. *Glazed Tile,* 18th c., Cuzco, Peru ... 142

21. D. Valadés, *Fray Pedro de Gante Instructing Indians,* 1579 ... 143

22. *Saint Isidore the Farmer,* 19th c., Mexico ... 143

23. *Miraculous Image of Our Lady of Talpa,* 17th c., Jalisco, Mexico ... 160

Index

Boldface page numbers refer to illustrations.

Abadengo, Salamanca, 88
Academy of San Carlos, 37
Academy of San Fernando, 37
Adoration of the Magi, 142, **184**
Agost, Alicante, 74
Alba de Tormes, Salamanca, 24, 71, 74
Alcora, Castellón, factory at, 64
Alfajalauza, Granada, 33
Alfonso II, 108
Alfonso III, 108
Alfonso X, *Cantigas,* 108
Amades, Joan, 29, 116
Andalucía: architectural iron-work, 32; bacon tables, 88; ex-votos in, 111–12; Mallorca chairs, 84
Andújar, Jaén, 75
apparel, traditional, 34, 153
apparition accounts. *See* Virgin Mary
Aracena, Huelva, 75
Aragón: ex-votos in, 112; functional ironwork, 32
Aranda, Count of, 64
Aranda de Duero, Burgos, 71
Arroyo de la Luz, Cáceres, 71
Assumption of the Madona Santa María (Saint Mary Madonna), 136
Assumption play of Elche, 134–36
Asturias, ex-votos in, 112–13

autos sacramentales, as teaching tool, 134

Bailén, Jaén, 75
Balearic Islands, pottery in, 75
Bantel, Linda, 27
Barcelona: patron saint of, 96; as print center, 43; street fairs in, 35
Basque Country, pottery in, 71
Basque jugs, 71
Battle, Coloma, 126; *Greeting Cards,* **126**
beds. *See* furniture
Benamejí, Córdoba, 67
benches. *See* furniture
Biar, pottery center, 64
Boat Rock, 96, **96**
Bonaparte, Joseph, 50
Bonaparte, Napoleon, 47
botijuela, 129
Burgos, decorated beds in, 88
Burke, Marcus, 27

Cáceres, 89
Cádiz Province, 78
Calanda, Teruel, 74, **75**
Calderón de la Barca, Pedro, 134
Campo Charro, 88
Camporreal, Madrid, 74
Canary Islands, pottery in, 70, 78
Cantabria, 70–71
cantareros, 67
Carbellino, Zamora, 70

Carlos III, 66
Carnaval, 31, 132
Carnegie Foundation, 27
Carvalho-Neto, Paolo de, 107
Castañón, Joaquín, *Saint Isidore the Farmer,* **171**
Casteldurante, 64
Castellar de Santiago, Ciudad Real, 74
Castellar de Santisteban, Jaén, 108
Castilla–La Mancha, ex-votos in, 113
Castilla–León, 88; ex-votos in, 113, 116
Castro, Américo, 156
Cataluña, 32, 88; ex-votos in, 116
Catholic Church: efforts to destroy pagan shrines, 153, 165; evangelization of Indians, 161–62, 164; objections to nature worship, 164; objections to religious performance, 136; objections to saint cults, 111, 153, 161; and religious imagery, 96, 100
Catholicism: devotion to miraculous images, 159; European view of, 161, 162; Indian view of, 162; performance associated with Catholic festivals, 129, 132–34; role of indigenous people in, 156; secular performance in defiance of, 134;

Catholicism (continued)
 in sixth-century Spain, 24
Catholicism, folk, 159–62,
 164; survival of pre-Chris-
 tian rituals in, 162, 164; in
 20th century, 164–67
Ceclavín, Cáceres, 71, 74
Celts, presence in Spain, 24, 32,
 107–8
ceramics, 62–79. See also
 pottery
Cerro de los Santos sanctuary,
 Albacete, 107
chairs. See furniture
chests. See furniture
Chorteleg, Ecuador, pottery of,
 149, **149**
Christ Child, symbols of in folk
 art, 185, **185**
Church of San Clemente, 84
Cigarralejo sanctuary, 107
Cobo Ruíz de Adana, J., 111
Coca, Segovia, 71
cofradías, 156, 172
Collado de los Jardines sanctu-
 ary, Sierra Morena, 108
Colmenar de Oreja, Madrid, 74
Columbus, Christopher, 25, 97,
 100
Constantino, Niño Fidencio,
 165–66, 168 n. 22; and
 Fidencista cult, 166–67
Consuegra, Toledo, 74
Cordero, Gil, 97
Córdoba: ivory workshops, 108;
 pottery center, 67, 75
Corpus Christi: in Americas,
 145; as occasion for perfor-
 mances, 132; procession, 34,
 95; Spanish roots of 153,
 156–57
Cortegana, Huelva, 75
Cortés, Hernán, 97, 100
Council of Trent, 40
Counter-Reformation, 37, 39
Cristo del Humilladero Her-
 mitage, and "multiple ex-
 voto," 117, 120
Cross of the Angels, 108
Cross of Victory, 108
Cubero, José, 4; *Genre Figures
 Showing Regional Attire,* 6–7

Cuerva, Toledo, 74
cupboards. See furniture
Cuzco, Peru, 145, 156

Dalevuelta, Jacobo, 166
Dalí, Salvador, 25
dance of Moors and Christians,
 138
de Aguila Tobar, Juan, 179
de Bustamante, Fray Francisco,
 161
de Gante, Fray Pedro, 142, **143,**
 151
de Guevara, Antonio, 146
de Herrera, Fray Miguel, 181;
 Our Lady of the Boat, **181**
de la Cruz Cano, Juan, 30, 34;
 *Collection of Spanish Costumes,
 Both Old and New,*
 34, 47; *Man from Aragón,
 Woman from Aragón,* **30**
de la Espada, Felipe: *Our Lady
 of Montserrat,* **178**
de Larrea Palacín, Arcadio, 130
de Santamaría, Fray Juan, 117
de Talavera, Fray Hernando,
 39–40
d'Harnoncourt, René, 27
Díaz, Porfirio, 27
Díaz Viana, Luis, 138
Diego, Juan, 160
Diego Bernardino, Juan, 161
Dolores Hidalgo, Mexico, 154
Douglas, Mary, 133
dressed images, 172, **172,** 173,
 173

Ecuador, 27
Egan, Martha: *Milagros: Votive
 Offerings from the Americas,*
 28; *Relicarios: Devotional Min-
 iatures from the Americas,* 28
El Matamoscas, 50
El Museo de las Familias, 50
El Papagayo, 50
El Semanario Pintoresco, 50
El Señor del Calvario, 123, **123**
Elche, 107, 134–36
embroidery, 33–34, 57, **57,** 60–
 61, 61, 88
engraving. *See* prints
Epton, Nina, 136

esperpento, 49
Estampa Popular movement, 51
Ethnographic Museum of
 Hamburg, 78
Extremadura, 32, 88; ex-votos
 in, 117, 120
ex-votos: in Andalucía, 111–12;
 in Aragón, 112; as art, 109; in
 Asturias, 112–13; in Castilla–
 La Mancha, 113; in Castilla–
 León, 113, 116; in Cataluña,
 108, 116; characteristics of,
 109; Cross of the Angels, 108;
 Cross of Victory, 108; in
 Extremadura, 117, 120; in
 Galicia, 120; indicators of so-
 cial structure, 111; in La Rioja,
 120; link between generations,
 109–10; painted, 110–11; schol-
 arly value, 111; types of, 108,
 110, **110, 111,** 117; in Valencia,
 116–17. See also votive art

Faenza, 64
fallas, 23, 31
Faro, Asturias, 70, 71
festivals: link with pagan rites,
 150; saint's day celebrations,
 95, 96, 132. *See also names of
 festivals*
Folk art
 Latin American, 140–43;
 clothing, 153; effect of Span-
 ish Conquest on, 150; and
 hispanidad, 26–28, 141–42,
 153; religious, 142–43; tradi-
 tional vs. commercial, 146
 Spanish, 23–24, 25–26, 53; role
 in rites of passage, 125–27
Fontaneda Collection, Castle of
 Ampudia, 116
Foster, George, 28, 134; *Culture
 and Conquest,* 28
Fraga, Huesca, 74
Franciscans, 97
Franco, 32
Fresno de Cantespino, Segovia,
 71
Fundación Machado, 111
furniture, 81–93; architectural
 motifs, 84, 89; beds, 88;
 benches, 82, 84; chairs, **83,**

83–84, 86, **86**; chests, 87, **87**, 89, 90, **90**, 91; cupboards, 92–93; history of, 81–82; hutches, 92; mass-produced, 93; materials, 82; Roman influence on, 82, 88; settles, 85; simple seats, 82–83; Spanish characteristics, 81, 84, 91; tables, 88–89; trunks, 91–92, **91**

Gaban Hernández, Manuel, *Our Lady of Hormigueros,* **177**
Galicia, ex-votos in, 120
García Rodero, Cristina, *Festivals and Rituals of Spain,* 95
Gaudí, Antoni, 25
Geertz, Clifford, 138
Gerona, religious workshops of, 172
Giants and Big-Heads. See *gigantes y cabezudos*
gigantes y cabezudos, 23, 31, 34–35, 156; in procession, 137, **137**; symbolism of, 133–34
Gilberti, Fray Maturino, 161
glasswork, 59, **59**
Goya, Francisco de, 25, 49; *Los Caprichos,* 37, 49; *Los Desastres de la Guerra,* 37, 49; *Los Disparates,* 49; *Los Proverbios,* 37, 49; *La Tauromaquia,* 37, 49
Granada, 64, 78
Gredos Mountains, Spain, 153
Greenwood, Davydd, 138
Griffith, James, 162, 164
Guanajuato, Mexico, 27, 152
Guarrazar, Toledo, 108
Guatemala, 27, 145, 152
Guindilla, 50

Hermandad de Romeros (Pilgrims' Brotherhood), Jaca, 112
Hispanic Society of America, 78
Holy Week, 95, 132
horn carving, 56, **56**, 142, 147, **147**. *See also* shepherds' art
Huizinga, Johan, 130, *Homo Ludens,* 130
hutches. *See* furniture

Iberian Peninsula. *See* Spain
imágen vestidera. See dressed images
Inquisition, the, 47
ironwork, 32–33, **54–55**, 92, **92**
ivory art, 108

Jerez de la Frontera, 55
Jeronimites, 97
jewelry, 102, **102**, 103, **103**
Jiménez de Jamuz, León, trick jugs, 71

La Almudena, 145
La Bisbal, Gerona, 74
La Celestina, 131
La Coruña Province, 71
La Ilustración Espirita, 168 n. 22
La Inmaculada, 97, 160, 172, **172, 173**
La Luz sanctuary, Murcia, 108
La Rambla, Córdoba, 67, 75
La Rioja, 88, 120
La Serreta sanctuary, Alcoy, 107
Lady of Elche, 107
Latin America: African influence on, 150–51; cultural diversity of, 150; evangelization in, 150, 151; independence from Spain, 27
Leante, Rafael, 112
Llamas de Mouro, Asturias, 71
Llano de la Consolación sanctuary, Albacete, 107
Lope de Vega, 108, 134
Lora del Rio, Sevilla, 75
Lorca, Murcia, 33
lost-wax technique, 108
Lucena, Córdoba, 67, 75
Lugo Province, 71
Luque Romero, F., 111

Magdalena, Sonora, 164
majolica. *See* pottery
Manises, Valencia, 33, 64, 71, 75, 92
Mare de Deu de la Cisa, 45, **45**
María Salomé, 136
Martínez, Miguel, *Platter with Oriental Willow Motif,* **155**
Mérida, Badajoz, 107

Metropolitan Museum of Art, 28
Mexico, history of, 27
Mexico: Splendors of Thirty Centuries (exh.), 27–28
Middle Ages: furniture in, 81, 83, 88, 91, 92; theater in, 131
milagros (milagritos), 28, 110, **110**, 189
miracles, 159, 164, 167
miraculous images, 160, **160**, 161–62
Miró, Joan, 25, 51
modernista (art nouveau) movement, 33
Mondoñedo, Lugo, 24
Monte Testaccio, Rome, 63
Montiel Family, 145; *Dish with Sun Motif,* **144**
Montserrat, shrine of, 100
Mota del Cuervo, Cuenca, 70, 74
Moveros, Zamora, 70, 71
mudéjar, 82, 117
Muelas de Pan, Zamora, 71
Museo Arqueológico Nacional, 78, 107
Museo de Artes y Costumbres Populares, 78
Museo Nacional de Antropología, 25, 78
Museo Nacional de Arte de Cataluña, 84
Museo Nacional de Arte Romana, 24
Museo Nacional de Artes Decorativas, 78
Museo do Pobo Galego, 29
Museo del Prado, 25
Museo del Pueblo Español, 78
Museo de Reina Sofía, 25
Museu d'Arts, Industries i Tradicions Populars, 25, 33
Museum of American Folk Art, 23
Muxia, Galicia, 96

Navarra, 32, 71
Navarrete, La Rioja, 71
Níjar, Almería, 78
Nuestra Señora de la Barca, 24, 96, 181, **181**

Nuestra Señora de Cisa, 118, **118**
Nuestra Señora de Cocharcas, 180, **180**
Nuestra Señora de la Consolación, 44, **44**
Nuestra Señora de Copacabana, 180
Nuestra Señora de la Cucva Santa, 174, **174**, 175, **175**
Nuestra Señora de los Dolores, **94**, 95
Nuestra Señora de Guadalupe. *See* Virgen de Guadalupe
Nuestra Señora de Hormigueros, 177, **177**
Nuestra Señora de Montserrat, 159, 176, **176**, 177, **177**, 178, **178**
Nuestra Señora del Pilar, 159
Nuestra Señora de los Remedios, **179**, 179
Nuestra Señora del Rocío, 24, 99, 159
Nuestra Señora del Rosario, 160
Nuestra Señora de San Juan de los Lagos, 160
Nuestra Señora de Talpa, 160, **160**
Nuestra Señora de Vignet, 28

Ocaña, Toledo, 74
olleros, 67
Our Lady of the Mineshaft, 182, **182**
Our Lord of Consolation, feast day of, 132

Padre Pio, 165
Palencia, 88, 108
Palma del Río, Córdoba, 67, 75
papier-mâché, 31, 35, 132
Parés, F., 116
pastoradas, 136
Paterna, 64
patron saints, 96; legends of, 134–35; personification of, 153
Pereruela, Zamora, 70, 71
Performance, traditional: associated with Catholic festival, 132–34; *autos sacramentales,* 134–35; Catholic objections to, 136; dance of Moors and Christians, 138; difference between religious and secular, 129; Giants and Big-Heads, 132–34, **132**, **133**; *juegos de cortijo,* 129–132; *pastoradas,* 136; as plays, 130; *ramos,* 136; revival of, 136, 138
Peru, pottery of, 27, 155, **155**
Picasso, Pablo, 25, 51
pilgrimage, 96, 97, 99
Pisano, Francisco Niculoso, 64
Pizarro, Francisco, 153
Ponga, José Luis Alonso, 134
porcelain, 66. *See also* pottery
Porter, Katherine Anne, *Outline of Mexican Arts and Crafts,* 27
Posada, José Guadalupe, 51
posadas, 134, 139 n. 15
Posadas, Córdoba, 67, 75
potter's wheel, 63, 67, 70
pottery
 Latin American: connection to Spain, 141; decorative motifs, 154, **154**, 155, **155**; majolica, 27, 64, **144**, 145, 148, **148**, 149, **149**, 152, **152**
 Spanish: collecting, 78; craft tiles, 64; decline in traditional, 66–67; design motifs, 68, **68**, 70; family-run business, 67; firing, 70; glazes, 26–27, 33, 63–64, 70; history of, 63–64, 66; influences on, 64, 69, **69**; modeling methods, 67, 70; *olla maja,* 74; Pickman (La Cartuja), 66; types, 24, 63, 66, 127, **127**; women-made, 33, 67, 70, 71, 74, 78
prints: Counter-Reformation, influence of, 37, 39; engravers, 38, 47; and freedom of press, 50; genre, 38, 39, 41, **41**, 42, **42**, 49, 50; grotesque, 48, **48**, 49; history of, 36–51; as illustrations, 38, **38**, 39, **39**, 40, **40**; *juegos galantes,* 47, 49; ludic, 39, 43; praise songs *(goigs),* 36, 37, 43, 176, **176**; propagandistic, 38, 43, 50, 51; religious, 38, 39, 40, 43, 51
Protestantism, 39, 168 n. 7
Puebla, Mexico, 27, 152, **152**, 179
Pueblo Indians, 168 n. 14
Puente del Arzobispo, Toledo, 24, 78; influence on Latin America, 27, 64; producer of classic pottery, 33, 64, 65, **65**, 71, 92
Puente Genil, Córdoba, 67, 75, 78
puppets, **128**, 129

Quart, Gerona, 74

reducciones, 151
reliquaries, 28, 142
retablos, 146
Ribera, José de: *Drunken Silenus,* 49; *Martyrdom of Saint Bartholomew,* 49
Ribesalbes, Castellón, 64, 92
Rodríguez Becerra, Salvador, 111
Rodríguez de Guzmán, M., 99; *Romería del Rocío,* **98–99**
Roman Empire, 24, 63, 82
Romanesque, 100
Rome, as pilgrimage site, 159
Royal Factory of La Moncloa, 66
Royal Porcelain Factory of the Buen Retiro, 66
Ruiz de Luna, Juan, 66

Sacred images: gold objects attached to, 183, **183**; "made without hands," 159, 160; relationship to pagan images, 161–62; as teaching tool of the church, 162, 186, 187
Saint Thomas, 135
saints: beneficial action worked by, 43, 96, 108; living, 165–66; as models of exemplary behavior, 143; personification of, 145–46; San Antonio de Padua, 96, 160, 183, **183**; San Bernardino, 162, 168 n. 9; San Blas, 43, 95, **96**, 145; San

Cristóbal, 119, **119**; San Francisco Javier, 160, 162, 164, 167; San Isidro Labrador, 46, **46**, 96, 169, **169**, 170, **170**, 171, **171**; San Ramón Nonato, 96, 106, **106**

Salamanca, 34, 89, 92

Salvatierra de los Barros, Badajoz, 71

San Xavier del Bac, Arizona, 164

Sandoval, Jerry, *Saint Isidore the Farmer*, **170**

Santa de Cabora. *See* Urrea, Teresita

Santiago (Saint James): adaptable image of, 156–57; in the Americas, 145; and myth, 156; and Nuestra Señora de la Barca, 181; representations of, 105; Spanish roots of, 156–57; warrior legend, 156

Santiago de Compostela, Galicia, 23, 159

sardana, 23

Second Vatican Council, 136

Señor Cristo de Zalameda, **188**

settles. *See* furniture

Sevilla, 43, 64

shepherds' art, 32, 56, **56**

Sobré, Judith, 28

Spain: cultural diversity of, 150; demographics of, 24, 31, 32; festivals of, 31, 95; fine arts of, 25; geography of, 31; history of, 24–25; Islamic, 24–25; politics of, 49–50, 51; uniqueness of, 31

Spain and New Spain (exh.), 27

Spanish Civil War, 50, 51, 111

Spanish War of Independence, 47, 49, 50

Stations of the Cross, as teaching tool, 186, **186**, 187, **187**

tables. *See* furniture

Talavera de la Reina, 27, 64, 65, 66, 71, 74, 78, 92

Tepeyac, Mexico, 160, 164

Teruel, 64, 77, **77**

textiles, 33. *See also* embroidery

Tiber River, 63

tinajeros (jar makers), 67

Tinta, Peru, 145

Tohono O'odham (Papago), 162, 164

Torredonjimeno, Córdoba, 108

Trapero, Maximiano, 136

Triana, Sevilla, 27, 64, 71, 73, 75

trunks. *See* furniture

Ubeda, Jaén, 75

Urrea, Teresita, 165–66, 168 n. 19

Utrera, Sevilla, 44, 111

Valadés, D., 142; *Fray Pedro de Gante Instructing Indians*, **143**

Valencia, 23, 31, 43

Valencia de Don Juan Museum, 78

Valencia Province, 88, 116–17

Vasco de Quiroga, Bishop, 151

Vázquez Soto, José María, 111

Velázquez, Diego, 25

Verge de la Mercé, 35

Verúd, Lérida, 74

Virgen de la Ayuda, **36**, 37

Virgen de la Consolación, 24

Virgen de Guadalupe: cult of, 161; ex-votos to, 163, **163**, legend of, 97, **97**, 100, 160; shrine, 164

Virgen del Rosario, 121; de Chichinquira, 183, **183**

Virgin Mary: apparition accounts, 95–96, 142, 179; in Assumption play of Elche, 135–36; cult of, 95; "dressed image," **158**, 159

Visigoths, 24, 108

Visiones del Pueblo (exh.), 23

votive art: history and origins, 107–9; maritime, **27**, 28, 114, **114**, 115, **115**, 118, **118**, 119, 122, 123, **123**; as offerings (*see* ex-votos); prototypes, 106–9.

votive paintings, 33, 100, **105**; on glass, 110–11; as source of cultural information, 106, 109–10; on wood, 110. *See also* ex-votos

Yoeme (Yaqui), 164

Zamora Province, 85

Zaragoza Province, 74

Zarzuela de Jadraque, Guadalajara, 70

Zurbarán, Francisco de, 25

Contributors

STANLEY BRANDES is former chairman of the Department of Anthropology at the University of California at Berkeley. He has conducted research in Mexico and Spain, including extensive investigations in Anadalucía, Cataluña, and Castilla. He is the author of *Migration, Kinship and Community: Tradition and Transition in a Spanish Village* (1975) and *Metaphors of Masculinity: Sex and Status in Andalusian Folklore* (1980).

ANDRÉS CARRETERO PÉREZ is assistant director of Spain's Museo Nacional de Antropología, in Madrid. He is a specialist in Spanish popular ceramics, and he has published and lectured widely on that subject.

MARÍA CONCEPCIÓN GARCÍA SÁIZ is senior curator of the Colonial Section of Madrid's Museo de América, which houses Europe's finest collection of Spanish colonial art. She has lectured all over the world and has published dozens of important articles related to her various specialties. Among her most important books are *El mestizaje americano* (1985), *Las castas mexicanas: Un género pictorico americano* (1989), and *Los Palacios de Nueva España: Sus tesoros interiores* (1990).

MARÍA DEL CARMEN MEDINA SAN ROMÁN is an art historian with Sevilla's Fundación Machado. Her specialty is Spanish folk art, with an emphasis on votive expression. She has published and lectured throughout Spain. Two of her most recent articles are "Religiosidad popular: Ex-votos, donaciones y subastas" (1989) and "Actualidad de los museos etnográficos en Andalucía (1995).

MARION OETTINGER, JR., is an anthropologist and senior curator of the San Antonio Museum of Art. He has conducted extensive anthropological and folkloric research in Mexico, Central and South America, and Spain. He has taught at Cornell University, Occidental College, the University of North Carolina at Chapel Hill, and the National Autonomous University of Mexico. Dr. Oettinger's most recent books include *Folk Treasures of Mexico: The Nelson A. Rockefeller Collection* (1990) and *The Folk Art of Latin America: Visiones del Pueblo* (1992).

MARÍA ANTÒNIA PÉLAUZY is a longtime collector of Spanish and international folk art. Owner of a legendary folk art store in the Gothic Quarter of Barcelona, Ms. Pélauzy has been at the center of Spanish folkway studies for over twenty-five years. She is best known for her valuable book *Spanish Folk Crafts* (1978), the only modern overview publication on the subject.

CARLOS PIÑEL is one of Spain's foremost collectors and authorities on folk art. Piñel oversees the Caja España's important collection of popular art in Zamora and is in charge of folkloric research in and around the region of Zamora. He has lectured widely, and his most recent publications include "El arte popular en el viejo Reino de León."

VICENTE RIBES IBORRA is an internationally recognized historian who is with the Universidad Internacional Menéndez Pelayo in Valencia. A native of Xátiva (well-known for its popular graphics), Dr. Ribes has spent the past ten years conducting research on historical currents between the Valencia region and Mexico and other parts of the Americas. He has done extensive fieldwork in Mexico and has published in and about that country. His publications are many and varied, and he has lectured all over the world. Dr. Ribes's most recent book is entitled *La industrialización de la zona de Xátiva en el context Valencia.*

WILLIAM WROTH was curator of the Taylor Museum in Colorado Springs between 1976 and 1983. Later, he served as project director and guest curator for the Hispanic Heritage Wing of the Museum of International Folk Art in Santa Fe. Dr. Wroth has published extensively and lectured widely on subjects related to art of the southwestern United States. Among his many books are *Christian Images in Hispanic New Mexico: The Taylor Museum Collection of Santos* (1982), *Weaving and Colcha from the Hispanic Southwest* (1985), and *Images of Penance, Images of Mercy: Southwestern Santos in the Late Nineteenth Century* (1991).

PHOTOGRAPHIC CREDITS

We wish to thank the following photographers, collectors, and institutions for providing photographic material and permitting its reproduction: The Brooklyn Museum, pl. 95; The Hispanic Society of America, New York, pl. 2; Tom Humphrey, pls. 1, 22, 61, 63–64, 80, 82; Meadows Museum, Southern Methodist University, Dallas, pl. 46; The Metropolitan Museum of Art, New York, pl. 96; Museo Nacional de Artes Decorativas, Madrid, pls. 23, 29, 41; Museu d'Arts, Industries i Tradicions Populars, Barcelona, pls. 28, 51, 56; Museu Marítim de Barcelona, pls. 5, 40, 52–55, 57–58; Gustavo Nacarimo, pls. 28, 51, 56; New Orleans Museum of Art, pl. 90; Marion Oettinger, Jr., figs. 1–3, 8–19; Miguel Angel Otero, figs. 4, 6–7, pls. 6, 19–20, 25–27, 31, 33, 47–50, 59–60, 67; Adolfo Sánchez de la Cruz, fig. 5; Valery Taylor Gallery, New York, pl. 94; Peggy Tenison, fig. 20, pls. 3–4, 7–18, 21, 24, 30, 32, 34–39, 42–45, 51–58, 62, 65–66, 68–74, 75, 78–79, 81, 83–88, 91–93, 97–100; August Uribe, New York, pls. 76–77; Philip Wrench, Houston, pl. 89.